Rembrandt

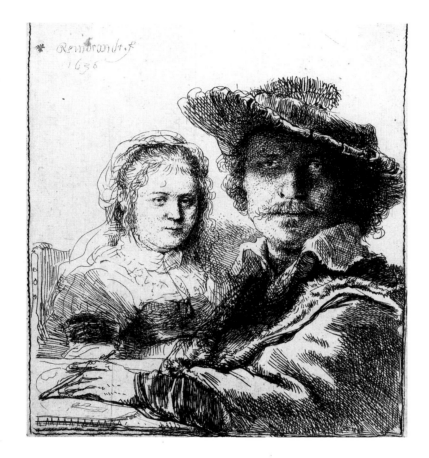

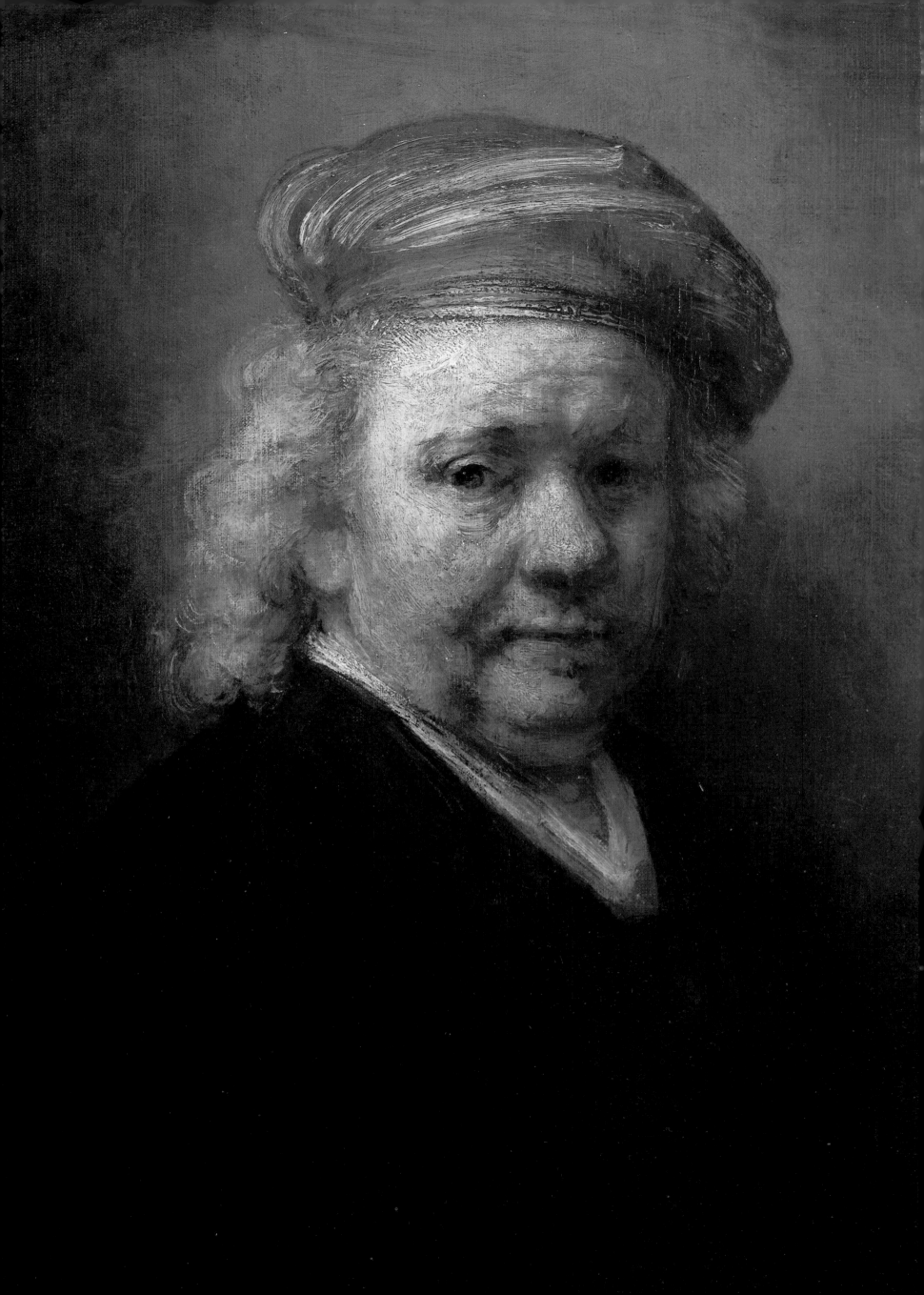

Rembrandt

CHRISTOPHER BAKER

CHARTWELL
BOOKS, INC.

Published by
CHARTWELL BOOKS, INC.
A Division of BOOK SALES, INC.
110 Enterprise Avenue
Secaucus, New Jersey 07094

Produced by
Brompton Books Corp.
15 Sherwood Place
Greenwich, CT 06830

ISBN 1-55521-856-3

Printed in Hong Kong

PAGE 1: Rembrandt *Self-Portrait with Saskia*,
1634, British Museum, London.

PAGE 2: Rembrandt *Self-Portrait* (detail), 1669,
The Mauritshuis, The Hague.

Contents

Introduction

A New Nation

The painter, printmaker, and draftsman, Rembrandt Harmensz. van Rijn, was born in the town of Leiden in 1606. His birthplace was at that time part of the newly created United Provinces of the northern Netherlands. During the artist's lifetime this young political confederation was to experience its greatest period of economic power and artistic activity, which is often with justification referred to as a 'golden age'. An outline of its emergence helps both to explain this vitality and to place Rembrandt within the culture in which he lived and worked.

Fifty years earlier, in the mid-sixteenth century, the whole of the Netherlands was administered on behalf of the rulers of Spain, the Hapsburgs, as part of their vast global empire. The Spanish kings, who saw themselves as defenders of the Catholic faith and Church, appointed regents to control the region, and maintain the supremacy of Catholicism.

Gradually during the second half of the century native opposition to this domination by a foreign power grew. At a local level resentment developed for a number of reasons, including awareness of the economic benefits which might be gained from greater independence, opposition to a centralized administration, and rejection of the imposition of Catholicism on a population which included many Protestants. This unease manifested itself in a number of uprisings, such as the *Beeldenstorm* or Iconoclasm of 1566, a popular revolt against Philip II of Spain's intolerance of Protestantism, which involved the destruction of many Catholic works of art.

As the rebellion gained momentum, an increasingly bitter war was waged against the Spanish military forces, who were initially led by the Duke of Alba. It started in 1568 and has become known as the Eighty Years' War,

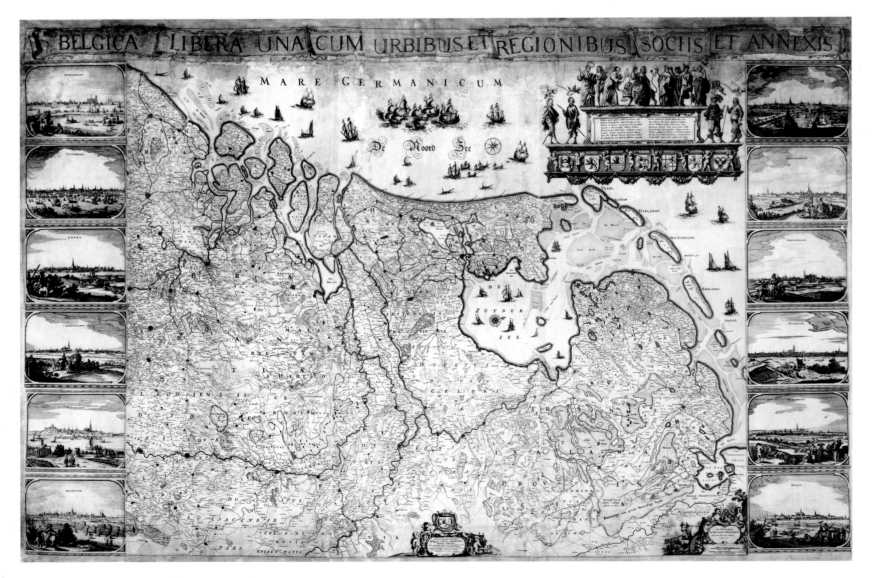

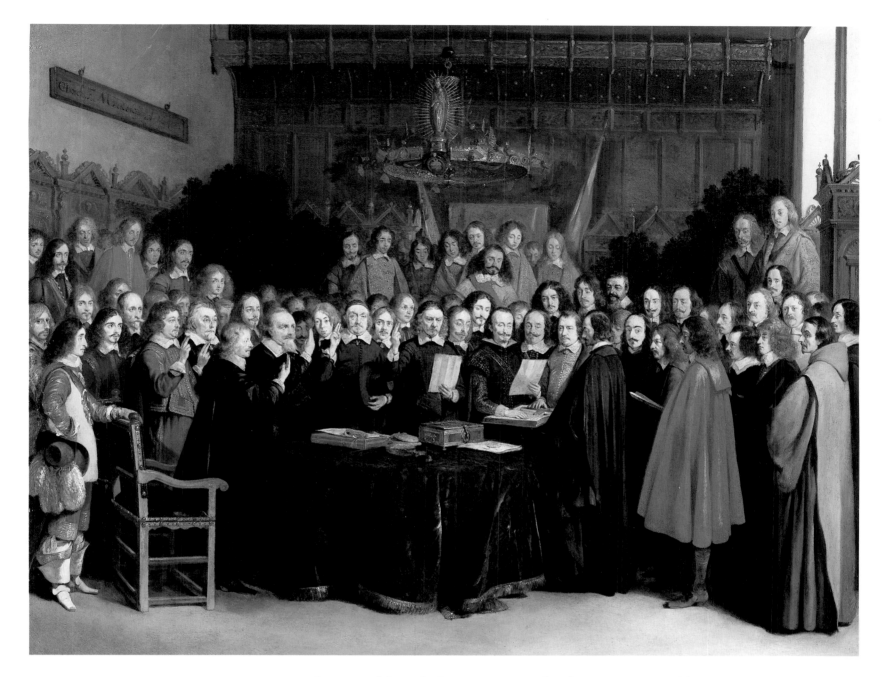

ABOVE Gerard ter Borch (1617-81) *The Swearing of the Oath of the Ratification of the Treaty of Münster, 15 May 1648,* 1648, oil on copper, 17¾ × 22¾ inches (45.4 × 58.5 cm), The National Gallery, London. The Dutch had fought to free themselves from Spanish dominance for many years, and their independence was only completely recognized by Spain when this treaty was signed. The Dutch delegates with their hands raised swear an oath, while the leader of the Spaniards, the Conde de Peñaranda, rests his hand on an open Bible. The artist has depicted himself at the extreme left, looking out at the viewer.

LEFT Nicolaes Visscher (1618-1709) *Map of the United Provinces,* 1667, Musée du Louvre, Département des cartes et plans, Paris. This map, like many of the region produced in the seventeenth century, shows north to the right. It is framed by twelve views of the most important cities in the Provinces; Amsterdam is shown at the left, second from the top.

because although there were periods of reprieve, such as the truce which lasted from 1609 to 1621, the struggle was only finally concluded by the Treaty of Münster of 1648. The second period of conflict, which lasted from 1621 to 1648, formed part of the broader European religious and political crisis known as the Thirty Years' War. Much of the fighting took place in Flanders, a region which is approximately covered by modern Belgium.

At first the Netherlands fought against Spain under the leadership of William of Orange-Nassau (1533-84), known as 'The Silent.' He attempted unsuccessfully to unify the seventeen provinces which formed the region against foreign domination, and was assassinated by an agent of the Spanish king, so becoming an important martyr for the cause of independence.

Although no single event is universally recognized as marking the foundation of the new nation which emerged from this struggle, perhaps the most important political break with the old regime came in 1579, when seven of the northern provinces (Holland, Zeeland, Utrecht, Gelderland, Overijssel, Friesland, and Groningen)

were joined by the Union of Utrecht to provide each other with assistance. Two years later they together renounced Philip II as their king. This confederation, which became the Republic, or United Provinces, evolved into what many have seen as the political and economic success story of seventeenth-century Europe.

It remained intact until the invasion of Napoleon in 1795, while the southern provinces, which had opted for Catholic allegiance, stayed under Spanish control until they passed to Austria in 1713.

The defeat of the Spanish Armada by the English in 1588 is often seen as an earlier symbolic marker of the further decline of Spain's prestige and power. The northern United Provinces took full advantage of this new situation. They blockaded the mouth of the river Scheldt, so closing access to the sea for Antwerp in the south. As a result, the economic strength of this city waned, and Amsterdam in Holland, the richest northern province, found a new role as the dominant trading center not only of the immediate seaboard, but also of northern Europe. The population of Amsterdam, where Rembrandt was to

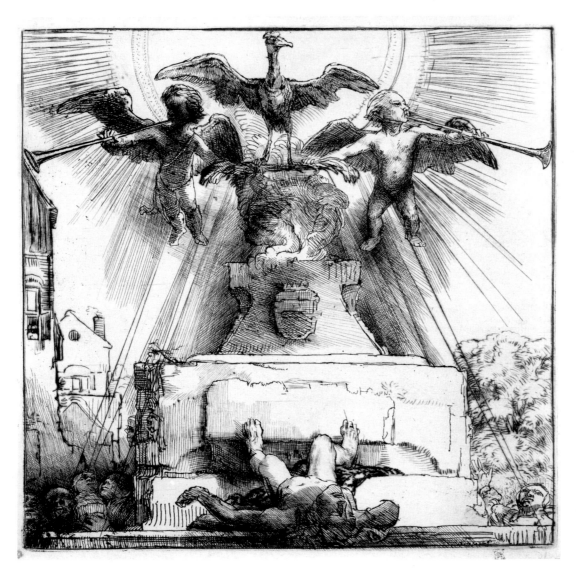

LEFT Rembrandt *The Phoenix, or The Statue Overthrown (An Allegory)*, 1658, etching and drypoint (only state), 7 × 7⅛ inches (17.9 × 18.3 cm), Museum het Rembrandthuis, Amsterdam. The phoenix rising from the pedestal is a symbol of resurrection; it appears to have triumphed over the statue which has fallen in the foreground. The meaning of this allegory is not entirely clear, and numerous theories which might explain it have been proposed. According to one of them, it could be intended as a political statement which refers to the victory of the Dutch over the Spaniards.

BELOW Rembrandt *View of Amsterdam, c.*1640, etching (only state), 4⅜ × 6 inches (11.2 × 15.3 cm), Museum het Rembrandthuis, Amsterdam. The city was the capital of Holland, the richest of the United Provinces. It grew during Rembrandt's lifetime to become the most prosperous center for trade in northern Europe. Here the artist shows a view of its skyline from the north-east, looking across the surrounding meadows.

RIGHT Jacob van Ruisdael, *View of the Amstel, Looking toward Amsterdam*, c.1675-80, oil on canvas, 20¼ × 25¾ inches (52 × 66 cm), Fitzwilliam Museum, Cambridge.

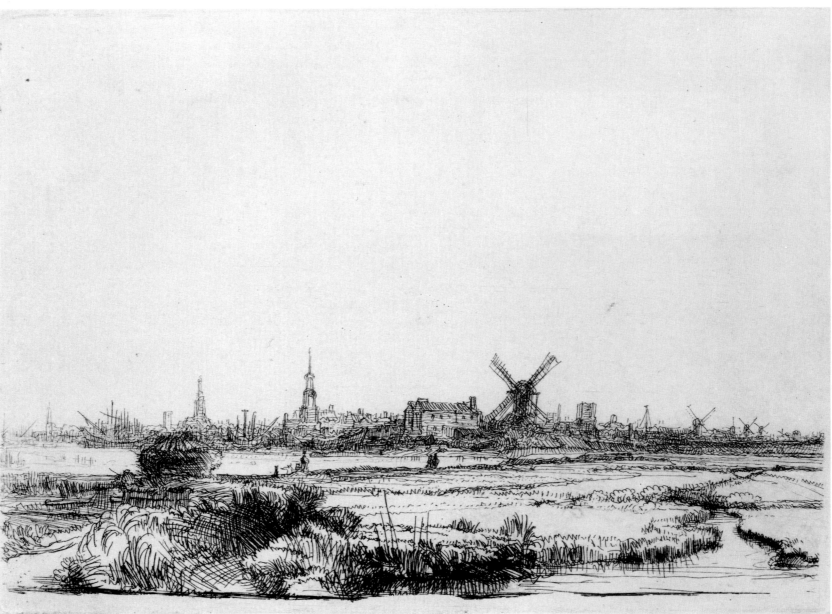

spend most of his life, reached about 150,000 by 1648.

The seven northern United Provinces, although retaining some of the nuances of their individual political organizations, were linked by various means. These included the States General, a form of assembly which was chiefly concerned with joint foreign policy. They were also unified in part by acknowledgment of the importance of the Stadholders, descendants of William of Orange-Nassau, whose 'court' was based in The Hague. These aristocrats held the title of captain-general of the union, and proved themselves as military leaders (pages 10-11).

Although their patronage of the arts was tame by European standards, and quite unlike that lavished in absolutist states such as France and Spain, it was not negligible. In terms of painting the stadholders mainly ordered works from southern Flemish artists, but Rembrandt was to be commissioned to paint an important series of religious pictures for their court. This episode provides a useful measure of the contemporary esteem the artist enjoyed early in his career.

Attempts at centralizing power by the Stadholders were checked by a number of forces. One of the most significant of these, in view of the fact that the population was predominantly urban, was the power of the cities. Artists tended to benefit from civic pride because an important way of expressing and focusing it was to commission public works of art that embodied communal values. Projects Rembrandt was involved with which can be linked with such ideals, include his contribution to the decoration of the New Town Hall in Amsterdam in the 1660s. Earlier the painter also executed a group portrait of a militia company, whose members helped defend the city, and officers of guilds who controled its economic life.

In religious terms, a state of tolerance characterized life in the United Provinces. Almost uniquely in Europe at the time, although Protestantism in its various forms dominated, the practice of other types of belief such as Catholicism and Judaism was allowed. This freedom attracted many immigrants, and in part at least resulted in the cosmopolitan nature of the society for

which the Netherlands is still known. It did not, however, extinguish controversy. There were, for example, fierce disagreements between different groups of Calvinists – the Remonstrants and Counter-Remonstrants, who diverged because of the relative severity of their faiths. Their animosity nearly resulted in the outbreak of civil war during the peace of 1609-21.

Before the creation of the United Provinces, the economy of the northern Netherlands tended to be based on a disparate range of fishing and farming communities. But during the 'golden age' economic power became increasingly concentrated on the prosperity of the predominantly Calvinist traders and bankers in the cities. Their commercial interests across the globe were to expand dramatically during the century, notably in the direction of the New World, and primarily as a result of the strength of the Dutch navy and merchant fleet. This growth began while Prince Maurits of Orange (1567-1625), the son of William 'The Silent' was Stadholder, and continued under the leadership of his younger brother, Frederik Hendrik (1584-1647).

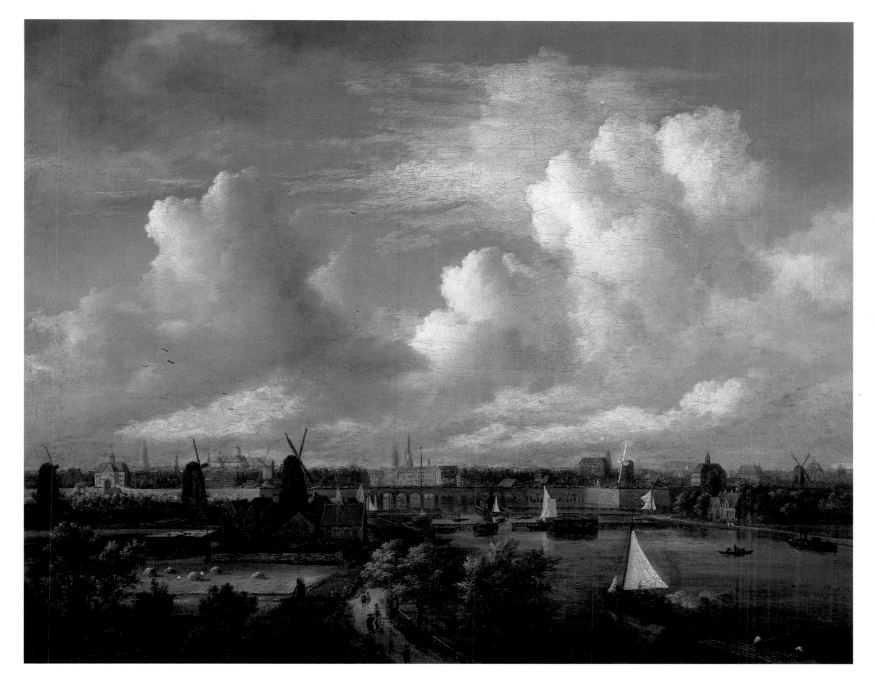

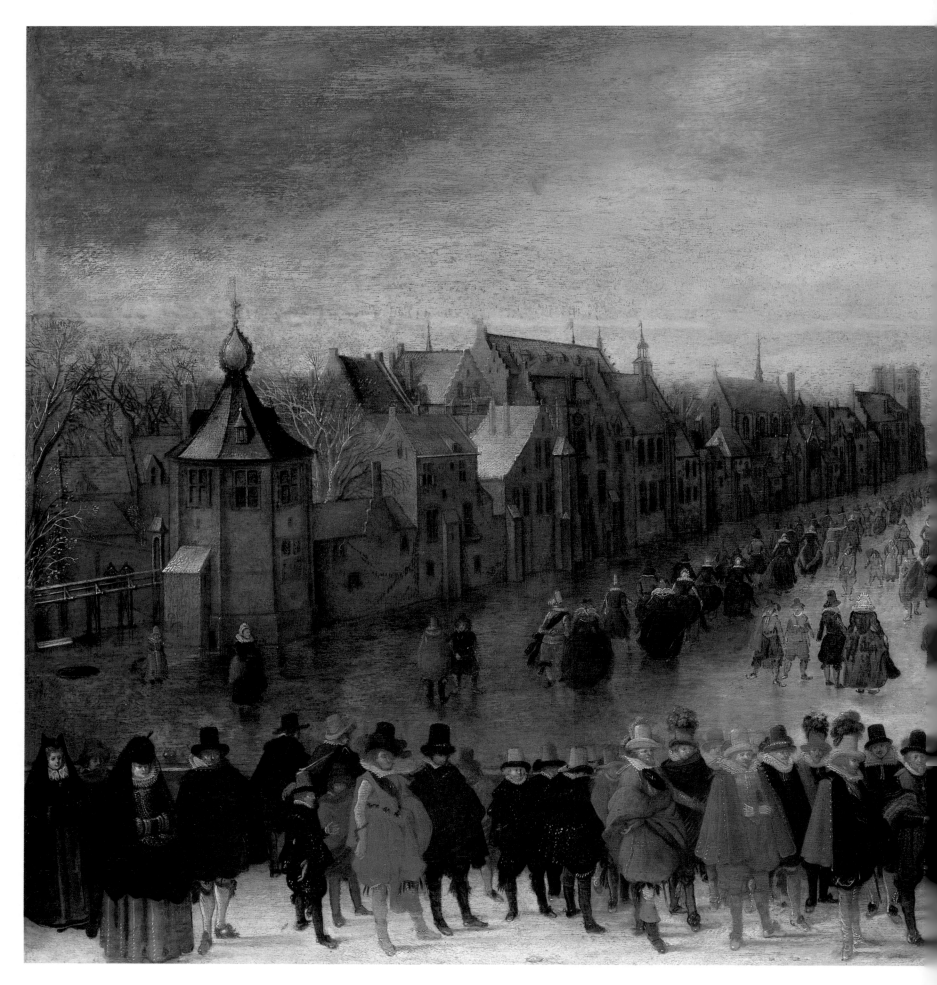

Adam van Breen, *The Vijverberg, The Hague, in Winter, with Princes Maurits and Frederik Hendrik and their Retinues in the Foreground*, 1618, oil on wood, 28 × 52⅛ inches (71.5 × 133.5 cm), Rijksmuseum, Amsterdam. The princes were sons of William of Orange-Nassau (1533-84). As Stadholders whose 'court' was based in The Hague, they were to provide military leadership for the northern United Provinces. Frederik Hendrik was also to become an important patron of Rembrandt. Here they are shown with a detachment of halberdiers and a retinue of pages.

In 1602 the Dutch East India Company was founded, and in 1621 the Dutch West India Company was established. Five years later Manhattan was acquired from the Indians; the new settlement there, New Amsterdam, was renamed New York only when the English took control in 1664.

In the early 1640s the Republic's concerns spread even further, when the Dutch navigator Abel Tasman discovered and named Tasmania and New Zealand. The income of a number of Rembrandt's patrons was intimately related to all these developments. They fostered wealth at home which could be spent among other things on the acquisition of paintings, and exotic imported merchandise, such as porcelain and carpets. Such luxuries were used to decorate the patrician, canal-side houses in Amsterdam and The Hague.

One significant qualification ought, however, to be added to this impression of untroubled economic buoyancy. Boom was followed by

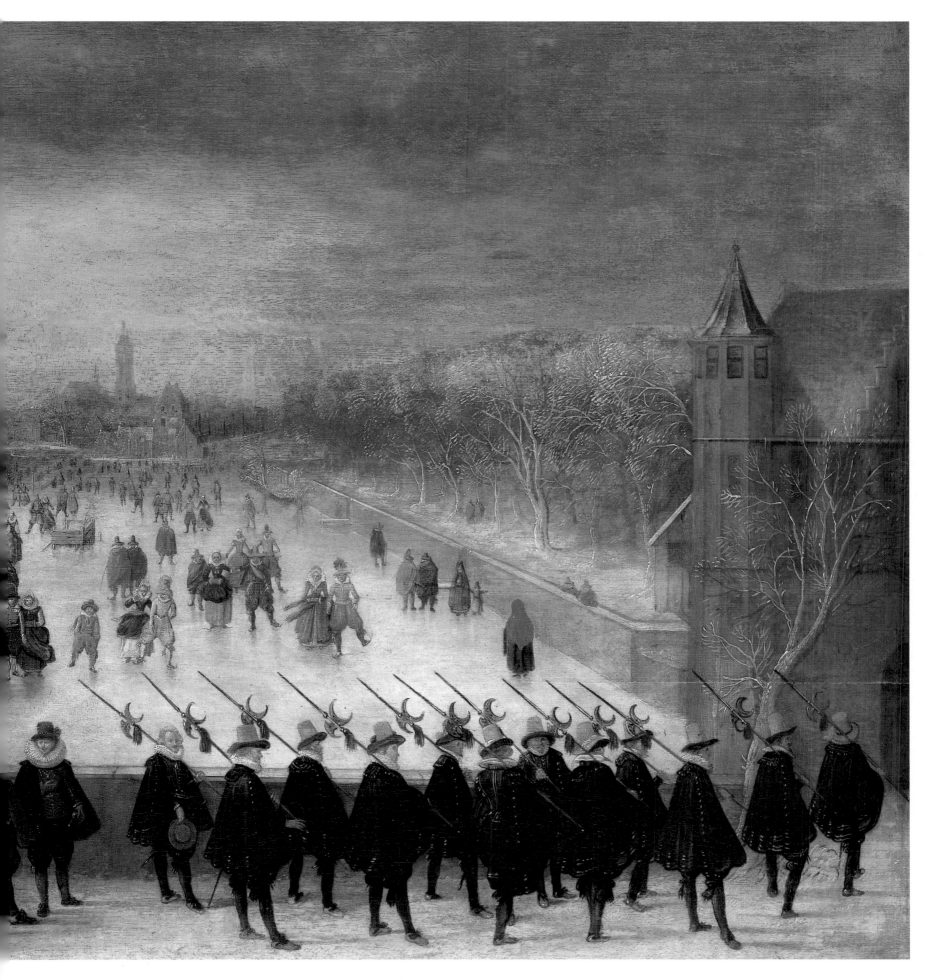

periods of slump, notably in the 1650s, partly as a result of waging wars over colonies. Many people, including Rembrandt, were quite directly and disastrously affected by the consequences of such shifts in fortune.

The Art Market

The strength of international trading networks, such as those outlined above, was mirrored by that of domestic ones, which included a lively market for paintings and prints. There appear to have been few social barriers to their ownership; amazed early seventeenth-century English travelers record that paintings could be seen even in the most humble dwellings, and that they were freely traded at markets across the Provinces. According to John Evelyn, who visited Rotterdam in 1641:

. . . 'tis an ordinary thing to find, a common farmer lay out two or three thousand pounds in this commodity [ie paintings], their houses are full of them, and they sell them at their kermesses [fairs] to very great advantage.

Here paintings are described as an investment, a commodity into which excess capital could be transferred, or from which it could be realized. Some truth lies behind this estimation of how they were perceived, but they also served, more importantly in a great many instances, a large variety of other

11

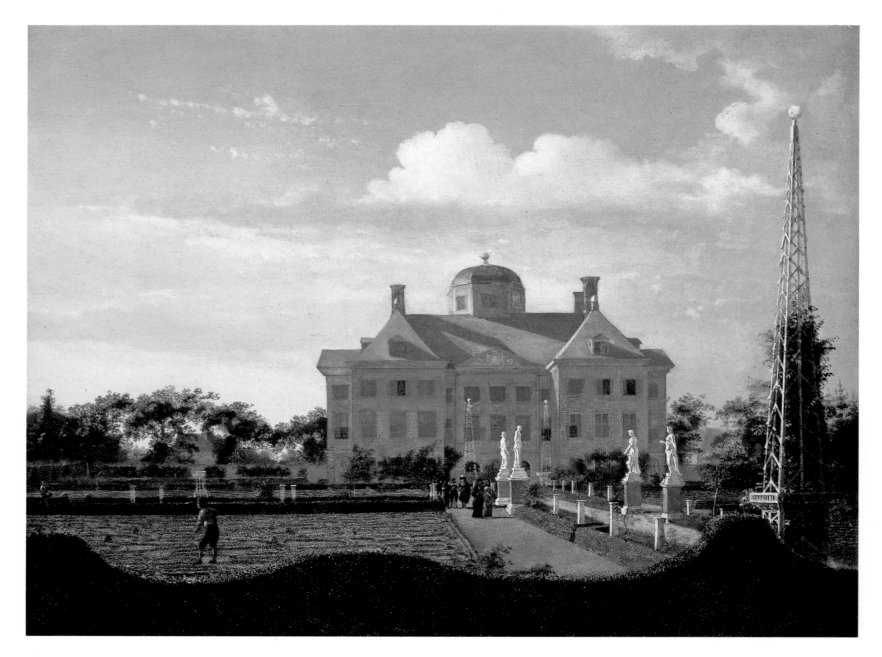

– aesthetic, decorative, religious, didactic, and commemorative – needs.

The extent of this demand meant that there was work for a great many painters. Rembrandt appears to have taken advantage of this exceptional situation by maintaining a very active studio, providing himself with additional income through the training of others, and spreading his ideas and techniques. One of the results of this process is that it is now often very difficult to discern the differences between the work of the master and that of his numerous pupils and assistants.

Although many pictures were produced for the open market, commissions were also made, principally for portraiture in its various forms. These came both from individuals and, as has been mentioned, civic bodies. Because there was virtually no native aristocracy, apart from the members of the House of Orange, those who could afford to have their portraits painted tended in the main to come from the urban merchant and regent classes.

Rembrandt initially secured success in Amsterdam as a portraitist. He painted single and double family portraits for domestic contexts, and group portraits for more public consumption.

The cost to the patrons was dependent upon the size, format and complexity of the work, as well as the reputation of the artist.

Religious paintings were produced for private individuals, but commissions for them tended not to be forthcoming from the Reformed Church, because unlike the Catholic hierarchy, it favored undecorated interiors for its buildings. As a result the artist Samuel van Hoogstraten could complain in his book on painting of 1678, that 'The best careers [for painters], that is [in] the churches, no longer exist.'

The religious pictures Rembrandt painted were mostly relatively small narratives, rather than large, static devotional images, which were intended for collectors. He also drew on historical and mythological sources in order to produce such paintings. Narrative works with all of these different types of subjects (Biblical, historic, and mythic) are collectively referred to as 'history paintings'. These types of images are more fully discussed later when early influences on the artist are considered (see pages 20-21).

A vast quantity of pictures which reflected the environment in which they were created was also produced in the Netherlands during Rembrandt's lifetime. These included landscapes, cityscapes, everyday interiors of all classes, and still lifes. Artists tended to specialize in one or other of these types of painting. Rembrandt himself experimented at various times with these different forms, but essentially remained a portrait and history painter. His work can never be simply categorized, however, because he frequently developed complex cross references between different categories of images, so creating 'historiating' portraits, and placing self-portraits in history paintings.

As well as there being differences in the subjects in which artists specialized, there was also variation in terms of the stylistic traditions within which they worked. The maintenance and development of such trends was in part dictated by where painters were active. The artistic identities of regions and cities were to a certain extent dependent upon the qualities of the principal painters working there, and were sustained by the way in which painting, like other economic activities, was subjected to local protectionism; artists, like stonemasons or barrel makers, usually had to belong to a civic guild in order to practice and teach.

LEFT Jan van der Heyden (1637-1712) *The Huis ten Bosch at The Hague*, c.1668-72, oil on wood, 8½ × 11⅛ inches (21.6 × 28.6 cm), The National Gallery, London. This residence was built in 1645-52 for Amalia van Solms, the wife of the Stadholder, Prince Frederik Hendrik.

BELOW Jan van der Heyden (1637-1712) *View of the Westerkerk, Amsterdam*, 1660, oil on oak, 35⅜ × 44¾ inches (90.7 × 114.5 cm), The National Gallery, London. This serene townscape shows a view of the Westerkerk (built 1620-31), one of the major Protestant churches in Amsterdam, in which Rembrandt was buried in 1669. Van der Heyden has painted it, and the surroundings, with an extraordinary attention to detail that is characteristic of his works; on one of the boards which protect the young trees in the foreground can be seen a poster that advertises a sale of paintings.

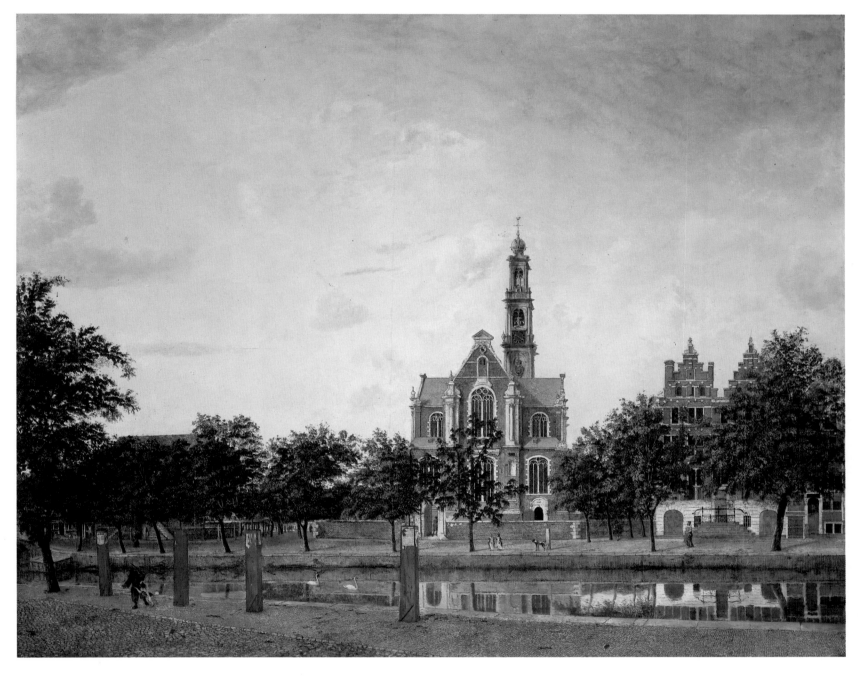

Towns and cities in the Republic were far from isolated. Communications, notably via waterways, were relatively efficient, and traveling artists spread innovations. Rembrandt moved from his home in Leiden to Amsterdam, initially because he wanted to be trained by a particular painter who was active there, and later because the market for paintings in the city was altogether more profitable.

Paintings themselves were also transported at this period, not just across the Republic, but also across Europe. This meant that artists had opportunities when visiting either private collections or auctions to be exposed to works from a whole variety of different sources. Rembrandt took advantage of these opportunities and appropriated a number of ideas as a result of such encounters.

The most affordable and easily transportable works of art were drawings and prints. These also provided inspiration to working artists and helped disseminate new ideas to a very wide constituency. Rembrandt certainly benefited from this dialogue as well; he collected prints by people he admired, and the sale of his etchings resulted in the spread of his own reputation across the continent.

The Early Years, 1606-25

Leiden, 1606-23

Leiden (below), where Rembrandt was born, is situated south-west of Amsterdam on a branch of the Rhine. The city traditionally produced and traded in cloth and beer. It still retained at the outset of the seventeenth century medieval walls, which encircled a population of 40-45,000 inhabitants.

It had played a significant and symbolic role in the struggle against Spain for independence, and some of the consequences of this process helped formulate the character of the city the artist would have known. In 1573-74 Leiden was besieged by the Spanish, and it was not saved until October of 1574 when William of Orange-Nassau broke the dikes, so flooding the surrounding countryside and enabling a Dutch fleet to sail up to the city walls. Because of the fortitude

of the citizens, William granted Leiden the right to establish a university, which in the seventeenth century was to become a very important center of learning. It attracted scholars from across Europe, including the French philosopher Descartes.

Artistically the city had quite a prestigious history, although by the time of Rembrandt's birth it was not a notable center for painting. The work of Lucas van Leyden (active 1508, died 1533), a painter, engraver and designer of stained glass who knew Dürer, marked an earlier high point. Profiles of such artists were included in a guidebook to Leiden which was written by the local burgomaster and bookseller Jan Jansz. Orlers (1570-1646), and published in a second edition in 1641. This text also contained information about notable contemporaries, and includes the first known biography of Rembrandt.

Although tantalizingly short, it forms the basis of any consideration of his early years and education in the city. The sparse facts it provides have been complemented by art historians with documentation (notices of burials and baptisms, and records of buying works of art and property) and informed conjecture based upon knowledge of contemporary attitudes and schooling.

Lives of the Artist

In addition to using the work of Orlers and related documentation, it is possible to extract information on the life of the artist from biographies and commentaries published after his death, of which these are the most important:

Joachim von Sandrart (Nuremberg, 1675)
Samuel van Hoogstraten (Rotterdam, 1678)
André Félibien (Paris, 1685)

LEFT Pieter Bast *Map of Leiden*, 1600, engraving, 14⅝ × 17⅛ inches (37.5 × 44 cm), University Print Room, Leiden. Leiden was, at the time of Rembrandt's birth in 1606, the second-largest city in the United Provinces, after Amsterdam.

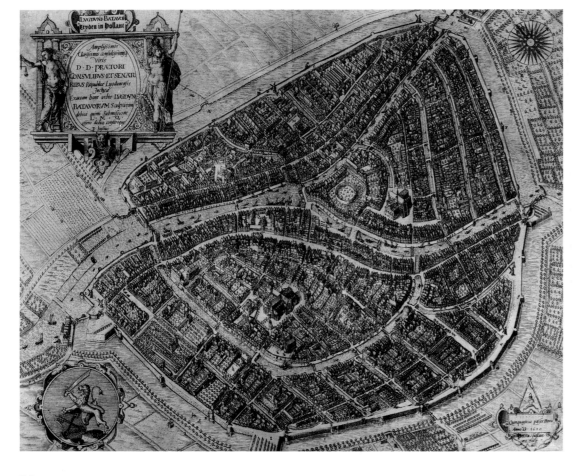

RIGHT Hendrick van den Burgh *Graduation Ceremony at the University of Leiden*, c.1650, oil on canvas, 28 × 23 inches (71.5 × 59 cm), Rijksmuseum, Amsterdam. The painting is signed at the center on the parapet: *HUB* (in monogram). A young doctor with two professors emerge from the gateway. In 1620, at the age of 14, Rembrandt was recorded as a 'student of literature' at the university, which was a major center of learning in the United Provinces, to which scholars from across Europe were attracted.

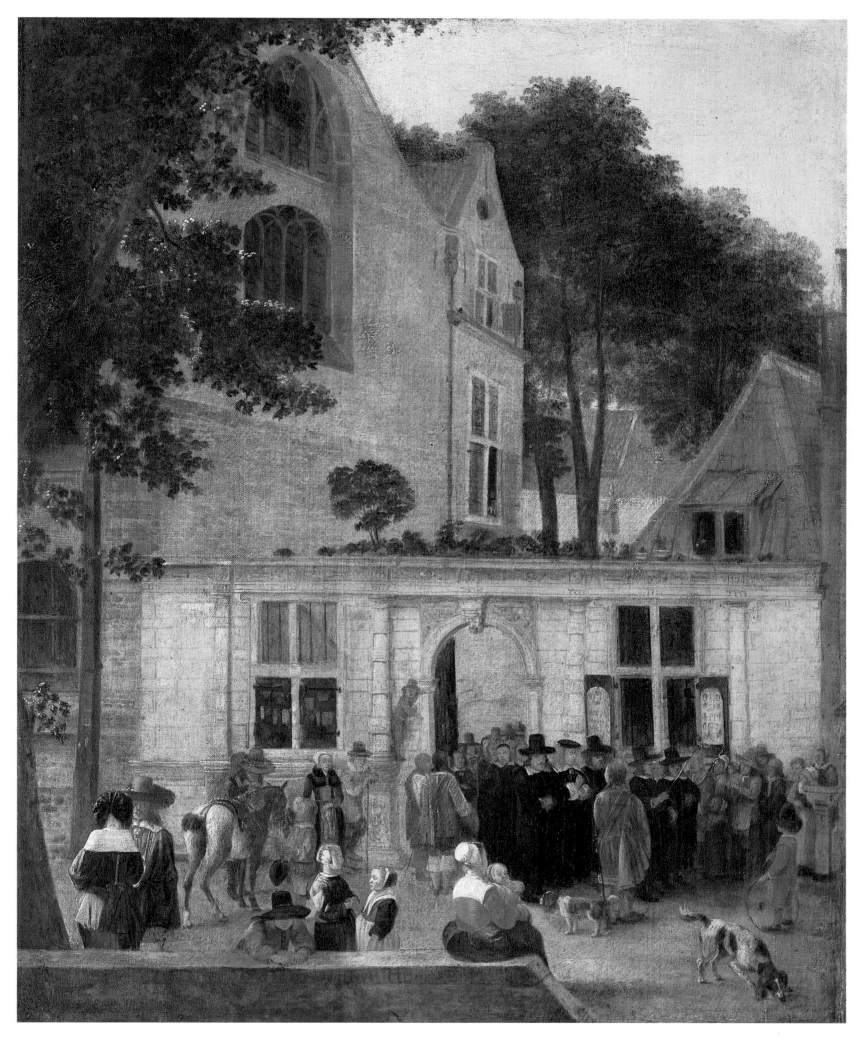

Filippo Baldinucci (Florence, 1686)
Roger de Piles (Paris, 1699)
Gerard de Lairesse (Amsterdam, 1707)
Arnold Houbraken (Amsterdam 1718, 1719 and 1721)

These tend to reveal as much about the particular preoccupations of their authors, as about the subject under scrutiny, and become encrusted with legend the further they are removed from Rembrandt's lifetime.

Some of the more reliable material can, however, be derived from the writings of students of Rembrandt, or those which are based on their testimonies. Hoogstraten was one of his pupils, and Baldinucci's biography relies upon in-formation given to him by Rembrandt's apprentice Bernhardt Keil (who had departed from Amsterdam by 1651). Houbraken was in turn a pupil of Hoogstraten.

By contrast Sandrart was a German writer and artist who had worked in Amsterdam in the late 1630s. He would probably have had direct contact with

Rembrandt's work, but his discussion of it is colored by his own classicist outlook.

André Félibien and Roger de Piles were both French connoisseurs who brought their academic theories to bear on the work of the artist. De Piles lived for a time in the Netherlands, and is perhaps most famous for his *Balance de Peintres* of 1708, in which he awarded past masters marks for composition, drawing, color, and expression. According to his tabulation Rembrandt scored a total of 50, while Rubens and Raphael achieved a spectacular 65 each.

With the biographies of the later eighteenth century which were based upon these studies, the cult status of the artist developed further, and it becomes progressively more difficult when looking at them to discriminate between fact and myth.

Rembrandt's Youth

Rembrandt Harmensz. van Rijn was, according to Orlers, born on 15 July 1606. No record of his baptism has been found. He was the ninth of ten children, only four of whom survived to adulthood. His father, Harmen Gerritsz. van Rijn was a miller like all of his forebears, while his mother, Cornelia Willemsdochter van Zuytbroek, was the daughter of a baker. The name van Rijn is thought to derive from the description given to one of the family's mills, which was situated close to the river Rhine.

Rembrandt's parents were married in 1589 in the Calvinist Pieterskerk, which was one of the two major churches in Leiden, where they, along with all the artist's brothers and sisters, were also to be buried. As such they can at least nominally be regarded as Calvinists. The nature of Rembrandt's own religious beliefs, however, remains a matter of debate. He has also been described as a Calvinist, but his adult acquaintance included people from various religious groups, and later in life he was to ignore the dictates of the Reformed Church. The evidence of his works would suggest, however, that the artist had closely studied the Bible, and deeply contemplated the nature of his faith.

The van Rijn home was on the Weddesteeg, not far from the wall which skirted the edge of Leiden. Very close to their house and within the city fortifications were two windmills that had belonged to members of the family, conspicuous symbols of the means by which they made their money. The wealth of the family can be judged by looking at Rembrandt's mother's will. She died in 1640 and left a little less than 10,000 guilders, which in contemporary terms was quite a considerable sum. It was to be divided between her four heirs – Rembrandt himself, his sister Lysbeth, and their brothers Adriaen, who was by that time a shoemaker, and Willem, who had continued the family tradition and become a baker.

That a painter should come from such a non-artistic background may seem odd, but was not entirely untypical. There certainly were many families of painters in the Netherlands in which training and styles were passed on from generation to generation (as was the case, for example, with the Cuyp, Ruysdael, and van de Velde clans). But a number of significant Dutch artists of the period, such as de Hooch and Fabritius, were the children of quite disparate parents – their fathers were a mason and schoolmaster respectively. What links all of these men, and most painters of the period, is that they tended to come, like Rembrandt, from a middle-ranking, trade, craft or professional background, rather than any higher or lower in the social structure.

Rembrandt's education may have started when he was about six years old in 1612; in that year he was probably sent to a city school to learn to read and write. The first mention the biographer Orlers makes of it is a reference to learning Latin, which the young artist would have done subsequently at the Leiden Latin School, near the Pieterskerk, which he probably attended from about 1615 to 1619. Latin was the language of scholarship and legal matters, and a knowledge of it was a prerequisite for entering the city's university.

The exact duration of Rembrandt's schooling has not been established, but it appears that it was cut short because according to Orlers, who said that his parents wanted him to progress to the Academy (ie. university) after having learned Latin:

He had not the least urge or inclination in that direction, because his natural talent was for painting and drawing only. His parents had no choice but to take him out of school and, as he wished, apprentice him to a painter.

Because of the absence of any other sources we have to take Orlers' word. But it should perhaps be noted that it had become something of a convention in artist's biographies by the seventeenth century to describe the subject in question as a single-minded prodigy who displayed a 'natural' inclination for art almost from infancy. In addition it is worth remembering that this biography is filtered through the pen of a man who took pride in his native city and its sons.

Rembrandt's apprenticeship as a painter probably started around 1619/1620, when he was 14 years of age. What confuses matters at this point is that in May 1620 he is documented as a student at the university. It is surmised that he was taken out of the Latin School before completing his work there, but had acquired enough knowledge of Latin to enter the university. He may have registered as a student

while working as an apprentice because the academic status brought with it advantages, such as exemption from certain taxes and service in the civic guard (Schwartz 1985).

It is impossible to estimate with accuracy the extent of Rembrandt's pre-apprenticeship education. But a few surviving letters by him, and inscriptions on works, certainly attest to his literacy, and it can be inferred from his paintings and graphic output that he was able to interpret carefully numerous texts which were used as sources. In addition to this we know he owned a variety of books (some were listed in an inventory of 1656), and that included among his adult circle of friends and patrons were a number of learned figures.

A First Apprenticeship

[His parents] brought [Rembrandt] to the able painter Jacob Isaacsz. van Swanenburg for instruction and training. He stayed with him for about three years, during which time his progress was so great that art-lovers were amazed.

Orlers, 1641

Unfortunately nothing is known of Rembrandt's work from this period, so no estimate of his 'progress' at this stage can be made, but paintings by Swanenburg survive, and information about contemporary training can be gleaned from various sources.

Jacob Isaacsz. van Swanenburg (1571-1638) was from a prominent local family. He was a son of the artist, Isaac Claesz. van Swanenburg (1537-1614), who had been the most important painter in Leiden in the later sixteenth century. Perhaps most notable among his father's achievements is the fact that Isaac was the master of Otto van Veen (1556-1629), who had in turn taught the greatest painter of the period from the southern Netherlands, Peter Paul Rubens (1577-1640). Jacob's brother, Willem (1580-1612), produced the first engraving after a Rubens painting.

Jacob Isaacsz., Rembrandt's master, is an artist who unfortunately we know relatively little about. It appears that he traveled to Rome and Naples and specialized in depicting street scenes, architectural views, and nocturnal occult subjects.

An example of this third type of work, which is still in Leiden, is his *The*

Sibyl showing Aeneas the Underworld (above). Such dark visions of hell illustrate the appeal which the works of Hieronymous Bosch (*fl* 1474-1516) clearly held for him. In view of the fact that he painted works of this type it is perhaps not surprising that one of the few pieces of information we have about the career of this peculiar man is that he was castigated by the Inquisition in Naples for having sold a painting of a witches' sabbath.

Rembrandt, who was still probably living in his parents' house while attached to Swanenburg, appears not to have adopted any stylistic influence from his paintings. Later works by him show absolutely no association with them. His next master was to have a far greater influence in such matters, but it must have been from Swanenburg that the young painter learned the rudiments of painting, in terms of preparation and procedure. What this may have meant in practice it is possible to reconstruct, at least in part, from contemporary texts on an artist's training, a few surviving images which record aspects of the process, and evidence provided by modern technical analysis of works of the period.

RIGHT Michelangelo Merisi da Caravaggio (1573-1610), *The Supper at Emmaus*, c.1598-1602, oil on canvas, 55 × 76⅝ inches (141 × 196.2 cm), The National Gallery, London. Works by Caravaggio such as this, with their clear bright colors, dramatic lighting, and emphatic gestures, were a powerful influence on the paintings of Rembrandt's teacher, Pieter Lastman. Through him, and other followers of Caravaggio who returned from Italy to the Netherlands, Rembrandt acquired a knowledge of such precedents.

An artist's training at this time was not strictly ordered, and heavily depended on the attitudes of the master to whom the apprentice was attached. The process would involve watching, initially carrying out mundane tasks and gradually being allowed to take on additional responsibilities.

A painter would have to learn how to choose the support for a work. The majority of Rembrandt's early works are painted on oak panels. They were probably bought, rather than being made by the artist, and conform in many instances to standard sizes. Only on rare occasions did Rembrandt, during his formative development, use other supports, such as paper and copper. Later he used wood, paper mounted on wood, and canvas stretched over a frame.

While a pupil, and during his independent development, an artist would acquire a knowledge of the properties of different supports. Copper, for example, could only be used for small works, but would provide a very smooth surface upon which to paint, while canvas, because it is relatively lightweight, was the only practical support for very large projects. More subtle decisions would also probably have to be made about the fineness of the weave of a canvas; personal preference and the nature and cost of the commission would be factors.

A support had to be primed before being used. This would seal it and ensure that a suitable surface was ready to be painted on, and was just the sort of task that a pupil might be expected to carry out, that is assuming the support had not already been bought prepared. The priming would first probably involve applying glue and then covering this with a mixture of chalk and glue (the ground) which could be smoothed down. This might then be followed by a thin covering of paint. Every choice made about the structure of the work in terms of color and texture from the support upward was likely to have an effect on its finished appearance.

The type of paint Rembrandt and his contemporaries used was made from a combination of a medium (natural oils, such as walnut or linseed) and ground pigment, which provided the color and came from various mineral or vegetable sources (eg lead white, which was manufactured, and naturally occurring substances such as earth pigments which could be used for reds and browns).

The process of grinding the pigments and mixing them with the oil would probably take place in the studio and be carried out by pupils or assistants, although there is some evidence to suggest that commercial suppliers of ready-prepared pigments were emerging in the seventeenth century. The choice of paint would be loaded onto a palette and the composition thinly established before being worked up. Working out compositions was sometimes done by Rembrandt on paper, but it appears that more often he developed his ideas, frequently changing them quite radically, actually on the panel or canvas. X-rays of his work reveal these alterations.

He must have had to learn and exploit the properties of different types of paint. Paint which consisted of a fair amount of medium as opposed to pigment could be used in thin layers to create glazes, while that which was rich in pigment might be employed for building up thick impastoed regions where strong color accents or heavily textured details were required.

An artist's training would not simply be of a technical nature; the development of such knowledge would run alongside its practical application. Pupils' skills at draftsmanship would be tested by drawing after models and casts in the studio, and possibly depicting scenes outside. They then might be allowed to contribute to unimportant areas of a work, and slowly be given more responsibility, until it became apparent that they were sufficiently competent to work alone.

It is clear that Rembrandt's technical and artistic facility evolved as he practiced later as a master in his own right, but the foundation for it must have been established, as was traditional, in the studios of others. Rembrandt's parents would have had to pay for his training; in spite of the fact that the artist was probably living at home, it may have cost as much as 100 guilders a year, which is what the painter himself is recorded as charging for tuition in 1630.

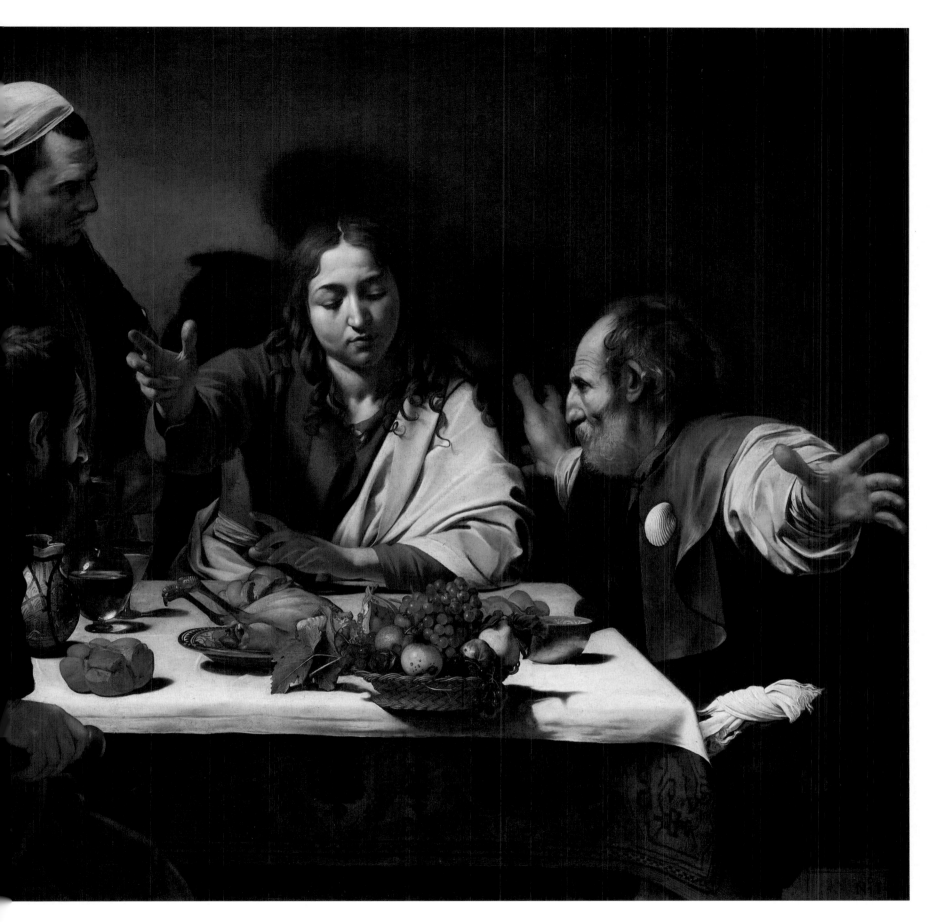

Amsterdam and Lastman, 1624

It was clear that [Rembrandt] was going to become an outstanding painter.

His father consented to take him to the famous painter [Pieter Lastman], who lived in Amsterdam, for more advanced and better instruction.

Orlers, 1641

Orlers was here writing with the luxury of having seen Rembrandt enjoy almost a decade of success in Amsterdam, so could assert with confidence that it had been predicted that he would move on to greater things. But the young artist must have made quite an impression in order to justify his further spell of training, which lasted for about six months, and attachment to Pieter Lastman who was at the time a leading painter.

Lastman is thought to have been born in Amsterdam around 1583. After some tuition he traveled to Italy, where he had arrived, according to the biographer van Mander, by 1604. He appears to have remained in southern Europe for only about three years, but his experiences there were to be fundamental to his own development and that of his pupils, such as Rembrandt.

It was to Rome that the artist was drawn – a city irresistible at the time to painters from all over Europe. The attraction for many was the potential for patronage from the vast papal court, but also, perhaps more importantly, the opportunity to experience past artistic glories and exciting contemporary developments. A large community of immigrant artists was inspired by the climate, the classical heritage of the surroundings, the work of the revered masters of the early sixteenth-century High Renaissance, and current trends.

Lastman was most strongly inspired by the work of two artists who were painting in Rome while he was there – Elsheimer and Caravaggio. Adam Elsheimer (1578-1610) was a German miniaturist painter and printmaker,

RIGHT Meindert Hobbema (1638-1709) *A View of the Haarlem Lock and the Herring-Packers' Tower, Amsterdam, c.*1663-65, oil on canvas, 30 × 38¼ inches (77 × 98 cm), The National Gallery, London. Dutch flags can be seen fluttering in the breeze on some of the masts in the background.

BELOW Pieter Lastman, *Christ on the Cross*, 1616, oil on canvas, 35⅜ × 53¾ inches (90.5 × 137.5 cm), Museum het Rembrandthuis, Amsterdam. Lastman, the leading history painter in Amsterdam, was Rembrandt's second master. His works, which were notably influenced by the paintings of Elsheimer and Caravaggio, were to inspire the young artist. Rembrandt first sought to emulate and then to surpass such models.

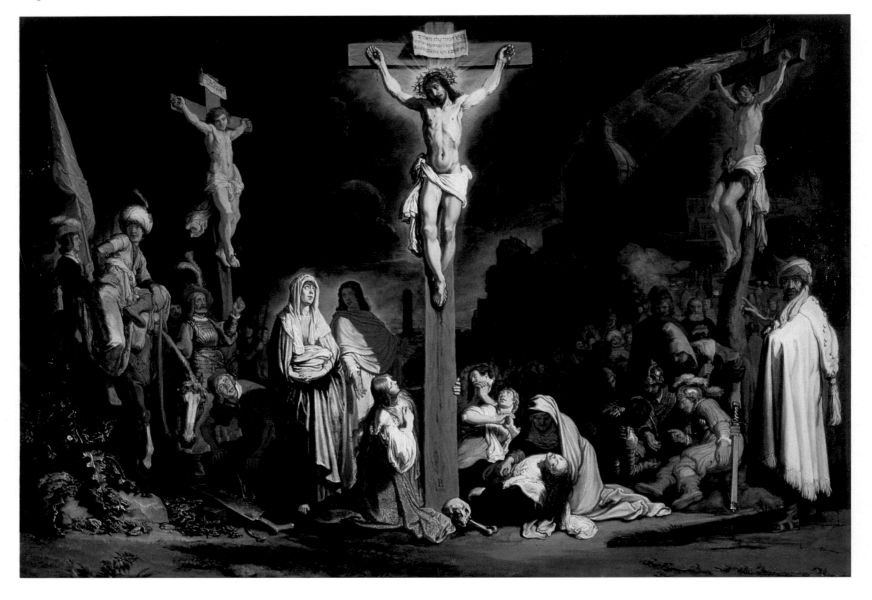

who, with the brilliant colors, inventive compositions and evocative landscapes of his precise works (page 23), had a wide appeal.

The Lombard painter Michelangelo Merisi da Caravaggio (1573-1610), by contrast, worked on a larger scale and became famed for the novel drama, 'realism', and theatrical lighting of his paintings (page 18/19). The way in which he manipulated contrasts of light and dark (*chiaroscuro*) to create a sense of movement, establish a mood, or develop the narrative, was to prove an inspiration to artists from all over Europe who came into contact with his work.

Rembrandt's link with such developments, which were to have a profound influence on his art, came through men such as Lastman, and the work of other Dutch artists who had returned from Rome and reinterpreted the new visual language Caravaggio had created. A notable community of such painters (*Caravaggisti*) worked in the city of Utrecht (eg Hendrick Terbrugghen, 1588-1629, Gerard van Honthorst, and Dirck van Baburen, c.1590-1642).

Both Caravaggio and Elsheimer painted what came to be known as 'History Paintings' – narrative works which depict elevated subjects from re-

ligion, mythology, or history, rather than more mundane themes. Such pictures often had a clear didactic function, and included a number of figures who were appropriately depicted in view of their roles, and whose actions and appearance could be clearly 'read' by the viewer. They were regarded as the most demanding and consequently the most prestigious type of work an artist could undertake.

History paintings (from the Italian *istoria*) were initially praised in the fifteenth century by the Florentine humanist Leon Battista Alberti (1404-72). His ideas were reinterpreted in the

Netherlands at the outset of the seventeenth century by the artist and writer Carel van Mander in his guide for painters, *Het Schilder-Boek*, which was published in 1604. Van Mander advised artists to work after the Italian model and concentrate on the

perfection of figures and histories ... [while relegating] ... Animal pictures, kitchen pieces, fruit still lifes, flower pieces, [and] landscapes.

Many of Rembrandt's contemporaries did not take such advice, and as a result a number of the most spectacular artistic products of the period are, for example, paintings of landscapes and still lifes. However, he had been taught by an artist grounded in the Italianate tradition, and can be categorized as a 'history painter.'

The artist did not exclusively produce such works, and by no means slavishly copied examples of them from southern Europe, but they form a significant part of his output, and because of the respect they engendered were probably an important element in terms of his expectations of prestige.

Such prestige was enjoyed by Lastman, who is recorded as having re-turned to Amsterdam from Italy by March 1607. As far as is known he lived in the city until his death in 1633, and enjoyed a very successful career as a painter and teacher, who could count among his many patrons King Christian IV of Denmark. Lastman's *Christ on the Cross* (left) of 1616 effectively illustrates the qualities of his work. It combines precise characterization and definition of the attitudes of individuals with a clear overall interpretation of the narrative. Strong local colors are brightly lit against a darkened backdrop. These elements were to be followed by Rembrandt.

One further aspect of Lastman's preoccupations, which is particularly worth noting and was also to affect the younger painter, is the picturesque Elsheimer-inspired orientalism he employs, here apparent in the exotic costumes of those beyond the inner circle of sacred mourners.

Rembrandt's period of training under Lastman was certainly vital in terms of the stylistic development of his work, but was also important because it probably gave him an opportunity to enter the cosmopolitan society of Amster-dam, the city in which he was eventually to settle. Amsterdam was far larger and more powerful in commercial terms than Leiden. The philosopher Descartes described it as a place where:

everyone is so engrossed in furthering his own interests that I could spend the whole of my life there without being noticed by a soul.

This impression of self-absorption conveys something of the way in which the vast majority of the citizens were in one way or another preoccupied with trade. The city had the largest merchant fleet of any in the Republic, and could claim to be the banking capital of the world (having superseded Venice). It grew in size quite rapidly during the seventeenth century and contained a population that was more culturally diverse than that of almost any other northern European urban center.

Such diversity was also apparent in terms of the work of the artists who were active there. This situation was quite unlike that in smaller centers such as Delft where more homogeneous styles of painting could be found, and was probably consequently a more exciting stimulus for a young artist.

21

Rembrandt Established as a Master

Religion and Morality, 1625-28

After having studied under Lastman Rembrandt appears to have regarded himself as sufficiently qualified as a painter to work as a master in his own right. Initially he returned to Leiden and set up a studio in 1625, probably in the first instance in his parents' house on the Weddesteeg. It was a common practice for artists to combine their home and place of work; Lastman, for example, lived and worked in his mother's house in Amsterdam.

In order to practice as a painter and teach in most of the towns in the United Provinces it was necessary to become a member of the local Guild of Saint Luke – the painters' guild. The guild's role was essentially to maintain a level of quality and settle disputes. As was the case elsewhere in Europe, the guild was named after Saint Luke, because according to a legend he had painted a portrait of the Virgin.

Leiden however was one of the very few centers for painting where at this time there was no guild (although one

was to be established there in 1648). Later, when Rembrandt settled in Amsterdam, he had to follow the appropriate procedure and join the guild there, of which he is recorded as being a member from 1634.

The earliest of the artist's universally recognized paintings dates from 1625, the first year of his independent practice in Leiden. Claims have been made for other works, but it appears that the *Stoning of Saint Stephen* is the first of Rembrandt's signed pictures to have survived to our own day. It was dis-

RIGHT Adam Elsheimer (1578-1610) *The Stoning of Saint Stephen*, c.1603-4, oil on copper, 13½ × 11⅛ inches (34.7 × 28.6 cm), The National Gallery of Scotland, Edinburgh. Elsheimer's work was one of the strongest influences on Pieter Lastman, and seems in turn to have inspired his pupil, Rembrandt. Something of the nature of this influence can be seen by comparing Rembrandt's version of the *Stoning of Saint Stephen* with that of Elsheimer. The suggestion here is not that Rembrandt would necessarily have seen this work, but rather that he may have known of it through the medium of a print made after it, or a painted copy.

LEFT Rembrandt *The Stoning of Saint Stephen*, 1625, oil on wood, 35 × 48¼ inches (89.5 × 123.6), Musée des Beaux-Arts, Lyon. This is the earliest known signed and dated painting by Rembrandt; it is inscribed: *Rf. 1625*. The artist has depicted the proto-martyr, Saint Stephen, being stoned to death outside Jerusalem. The face which can be seen just above the head of the saint is thought to be the first of Rembrandt's many painted self-portraits.

covered in Lyon by the art historian Horst Gerson in 1962.

Saint Stephen was the first Christian martyr, or the proto-martyr. His death is recounted in the New Testament (Acts 7: 54-60). According to the Biblical narrative he was a deacon who was accused of blasphemy and summoned before a legislative council in Jerusalem. He had a vision in which he declared that he saw . . . 'the Son of Man standing at God's right hand!', and was then thrown out of the city and stoned to death by a mob.

The painting, which was executed when the artist was only 19, along with a number of the Leiden-period pictures, appears as a surprise to those more familiar with the creations of Rembrandt's maturity. But it makes sense in stylistic terms as a work inspired by Lastman, and through him precedents such as Elsheimer and Caravaggio.

The dramatic lighting, bright colors and animated, crowded composition all relate to Elsheimer in particular. These links can be illustrated when a comparison is made with the earlier

artist's own version of the same subject which is now in The National Gallery of Scotland, Edinburgh (above). This was quite an influential work; it was known to painters such as Paul Bril, Teniers the Elder, and Rubens.

In both Elsheimer's and Rembrandt's paintings a brilliant beam of light runs from top left to bottom right to denote the saint's vision and isolate him in the crowd. Elsheimer shows the source of it, with God and Christ at the upper left, but Rembrandt chooses to imply more simply its divine source by depicting the seated figure of Saul in the background, apparently looking up at the sky. There are other associations between the two pictures. Rembrandt has used eclectic architectural elements to suggest Jerusalem, and clothed many of his figures in rich and exotic costumes, in a manner similar to Elsheimer (compare the horsemen at the left in both works).

Rembrandt's picture includes the first known self-portrait by the artist – in the form of the horrified figure peering from under the arm of the man who holds a stone above his head. It is also

tempting to see Rembrandt's features in both those of the stone-thrower and the saint. These studies are the earliest in a long and unique series of self-portraits which are one of the greatest achievements of Rembrandt's work. Although many artists depicted themselves in various guises, no other painter (with the possible exception of van Gogh), so persistently questioned the nature of his or her own likeness. The self-portraits have sometimes been seen as a visual autobiography but, as will become apparent, do not always comfortably fit in with the known facts of the artist's life. Rembrandt's studies of his own changing physiognomy and states of mind were certainly in many instances self-contained exercises, but were also on a number of occasions, as is the case here, part of a process which informed the characterization of figures in his history paintings.

Rembrandt later, in 1635, treated the same subject, *The Stoning of Saint Stephen*, in an etching (overleaf). In this 'close-up' depiction of the martyrdom, he re-used with variations a number of the poses developed in the painting.

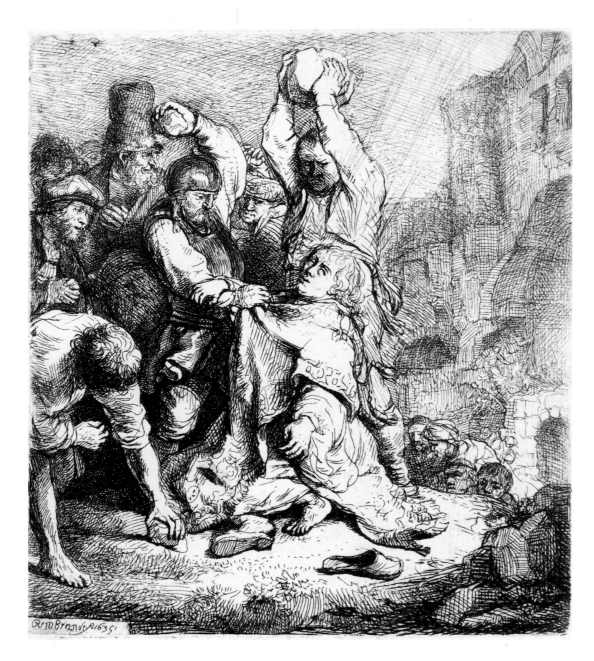

RIGHT Rembrandt *The Music Party*, 1626, oil on wood, 24¾ × 18½ inches (63.4 × 47.6 cm), Rijksmuseum, Amsterdam. Signed and dated: *RH. 1626*.

LEFT Rembrandt *The Stoning of Saint Stephen*, 1635, etching (only state), 3¾ × 3⅜ inches (9.5 × 8.5 cm), Museum het Rembrandthuis, Amsterdam. Signed at the lower left: *Rembrandt f. 1635*.

There is often in the artist's work a rich vein of relationships, in terms of formal and thematic ideas, between his painted and graphic output.

Rembrandt's early artistic evolution was quite rapid. In his first few years of independence he tried a variety of subjects and quickly moved on from the heavily derivative nature of the *Saint Stephen* composition to works of greater originality.

In the following year, 1626, the artist painted *The Music Party* (right), a genre (or everyday) scene which appears also to be intended as a moral allegory. It contains four figures, whose ages and sexes contrast, and who are shown music-making in a brilliantly lit interior. The seated woman sings while her male companions play a harp and a viola da gamba. In the foreground a lute, violin, and pile of books are arranged so as to form a disorderly and elaborate still life. The viewer is led into the work as a result of the contrast between the framing shadows in this area and the concentration on the sheen of the textiles in the middle ground.

Ostensibly the subject is straightforward, but knowledge of contemporary works and sources show it in quite a different light, as a complex didactic image. The theatrical costumes of the figures in the first instance signify the out-of-the-ordinary nature of the subject.

In the seventeenth century the harmony which could be created with music and its seductive quality were seen as being analogous to human relations, and many paintings with musicians were intended to have erotic overtones. What underlines such a train of interpretation in this case is the subject of the painting hanging on the wall in the room the musicians inhabit. It shows part of the story of Lot, who with his family escaped from the depraved city of Sodom, and as such in this context might be intended to warn against sexual freedom. Such a reading is backed up further by a suggestion made by Gary Schwartz (1985) that the singer is based upon a figure from a contemporary emblem book who represents a 'woman without shame.' Such books, which were filled with images linked with moralizing texts, were often used as source material by painters. So overall the theme can be interpreted as a subtle castigation of sensual pleasure.

It has been suggested that this theme may have been established by a learned adviser to the artist, but this might not necessarily be the case, because ideas such as those explored here could easily have been appropriated by Rembrandt himself from many other contemporary paintings and texts.

Juxtaposing the head of an old woman with that of a young one, as in *The Music Party*, was a device particularly developed by Caravaggio and his followers. In a number of instances in paintings of this sort the older woman takes on the role of procuress. The physical type Rembrandt defined for her in this secular context he also used in a very different way for one of the dominant subjects in a religious work painted in the same year, *Tobit and Anna with the Kid* (page 26). With this picture the artist reached a new stage in his development. He has moved beyond the slightly jarring quality of the color combinations of the *Music Party* and the earlier insecurity of the *Saint Stephen* composition, to establish a poignant narrative which is unified chromatically, and defined by an ingenious and balanced lighting scheme.

The story of Tobit and Anna is told in the Book of Tobit, one of the Apocryphal books of the Bible. According to

RIGHT Rembrandt *Two Old Men Disputing*, 1628, oil on wood, 28¼ × 23¼ inches (72.3 × 59.6 cm), National Gallery of Victoria, Melbourne, Felton Bequest. The subject of this painting has become a matter of protracted debate. The problem is essentially that the work recalls earlier depictions of the Saints Peter and Paul, but that the men here do not have the attributes they are usually represented with – keys and a sword, respectively.

LEFT Rembrandt *Tobit and Anna with the Kid*, 1626, oil on wood, 15⅝ × 11⅝ inches (40.1 × 29.9 cm), Rijksmuseum, Amsterdam. Signed and dated at the lower left: *RH. 1626*. Tobit, who was blind, unjustly accused his wife, Anna, of having stolen the kid she holds. She told him that it was a gift, and he, realizing his mistake, prayed to 'depart and become dust' (Tobit 3:6). This is the first of Rembrandt's works which depict a scene from the Apocryphal Book of Tobit. Rembrandt had a particular fascination for this source, and returned to it on a number of occasions.

the narrative, Tobit had been blinded by the bizarre accident of having the droppings of sparrows fall into his eyes. His wife Anna entered their house on one occasion holding a bleating kid, and he started to accuse her, without justification, of having stolen it. She in turn told him that he was too quick to suspect others and he began to pray because he recognized his own inner blindness and sought forgiveness from God.

Rembrandt concentrates on the contrast between his remorse and her incomprehension. The couple are placed in a rustic interior which is flooded by yellow light from the window at the upper left, and warmed and lit further by the fire. The paint is applied in a smooth and creamy manner, even though it is used to define what are often rough textures and forms. This technique gives a clarity of equal insistence to much of the work – an approach quite unlike the procedures of Rembrandt's maturity.

A number of other elements, however, in this, the artist's first masterpiece, prefigure future preoccupations, such as the way in which he depicts old age with profound sympathy.

Subjects from the Apocryphal Book of Tobit were depicted by Rembrandt on a number of occasions. He seems to have had a particular sympathy for the dominant themes in the text – the loss and re-establishment of faith, the intervention of the supernatural in the lives of mortals, and the importance of the family. This preoccupation ought to be seen in the context of the decisions which had recently been made in the United Provinces about the authority of the scriptures.

Seven years before, at the Synod of Dordrecht (1619), it was decided which Biblical books should be included in the official Dutch translation of the scriptures. The sanctity of the Book of Tobit and other parts of the Apocrypha was denied. But Rembrandt clearly felt that this was no reason to stop drawing on such sources, which appear to have formed a significant part of the popular Biblical culture of the age.

While *Tobit and Anna* is concerned with a temporary loss of faith, *The Rich Man from the Parable* (pages 28/29), which Rembrandt painted a little later, has as its theme the folly of only having faith

Rembrandt *The Rich Man from the Parable*, 1627, oil on wood, 12½ × 16⅝ inches (31.9 × 42.5 cm), Gemäldegalerie, Berlin. Signed and dated: *RH. 1627*. According to Christ's parable the wealthy man stored up his riches, but was told 'This night thy soul shall be required of thee; then whose shall those things be, which thou has provided?' (Luke 12:19-20). The man may be shown wearing glasses, because in an ironic manner this could signify his inability to see the truth.

in material gain. In it the artist depicted a darkened room in which a man wearing glasses and holding a candle seems to be pausing from counting money and poring over his accounts. Some coins lie on the table before him with a miniature pair of scales beside them. The light from the candle, which is defined with great virtuosity, creates an arc that has as its focus the tired eyes and single-minded expression of the subject.

He was relatively recently identified by a researcher as the Rich Man from Christ's parable, whose story is recounted in the Gospels (Luke 12: 13-21). The man was a wealthy landowner who sought to store away his riches so that he could live at ease, but God declared:

Thou fool, this night thy soul shall be required of thee; then whose shall those things be, which thou hast provided?

So the darkness is that of night, and the manner in which Rembrandt has lit it is particularly reminiscent of the *chiaroscuro* effects developed in Utrecht by followers of Caravaggio, such as Honthorst and Terbrugghen. The text and such pictorial precedents must have formed the basis of his approach to the subject, but as is frequently the case he built upon them with great ingenuity. In his hands the use of light takes on a thematic role – the single candle attests to the fool's miserliness, and the surrounding darkness to his isolation. The clock, which can just be made out in the gloom at the upper left, implies that the time left to him is slipping by, and the fact that he is wearing spectacles might signify in an ironic manner, as it had in earlier Netherlandish and German art, his inability to see the truth.

The way in which Rembrandt employs light for narrative purposes may help provide the key to establishing the subject of a more enigmatic painting by him of 1628, which is

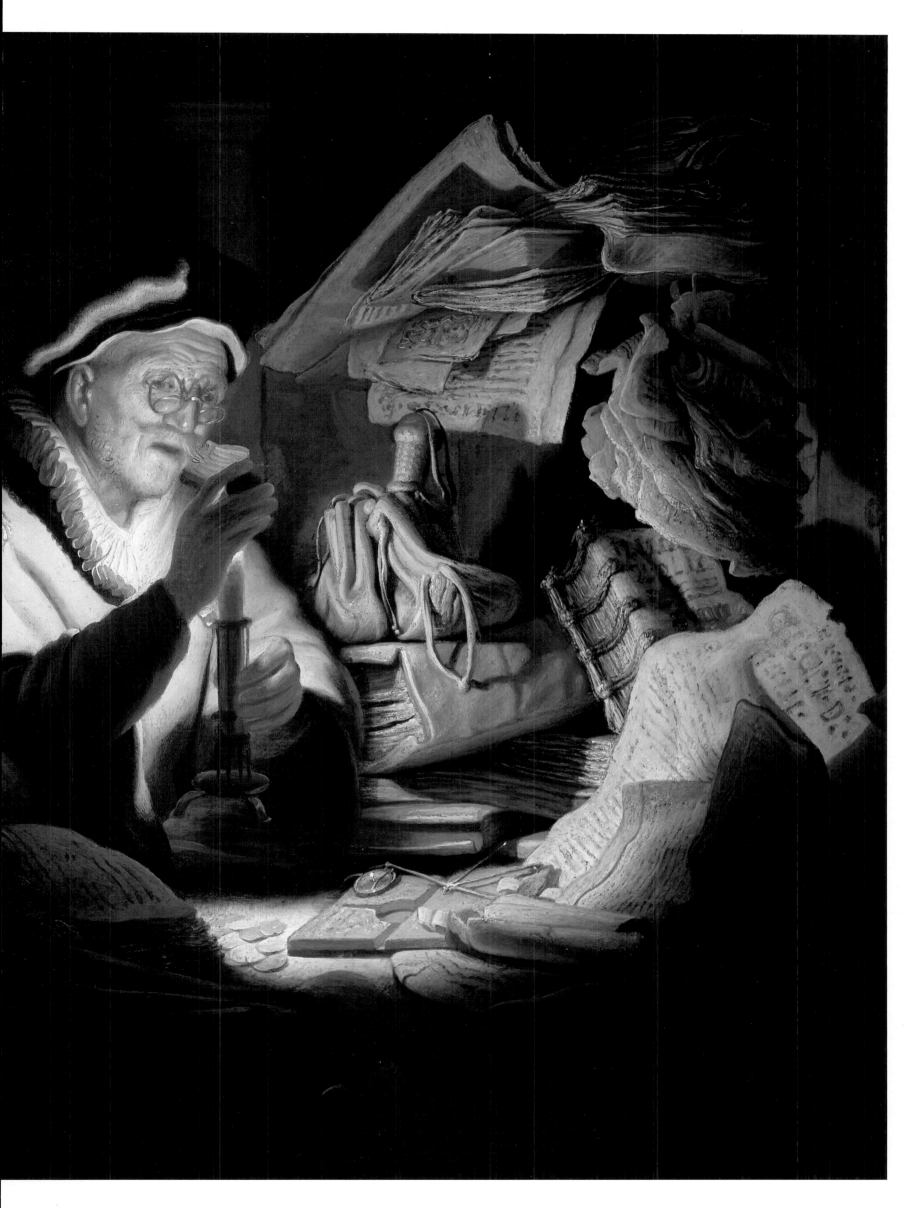

Rembrandt *Christ at Emmaus*, c.1628, oil on paper stuck to wood, 14⅝ × 16½ inches (37.4 × 42.3 cm), Musée Jacquemart-André, Paris. After the crucifixion two disciples invited a figure they did not know to be Christ to dine with them. They eventually recognized who he was however, once he broke bread as he had at the Last Supper (Luke 24: 30-31). Here the viewer is also ingeniously involved in the process of recognizing Christ's identity; because of the way he is silhouetted against the light on the table, he appears from our viewpoint to have an aureole. Naturalistic lighting is given supernatural significance.

known by various titles, but is at present perhaps best to call *Two Old Men Disputing* (page 27). It has been suggested that the men in question are the saints Peter and Paul (the latter with his back to the viewer), and that they are shown debating a theological point. The light falls across the book that is between them. Its illumination in this way may indicate the divine nature of the issue they dispute, or simply concentrate attention on their differences.

But these are highly subjective readings of the image, and it is not by any means clear if the subjects are Christian at all. They do not have the usual attributes of Peter and Paul – keys and a sword – and appear to be seated in a study with a desk at the right and a globe behind them, surroundings commonly found in contemporary images of philosophers and alchemists. Rembrandt often broke with traditional means of representation and so could have painted the saints without their attributes, but is just as likely to have produced a work during his youth which fitted into the recognizable 'type' of philosopher paintings that a number of other artists painted.

It appears that the identification of the subject has not been lost, but was never entirely clear from the outset. This is known because the picture's first owner, an important early patron of Rembrandt, Jacques de Gheyn III (1596-1641), did not describe it with any precision in his will. De Gheyn, the subject of an attractive portrait by Rembrandt now in the Dulwich Picture Gallery, London, was himself an engraver and painter. Rembrandt's association with him was probably significant in terms of promoting future patronage, because he was a good friend of Maurits Huygens, the brother of Constantijn Huygens, who brought Rembrandt's work to the attention of the Court in The Hague (see pages 105 *et seq*).

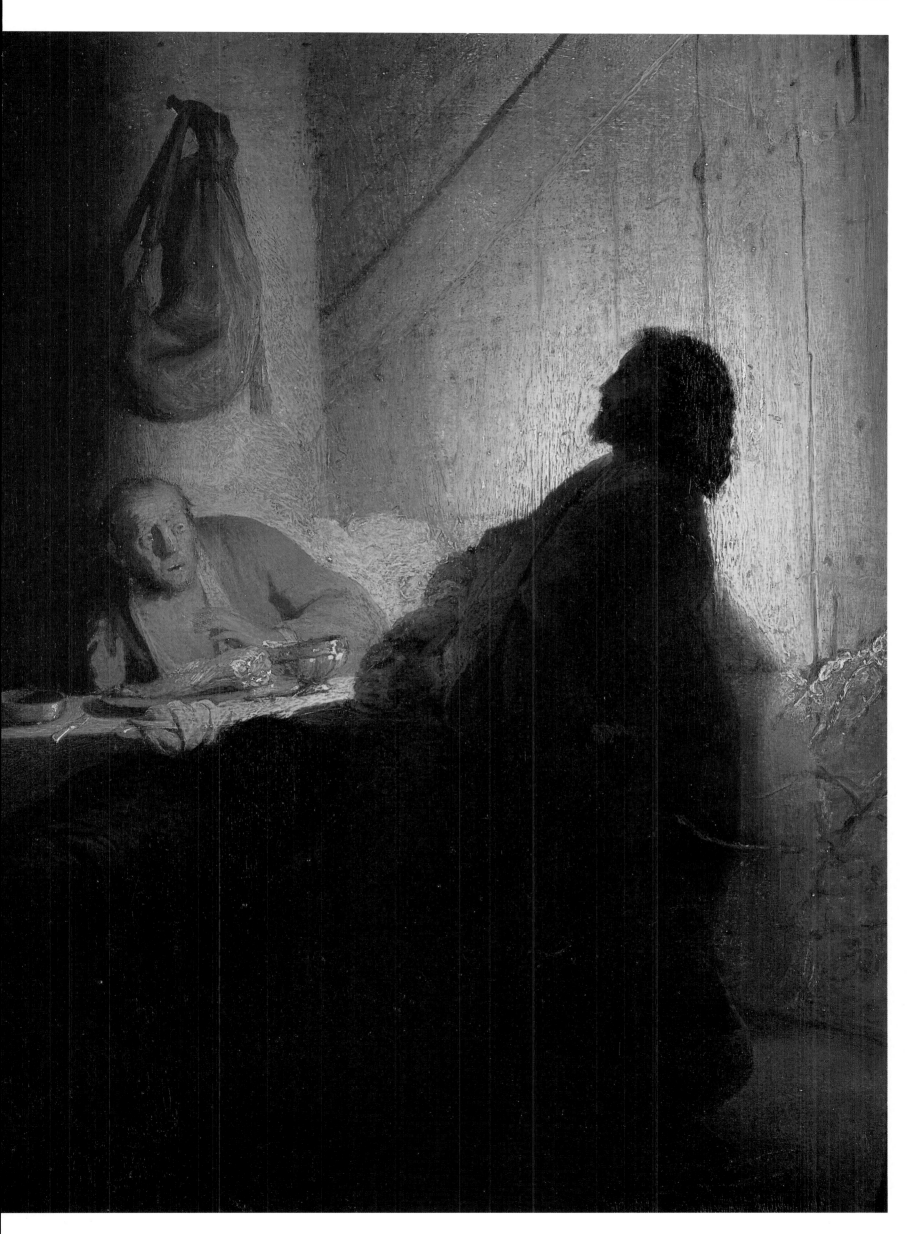

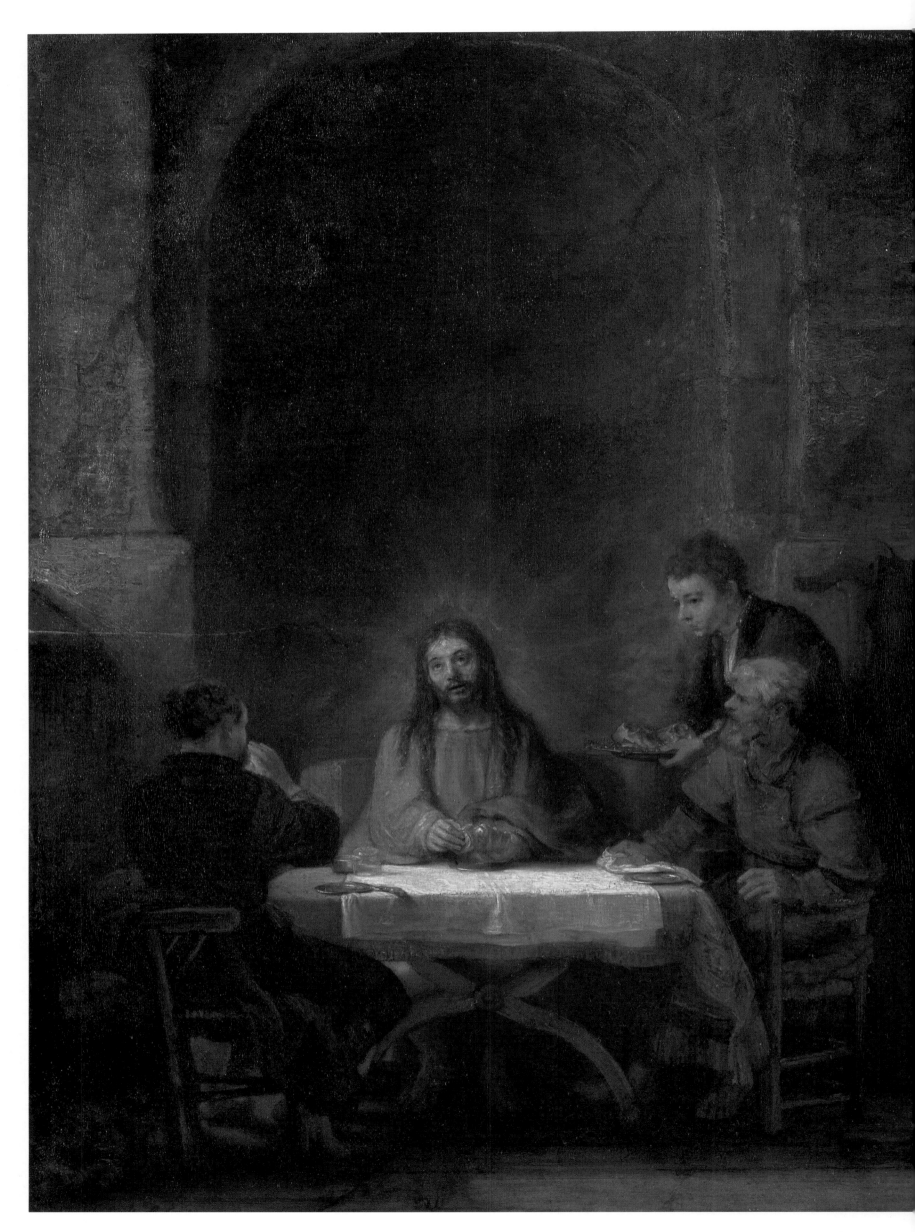

Rembrandt *Christ at Emmaus*, 1648, oil on
wood, 26½ × 25⅜ inches (68 × 65 cm),
Louvre, Paris. This is a later interpretation of a
subject Rembrandt first treated as a young
painter. Christ now faces the viewer, his status
is emphasized by the alcove which frames
him.

Such ambiguity over interpretation is
not encountered when considering
Rembrandt's approach to a well-known
Biblical text, even though he rethought
a familiar story afresh. His *Christ at
Emmaus* (page 30/31), which is dated to
about 1628, is one of his most succinct
and effective transformations of this
type.

Artists in the past had treated two
elements in the story – the road to
Emmaus and the supper at the village.
Rembrandt opted for the latter, which
forms the climax of the narrative. After
the Crucifixion two disciples invited a
man they did not know to be Christ to
dine with them. They eventually recog-
nized him as he broke bread in the way
he had at the Last Supper (Luke 24:
30-1). One of them remains seated at
the table – his expression capturing
both the shock of his reaction and the
creeping realization of who is before
him. The other is at first harder to dis-
cern – he has fallen to his knees in the
shadows at Christ's feet.

Christ himself is silhouetted before
an unseen light source, so he appears
from the viewer's point of view to have
an aureole. This device ingeniously in-
volves the onlooker in the act of re-
cognizing his divinity, the key element
of the story. A tonal balance across the
work is achieved because, in the back-
ground at the left, a woman who is also
lit from behind can just be seen, per-
haps preparing food. She is presum-
ably oblivious to the significance of the
event taking place.

It has been suggested that the idea of
placing a silhouetted man set at the left
of an interior in this manner was in-
spired by an engraving by Hendrick
Goudt after a painting by Elsheimer,
called *Jupiter and Mercury in the House of
Philemon and Baucis* (1612). This source
may well have given Rembrandt the
initial inspiration, but he moves far
beyond such a precedent, by imbuing
naturalistic lighting effects with super-

natural significance. He was to use this
device in a number of different contexts
later.

The physical structure of *Christ at
Emmaus* is of particular interest. It is the
first work in oil Rembrandt painted on
paper (all those already discussed have
wooden supports). Later, during the
1630s, the artist executed some works
on paper which appear to have been in-
tended as preparatory to a series of
prints. It is debatable whether he was
thinking of *Christ at Emmaus* in such
terms because at this stage he had not
embarked on such ambitious graphic
projects, but this experiment must have
formed the basis upon which the de-
cision to use such a procedure later
rested.

Twenty years later Rembrandt was to
return to the subject of *Christ at Emmaus*
with a painting which is now in the
Louvre (left). In this case he opted for a
more traditional frontal and central
representation of Christ at the supper,
of a type developed by artists such as
Caravaggio (page 18). The work is far
less dramatic than his earlier interpre-
tation, and the architecture rather than
the light tends to have been used to
emphasize the status of Christ, who is
placed as the focus of a large framing
alcove.

Early Self-Portraits, 1628-30

... The ... benefit ... from the depiction
of the emotions which you can find before
you, namely in a mirror, where you can be
exhibitor and viewer at one and the same
time.

Samuel van Hoogstraten, 1678

It is from the last two years of the 1620s
that the earliest independent self-por-
traits by Rembrandt come. As has been
mentioned, it appears that before this
period the artist had studied his own
features, and used them as a source for
history paintings. These works were

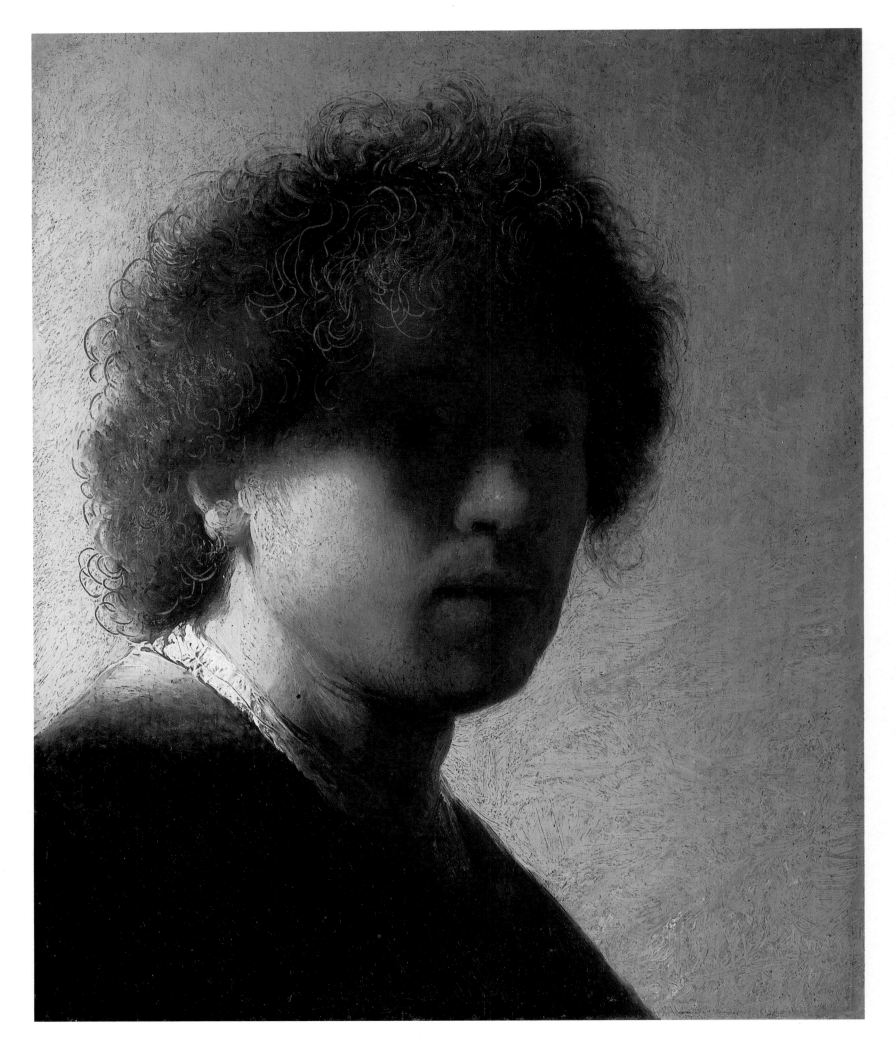

Rembrandt *Self-Portrait*, *c*.1628, oil on wood,
8¾ × 7¼ inches (22.5 × 18.6 cm),
Rijksmuseum, Amsterdam. This is thought to
be the earliest independent painted self-
portrait by the artist. Most of his face is in
shadow; this effect, which Rembrandt was
later to deploy on a number of occasions, gives
a convincing impression of three-
dimensionality, and of the potential for further
movement round into the light.

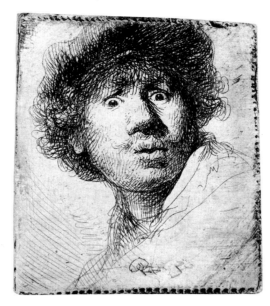

LEFT Rembrandt *Self-Portrait, Open-mouthed*, 1630, etching (only state), 2 × 1¾ inches (5.1 × 4.6 cm), British Museum, London. By making studies of extremes of expressions of this sort, the artist built up a pictorial repertoire of 'faces' which he could re-use in history paintings.

used in that fashion, but also increasingly develop a status of their own, and can be considered as the groundwork for Rembrandt's later obsession with recording himself.

It is tempting to see in them a new degree of self-awareness and assurance, but easy to forget that there may also have been very simple practical reasons why the artist depicted himself. A variety of models would have been costly, but for the price or loan of a mirror Rembrandt could have complete control over the most reliable and cheapest of subjects – his own face.

The artist experimented with various techniques and lighting arrangements in these exercises. He seems also to have been testing how far he could explore in terms of extremities of expression. Other artists, notably the Italians Bernini and Caravaggio, also made studies in their youth by drawing and painting before a mirror.

Rembrandt's *Self-Portrait* from the Rijksmuseum, which was probably painted in 1628 (left), is a work of considerable novelty in terms of illumination. The artist turns toward the viewer, but most of his face remains in shadow. Only his right cheek and nose catch the light. He appears slightly apprehensive, but this is not so much a character study as an exploration of unconventional *chiaroscuro*, which animates the work because the implication of further movement round into the light is conveyed.

A number of the lines used to define the silhouetted strands of his hair at the left, and the lighter locks above his brow, were created by dragging an implement, which was probably the blunt end of his brush, through the paint. The filigree effect achieved (which had earlier been used for the fur of the kid in *Tobit and Anna*) Rembrandt was later to use on a number of occasions.

The experiments Rembrandt made with extremes of facial distortion at this

period appear as defiant challenges to the viewer. Two of these apparently uninhibited physiognomic studies (above and below) seem almost comic, but no doubt played a serious and useful role by informing later character-

BELOW Rembrandt *Self-Portrait, with Open Mouth*, c.1628-29, pen and brown ink with gray wash on paper, 5 × 3¾ inches (12.7 × 9.5 cm), British Museum, London. Here Rembrandt again uses the bold *chiaroscuro* employed in the contemporary Rijksmuseum painted self-portrait.

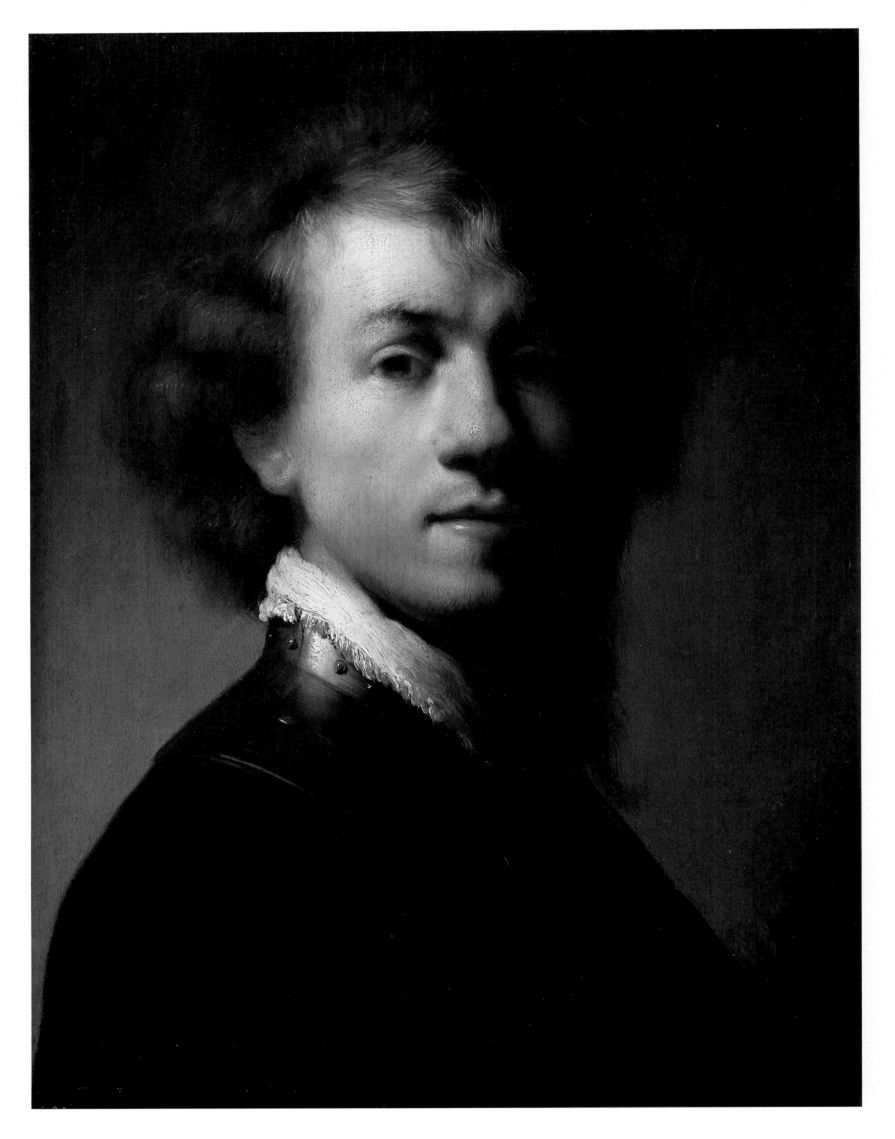

LEFT Rembrandt *Self-Portrait, c.*1629, oil on wood, 14¾ × 11¼ inches (37.9 × 28.9 cm), The Mauritshuis, The Hague. Here the twenty-three-year-old artist seems to have adopted a haughty public persona. This work was probably painted in the year that he first came into contact with Constantijn Huygens, who was to commend his work to the Stadholder; it may as such reflect the type of image he wished to propagate in order to secure such patronage.

BELOW Rembrandt *Rembrandt's Studio with a Model, c.*1650, pen and brown ink and wash on paper, 8 × 7⅜ inches (20.5 × 19 cm), The Ashmolean Museum, Oxford. Control over lighting in a studio was all-important. One way to achieve this was to have a series of blinds and shutters at the window which could be manipulated to create the required effects.

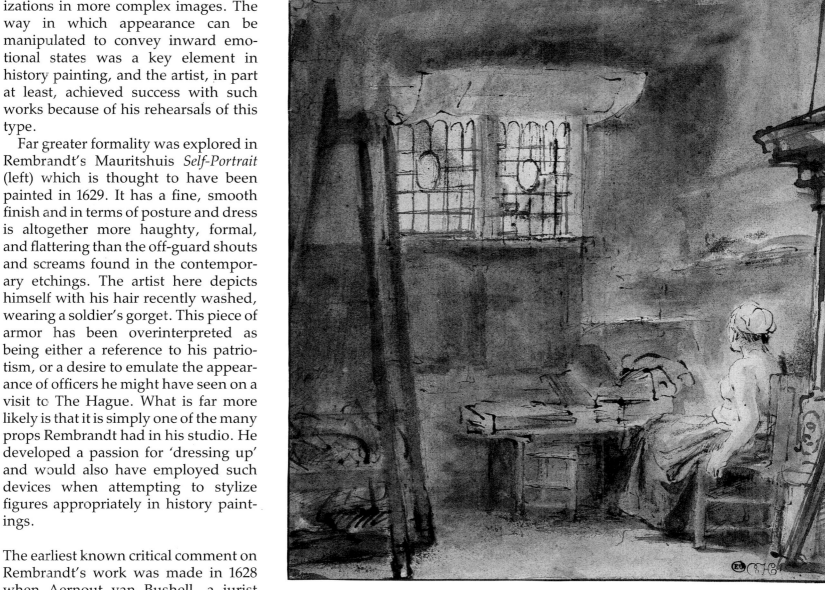

izations in more complex images. The way in which appearance can be manipulated to convey inward emotional states was a key element in history painting, and the artist, in part at least, achieved success with such works because of his rehearsals of this type.

Far greater formality was explored in Rembrandt's Mauritshuis *Self-Portrait* (left) which is thought to have been painted in 1629. It has a fine, smooth finish and in terms of posture and dress is altogether more haughty, formal, and flattering than the off-guard shouts and screams found in the contemporary etchings. The artist here depicts himself with his hair recently washed, wearing a soldier's gorget. This piece of armor has been overinterpreted as being either a reference to his patriotism, or a desire to emulate the appearance of officers he might have seen on a visit to The Hague. What is far more likely is that it is simply one of the many props Rembrandt had in his studio. He developed a passion for 'dressing up' and would also have employed such devices when attempting to stylize figures appropriately in history paintings.

The earliest known critical comment on Rembrandt's work was made in 1628 when Aernout van Bushell, a jurist from Utrecht, recorded in his unpublished notes on paintings and artists that Rembrandt was 'greatly praised, but before his time.'

It was in the same year that the artist took in his first pupils, Gerrit Dou (1613-75) and Isaac Jouderville (1612-45/8). Dou's elaborate and extremely detailed paintings, particularly of genre scenes, brought him considerable success. He in turn inspired a following of a number of other Leiden artists who became known as the *fijnschilders* (fine painters), because of the meticulous nature of their technique. Rembrandt

moved away from such an approach, particularly when he later settled in Amsterdam, but the precision of some of his earlier works can be seen as being at the root of this tradition.

By taking in pupils Rembrandt was perpetuating the means of artistic training from which he had benefited. There were probably sound financial reasons for doing so; as well as apprentices, the artist later took under his wing paying pupils and qualified painters who required additional guidance. Over the span of his long life Rembrandt taught in this way a large number of artists.

At a time when we know Rembrandt's achievements were being admired by contemporaries, and he had decided to establish himself as a teacher, it seems appropriate that he should produce a memorable image of his studio, which is both an invaluable record of the environment in which he worked, and appears to explore the nature of an artist's calling.

The Artist in His Studio, (page 38), which was probably painted in 1629, shows a young painter standing some way back from a large easel, on which rests the panel he is currently working

Rembrandt *The Artist in His Studio*, *c.*1629, oil
on wood, 9¾ × 12½ inches (25.1 × 31.9 cm),
Museum of Fine Arts, Boston. The artist
appears to be Rembrandt himself. In an
uncluttered studio he stands back to
contemplate the work he is currently occupied
with, which dominates the whole picture. This
emphasis on the artwork, rather than artist, in
such a work is a considerable novelty. It has
been suggested that what was intended was a
consideration of the way a painting is
conceived in the mind of the artist.

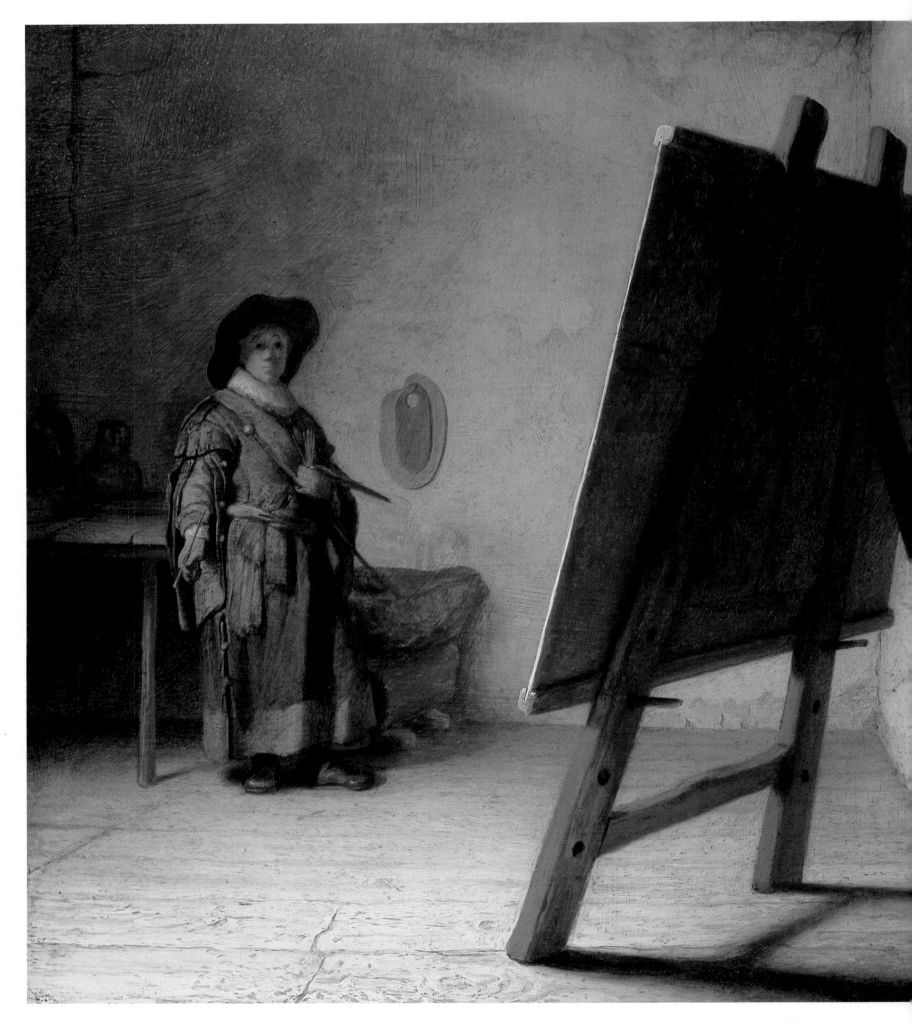

at. The identity of the artist has in the past been debated, but it appears to be Rembrandt himself. His features are comparable to those found on contemporary etched self-portraits.

He has depicted himself wearing a rather foppish hat, ruff, and blue gown over his clothes, the unbuttoned sleeves of which allow for considerable freedom of movement. In his right hand he holds the single brush he is presumably currently using, and in his left, a bundle of brushes, a palette, and a maulstick. On the table behind him are a bottle and an earthenware jar which might contain oil or pigments, and on the wall to the right of the artist hang two palettes which have not yet been loaded with paint. Below these is a large worn stone (which lies on a tree trunk) that would have been used to grind pigments on. The panel on the easel rests upon two pegs and has battens attached to it at the top and bottom to prevent it from warping.

The studio Rembrandt has painted is defined with a precision quite unlike the more freely executed backgrounds in many of his later works, to the extent that it is hard to believe it is not his own. The paint is manipulated so that its texture in part simulates that of crumbling plaster or wooden floorboards. The sunlight enters the room and falls on the easel from an unseen window at the upper left.

According to the writer Sandrart (1675), an artist's studio should have a window in the upper part of the room and it should be north-facing, because it is from that direction that the most constant source of natural light comes. The principal light source in a great many of Rembrandt's paintings falls from the upper left and it seems probable that this can be explained because he, like many right-handed painters, kept the light source on that side so that shadows would not be cast across a painting while he was working on it.

The way in which the lighting in a studio can be manipulated in order to suit the preferences of the artist is illustrated in a drawing by Rembrandt of a studio he used in the early 1650s (page 37), which is now in the Ashmolean Museum, Oxford. In this work a model is seated at the right near to what appears to be a large chimneypiece, while at the left stands the artist's easel. The window which dominates the studio is divided into two sections; shutters close off its lower half, but the upper section is opened so that the room is flooded with light.

In the *Artist in His Studio* the painter stands some way back from the easel, deep into the picture space. Rembrandt may well have worked standing up, but it seems to have been more common for painters to have worked seated – that, at least, is how they often appear in other seventeenth-century depictions of studios (page 40).

The distance between the artist and the panel may simply imply that he is backing away to judge the effect he has created. But it has with some credence been suggested that because of the way in which the easel dominates the picture and Rembrandt gazes upon it, what is intended is a representation of how a work of art is conceived in the mind of the artist.

The notion of recording or celebrating the cerebral aspects of painting was one that seems also to have been explored later by Rembrandt's great contemporary from Delft, Johannes Vermeer (1632-75). His *The Art of Painting* (page 40) of about 1666 has been interpreted as a celebration of its status. In it an artist (who is not necessarily Vermeer himself) depicts a woman dressed as the muse of history, Clio. The laurels she wears symbolize fame and the book she holds, history itself. As history painting was seen as the most testing activity for a painter, it appears that Vermeer was concerned, like Rem-

39

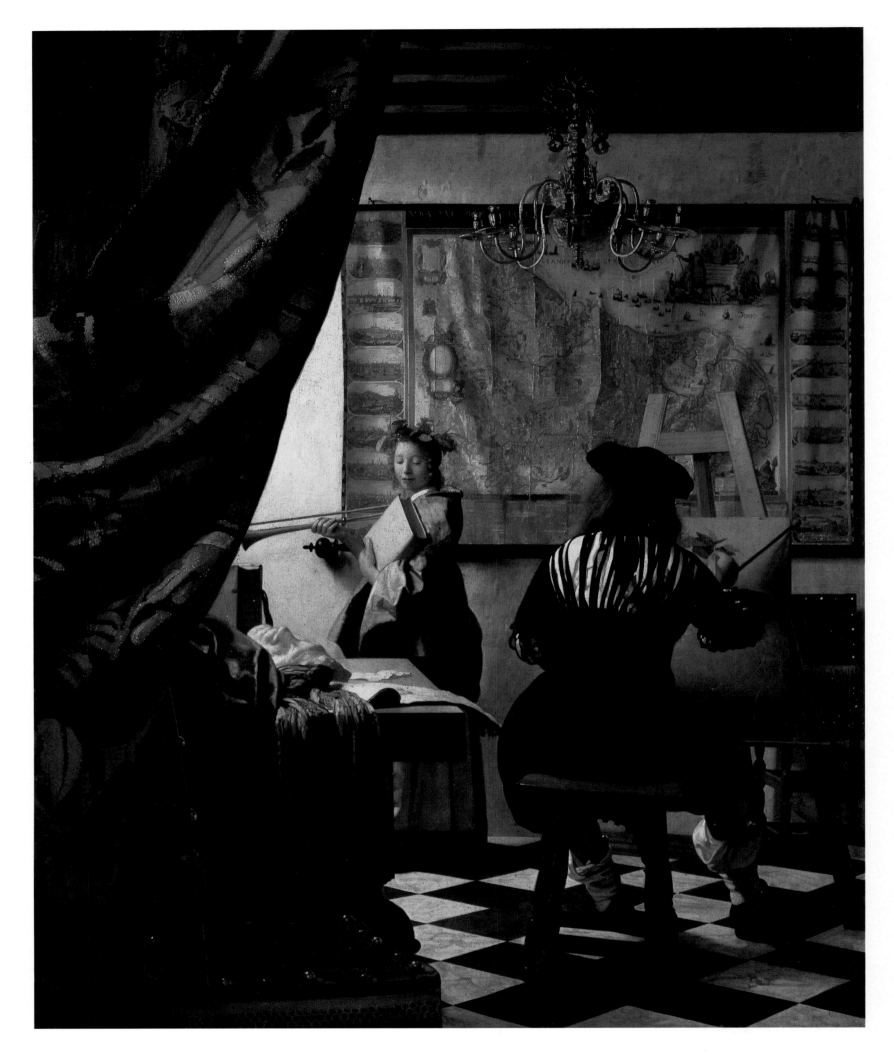

Johannes Vermeer (1632-75) *The Art of Painting*,
c. 1666, oil on canvas, 46¾ × 78¼ inches (120 ×
200 cm), Kunsthistorisches Museum, Vienna.
Vermeer shows an artist working seated – this
was a far more conventional means of
representation than that chosen by Rembrandt
in his painting of a studio of around 1629. The
two works do, however, perhaps have
thematic elements in common; it appears that
they are both considerations of the intellectual
aspects of painting.

RIGHT Thomas de Keyser (1596/97-1667) *Portrait of Constantijn Huygens and his (?) Clerk*, 1627, oil on oak, 36 × 27 inches (92.4 × 69.3 cm), The National Gallery, London. The sitter's coat of arms is depicted at the top of the tapestry. He was an important figure in terms of furthering the careers of both Rembrandt and Jan Lievens. Huygens visited them in 1629, wrote of his praise for their work, and was probably responsible for introducing them to patronage from the Court in The Hague.

brandt, with recognition of the intellectual demands on an artist. He may also have been indicating how such work could enhance the reputation of the country the painter came from, by placing a map of the Netherlands in the background.

Rembrandt and Jan Lievens

During the late 1620s and up until about 1631 Rembrandt's painting and career became intimately related to that of a fellow artist from Leiden, Jan Lievens (1607-74).

What we know of Lievens' early life is, like that of Rembrandt, dependent on the word of Orlers. According to the writer, Lievens was born on 24 October 1607 and began to train as a painter when as young as eight years old, with an artist called Jan van Schooten. Orlers goes on to say that in about 1617 Lievens went to Amsterdam where he spent two years in the studio of Pieter Lastman. This means that, although slightly younger than Rembrandt, Lievens had passed through his artistic education before him.

The artist apparently then returned to Leiden and set up a studio. It was perhaps inevitable that the two young painters should make contact, in view of the fact that their early developments ran in parallel. A number of quite close stylistic and formal links between their respective paintings from the end of the decade has led many to suggest that they worked together and may have shared a studio. In some instances the links between their works at this point are so strong that they have led to confusion over whether paintings can be attributed to one or the other artist.

The evidence of his early pictures suggests that Lievens was an accomplished painter by whom in the first instance Rembrandt may have been overshadowed.

The relative merits of the work of both men were outlined in a autobiography of 1629-31, written by Constantijn Huygens (1596-1687). Huygens was a successful diplomat who had been knighted by James I of England in 1622, and from 1625 worked as secretary and artistic adviser to the Stadholder, Prince Frederik Hendrik of Orange. He was a man of influence and accomplishment who could with ease write poetry, play musical instruments, command a number of languages, and design buildings.

Some of these qualities are referred to in a fashionable portrait of Huygens by Thomas de Keyser (1596/7-1667) (above), which was painted about two years before the sitter wrote his commentary on the artists. He is shown receiving a note from an attendant, while seated at a desk that is draped with an oriental rug. Behind him hangs a tapestry which appears to be decorated with a scene that shows Saint Francis before the Sultan. On the table are a pair of globes, a *chittarone* (a type of lute), architectural drawings, and compasses.

There are a number of ways in which Huygens could have come to hear about Lievens and Rembrandt. From the latter's point of view there are perhaps two important links: the fact that the uncle of Swanenburg (Rembrandt's first master) was a governor of Huygens, and Jacques de Gheyn, one of the painter's important early patrons, was one of his brother's best friends.

Huygens described in his *Vita*, which only exists in manuscript form, in glowing terms and at some length the achievements of Rembrandt and Lievens. This contemporary estimation of the merits of their work is of considerable interest and so worth quoting from fairly extensively.

If it were said that they alone are destined to equal the greatest of mortals . . . this would yet belittle their achievement . . . Their parentage forms the weightiest argu-

BELOW Rembrandt *The Raising of Lazarus*, c.1630, oil on wood, 37½ × 31⅝ inches (96.2 × 81.5 cm), The County Museum of Art, Los Angeles. Christ and the other figures appear to be looking toward the center of the composition, rather than at Lazarus who is placed to the right. X-rays of the painting reveal that initially Rembrandt painted him in the middle; he seems to have decided to move him, but to have left the other characters where they were initially placed.

RIGHT Jan Lievens (1607-74), *The Raising of Lazarus*, 1631, oil on canvas, 40¼ × 43¾ inches (103 × 112 cm), Museum and Art Gallery, Brighton. Signed and dated to 1631. Lievens came into close contact with Rembrandt in the late 1620s, and it appears that the two young artists may have shared a studio. The figures in this work are very similar in terms of facial type to those in Rembrandt's interpretation of the same subject.

ment I know against the so-called nobility of blood . . . One of my young men has an embroiderer – a commoner – for a father, and the other a miller, though of quite a different grain than himself. Who could not be amazed to see such talent and ability come from these farmers. As for the teachers they are known to have had, I find them to be the kind that are barely above the repute of a commoner . . . I am convinced that even if no one had led the way . . . they would have reached the same point they have now attained . . . Rembrandt surpasses Lievens in getting to the heart of his subject matter and bringing out its essence, and his works come across more vividly. Lievens is superior in the proud self-assurance that radiates from his compositions, with their powerful forms . . . Lievens, in part due to his youth, is charged with the great and the glorious, and is inclined to depict the objects and models before him larger than life. Rembrandt on the other hand,

obsessed by the effort to translate into paint what he sees in his mind's eye, prefers smaller formats, in which he achieves effects that you will not find in the works of others . . . they are content, and do not think it worth while to take the few months required to visit Italy. This is a touch of madness in talents that in other respects are exceptional.

Huygens' feeling that the painters should go to Italy is symptomatic of a widespread contemporary attitude which held that a visit to the south, and Rome in particular, such as Lastman's, formed an essential part of a successful artistic education. The damning estimation of the masters of the two painters which he makes refers, it can reasonably be assumed, to their first teachers, rather than Lastman, who was widely acknowledged as a painter of considerable standing. It is possible

to put to the test the author's comparison between the two painters' work by considering their respective painted depictions of the same subject, *The Raising of Lazarus*. Rembrandt's version (left), dates from about 1630, while that of Lievens (above), is dated to the following year. Rembrandt also etched and drew the subject at this period, and Lievens made an etching of it. The precise chronology of all of these works is problematic to establish, but the important factor is that both men worked on the same subject in different media over a relatively short period of time, and it appears that ideas and an element of competitiveness flowed between them.

The story of the raising of Lazarus is told in the gospel of Saint John. Lazarus, who was the brother of Martha and Mary of Bethany, was dying at Bethany. Jesus was sent for, but by the

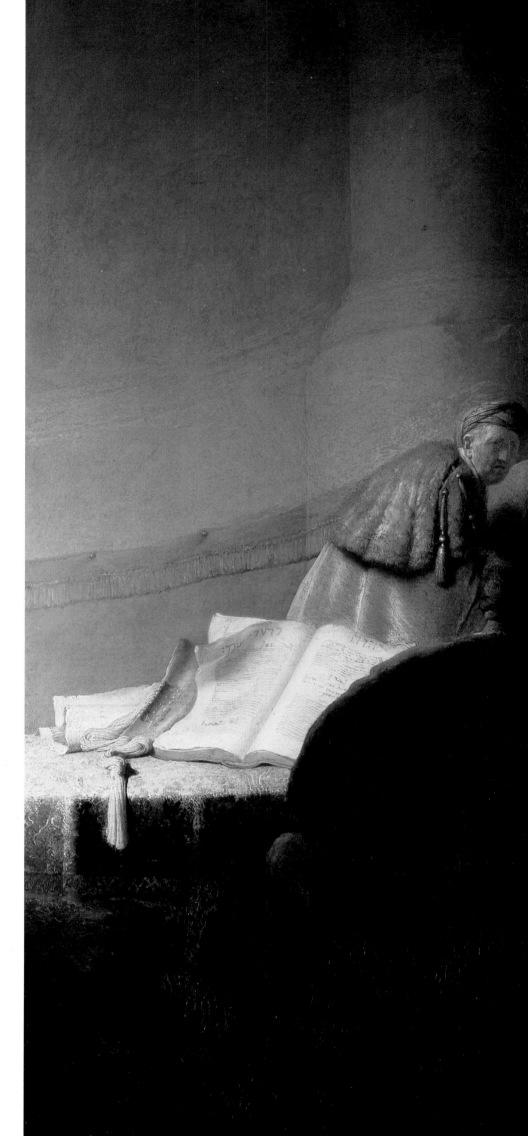

RIGHT Rembrandt *The Repentant Judas Returning the Thirty Pieces of Silver to the Chief Priests and Elders*, 1629, oil on wood, 30⅝ × 40 inches (79 × 102.3 cm), private collection, England. This brilliant exercise in storytelling is perhaps the greatest achievement of Rembrandt's years in Leiden. The priests had bought information about the whereabouts of Christ from the apostle Judas. He here returns the payment before going out and hanging himself.

time he arrived Lazarus had been dead for four days.

Then they took away the stone from the place where the dead was laid. And Jesus lifted up his eyes, and said, Father, I thank thee that thou hast heard me . . .
And when he thus had spoken, he cried with a loud voice, Lazarus, come forth.
And he that was dead came forth, bound hand and foot with grave clothes.

John 11: 41-4

Lievens chose to depict the slightly earlier moment in the narrative when Christ lifts up his eyes to address God, while Rembrandt chose his exclamation 'Lazarus come forth.'

The 'proud self-assurance' of Lievens' compositions which Huygens referred to is effectively illustrated by his interpretation. He boldly isolated Christ against a darkened backdrop, and created a link between the arms of Lazarus and the other figures present with the huge swathe of cloth which is drawn up from the grave. Rembrandt, by contrast, decided to relate Christ's gesture and expression far more closely to those of the other figures, who on close inspection are generically very similar to those in Lievens's work.

One further comment Huygens makes about Rembrandt's work is particularly worth emphasizing. The writer noted that the painter was able to achieve dramatic effects in spite of the small scale of his paintings; this ability to defy such constraints was to be repeated in several of Rembrandt's maturer history paintings.

Some of Huygens' most perceptive and poetic comments in his *Vita* are reserved for another of Rembrandt's great exercises in storytelling of these years, *The Repentant Judas Returning the Thirty Pieces of Silver to the Chief Priests and Elders* (right), of 1629.

According to the gospels the Apostle Judas, who had told the chief priests

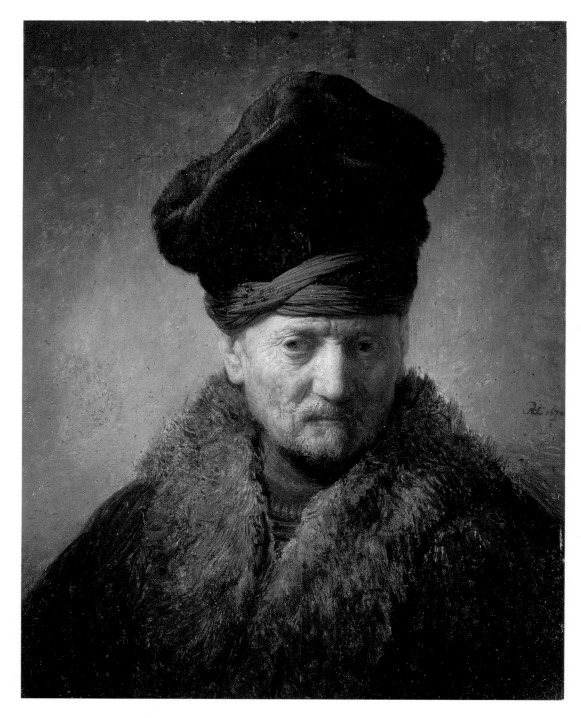

LEFT Rembrandt *Bust of an Old Man in a Fur Cap*, 1630, oil on wood, 8⅝ × 6⅞ inches (22.2 × 17.7 cm), Tiroler Landesmuseum Ferdinandeum, Innsbruck. Signed: *BRHL 1630*.

RIGHT Rembrandt's circle, *A Man in a Gorget and Plumed Cap*, c.1631, oil on wood, 21⅝ × 20 inches (56 × 51 cm), J Paul Getty Museum, Malibu. The model appears to be the same figure the artist painted in the previous year.

composition is the book, or scriptures, at the left. It is perhaps not insignificant that the elders are shown turning away from it. Their varying reactions can be compared with those of the figures at the graveside in Rembrandt's *The Raising of Lazarus* (page 42).

There were few precedents for depicting this scene and so Rembrandt had to create a new formula. The difficulties involved are revealed by x-rays that show how the composition was altered several times before the solution he was satisfied with was arrived at. Potential answers to the problems he faced were worked out as the painting progressed in drawings, but most of the alterations were made on the panel itself.

Rembrandt, along with other artists, clearly thought the toil worthwhile because the *Repentant Judas* remained in his possession for some years, and was copied by various contemporaries.

Rembrandt's Parents?

The artist's ability to depict with both sympathy and poignancy the effects of aging is apparent in most of his history paintings of the Leiden years. He also made something of a specialty of single-figure studies of old men and women at this time, who are in some instances presented in the guise of a Biblical figure, and on other occasions character studies without attributes. In contemporary terminology such works were called 'tronies,' a term for depictions of heads of interesting but unidentified individuals which were painted in an pleasing manner. Many of these works have at various times been referred to as portrayals of either Rembrandt's mother or father. He may well have turned to members of his family as readily available models, but unlikely that they can be identified in this way with any certainty. None of the pictures in question are docu-

and elders where Jesus could be found, repented and returned the thirty pieces of silver he had been given:

Saying I have sinned in that I have betrayed the innocent blood. And they said, What is that to us? See thou to that.
And he cast down the pieces of silver in the temple, and departed, and went and hanged himself.

Matthew 27: 3-5

For Huygens:

I would have [this picture] stand as an example of what is true of all his work. Call all Italy, and whatever survives of Antiquity that is beautiful or wonderful. That single gesture of the desperate Judas – that single gesture, I say, of a raging, whining Judas groveling for forgiveness he no longer hopes for or dares to show the smallest sign of expecting, his frightful expression, hair tangled, his torn garment, his arms twisted, hands clenched bloodlessly tight, fallen on his knees . . . that body, wholly contorted in despair, I contrast with all the art of time past, and recommend to the attention of all.

This commentary is so immediate that it is reasonable to suppose the writer made some notes which probably formed the basis of it actually in front of the work. The figure of Judas which Huygens singles out for praise does provide a perfect and terrifying foil for the rejection, incomprehension and pomposity of the priests and elders. His posture had in part been rehearsed earlier by the artist in his depiction of Tobit (page 26).

The scheme of lighting, as by now might be expected from Rembrandt's work, forms an integral part of the manner in which he has retold the narrative. Judas and the coins are lit from the upper left and the shadows cast around this foreground group concentrate attention on them. The sheen on the decorative elements of the elders' clothes contrasts with the dull rags of the penitent. At the right two dimly illuminated figures climb the stairs; unaware of the drama and set back in space, they play a similar role to the woman in the *Christ at Emmaus* (page 30/31). The most brilliantly lit part of the

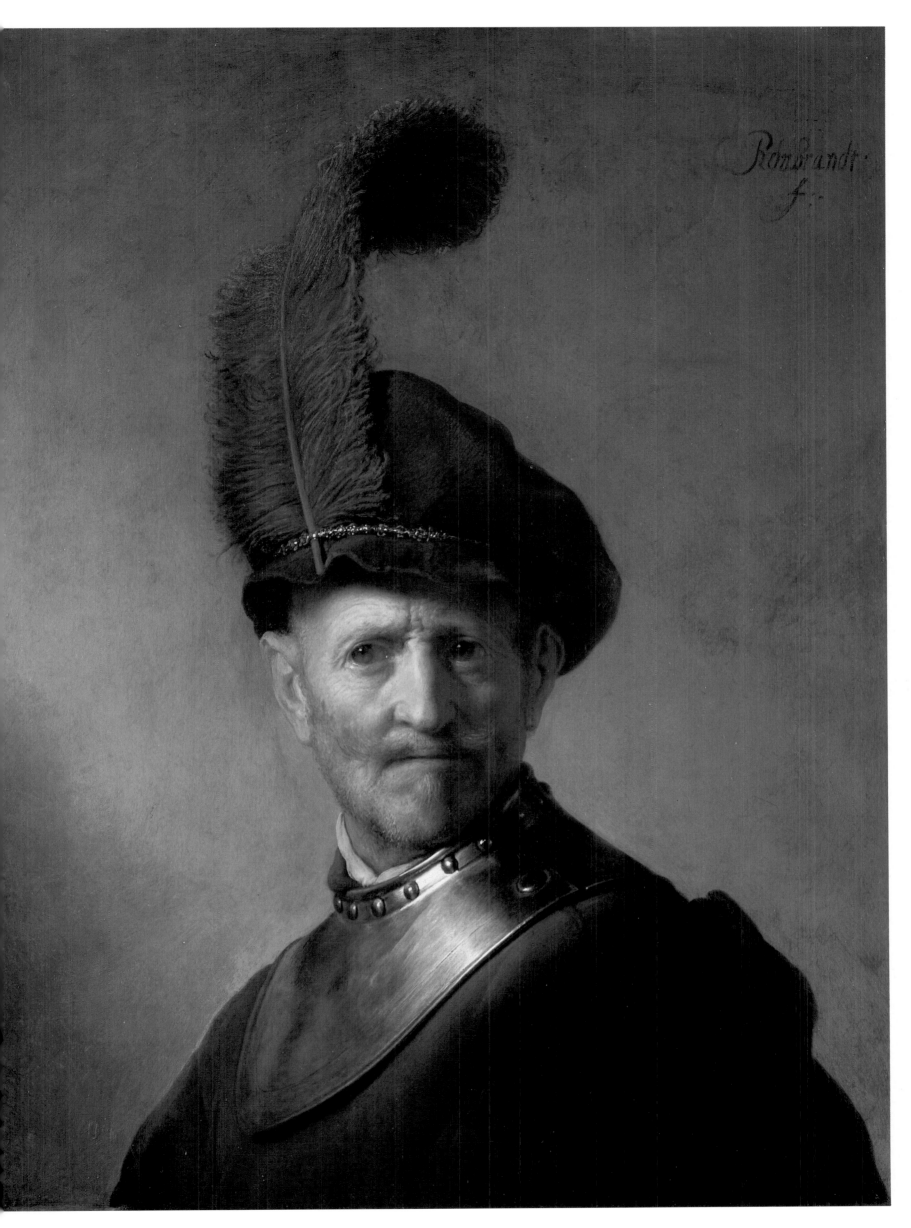

LEFT Rembrandt *Two Studies of Old Men's Heads*, c.1639, pen and brown ink on paper, 3⅛ × 3⅝ inches (8.1 × 9.4 cm), British Museum, London.

RIGHT Rembrandt *Jeremiah Lamenting the Destruction of Jerusalem*, 1630, oil on wood, 22¾ × 18¼ inches (58.3 × 46.6 cm), Rijksmuseum, Amsterdam. This is in many ways the climax to Rembrandt's studies of elderly men of the early 1630s. Jeremiah prophesied the destruction of Jerusalem; it is not clear, however, if he is depicted here during his prophecy (with the city shown burning, as though in his mind's eye, at the left), or lamenting the prophecy coming true.

mented as depictions of the artist's parents, and on close inspection they appear to be of more than two distinct models.

Rembrandt's father, Harmen Gerritsz. van Rijn, was born in about 1568. He followed family tradition and worked as a miller throughout his life. He died in April 1630, and a group of Rembrandt's works dated to this year, or to the last part of the 1620s, that include elderly men have been described at different times as portrayals of him.

One of these pictures, *Bust of an Old Man in a Fur Cap*, which is signed in monogram and dated to 1630 (page 46), shows a subject who also appears in contemporary etchings by both Rembrandt and Lievens. He wears a type of tall fur hat which was worn by Polish Jews. His features are the most precisely worked region of the panel; the rest of the painting – the fur of his coat and background – are quite rapidly and freely painted. A gentle glowing effect is achieved across the entire work because Rembrandt exploited the hue and tone of the light yellow ground beneath the main paint layers by not fully covering it in most areas.

It seems almost certain that the same man also appears in *A Man in a Gorget and Plumed Cap* (page 47), which may have been painted a little later. Here the effect of smooth finish is quite different. The gorget may be the same as the one that appeared in Rembrandt's earlier *Self-Portrait* (page 36). The subject's impressively plumed hat is probably likewise a studio prop. Together

these attributes suggest that the figure is intended to be seen as a soldier.

Rembrandt employed the skills of characterization developed in 'tronies' of this sort in single studies of Biblical figures of the same period. These include his masterly *Jeremiah Lamenting the Destruction of Jerusalem* (right), of 1630. Jeremiah was one of the four so-called 'greater prophets' of the Christian Church. He prophesied the destruction of the city of Jerusalem, and his prophecy as well as the actual destruction are described in the Old Testament. Here he rests his head upon his hand and looks down in a manner which conveys his deep melancholy. He leans on a large book that is inscribed 'BiBeL', which may be intended as his own Book of Lamentations.

Through an opening at the left the burning city can be seen. The last king of Judah, of which Jerusalem was the capital, was blinded, and a man on the steps before the ruins, who holds his hands to his eyes, can probably be identified as him. Above the devastation a winged figure apparently holding a torch flies through the air. It is not entirely clear who this is intended to be – a personification of God's wrath.

This reading of the subject so far seems satisfactory, but problematic elements remain. According to the Bible the prophet was imprisoned during the destruction. So is he confined in this depiction, and what are we supposed to make of the riches which lie beside him? If he is in prison then the city may be represented here as what Jeremiah

can see in his mind's eye, using a device akin to the thought bubbles found in modern cartoons. The riches could be treasures saved from the Temple, but why would he be allowed to retain them when he was locked up? The answer might lie in the possibility that what we are witnessing is the prophecy, rather than the lament.

These ambiguities do not detract from the power of the image. When the painting was sold in Amsterdam in 1767 it was described as 'Very vigorous, fine in coloring and elaborately painted on panel.' There is a clear distinction between the verisimilitude with which the prophet is depicted – note the veins which run across the top of his feet and the wrinkles on his brow – and the broad sweeps used to establish the context, half-cave and half-ruin.

Rembrandt made a number of etched studies of the model he used for Jeremiah at about the same time. One of these, *An Old Man with a Flowing Beard: the Head Bowed Forward* (page 51), shows how in such works he explored the way in which light falls across the beard and the network of wrinkles on the brow of the man. A preparatory drawing for the contemporary etching *Saint Paul Meditating* (page 51), shows how the overall scheme of lighting employed for it was similar to that for the Jeremiah painting, with a darkened foreground contrasted with a diagonal shaft of light that runs the length of the composition.

Rembrandt was as much preoccupied at the turn of the decade with depictions of old women, many considered portrayals of his mother. Cornelia Willemsdochter van Zuytbroek was born in 1568. She married Rembrandt's father in 1589 at the age of 21 and bore ten children before her death in 1640. One of the few other facts known about her is that she was illiterate; in 1635 she gave permission for Rembrandt's marriage with a cross rather than a signature.

LEFT Rembrandt *An Old Woman: 'The Artist's Mother'*, *c.*1629 oil on wood, 23⅝ × 18½ inches (61 × 47.4 cm), Royal Collection, Windsor Castle © 1993 Her Majesty the Queen. At present there is no way of corroborating the assertion that this beautiful study is a depiction of Rembrandt's mother.

BELOW Rembrandt *Saint Paul Meditating*, *c.*1629-39, red and black chalk with gray and black wash on paper, 9¼ × 7⅞ inches (23.6 × 20.2 cm), Cabinet des Dessins, Musée du Louvre, Paris. This study, which is related to a contemporary etching by the artist of the saint, employs both a similar figure type and lighting arrangement to that found in Rembrandt's *Jeremiah* (page 49).

BELOW Rembrandt *An Old Man with a Flowing Beard: the Head Bowed Forward*, 1630, etching (only state), 35½ × 29⅝ inches (91 × 76 cm), Museum het Rembrandthuis, Amsterdam. Signed at the top right: *RHL 1630*.

Of the various works which have been described as depictions of her, perhaps the most appealing is a painting in the British Royal Collection (left), which can probably be dated to 1629. It is currently called *An Old Woman: 'The Artist's Mother'*, but there is no way of corroborating this assertion. It is not clear if the picture was intended as a portrait, 'tronie,' or even perhaps a depiction of a religious subject such as Saint Elizabeth; in early records it is simply called a picture of an 'old woman.'

She stares down in a meditative fashion, her face being only dimly illuminated and isolated in the surrounding darkness. She wears a high collar and a fur gown, and has a velvet hood which is richly decorated with gilt on the inside. The varying textures and hues of her skin are defined with extraordinary precision. This treatment has led some to suggest that the work is not by Rembrandt at all, but a painting by his companion and competitor, Jan Lievens.

X-rays of the panel reveal that the artist originally started work on quite a different composition; he appears to initially have used the support the other way around, and to have depicted an old man.

The painting has a very prestigious provenance. It is thought to have been given to King Charles I of England by Sir Robert Kerr at some point before 1633. Kerr could have acquired it when on a diplomatic mission to Amsterdam. He may have actually bought it directly from Rembrandt's studio, or possibly via an intermediary such as Constantijn Huygens.

The same model was used for other depictions of elderly women of these years, which are likewise often referred to, without justification, as depictions of Rembrandt's mother. Included among this group are an etching of her head (page 52) of 1628, and a depiction of the *Prophetess Anna* of 1631 (page 53), which is in many ways a foil for his Jeremiah painting discussed earlier (page 49). The shiny wrinkled hand of the richly dressed elderly subject runs

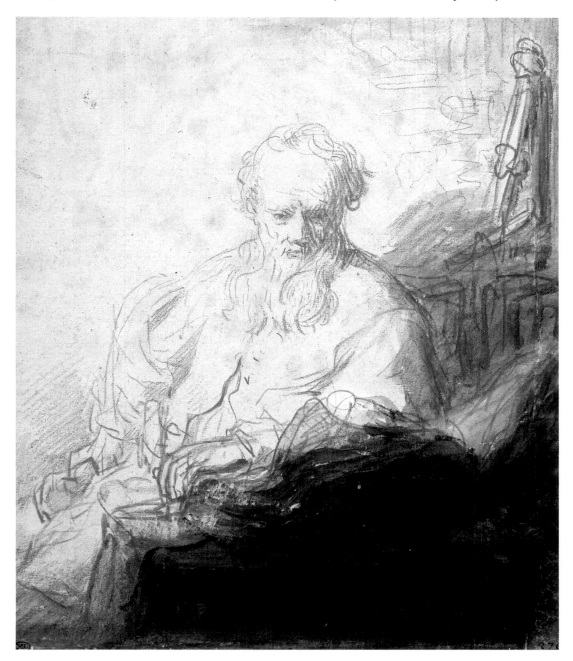

RIGHT Rembrandt *The Prophetess Anna*, 1631, oil on wood, 23⅜ × 18⅝ inches (59.8 × 47.7 cm), Rijksmuseum, Amsterdam. Anna recognized Christ as the Savior when she saw him being presented in the Temple by his parents. Here she studies the scriptures.

BELOW Rembrandt *Rembrandt's Mother, Full Face*, 1628, etching (state 2), 2⅜ × 2½ inches (6.3 × 6.4 cm), British Museum, London. Signed center left: *RHL 1628.*

across the lines of Hebrew text in a huge book which rests upon her lap. The light falls from behind her, catching the bloom on her velvety gown and illuminating the open pages. It reflects back from them up to her face in a weaker state, so that the concentration of her expression can be seen. Using a book in this manner to illuminate features was a device the artist returned to on other occasions (see page 166).

Anna was a prophetess who had an intimate knowledge of the scriptures, hence her scrutiny of the book here. She was an eighty-four-year-old widow who spent all of her time praying in the temple in Jerusalem. When Joseph and Mary took the Christ Child there to be presented, as was the custom, it was she who recognized him as the Messiah.

RIGHT Rembrandt *Seated Old Woman with Her Hands Clasped*, c.1635-37, red crayon on paper, 9¼ × 6⅛ inches (23.7 × 15.7 cm), Cabinet des Dessins, Musée du Louvre, Paris. This affecting study from life has, like almost all the artist's depictions of elderly women, at one time been described as a depiction of Rembrandt's mother.

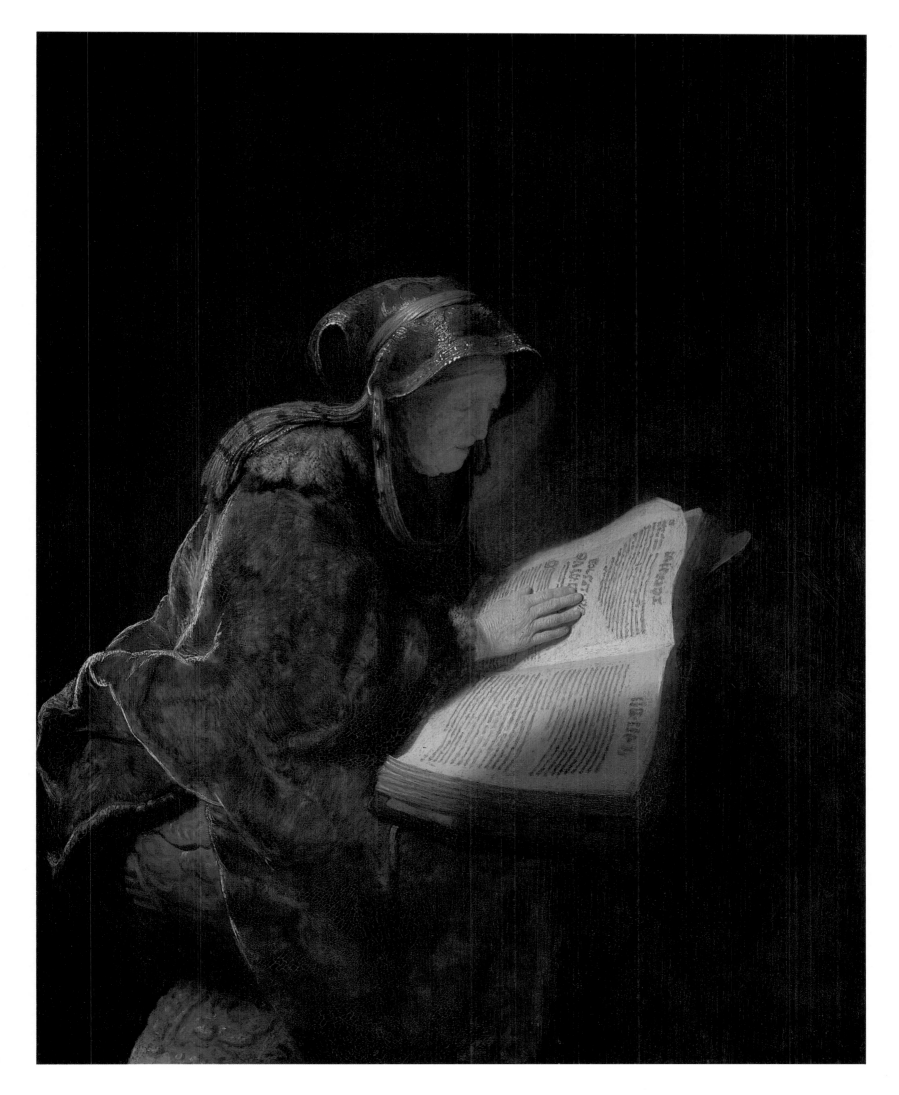

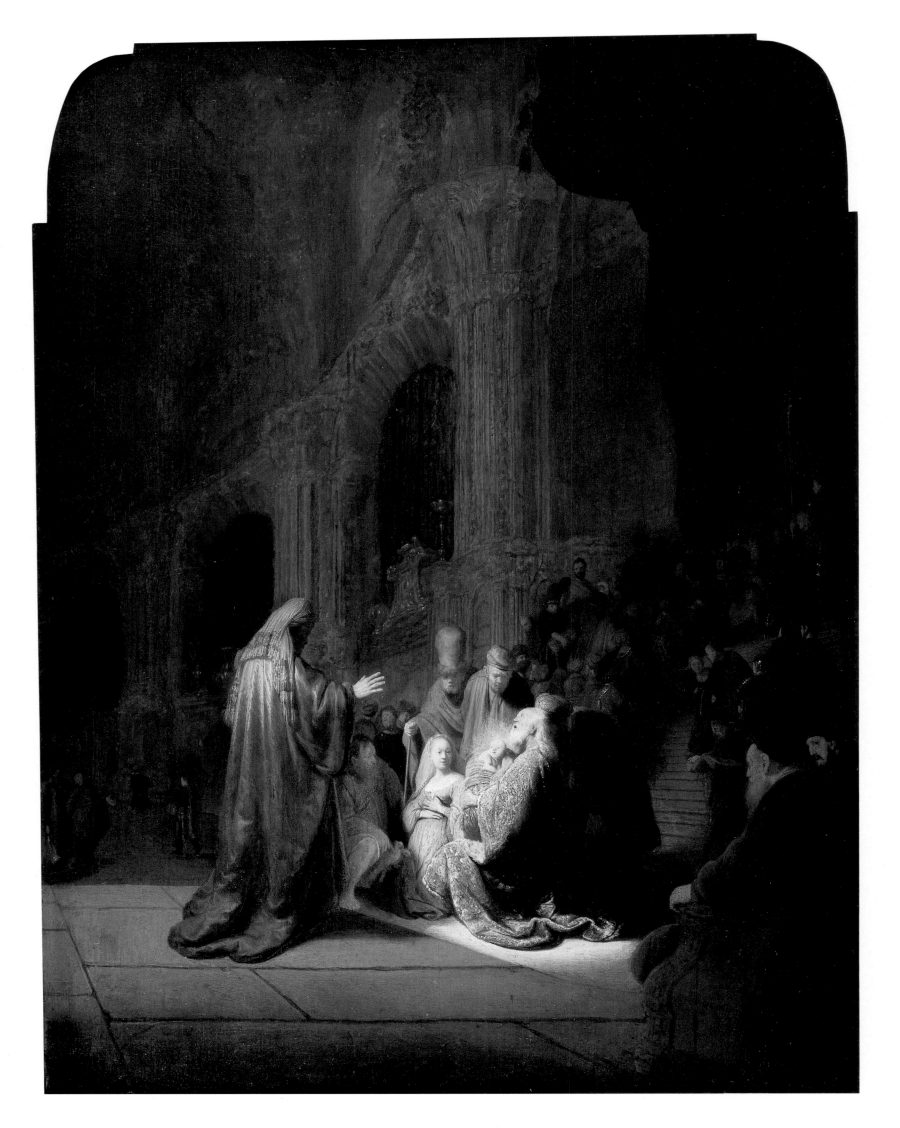

Rembrandt *The Song of Simeon*, 1631, oil on wood, 23¾ × 18⅝ inches (60.9 × 47.8 cm), The Mauritshuis, The Hague. Simeon, like Anna (page 53), recognized the status of the infant Christ when he was presented in the temple. Here he holds the child, and calls out in celebration, while Saint Joseph and the Virgin, who are also kneeling, look on. The figures are grouped by the light amid a huge cavernous space.

In the same year Rembrandt painted the prophetess, he also executed a depiction of another aspect of the Presentation of Christ, *The Song of Simeon* (left), which lies close thematically and technically to the former work. It has been proved that wood from the same tree was used for the panels of both paintings.

Simeon was, like Anna, an elderly devout figure who recognized the divinity of Christ in the Temple. He knew that he would not die until he had seen the Savior. Rembrandt shows him on his knees before a figure with arms spread, who may be Anna, holding the Christ Child and calling out:

Lord, now lettest thou thy servant depart in peace, according to thy word
For mine eyes have seen thy salvation,
Which thou hast prepared before the face of all the people;
A light to lighten the Gentiles, and the glory of thy people Israel.

Luke 2: 29-32

This central group is lit by a strong shaft of light in the middle ground, to which the eye is drawn because of the contrast with the surrounding gloom. The Virgin and Saint Joseph kneel on the floor of the Temple beside Simeon. Joseph is depicted carrying two doves – the traditional offering made on such occasions. The Holy Family are surrounded by the bustle of many people walking to and fro, mainly oblivious to the profundity of the event taking place. Attention is only paid to it by two almost comical figures wearing hats, who stand behind the Virgin, and the men on the bench in the right foreground, who are perhaps discussing the incident.

This is one of Rembrandt's few exercises in establishing a large architectural interior, and as such brings to mind Huygens' observation that the artist was able to conceive works in a grand manner in spite of the diminutive size of his pictures. The scale and decoration of the building can be compared with that later used in Rembrandt's *The Woman Taken in Adultery* (page 157), a work in which its articulation was similarly used to direct attention down toward the chief protagonists in the drama.

The Song of Simeon on initial inspection appears to have a limited chromatic range, but as it is scrutinized in detail it reveals a surprisingly rich diversity of reds, mauves, blues, greens and yellows, and as such marks a new stage in Rembrandt's development as an increasingly accomplished and subtle colorist.

55

Success in Amsterdam

Because his work pleased the citizens of Amsterdam, and he received frequent commissions for portraits as well as other pictures, he decided to move from Leiden to Amsterdam.

Orlers, 1641

It appears that Rembrandt made this second move from Leiden during the winter of 1631, about a year after his father had died. He settled in Amsterdam for the rest of his life, and with this relocation both his painting and career were to alter quite radically. The artist's companion, Jan Lievens, by contrast decided to travel to England and Antwerp, before establishing himself as a successful portraitist back in Holland.

Rembrandt had already been introduced to Amsterdam by his spell of apprenticeship with Lastman, and probably also established links with some of its inhabitants through Swanenburg, who is known to have been associated with regents in the city. Its appearance would have changed considerably in the intervening years because of expansionist building programs that were designed to accommodate the rapidly increasing population, which had grown particularly because of immigration from the southern Netherlands.

The artist invested 1000 guilders in the business of an art dealer, Hendrick Uylenburgh, who was based there, and subsequently moved into Uylenburgh's house which was in the Sintanthonisbreestraat. The size of this outlay

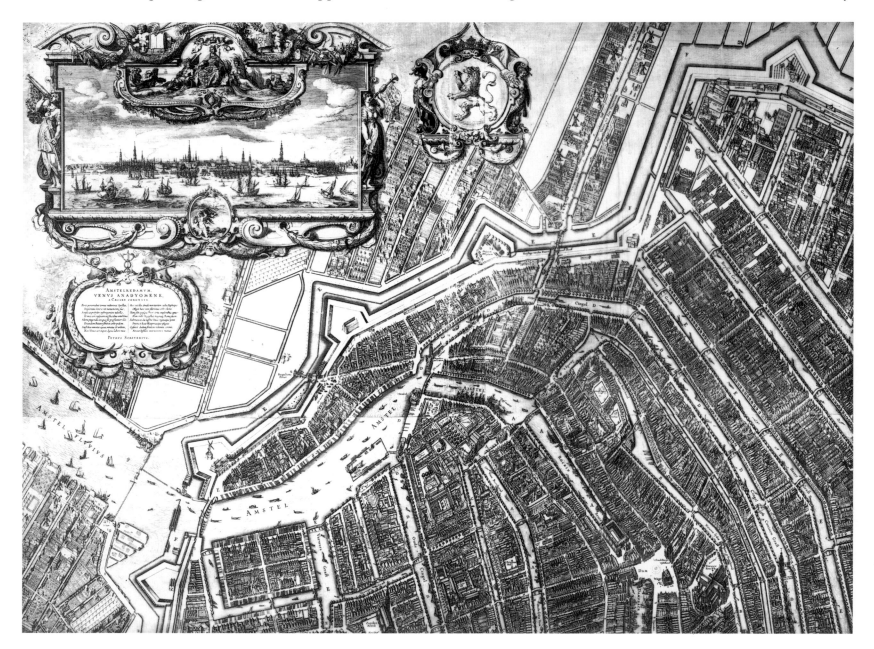

LEFT Balthasar Florisz. van Berckenrode *Map of Amsterdam*, 1625, engraving (made from nine plates), 54⅝ × 62½ inches (140 × 160 cm), Municipal Archives, Amsterdam. Rembrandt's brief period of training in Amsterdam under Lastman in 1624 was not only important in artistic terms, but also introduced him to what was probably the most cosmopolitan city in northern Europe. Amsterdam had a large merchant navy which particularly traded in furs, grain, and wood with the Baltic ports.

RIGHT Johan Martinus Anthon Rieke (1851-99), *View of the Rembrandt House in Amsterdam*, 1868, pencil and pen with brown ink and watercolor heightened with white, 13½ × 7⅜ inches (34.6 × 19 cm), Museum het Rembrandthuis, Amsterdam. This is the impressive town house into which Rembrandt and his wife Saskia van Uylenburgh moved in 1639.

gives an impression of Rembrandt's comfortable financial position at this period.

Uylenburgh was the son of a cabinet-maker to the king of Poland. He had worked as a painter in Denmark before establishing himself as a dealer in Amsterdam in the late 1620s. It seems that he provided studios and possibly materials for young painters in exchange for marketing their work. The relationship between the two men usefully emphasizes the way in which painting was very much a commercial, rather than dilettante, activity.

This factor also becomes apparent once the expansion of Rembrandt's studio during the 1630s is plotted. He continued the practice of taking in paying pupils, and Sandrart (1675) wrote that the artist 'filled his house in Amsterdam with almost countless distinguished children for instruction and learning.' Painters who passed through it at this period include Gerbrandt van den Eeckhout (1621-74), Govert Flink (1615-60), Jacob Backer (1608-51), Ferdinand Bol (1616-80), Jan Victors (1620-76), Gerrit Willemsz. Horst (1612-52) and Reynier Gherwen (d.1662).

Rembrandt himself developed a quite different approach to that pursued during his Leiden years, which was then redeployed by such men. He slowly moved away from the meticulousness associated with the *fijnschilders*, toward a freer style, the bravura of which was ideally suited to the portraiture for which he was becoming increasingly in demand.

As well as producing such pictures, Rembrandt was also regularly producing history paintings. Perhaps the most prestigious commission for work of this type he received was for a series of paintings of scenes from the Passion of Christ for the Stadholder. This patronage from the Court in The Hague was secured because of the links Rembrandt had made earlier with Constantijn Huygens, who worked as artistic adviser to Prince Frederik Hendrik.

The professional esteem and affluence Rembrandt enjoyed at this period ran in parallel with a happy personal life. In 1634 he married Saskia van Uylenburgh, the cousin of the art dealer with whom he initially lodged in the city. In 1635 the couple set up home in the Nieuwe Doelenstraat, and then two years later are recorded as living in part of a sugar refinery. This may seem a very odd address, but the decision could have been made for very practical reasons; it might have afforded the artist far more workspace.

LEFT Samuel van Hoogstraten (1627-78) *A Putto with a Cornucopia and a Painter Before an Easel*, detail of the exterior of *A Peepshow with Views of the Interior of a Dutch House*, 1655-60, oil on wood, 22⅝ × 34⅜ inches (58 × 88 cm), The National Gallery, London.

BELOW Rembrandt *Nicolaes Ruts (1573-1638)*, 1631, oil on wood, 45⅝ × 34⅛ inches (116.8 × 87.3 cm), The Frick Collection, New York. The sitter, here depicted at the age of 58, was a merchant from Cologne who had settled in Amsterdam.

In 1639, however, Rembrandt and his young wife moved yet again into a large house in the Sintanthonisbreestraat (page 57), which is now called the Rembrandthuis, and contains a collection of the artist's etchings. This building, which was near Uylenburgh's home, and in a fashionable and artistic area, had been improved by the famous architect, Jacob van Campen (1595-1657), in the 1620s. That they should have decided to live in such an impressive residence is a clear marker of the social standing Rembrandt obviously felt he enjoyed. It was never entirely paid for, however, and this piece of financial mismanagement was to contribute to the future economic problems the artist had to face.

Portraiture

He drew [an] abundance of Portraits, with wonderful Strength, Sweetness, and Resemblance.

Richard Graham, 1716

Portraits had not formed a significant part of Rembrandt's output during his formative years in Leiden, but the demand for such works in Amsterdam and The Hague was considerable, and the artist soon proved himself a worthy competitor in the market.

The commercial nature of portrait painting is effectively and succinctly illustrated by a detail from a work by one of Rembrandt's pupils, Samuel van Hoogstraten. *A Putto with a Cornucopia and a Painter Before an Easel* (above), comes from the exterior of Hoogstraten's *Peepshow with Views of the Interior of a Dutch House*, which is in the National Gallery, London. It shows a putto holding a cornucopia from which money spills, with an artist in the background

painting a portrait. The little banner the putto holds is inscribed *Lucri Causa* (for the sake of wealth). This image is com-

plemented by two other emblems of a similar type on the sides of the peepshow box, that illustrate the other

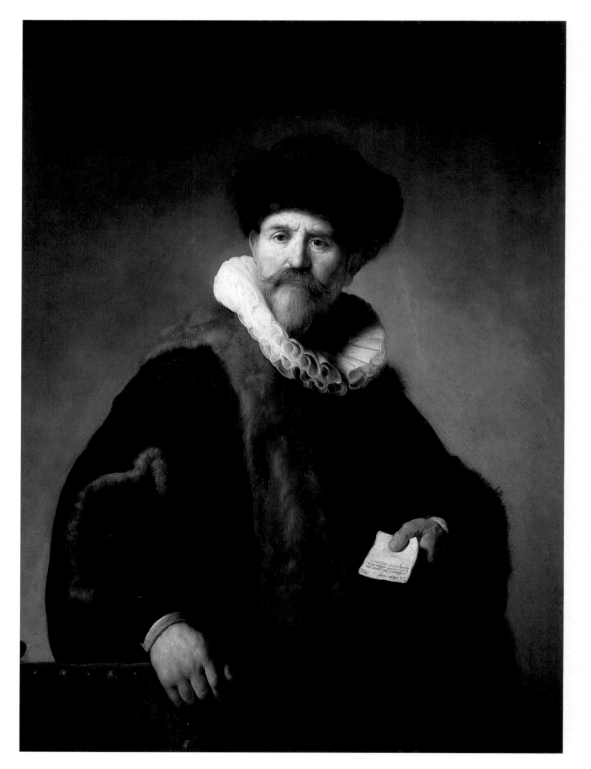

BELOW Michiel van Miereveld *The Anatomy Lesson of Dr Wiilem van der Meer*, 1617, Museum het Pinsenhof, Delft. This is an example of the type of painted anatomy lessons, in which the figures are very self-consciously posed, that preceded Rembrandt's innovations.

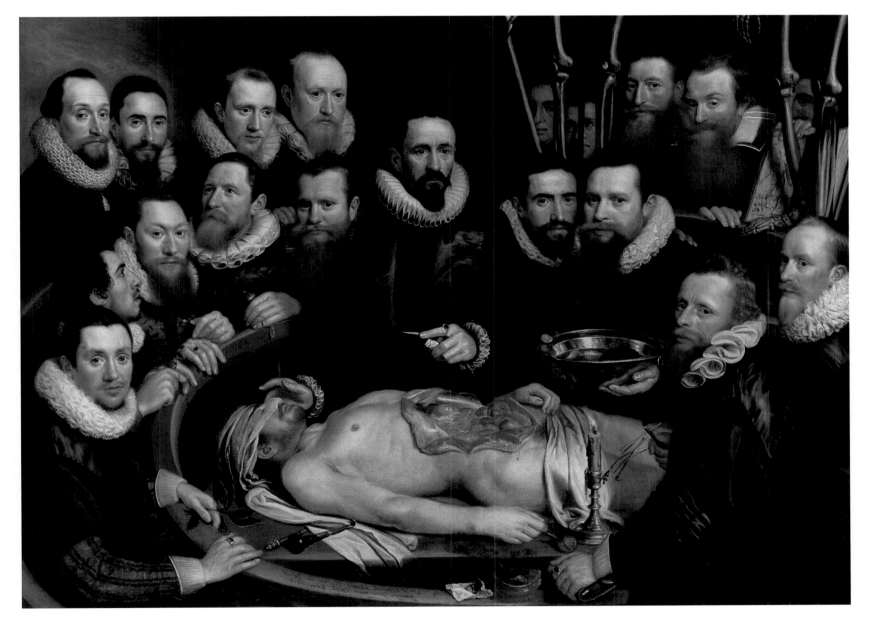

reasons for painting, according to the philosopher Seneca – for the love of art, and for fame. All three could be said to have applied to Rembrandt, with fame and wealth being particularly promoted at this period as a result of his portraiture.

The artist's sitters tended to come from the interconnected families of burghers who dominated the economic life of Amsterdam, and members and servants of the 'Court' who were based in The Hague. He increasingly received commissions from them because he

freed portraits from many of the conventions already set, and continually innovated, both compositionally and in terms of technical virtuosity.

It is little wonder that he was successful in this field in view of the fact that he was able to produce works of the quality of his depiction of *Nicolaes Ruts* (1573-1638) (left). This picture, which was executed in 1631, is probably his earliest portrait of an Amsterdammer.

Ruts was born in Cologne and settled in Amsterdam where he made money, although not altogether successfully,

from the trade between the city and Russia. The furs on his coat and hat may well be a reference to such an occupation – they were the sort of luxuries that were imported from Russia. This portrait of him may well have been commissioned by his daughter Susanna; it remained with his descendants until the beginning of the nineteenth century.

The design is bold and the sitter appears animated. The impression of vivacity is created in part by the alertness of his features and also because of

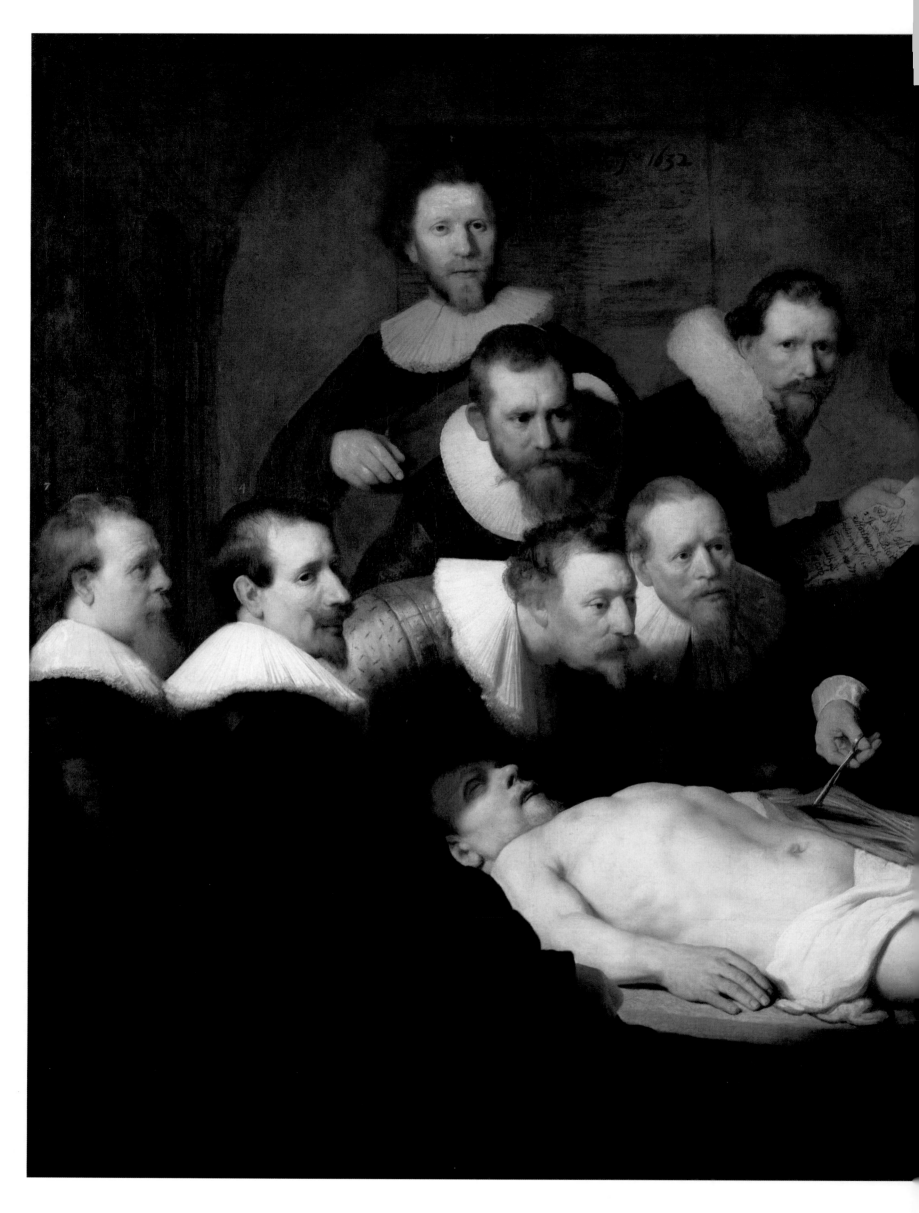

Rembrandt *The Anatomy Lesson of Dr Nicolaes Tulp*, 1632, oil on canvas, 66¼ × 84½ inches (169.5 × 216.5 cm), The Mauritshuis, The Hague. With this depiction of members of the Amsterdam surgeons' guild attending a dissection, Rembrandt animated a type of group portrait which had previously been explored in a far more stilted and less engaging fashion (page 59). It was a significant work in terms of furthering the artist's career because it would have come to the attention of academic, political, and artistic circles in Amsterdam.

the figure's slightly twisted pose. The impression given is that he has just turned away, but then swung back to confront the painter and viewer, perhaps about the note he holds, which is inscribed with the date the work was executed.

Rembrandt executed a number of single-figure, three-quarter length portraits such as this, but also proved himself as a painter of group portraits early on in his Amsterdam career. *The Anatomy Lesson of Dr Nicolaes Tulp* of 1632 (left), is his first masterpiece in this genre.

Recording in paint the dissection of a corpse was not in itself an innovation, but the naturalism and animation the artist brought to this scene was something quite new. Its effect can be highlighted by comparing Rembrandt's work with an earlier painting of the same type, Michiel van Miereveld's *The Anatomy Lesson of Dr Willem van der Meer* of 1617 (page 59). In this precedent the lesson appears to be an excuse for rows of portraits, whereas in Rembrandt's painting the impression is given that the lesson has just been interrupted, because although some of the subjects look up at the viewer, others remain intent upon the lecture. Rembrandt had the enviable ability to make his sitters appear unself-conscious.

But Rembrandt's painting is much more than simply a rethink of a tried formula. It is also a work of great technical virtuosity, and implicitly an important statement about the academic status of Amsterdam. In the year it was painted, 1632, a new university opened in the city – a rival to the prestige of the older center of learning in Leiden. One of the disciplines in which Amsterdam could claim respectability was anatomy, and this work is very much an illustration of that claim. In 1628 a Chair of Anatomy was created for the first time, and the first professor, the *Praelator Anatomiae*, was Tulp, who was the

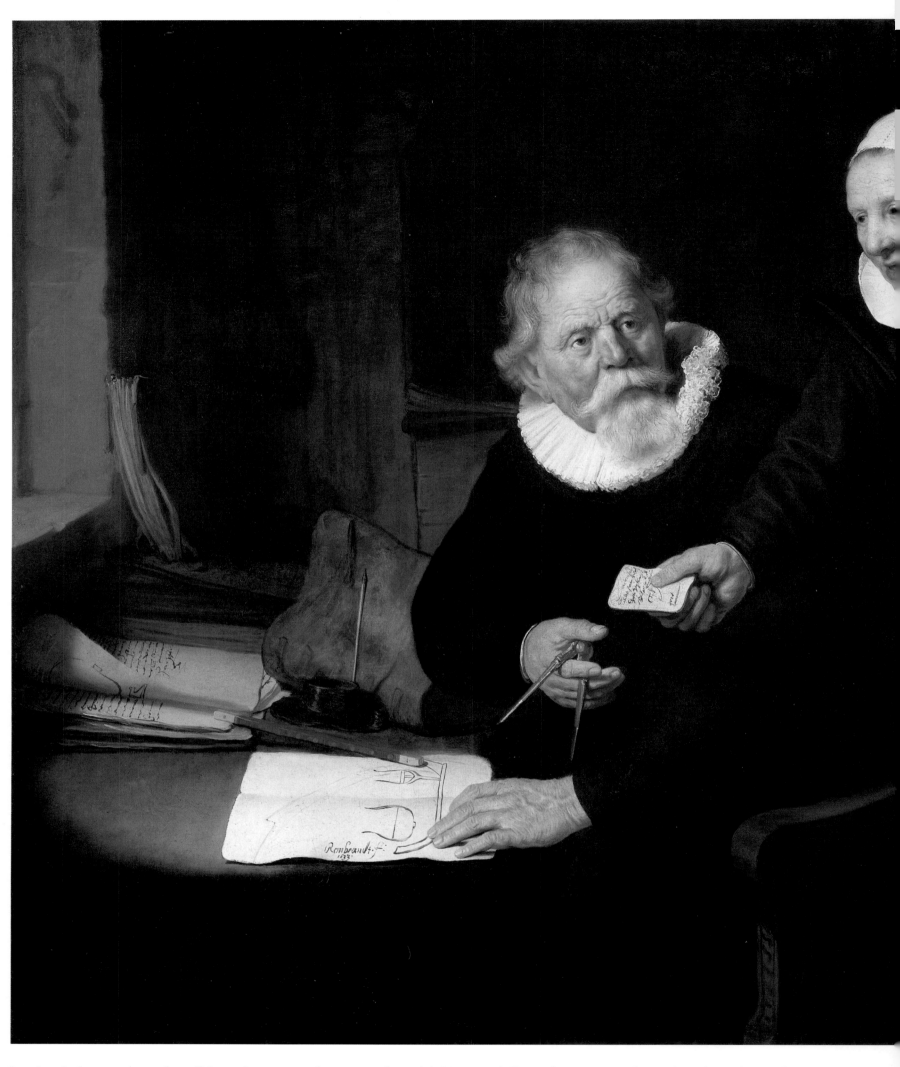

head of the surgeons' guild and a notable local politician. He was Curator of the Latin School and university, and a city magistrate.

Anatomy lessons of this sort only usually took place once a year. The corpses used were those of victims of the death penalty. In this case the

cadaver was that of Adriaensz. 't Kint of Leiden, who had offended on a number of occasions and was finally executed on 31 January 1632 after having being convicted for stealing a coat.

Tulp, whose status is emphasized because he is the only man wearing a hat, appears to be making a particular

point about the physiology of the arm to the attendant surgeons. That the rest of the corpse is unmolested shows that Rembrandt has not entirely realistically recorded the event, because on such occasions the abdomen was first cut open and the intestines removed – this was a necessary preliminary in view of

Rembrandt *Jan Rijksen (1560/61-1637) and Griet Jans (c.1560 – after 1653)*, 1633, oil on canvas, 44⅝ × 66 inches (114.3 × 168.9 cm), HM Queen Elizabeth II, Buckingham Palace. This is one of the artist's four surviving double portraits. Jan Rijksen was a shipbuilder, and his wife, Griet, the daughter of a shipbuilder. The couple were married in 1585. Rembrandt conceived their portrayal as an encounter, which immediately engages the interest of the viewer.

brandt's career. It was a prestigious work which would have caught the attention of academic, political, and artistic circles in Amsterdam, and so prompted subsequent commissions.

Different problems were encountered when trying to relate and animate figures in double portraits – a type of work Rembrandt also made a success of during his early years in the city.

In works such as his portrait of *Jan Rijksen (1560/1-1637) and Griet Jans (c.1560 – after 1653)* (left), of 1633, he again broke down the conventions of formality, and created a dynamic composition which a sale catalogue of 1811 described as 'the finest performance in his second manner . . . a truly wonderful performance, far above all praise.'

Jan Rijksen was a wealthy shipbuilder and his wife Griet was the daughter of a shipbuilder. In this work his profession, their relationship and their respective characters are all recorded in a moment of apparent simplicity which was actually devised with considerable artifice. Griet has just entered Jan's study with a message which her husband turns to receive. He looks up from a drawing on which the keel of a boat is plotted. He holds a pair of dividers, and on his desk rest other nautical notes along with an implement which is probably a ruler. The diagonal of her stance counterbalances the direction of the light.

It has been suggested that the relationship between the husband and wife as conceived here may reflect contemporary ideals about domesticity, according to which a man's intellect is complemented by a woman's industry. But it perhaps seems inappropriate to project onto the painting such notions, in view of the fact that much of the strength of Rembrandt's work lies in his ability to engage with individuals, rather than with types.

the fact that dissections of this sort lasted for three days. It is thought that the artist probably did not attend the lecture at all, and copied the arm from a preserved specimen.

The figures included had to pay individually for their portraits, and Rembrandt would have made drawn

studies of their features one by one before establishing the overall composition. We know who they all are because at a later stage their names were inscribed on the paper held by the man to the left of Tulp.

It is necessary to underline the significance of this picture for Rem-

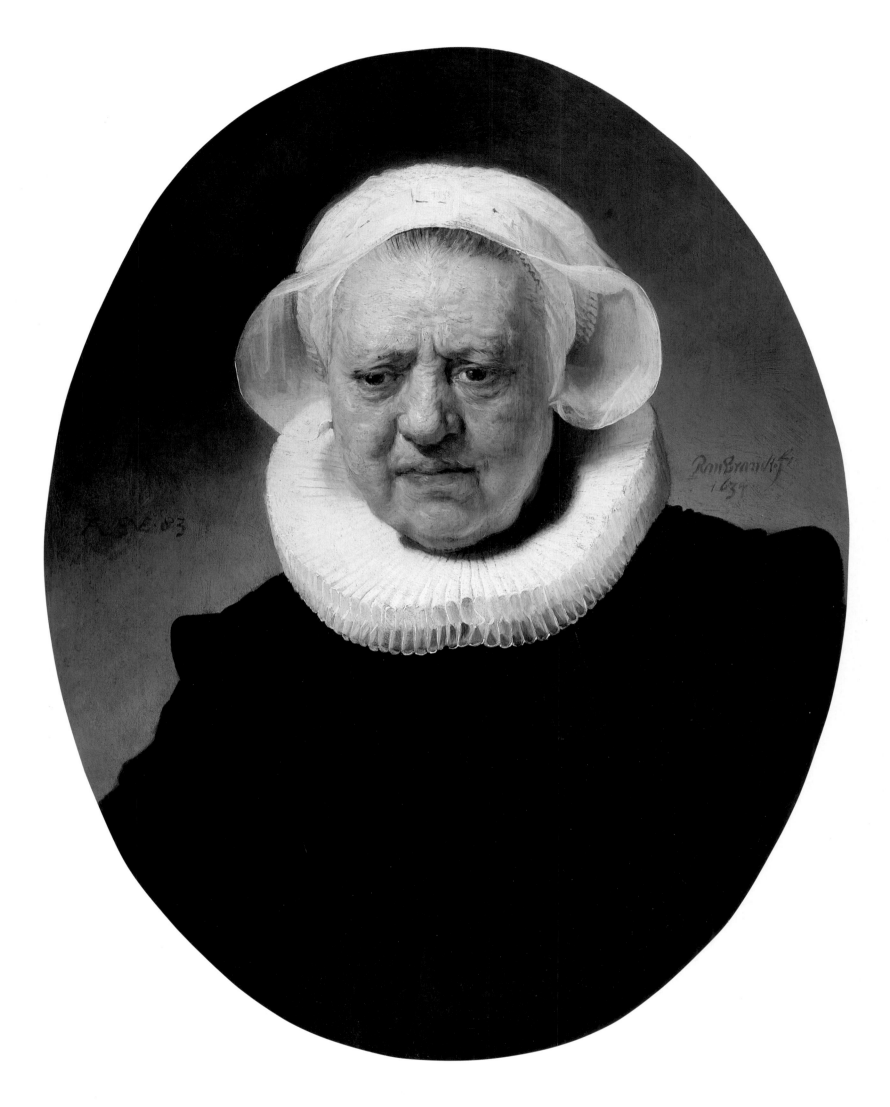

Rembrandt *Portrait of an Eighty-Three-year-old Woman*, 1634, oil on wood, 27¾ × 21⅝ inches (71.1 × 55.9 cm), The National Gallery, London. Signed and dated, center right: *Rembrandt f. 1634.* The sitter has not been convincingly identified; her age is inscribed at the left.

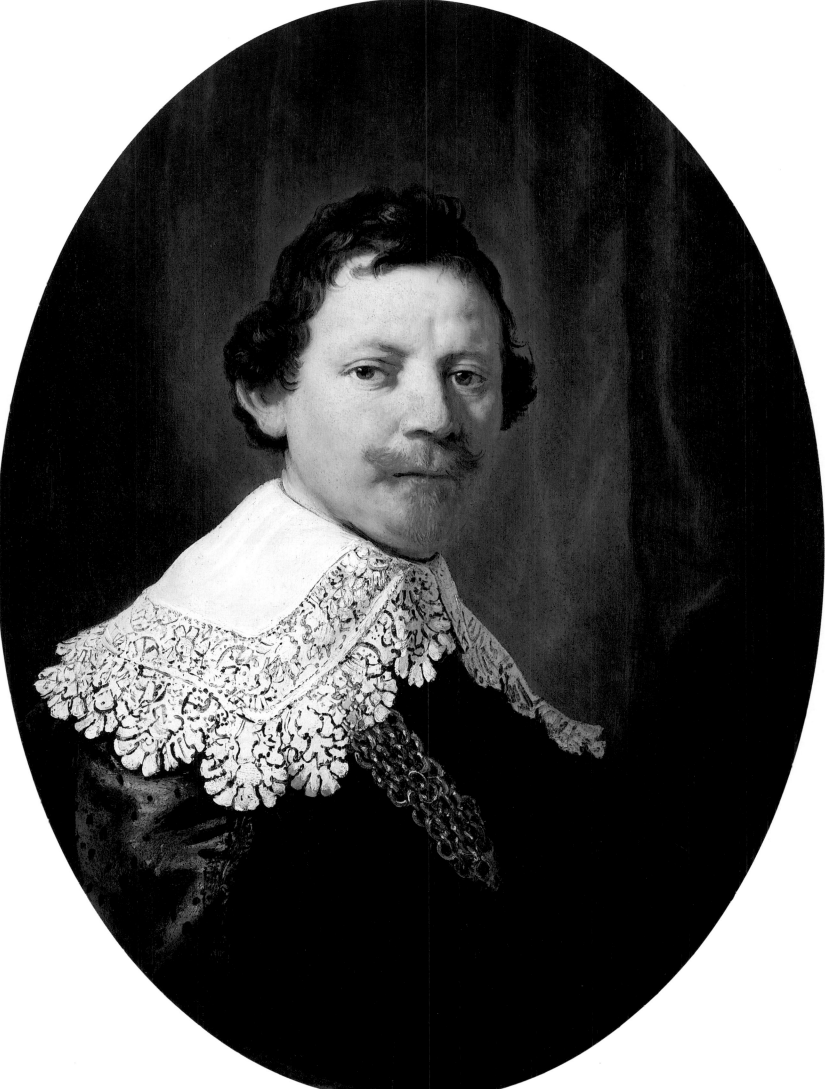

Rembrandt *Philips Lucasz.*, 1635, oil on wood,
31 × 23 inches (79.5 × 58.9 cm), The National
Gallery, London. Signed lower right:
Rembrandt/1635. Lucasz. was appointed
Councillor Extraordinary of the Dutch East
Indies in 1631.

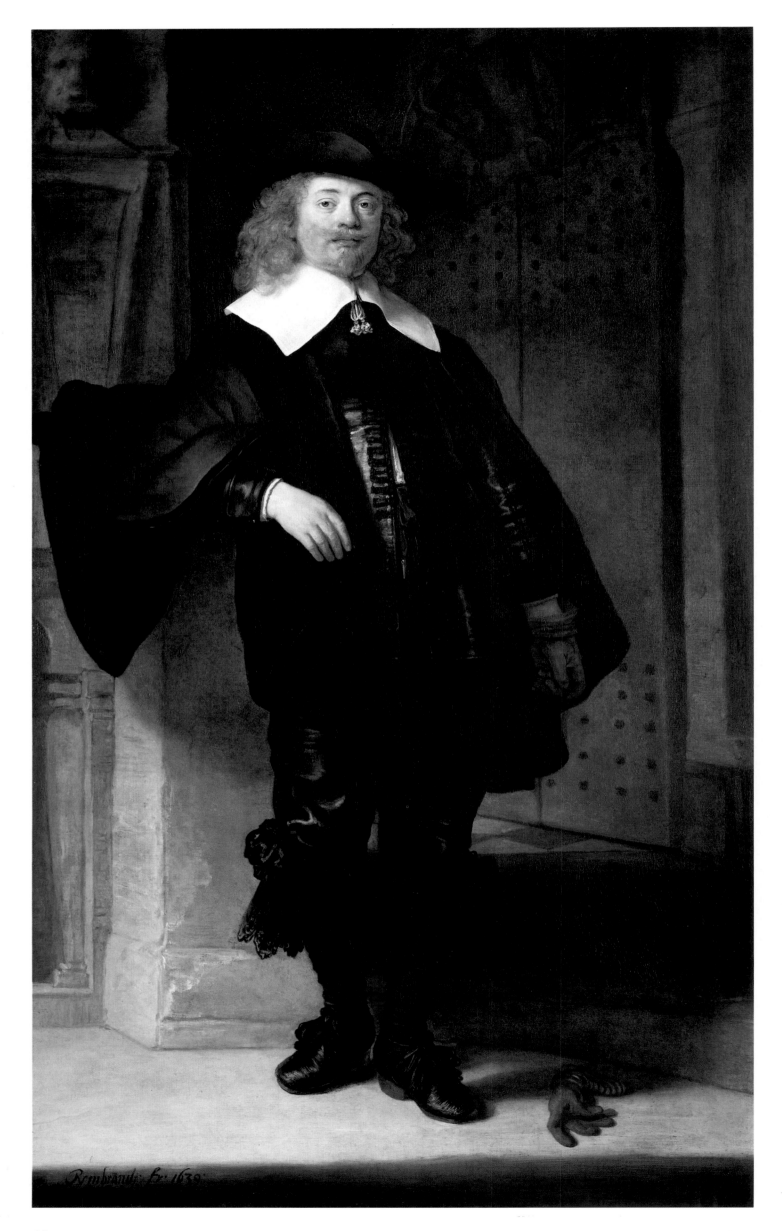

LEFT Rembrandt *Portrait of a Man, Standing*, 1639, oil on canvas, 78¼ × 48½ inches (200 × 124.2 cm), Gemäldegalerie, Kassel. The discarded gloves at the foot of this unidentified subject could signify a challenge, or his dominance over his wife, but neither suggestion has yet been proven.

The precision of the characterizations explored in such pictures is also found in a concentrated form in a number of Rembrandt's contemporary and more numerous bust-length portraits, which often follow the contemporary trend for oval images.

A particularly fine example of this type of work is his *Portrait of an Eighty-Three-Year-Old Woman* of 1634 (page 64). The age of the sitter is given on the inscription at the left. Rembrandt's ability not only to capture a likeness, but also to instil such an image with a sense of tangible presence, made his portraits stand apart from those of contemporaries. The wrinkled face is fluidly depicted, the expression appearing stern but vital. The paint is applied in a controled but quite rapid manner. On close inspection short strokes can be seen to run along the line of the form of the features being described.

Attempts have been made to identify the sitter. She has been described as Françoise Wassenhove, the wife of a preacher, and also as Rembrandt's grandmother, but neither of these suggestions is satisfactory.

Bust-length portraits were also produced by the artist on a number of occasions in pairs. *Portrait of Philips Lucasz.* (page 65) is one of a pair; its companion depicts the sitter's wife Petronella Buys (Wildenstein, New York, 1985). Lucasz. pursued a very successful career with the East India Company, becoming in 1631 Counsellor Extraordinary of the Dutch East Indies. In 1633 he returned to the Netherlands as the commander of a trading fleet and in the following year married Petronella Buys, whose family came from The Hague. The portraits were executed early in 1635 just before Lucasz. returned to the East Indies with his new wife. He died at sea in 1641 on his way to Ceylon; she returned to Amsterdam, remarried and died in 1670.

The pendants were recorded as being in the collection of Jacques Specx in 1655. Specx was an important patron of Rembrandt in the 1630s, and it is presumed that it was he who commissioned the works. He was employed by the East India Company, was the brother-in-law of Petronella, and appears to have been the person through whom the husband and wife met.

A technical examination of the *Portrait of Philips Lucasz.* has revealed that earlier in its history it looked quite different from the image which can now be seen. It is thought that the format of the painting was originally rectangular; this can be determined because the paint has been carried right up to the edges where it crumbles – suggesting that cutting took place. An x-ray shows the original inclusion of the sitter's left hand, which appears to be toying with his gold chain. The hand does not fit well with the oval format, but may have been shown when the work was rectangular, and then painted out when the format was altered (Bomford, Brown and Roy 1989).

Far more expensive than portrait busts, and consequently rarer, were full-length portraits. Rembrandt's *Portrait of a Man, Standing* (left) of 1639 is one of his most successful exercises in this more ambitious form of work. Although the quality of this depiction of an elegantly dressed figure is undeniable, many questions surrounding it have not yet found answers.

The subject appears to be standing in an interior which is lit by a bright shaft of sunlight. His wealth is attested to both by the quality of his clothing and to a certain extent by his surroundings. The door at the rear appears to have an ornate shell-like molding on its upper part and the man may be leaning on the edge of a large fireplace. The head of a term which decorates it stares out from the upper left.

But who is the man and what is the significance of the glove discarded on the floor? In the past he has been identified as Andries de Graeff, of whom, according to contemporary documentation, Rembrandt painted an expensive portrait. But his candidacy has been rejected because later depictions of Graeff show quite different features from those seen here.

An alternative identification of a man called Cornelis Witsen has been proposed. Witsen would have been 34 in 1639 when Rembrandt signed the portrait, so the sitter appears to be appropriately aged. He lent Rembrandt money and was a burgomaster of Amsterdam. In addition, later portraits of him appear similar to those of this figure, but no document yet confirms the link.

The act of throwing down a glove could be read as a challenge, but such an interpretation does not seem appropriate in view of the relatively gentle characterization. Alternatively, it may be intended to signify the authority of a man over his wife, but if this were the case the picture would have to have a companion portrait of a woman to make sense, and no such work has been found. The glove probably does have a specific meaning of this type, but also plays a pictorial role by creating an area of interest in the lower reaches of the portrait which otherwise would be neglected, given the inevitable attention which the face of the sitter draws.

In drawn studies of people of this period Rembrandt achieved a greater degree of intimacy and casualness than is found in his commissioned portraiture. One of the most attractive of these is a sketch of *Titia van Uylenburgh* (page 68) which is now in Stockholm. The drawing is inscribed as having been executed in 1639. It is a portrayal of the sister of Rembrandt's wife Saskia. With her glasses perched on the end of her

BELOW Rembrandt *Portrait of Titia van Uylenburgh*, 1639, Nationalmuseum, Stockholm. Titia was the sister of Rembrandt's wife Saskia van Uylenburgh.

arming in its casualness. Here the artist portrays himself tired, with wild hair and his shirt open to reveal his chest. His manic appearance is matched by the lively lines made by the pen. The artist appears to be sitting working at a table, with a palette hanging on the wall beside him.

Such works can be contrasted with the assurance shown in his more formal etched and painted self-portraits produced at the end of the decade. Of these, two which are closely related are particularly interesting in terms of the manner in which Rembrandt manipulated his pictorial sources to suit his own ends: the etched *Self-Portrait, Leaning on a Stone Sill* (page 70) of 1639, and the painted *Self-Portrait at the Age of Thirty-Four* (page 71) of the following year.

A distinct air of worldliness and comfortable success pervades both images. Although it has been suggested that it is problematic to establish links between Rembrandt's self-portraits and his life, it cannot be denied that when these works were made, Rembrandt's status as a respected artist and teacher in Amsterdam was appropriately assured. He was not as yet beset by the financial troubles that were later to hound him.

The impression of prosperity is established by the rich sixteenth-century clothing he wears, which is made of velvet and silk and lined with fur. The pose is confident and haughty, and derived from works by the High Renaissance artists Raphael and Titian.

Quite a lot is known about exactly how Rembrandt came across these precedents. On 9 April 1639 a sale was held in Amsterdam of a collection of Italian paintings belonging to Lucas van Ufflen. Rembrandt attended the event and witnessed the disposal of Raphael's *Portrait of Baldassare Castiglione* (Musée du Louvre, Paris). He

nose she scrutinizes her needlework in a moment of unself-conscious concentration, on one of what were no doubt her many visits to Rembrandt's household.

In another sketch of a woman in an interior which was probably executed in the same year (above right), Rembrandt employed a similar technique of setting off the definition of fine details against broad washed strokes. In this

case, the subject, who rests her glasses on the book on her lap, has not as yet been identified. She is an older woman who at first appears to be quite formally posed, but when looked at closely seems to be gently smiling at the artist.

The informal quality of these works was also carried over to some of the artist's depictions of himself of these years. His *Self-Portrait as an Artist* (right) of about 1633, which is in Berlin, is dis-

RIGHT Rembrandt *Seated Old Woman, With an Open Book on her Lap*, c.1639, pen and brown ink with brown wash on paper, 4⅞ × 4¼ inches (12.6 × 11 cm), Museum Boymans-van Beuningen, Rotterdam. The sitter, who rests her spectacles on the open book on her lap, has not been identified. She was at one time thought to be Margaretha de Geer, whom Rembrandt portrayed much later in his life (page 207), but this suggestion seems untenable.

LEFT Rembrandt *Self-Portrait as an Artist*, c.1633, pen and brown ink with brown and white wash on paper, 4¾ × 5⅜ inches (12.3 × 13.7 cm), Staatliche Museen Preussischer Kulturbesitz, Kupferstichkabinett, Berlin. This informal study can be contrasted with the more flamboyant self-portraits which date from later in the decade (page 71).

RIGHT Rembrandt *Self-Portrait, Leaning on a Stone Sill*, 1639, etching and drypoint touched with black chalk (state 1), 8 × 6⅜ inches (20.5 × 16.4 cm), British Museum, London. This self-portrait, and the artist's painted work of the same type of the following year (far right), both appear to have been influenced in terms of their design by Titian's painting (below), which Rembrandt could have known either in the original, or through a copy, in the collection of Alfonso Lopez in Amsterdam.

BELOW Titian (*fl* 1511-76). *Portrait of a Man*, *c*.1512, oil on canvas, 31¾ × 25⅞ inches (81.2 × 66.3 cm), The National Gallery, London. When Rembrandt knew this work it was thought to depict the great epic poet Ariosto (1474-1533). By emulating the portrayal of a 'poet' in his self-portraits of 1639 and 1640, it appears that the artist was entering the debate about the relative merits of the different arts.

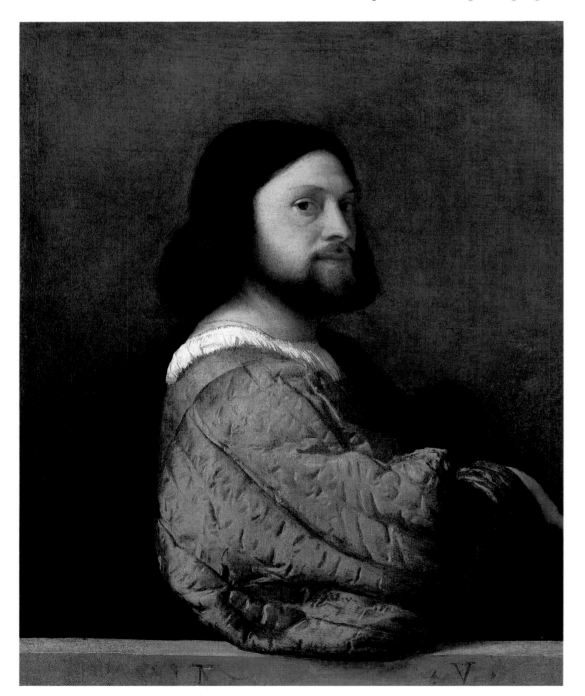

made a sketch of the work, which was bought by a Spanish merchant called Alfonso Lopez. Lopez also owned another painting which impressed the artist – Titian's *Portrait of a Man*, (below). Rembrandt probably saw this picture, which at the time was considered a portrait of the great epic poet Ludovico Ariosto, in Lopez's house.

He adopted aspects of the compositions of both the Raphael and the Titian when formulating his self-portraits, but drew most of his inspiration from the latter, particularly in terms of the direction of the pose, the prominence of the sleeve, and the use of the ledge (which has precedents in fifteenth-century northern and Italian works).

By referring to these famous works of the sixteenth century, Rembrandt was making a statement about the nature of his status on various levels. He was linking himself with the revered masters of the High Renaissance, and associating himself with the sitters, who were both thought to be exemplars of literary success (Castiglione the writer and Ariosto the poet). By using these models for his own portrait the artist may well have been consciously making a comparison between the arts of Painting and Poetry. Historically Poetry had been seen as one of the Liberal Arts which carried intellectual status, while Painting was considered a manual craft. So the artist, by linking the two, was elevating the standing of his work and profession.

His painted self-portrait (right) was originally rectangular. Such a format would have made it look even more similar to the Titian prototype. The canvas it is now on appears not to be the original; the paint layers were transferred to it from the support Rembrandt worked on at an unknown date, probably prior to the alterations which were made to the format. The surface of the work is very smooth, with the paint having been meticulously applied.

X-rays reveal two significant *pentimenti* (compositional changes); the artist's left hand was originally included with his fingers resting on the parapet, which would have disrupted the purity of the design, and initially the colored collar was more rounded and extended towards the right.

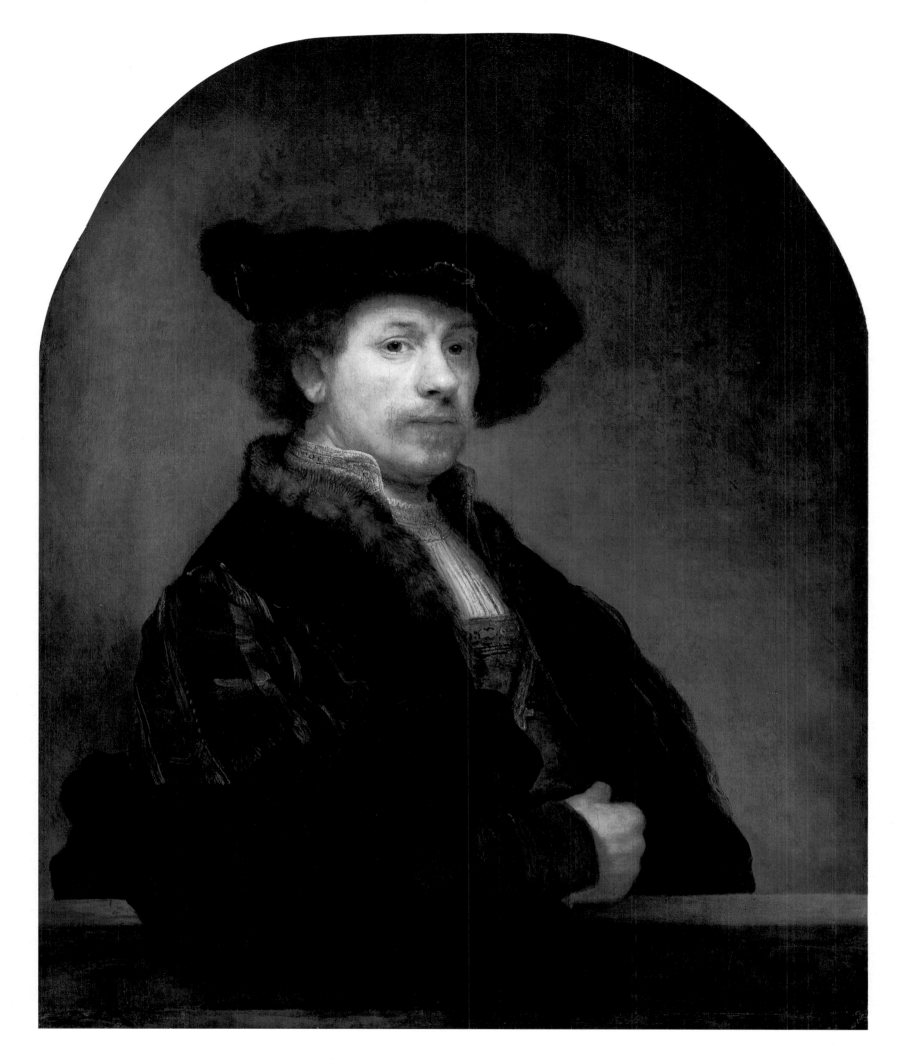

Rembrandt *Self-Portrait at the Age of Thirty-Four*,
1640, oil on canvas, 39⅞ × 31¼ inches (102 ×
80 cm), The National Gallery, London. Signed
and dated, lower right: *Rembrandt f 1640*. This
type of half-length depiction, with the artist
resting on a sill, was later to inspire a number
of similarly composed works by Rembrandt's
pupils.

Rembrandt *Artist Drawing from the Model (Allegory of the Glorification of Drawing)*, *c*.1639, etching (drypoint and burin) (state 2), 9 × 7⅛ inches (23.2 × 18.4 cm), British Museum, London.

The idea of making a statement about the prestige of his profession, which Rembrandt seems to have pursued in his self-portraits of 1639 and 1640, appears to have also been applied by the artist in contemporary depictions he made of himself drawing.

His unfinished etching of about 1639, *Artist Drawing from the Model* (right), is a work of this type. The composition of this intriguing image was being developed, probably while the etching plate was being worked on, in a drawing that is now in the British Museum (far right). In the sketch, which is executed in iron-gall ink, the artist can just be made out at the lower right, as he studies the nude model who stands on the platform before him.

The etching, although not complete, is filled with many more details, and provides information about the probable appearance of Rembrandt's studio, the procedure he followed when working on an etching, and the way in which he chose to consider the prestige of drawing, and by extension his artistic calling.

The top half of the composition has been almost finished in a number of areas, while the rest is outlined in very sketchy drypoint strokes. This procedure of working from the background to the foreground may reflect, although this is by no means universally agreed upon, the way in which he approached the development of his paintings. What is also of interest, is that this approach means the artist did not build up tonal qualities evenly across the image as might be expected, but seems instead to have moved from one precisely worked-up area to another.

A number of explanations for the unfinished state of the work have been proposed. It has been suggested that the artist left the plate in this state in order to illustrate the nature of his technique, or possibly so as to provide a challenge to pupils. According to a third theory he may have left it because the composition was unsatisfactory. It has also been surmised that the sketchy drypoint areas could have been considered appropriate as it appears the work is essentially about drawing.

The artist is seated and seems to be drawing on paper which rests on his lap. He looks up at the model, who holds a cloak and a huge palm frond. Behind him is an unmarked canvas stretched on an easel. Above hang various props which include pieces of armor and a hat with a feather, while at the upper left is a bust of a turbaned girl.

Rembrandt *The Artist Drawing from the Model*, *c.*1639, pen and brown iron-gall ink on prepared paper, 7⅜ × 6⅜ inches (18.8 × 16.4 cm), British Museum, London. This drawing was probably executed during the development of Rembrandt's etching of the same subject.

The pose of the model and her attributes recall personifications in earlier paintings of Fame and Truth. The implication would appear to be that Truth is Rembrandt's inspiration, and that by capturing it on paper he will secure Fame. He initially uses drawing in order to attain this, and will only later turn to the canvas and establish the design in paint.

Disegno (the Italian for drawing) had since the Renaissance, according to academic theories, meant both the act of drawing itself and the creation of an idea – or the underlying principle which forms the basis of all the visual arts.

Consequently this etching, which appears to emphasize and perhaps celebrate this process, has been subtitled *Allegory of the Glorification of Drawing*. As such it has thematically much in common with Rembrandt's earlier depiction of himself in a studio (page 38), if we accept that work as a study of the intellectual genesis of painting.

The subject also makes cross-references to the other arts. The way in which Rembrandt looks on the model is similar in some respects to representations of Pygmalion, the sculptor from the ancient world who fell in love with a work he had made and asked the goddess Venus to breathe life into it. The resemblance between Rembrandt's work and such a subject is so strong that in the eighteenth century the etching was entitled *Pygmalion*.

The modern title given to the work appears more convincing, but references to the art of sculpture remain. The turbaned bust at the upper right appears as a sculptural equivalent of the subject Rembrandt is committing to paper. Their juxtaposition here may be intended to refer to the old debate about the relative merits of the arts of sculpture and painting and drawing. In this instance the implication is perhaps that the latter is triumphant.

Grisailles

Although Rembrandt established his reputation in Amsterdam essentially as a portraitist, he did not by any means give up his work as a history painter. In the 1630s the artist executed an important group of Biblical paintings in grisaille (ie with mainly tonal rather than color changes). It has been suggested that these were intended as the basis for an ambitious series of etchings; with the subtleties of their shifts of tone rather than hue, they were particularly well suited to being preparatory to black-and-white graphic equivalents. Only one of them was directly used for this purpose, but it is useful to consider them as a group.

The artist's *Ecce Homo* (page 74) is the painting which was directly employed as the model for an etching. In it Christ, his hands chained, is brought before the people. Pilate, wearing a sumptuous robe and turban, converses with Jewish elders below him while soldiers

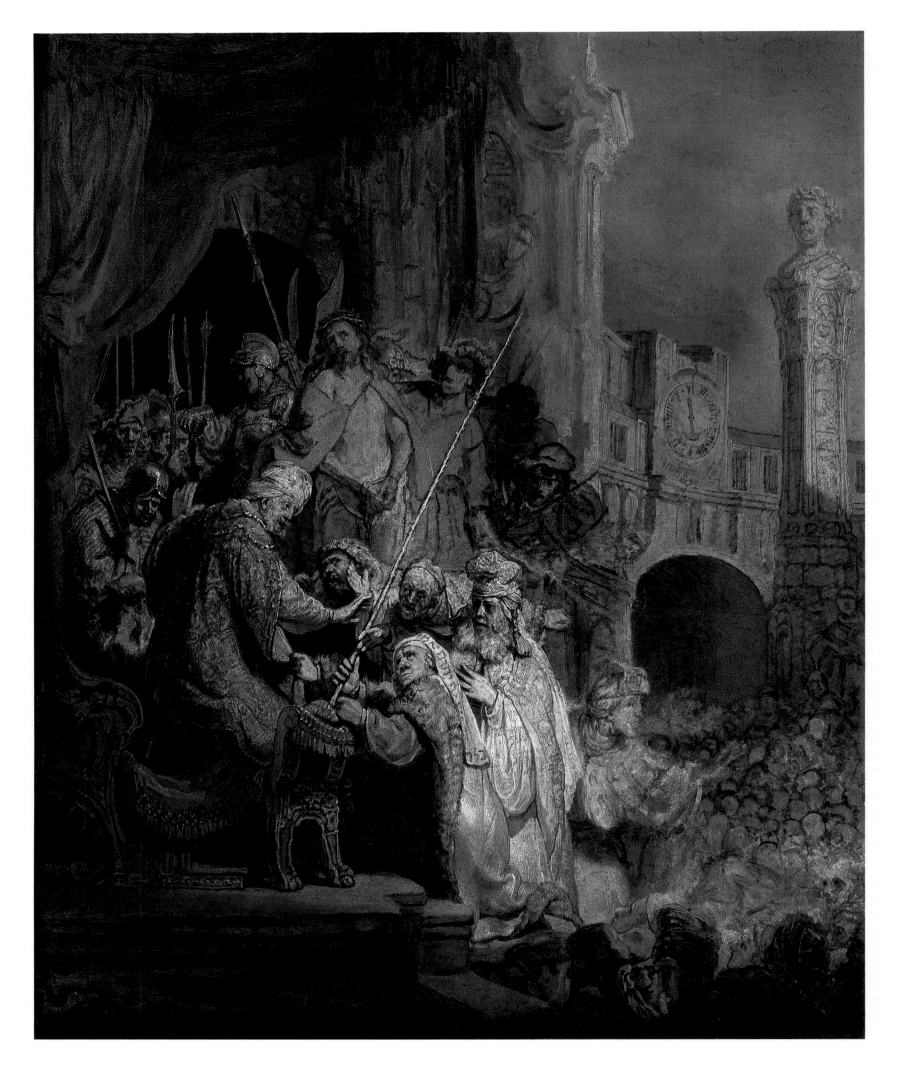

Rembrandt *Ecce Homo*, 1634, oil on paper stuck
on canvas, 21¼ × 17⅜ inches (54.4 × 44.5 cm),
The National Gallery, London. Signed beneath
the clock at the right: *Rembrandt. f./1634.* Christ
is presented to the people by Pilate. This
grisaille was used as a direct preparation for an
etching of the same subject by the artist
(right). The outlines of the composition were
indented when it was transferred to the
etching plate.

RIGHT Rembrandt *Ecce Homo*, 1636, etching (burin) (state 2), 21½ × 17½ inches (54.9 × 44.7 cm), British Museum, London. This etching is directly based upon Rembrandt's painted grisaille of the subject. It has been suggested that it was produced in collaboration with another artist called Jan van Vliet; such an association may explain why it was necessary to make such a detailed preparation for it. The clock which appeared in the painting has been removed, but a probable self-portrait introduced, in the form of the figure to the left of Christ and below the man with the feathered hat, who looks out at the viewer.

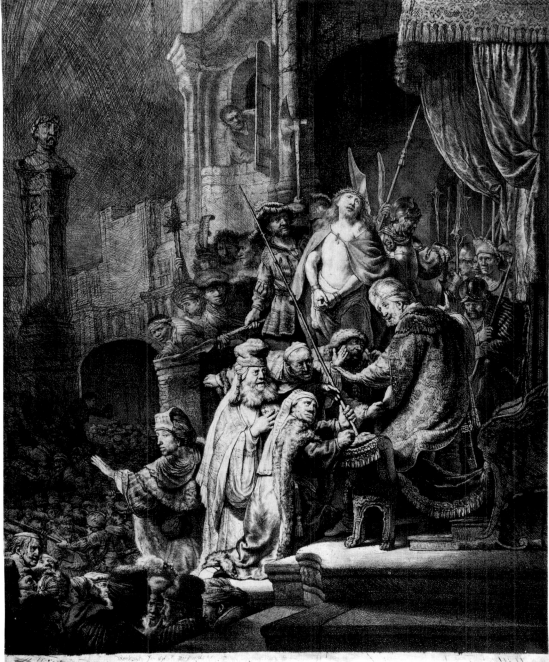

with halberds and pikes crowd in at the left, and a large crowd surges beneath the clock and bust of a Roman emperor at the right. The people, urged on by their priests, one of whom can be seen gesticulating toward them, demand the crucifixion of Christ.

Then came Jesus forth, wearing the crown of thorns, and the purple robe. And Pilate saith unto them, Behold the Man! [*Ecce Homo*]

Pilate . . . sat down in the judgment seat in a place that is called the Pavement, but in Hebrew, Gabbatha.

And it was the preparation of the Passover, and about the sixth hour: and he saith unto the Jews, Behold your King!

But they cried out, Away with him, away with him, crucify him. Pilate saith unto them, Shall I crucify your King? The chief priests answered, We have no King but Caesar.

John 19: 4-5, 13-16

Rembrandt took great care to interpret the text. Jesus appears in the artist's interpretation wearing the crown of thorns and robe. Pilate has just risen from 'the judgment seat.' The time of 'about the sixth hour' is recorded on the clock at the right of the painting (which has one hand, and the Roman numeral VI at the top of it). The priest's reference to Caesar is also implied in the picture by the presence of the bust of the Roman emperor at the right, a symbol of earthly power which is contrasted with the spiritual authority of Christ.

Ecce Homo was painted in 1634 and was used in the following years as the basis for a print, the second state of which (above), is dated to 1636. The etching is virtually the same size as the painting and far more elaborate in terms of the definition of detail, particularly as far as the crowd is concerned. Because the process of printing reversed the design, the composition had to be conceived in the painting in reverse, so that it would be 'corrected.'

The composition of the grisaille is based primarily on a strong diagonal accent of light which runs from the lower right to the upper left and links the protestations of the Jews with the sorrowful figure of Christ. This diagonal design is underlined by the placement of the two archways, and counterbalanced by the staff that the kneeling elder holds which points in the opposite direction.

Light plays an important role as an aid to narrative emphasis in the composition. In the grisaille the relationship between Pilate and the elders is highlighted, and as such appears as the core of the action, whereas in the etching it can be seen that Christ is more boldly lit and contrasted with the darkened archway, so drawing his presence more closely and obviously into the drama.

The support of the painting consists of a sheet of paper which has been laid onto a stretched canvas. A thin creamcolored ground appears to have been applied to the paper before the design was drawn on using ink. Next, the composition was embellished in broad strokes using dark earth colors. The areas which have been more meticulously worked up, such as the group of Pilate and the elders, have been depicted using gray, brown, lead white, and lead-tin yellow pigments (Bomford, Brown and Roy, 1989).

Cleaning of the painting has revealed that it is covered with a network of incised lines which follow the composition, and are particularly detailed on the most worked-up areas of the image. It is thought that these marks were made when the design was transferred to the etching plate. The transference could have taken place in a number of ways. The simplest technique would have involved tracing the indentations. But it is also likely that a sheet of paper, which may have been blackened with charcoal, was placed between the painting and plate, so that when the indentations were made with a stylus the design would be copied below.

Another grisaille that may also have been intended to form the basis of a graphic treatment is Rembrandt's *Saint John the Baptist Preaching* (below),

BELOW Rembrandt *Saint John the Baptist Preaching*, c.1634, oil on canvas laid on panel, 24¼ × 31¼ inches (62 × 80 cm), Staatliche Museen Preussischer Kulturbesitz, Gemäldegalerie, Berlin. This unsigned work entered the collection of Rembrandt's friend Jan Six, not long after it was executed. It includes more figures than any of the artist's other compositions. They represent the peoples of the world who are to a great extent either indifferent to, or doubting of, the message of salvation which the Baptist brings.

which was probably painted in the same year as the *Ecce Homo*. It lies close both stylistically and thematically to the former picture.

Here again one of the pictorial problems which had to be confronted by the artist was how to marshal effectively a large crowd scene, while not distracting in too great a degree from the main figure. The Baptist, whose scale is exaggerated by comparison with those around him, preaches to a multitude on the bank of the river Jordan, which can be seen at the left. As in the *Ecce Homo*, a bust, probably of a temporal ruler, is set up on a column, as a counterpoint to the spiritual focus of the work – Saint John.

The figures below him are not simply intended to represent the crowds who came to listen, but the peoples of the world. They are of both sexes, different ages and numerous nationalities. If you look closely at the work it is possible to spot figures wearing Indian, Japanese and African clothing; a group of Pharisees and Sadducees clustered together in the foreground; peasants, wealthy couples, crying children, coupling and defecating dogs, and many who appear very skeptical about the saint's calls to repent. Included among these is a probable self-portrait of the artist, in the

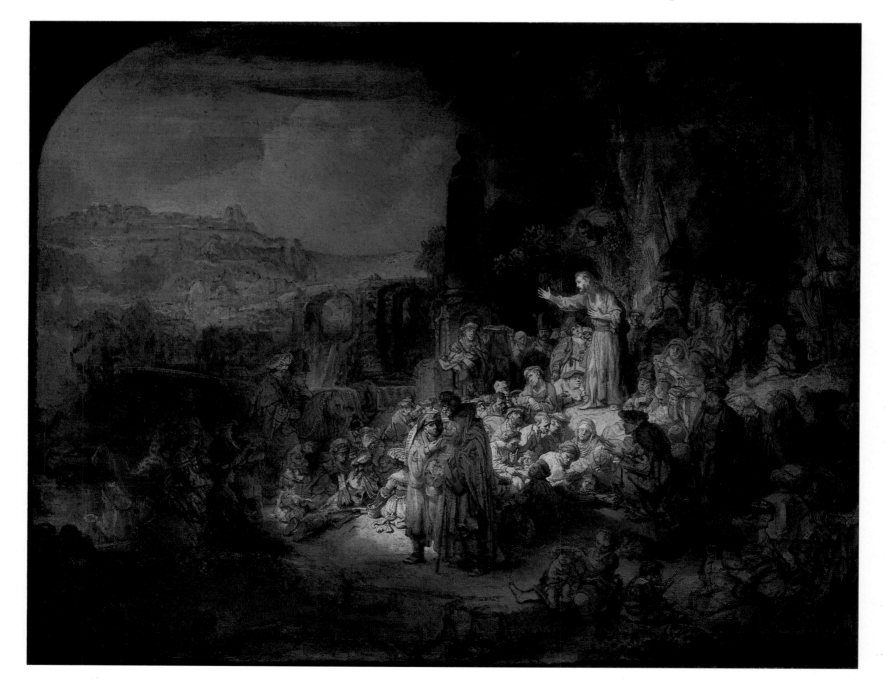

RIGHT Rembrandt *Design for a Frame for 'Saint John the Baptist Preaching,'* 1650s, pen and brown ink with brown wash and corrections in white on paper, 5⅝ × 8 inches (14.5 × 20.4 cm), Cabinet des Dessins, Musée du Louvre, Paris. This design was probably made for Jan Six, who owned Rembrandt's *Saint John the Baptist Preaching* (page 76).

BELOW Rembrandt *Christ and the Apostles on the Mount of Olives,* 1634, pen and wash and chalk on paper, 14 × 18⅝ inches (35.7 × 47.8 cm), Tyler Museum, Haarlem. The eloquent gestures of Christ can be compared with those of Saint John in Rembrandt's contemporary depiction of the Baptist (left).

form of a man wearing a plumed hat, slightly below and to the left of the saint. A sense of the multiplicity of humanity is further provided by the way in which the crowd's attention to what the Baptist is saying ranges from those who are engrossed to those who are asleep.

Saint John the Baptist Preaching is one of the few of Rembrandt's works for which we have information about the way the artist intended to have it framed. A drawn study by him survives (above), which shows an unusual type of structure that includes pilasters at either side.

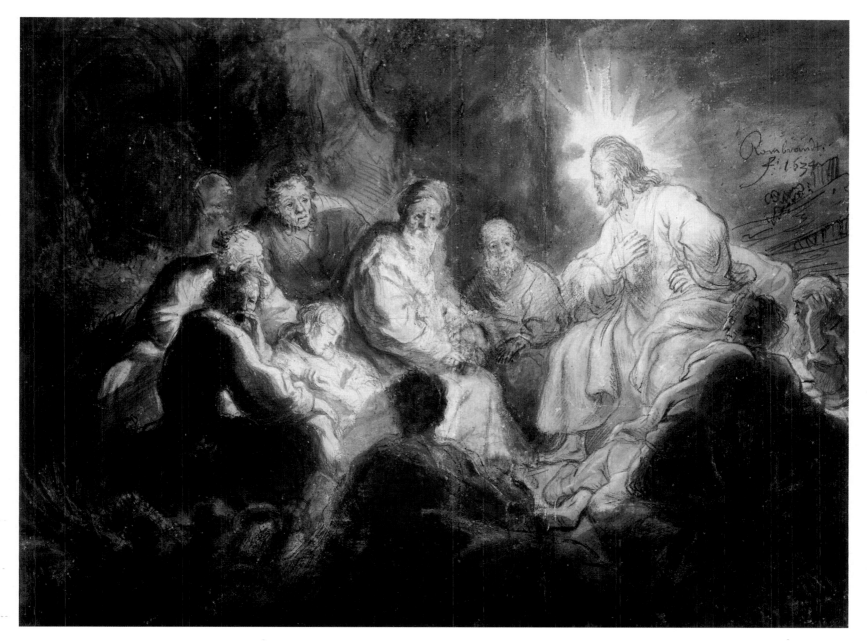

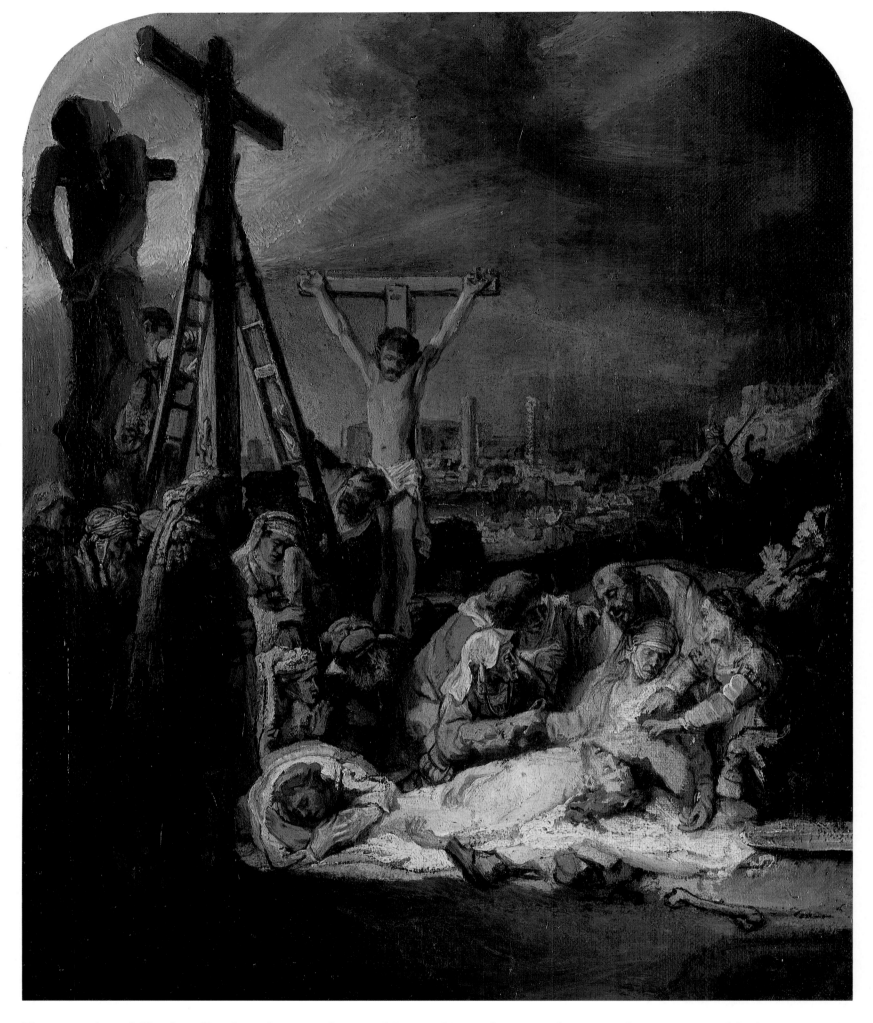

The narrative skills that Rembrandt deployed in his depiction of the Baptist, which enabled him to relate in a compelling fashion a dominant individual to a group of followers, were also used by the artist in the same year, in a more intimate drawn study of Christ and the Apostles (page 77). This highly finished and clearly signed drawing shows Christ on the Mount of Olives, passion- ately preaching to his acolytes, with one hand on his heart in a manner comparable to the eloquent gestures shown by the Baptist. The aged bearded figure standing next to Christ is Saint Peter, and the youthful one slumbering over to the left, Saint John. Even in this sacred company Rembrandt could not resist an element of irreverence – he shows one of the Apostles extrava- gantly yawning and looking out at the viewer.

Probably in the following year, 1635, the artist executed a third work in this group of painted grisailles, *The Lamentation over the Dead Christ* (above).

The sky has darkened over Calvary and Jerusalem, which can be seen in the background. Christ's body, brought

LEFT Rembrandt *The Lamentation over the Dead Christ*, *c*.1635, oil on paper and canvas mounted on oak, 12½ × 10½ inches (31.9 × 26.7 cm), The National Gallery, London. Christ has been brought down from the cross and is mourned over by the Virgin on whose lap his head rests. The Magdalen clasps his feet. Golgotha is here set before an imaginary view of Jerusalem. The areas at the top and the bottom of the composition (from the horizontal of the cross facing the viewer upwards, and the feet of the Virgin down) were not painted by Rembrandt.

BELOW Rembrandt *The Lamentation at the Foot of the Cross*, *c*.1634-35, pen and ink and wash with chalk, reworked in oil, 8½ × 9 inches (21.6 × 25.4 cm), British Museum, London. This complex drawing acted as a testing ground for compositional alterations made during the development of Rembrandt's painted *Lamentation*.

down from the cross, is laid across the lap of the Virgin. Her distraught expression and slumped pose convey the acute state of her grief. The Magdalen weeps, clasping Christ's feet. Other figures crowd around the Virgin attempting to console her, while a tearful woman dries her eyes beneath the crosses. A number of orientally clad figures, some of whom are on horseback at the right, look on, while the thieves remain crucified, the 'Good' one centrally, and the 'Bad' one at the left, his twisted body in shadow.

The actual incident depicted in this small work is not described in the Bible, but was often represented by painters; Rembrandt has followed much of the traditional imagery associated with this stage of the Passion, but has also inventively embellished it.

In his interpretation the Lamentation has not been isolated, but ingeniously placed within a continuum, because the figures climbing down the ladders imply an earlier stage in the story – the Deposition – and those in the back-

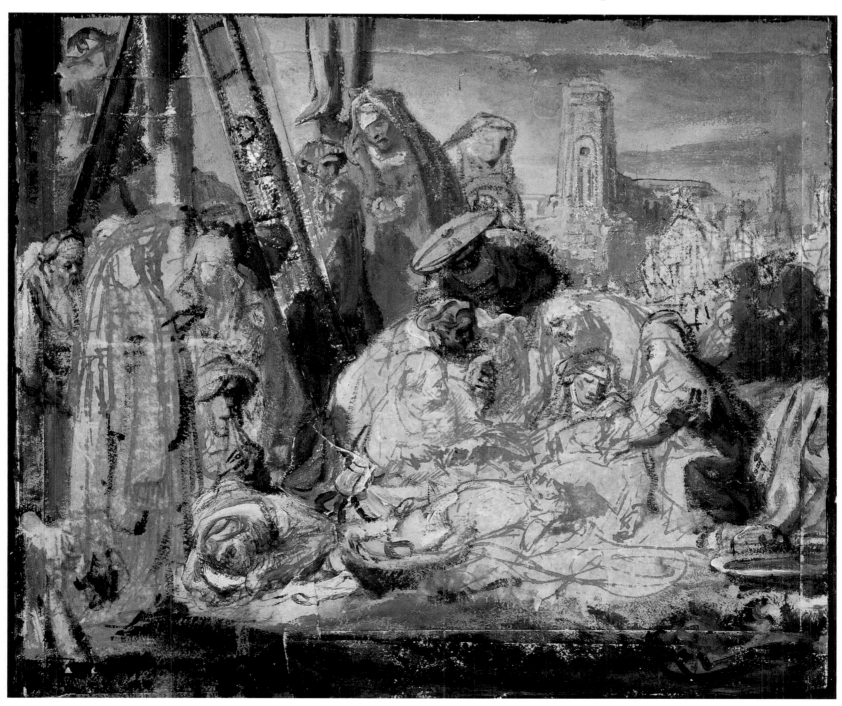

RIGHT Rembrandt *The Small Crucifixion*, c.1635, etching (only state), 3¾ × 2⅝ inches (9.5 × 6.7 cm), Museum Het Rembrandthuis, Amsterdam. Signed centrally at the top: *Rembrandt f.*

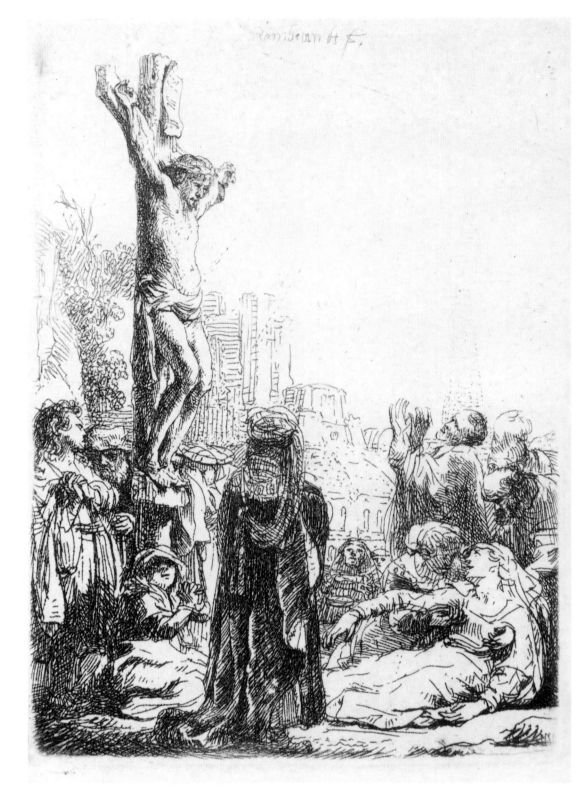

ground at the right may refer to a later occurrence. It has been suggested that the man with the feathered head-dress could be Joseph of Arimathaea, who asked for permission to bury Christ, so his presence therefore may prefigure the next episode – the Entombment.

The complexity of the narrative as Rembrandt has conceived it may go some way toward explaining the troubled evolution of the composition. Technical examination of *The Lamentation* by the scientific and conservation departments of the National Gallery, London, has shown that it is one of the most complex, in terms of physical structure, of all Rembrandt's works.

The work was formulated during three distinct stages. Initially the artist painted on a piece of paper which approximately coincides with the middle region of the work, extending from the top of the shortest cross to the feet of the Virgin. Areas of dark tone were laid on, and then gray and white highlights applied. Parts of the paper were torn away by Rembrandt, presumably because they included sections of the composition with which he was not satisfied.

Next the paper was mounted onto a slightly larger piece of canvas. For the design to be convincingly continued on the canvas the paint had to be densely worked there; at the same time the area of paper was also embellished.

In the final stage the canvas, with the paper on it, and further pieces of canvas above and below, was attached to a larger oak panel, with rounded top corners. This mounting probably took place in the artist's studio, but it would appear that the last areas to be completed were not painted until a later date, after the whole had been varnished. The regions at the top and bottom were not executed by Rembrandt; detailed analysis of the medium used and the style of the application of the paint shows how incompatible they are

with the rest of the image.

A lively drawing by Rembrandt in the British Museum (page 79), which has been worked up to different degrees of finish, can clearly be related to the *Lamentation*. The drawing seems not to be a preparatory work in the conventional sense, but rather a compositional study that was executed at the same time as the grisaille was being formulated. We can be precise about the relationship between the two, because the design established on the drawing was transferred to the painted version after the latter was mounted on canvas (see explanation above).

While developing the composition for the *Lamentation* Rembrandt was also exploring other parts of Christ's Passion in etchings. It is interesting to compare his *Small Crucifixion* (above) of about 1635 with the *Lamentation*. Although the scene shown precedes

the Lamentation, the arrangement of figures at the foot of the cross is similar to that found in the latter work.

In terms of chronology the next stage in the Passion of Christ is the *Entombment*. A few years after the *Lamentation* was executed Rembrandt painted a brilliantly economical grisaille of this scene, which is now in the Hunterian Art Gallery, Glasgow (right). It was not so meticulously worked as the Lamentation, but can be related to it, particularly because of the similarly dramatic nature of the livid lighting, and the comparable figure of Christ.

The work has also been associated with a depiction of the *Entombment* which Rembrandt painted for the Stadholder and delivered in 1639 (page 111), but it is not yet clear if it was a preparation for, or reworking of this design. For the moment it seems most

BELOW Rembrandt *The Entombment of Christ*, c.1639, oil on wood, 12½ × 15¾ inches (32.2 × 40.5 cm), Hunterian Museum and Art Gallery, Glasgow. The light cast by a candle or lantern held to the right only defines the mourners in the immediate vicinity of Christ; those in the darkness beyond are appropriately painted in a more summary fashion.

appropriate to consider it in relation to the other grisailles of the 1630s, because like them it may well have been intended as the basis for an etching.

The Entombment is described in all four gospels. Joseph of Arimathaea asked Pilate if he could take the body of Jesus after the Crucifixion. He placed it in his own tomb, which was 'hewn out of the rock.' The mourners included the Virgin, the Magdalen, and Nicodemus. Most of the figures here, with the exception of Christ and those closest to him, are impossible to identify. It is probable, however, that the bearded man positioned beside Christ's head and the figure wearing a hat and standing over him are intended as Joseph of Arimathaea and Nicodemus.

The light appears to be provided by a candle or lamp held by the man kneeling to the left of Christ. He seems to hold his hand over its source. Because the light is so close to Christ and reflects from his shroud it seems almost to emanate from him; again the artist has used the device, first employed in *Christ at Emmaus* (page 30), of imbuing naturalistic lighting with supernatural significance.

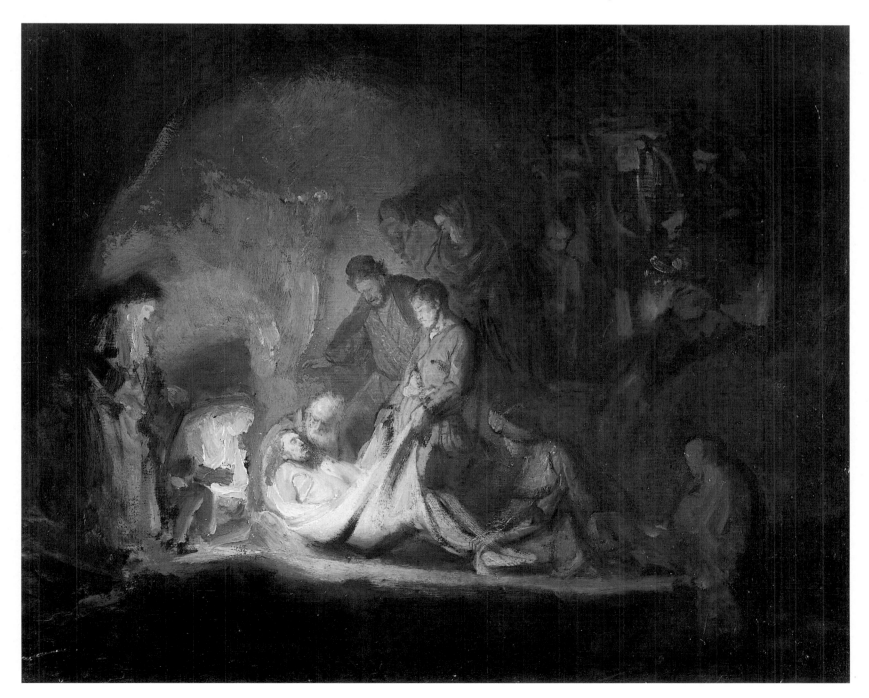

RIGHT Rembrandt *The Holy Family*, c.1634, oil on canvas, 71⅝ × 48 inches (183.5 × 123 cm), Alte Pinakothek, Munich. The Christ Child, after having taken his mother's milk, has fallen asleep. Saint Joseph, who leans on the cradle, smiles down at him. This is one of the artist's earliest large history paintings; the figures are just a little less than life-size.

BELOW Rembrandt *The Virgin and Child Seated by a Window*, c.1634-5, pen and brown ink and wash on paper, 6 × 5⅜ inches (15.5 × 13.8 cm), British Museum, London.

Color

Not all of the religious subjects Rembrandt painted in the 1630s were depicted as grisailles. He also executed a number of very accomplished works in which his skills as a colorist come to the fore. These can for convenience be grouped thematically into quieter, reflective subjects, and those in which Rembrandt's abilities as a dramatist are displayed. From the first group notably come his depictions of the Holy Family, and his treatment of the encounter between the Risen Christ and the Magdalen.

The Munich *Holy Family* (right), which is dated to about 1634, shows a scene of great intimacy on a scale not previously tested by the artist for a history painting; the figures are just a little less than lifesize. The Virgin, who is seated and has just finished feeding the Christ Child, looks down as he sleeps in a fur wrap on her lap. To the right is a cradle on which Saint Joseph

leans. He looks lovingly at the infant with a smile stealing across his face, and as such plays a more active role than he did in the work of many earlier artists who depicted him as an older man who was often asleep. On the wall at the back hang some of the tools of his trade as a carpenter.

The work was cut down in the eighteenth century on either side and was reshaped to make an arch at the top. The format of the top has been corrected, but the canvas was not expanded to display its original width. It has been suggested that at the lower left there was a fire and that the Virgin is here warming the feet of the Christ Child. But this seems unlikely because no light appears to be coming from that direction, the principal illumination appearing from the upper left. It catches the ruddy complexion of Joseph, which is contrasted with the white skin of the Virgin, and the combination of her muted red robe and the child's rich green clothing.

The whole is treated as a moment of ideal domesticity which must have been based in part at least on Rembrandt's studies of actual mothers and children. A contemporary drawing in the British Museum (left) at first appears simply to be a depiction of a mother and child, but can also be seen as a study of the archetypal mother and child – the Virgin and Christ. It is the head-dress of the woman, and links between the composition and a sixteenth-century print of the Holy Family, which suggest that it can be interpreted in this way. The barrier between observed relationships and idealized ones in Rembrandt's work is lightly crossed. This means that the latter seem familar, rather than distanced, and so elicit empathy which in part explains their power.

Something of the quality of calm and repose found in *The Holy Family* is also

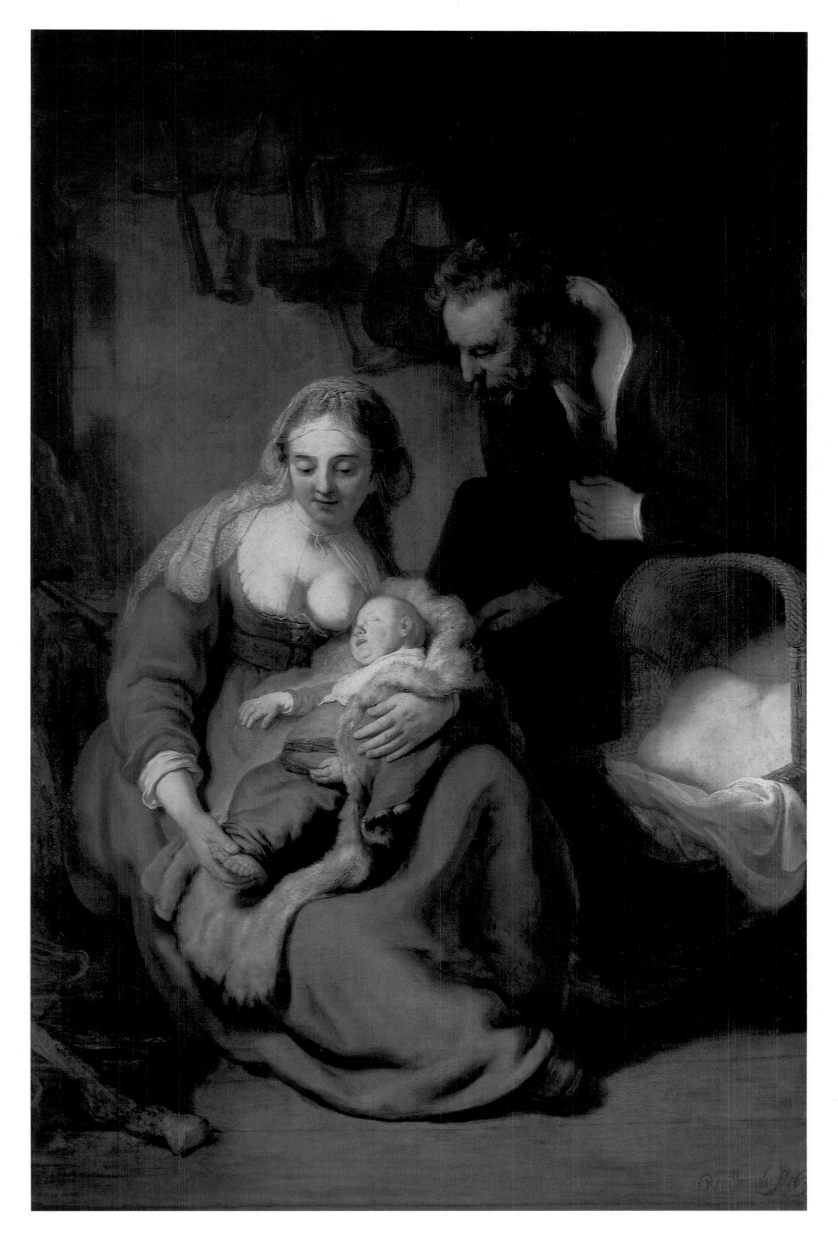

RIGHT Rembrandt *Christ as the Gardener Appearing to the Magdalene*, mid-1640s, pen and brown ink on paper, 6 × 5¾ inches (15.4 × 14.6 cm), Rijksmuseum, Amsterdam.

achieved in Rembrandt's *Christ Appearing to Mary Magdalen* (far right) of 1638, in spite of the fact that its subject is essentially a confrontational one.

Mary Magdalen visited Christ's tomb at first light after the Sabbath and discovered that it had been opened. With the help of two disciples she found that it was empty and, after they had left her, she looked into the sepulcher and saw two angels. They asked her why she was crying, and she answered that she wept because she did not know where her Lord had been moved to. Then she saw Jesus standing by her, and at first thought he was a gardener who had perhaps moved the body. Moments later she realized who he was, and he declared 'Touch me not, for I am not yet ascended to my Father' (John 20: 11-18). Rembrandt appears to have chosen the moment of her recognition, rather than the more frequently depicted point 'Touch me not' (*Noli me tangere*).

The analogy between dawn and the theme of resurrection was not lost on the artist. The sun rises over Jerusalem at the left. The first rays of light catch the edges of the foliage, the garment and hat of Christ, the face of the kneeling Magdalen, the edge of the tomb and the angel at the right. The saint, who turns with her handkerchief in her hands, is only halfway through the process of recognition. Christ has not finished speaking, and appropriately her face is only half-lit.

Christ is dressed as a gardener, with a broad-brimmed hat, spade and knife, while the Magdalen has her attribute, an ointment jar, beside her. Two women descend beyond the formal garden at the left; they have not been identified with certainty, but could be Joanna and Mary, the mother of James. Other figures, who are perhaps intended as the disciples, retreat over the bridge toward the city.

The landscape is of interest as one of the earliest quite carefully established contexts of this sort, which looks forward to the artist's independent painted works in this genre.

The brilliance of Rembrandt's conception was recognized early on by the artist's friend Jeremias de Decker (1609-66), who wrote a poem about the painting which was first published in 1660. A copy is pasted to the back of the panel:

When I read the story Saint John tells us
And then look at this artful scene,
Where, I ask, was pen ever so truly followed
By the brush, or dead paint so closely brought to life?

Christ appears to say to Mary 'do not tremble,
It is I, death has not overcome your Lord'.
She, half believing this, seems
To be between joy and sorrow, hope and fear.

As art dictates the rock of the tomb towers towards the sky
And rich shadows lend spectacle and power
To the whole. Friend Rembrandt, your masterly strokes,
I first saw used upon this panel;
And so my pen desired to rhyme with your gifted brush,
To praise with ink the paint you use.

De Decker beautifully describes the half-realization of the Magdalen – the crux of the action, as chosen by Rembrandt, and provides the highest form of acclaim that could be given to a history painting, by praising a narrative in paint as a perfect pictorial translation of its literary source.

The more frequently depicted moment at which Christ declared 'Touch me not for I am not yet ascended to my father,' was depicted by the artist in a drawn reinterpretation of the subject dated to the mid-1640s (above), which is now in the Rijksmuseum, Amsterdam.

The principles of this composition are not very different from those of the painting, with the landscape at the left, tomb at the right and Christ and the Magdalen centrally placed. But the angels are absent, and the artist includes a cross in the background, between the head of the Magdalen and the hand of Christ, so referring to his earlier Passion.

The 1630s was, as has been suggested, also a decade in which Rembrandt painted and drew some of the most dramatic and violent works of his entire career. Included among these is his extraordinary *Christ in the Storm on the Sea of Galilee* (page 86), of 1633. Drama

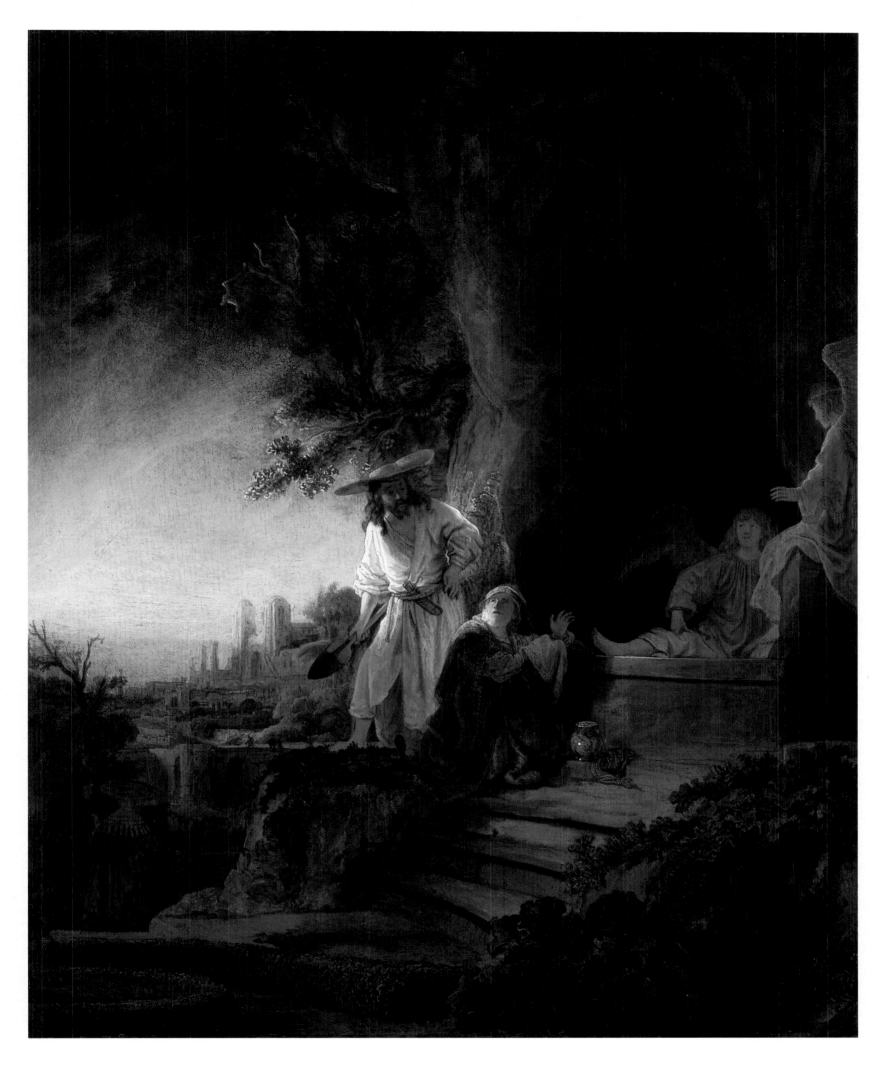

ABOVE Rembrandt *The Risen Christ Appearing to Mary Magdalen*, 1638, oil on wood, 23⅝ × 19⅜ inches (61 × 49.5 cm), HM Queen Elizabeth II, Buckingham Palace. Signed: *Rembrandt f. 1638*. The sun rises over Jerusalem at the left, and angels rest on Christ's empty tomb at the right. He appears to the Magdalen, who at first fails to recognize him and thinks she has come upon a gardener.

ABOVE Rembrandt *Christ in the Storm on the Sea of Galilee*, 1633, oil on canvas, 62½ × 49⅝ inches (160 × 127 cm), Isabella Stewart Gardner Museum, Boston. Signed: *Rembrandt f. 1633*. This is Rembrandt's only painted seascape. Christ was woken by his panic-stricken disciples; he rebuked them for having little faith and calmed the sea (Matthew 8: 23-26).

BELOW Rembrandt *Christ Walking on the Waves*, c.1632, pen and brown ink on paper, 6½ × 10⅜ inches (16.5 × 26.5 cm), British Museum, London.

BOTTOM Rembrandt *The Ship of Fortune*, 1633, etching (state 2), 4⅜ × 6½ inches (11.3 × 16.6 cm), Museum het Rembrandthuis, Amsterdam. Signed on the ship: *Rembrandt f. 1633.*

on the high seas could not be more terrifyingly imagined. The small boat filled with disciples is about to be inundated by a wave on the sea of Galilee as Christ, who is seated at the stern, is woken. He rebukes the panic-stricken disciples for their lack of faith and calms the sea. (Matthew 8: 23-26; Mark 4: 37-39; Luke 8: 23-24).

Other artists in the Netherlands in the seventeenth century specialized in painting maritime scenes, but this is the only occasion on which Rembrandt ventured into such work as a painter. He based the composition on a sixteenth-century print by the artist Martin de Vos.

At about the same time the artist also made a drawing of another aquatic incident from Christ's ministry, *Christ Walking on the Waves* (above right). The composition of this work is likewise constructed from intersecting diagonals. The subject, which as far as is known was never worked up by Rembrandt into a painting, comes from the gospel of Saint Matthew (14: 29-31). Christ at the left walks on the surface of the sea of Galilee, while Saint Peter attempts to follow him. The saint may be depicted twice here – firstly climbing down the side of the boat, and secondly in the water clutching at his master's outstretched hand. Another figure peers over the edge of the boat at the encounter.

A third memorable image of a boat, of quite a different kind, was also created by Rembrandt at this period. His *The Ship of Fortune* (below right) of 1633, employs a boat in the context of a complex allegory. This etching was used as a book illustration – it appeared at the front of Elias Herckmans' *Der Zee-Vaert Lof* (In Praise of Seafaring), which was published the following year.

The book starts with a description of the naval battle between Mark Antony and Augustus in 31 BC, in which the latter was victorious. To mark the re-

sulting peace the gates of the temple of Janus were symbolically closed, as they can be seen to have been at the upper left. The god Janus himself is represented in the etching by a bust with two faces; the one that looks out of the pic-

ture appears reminiscent of self-portraits of the artist. In the foreground Augustus, astride a fallen horse, wears a wreath of laurels. The boat at the right, which is about to put out to sea, is intended to refer to the expan-

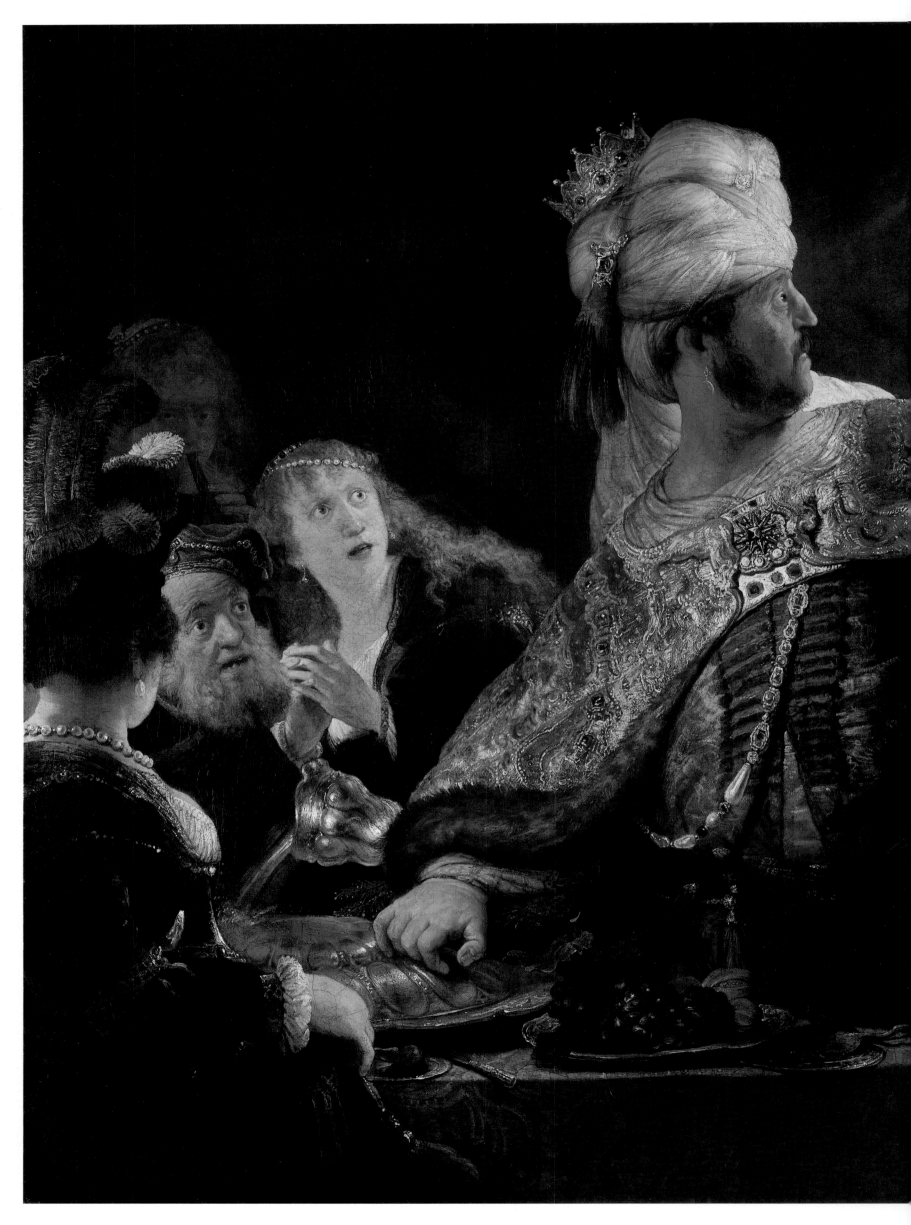

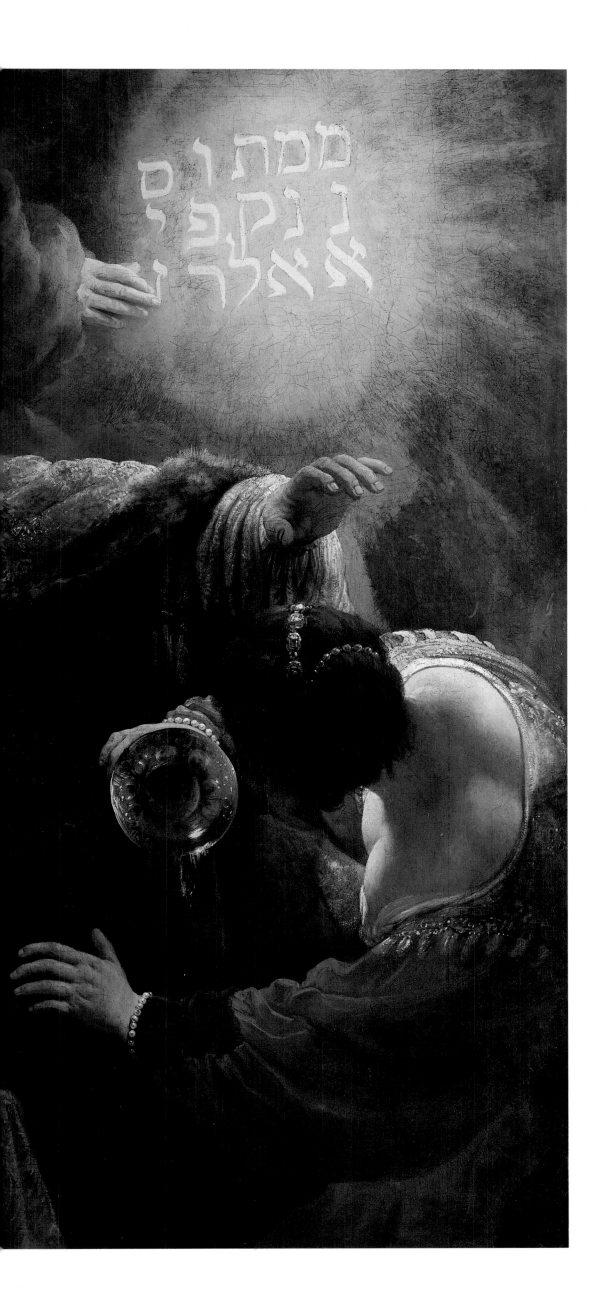

Rembrandt *Belshazzar's Feast*, *c*.1636-38, oil on canvas, 65½ × 81¾ inches (167.6 × 209.2 cm), The National Gallery, London. Belshazzar is startled by writing which miraculously appears on a wall in his palace during a feast. The only person who was able to interpret it was the prophet Daniel. When translated it meant that Belshazzar's kingdom would be divided and that he was to die (Daniel 5).

sion of sea trading that will come with peace. The naked woman standing holding up the sail, has been interpreted as both the goddess of War, and as the goddess of Fortune. The way in which Rembrandt has depicted her recalls the naked model in his *Allegory of the Glorification of Drawing* (page 72).

The most dynamic of Rembrandt's history paintings of the 1630s were quite different from *Christ in the Storm on the Sea of Galilee* and the works that can be related to it. They were depictions of incidents from the Old Testament, which show Rembrandt turning with new enthusiasm to the inspiration provided by the action and violence of some of Caravaggio's and Rubens's paintings. He would have become aware of these precedents through prints made after them, and from the work of other painters in the northern United Provinces, notably the community which worked in Utrecht, who were influenced by them. His pictures in this group employ rapid movement, selective lighting, and convulsed expressions to capture a moment of drama, and show the artist at his most theatrical. A particularly successful example of this type of work is his *Belshazzar's Feast* (left), of about 1636-38.

Nebuchadnezzar had stolen from the temple in Jerusalem gold and silver vessels, which his son Belshazzar, who is centrally placed, used at a feast. During the celebrations a hand miraculously appeared and inscribed a message upon the wall of the palace. The only person who could interpret it was Daniel, who translated the Hebraic script which said that the king would die that night and that his kingdom would be divided (Daniel 5).

This was an unusual Biblical subject to paint and Rembrandt took full advantage of the opportunity it provided for rhetoric. In his interpretation of the story Belshazzar, who wears a

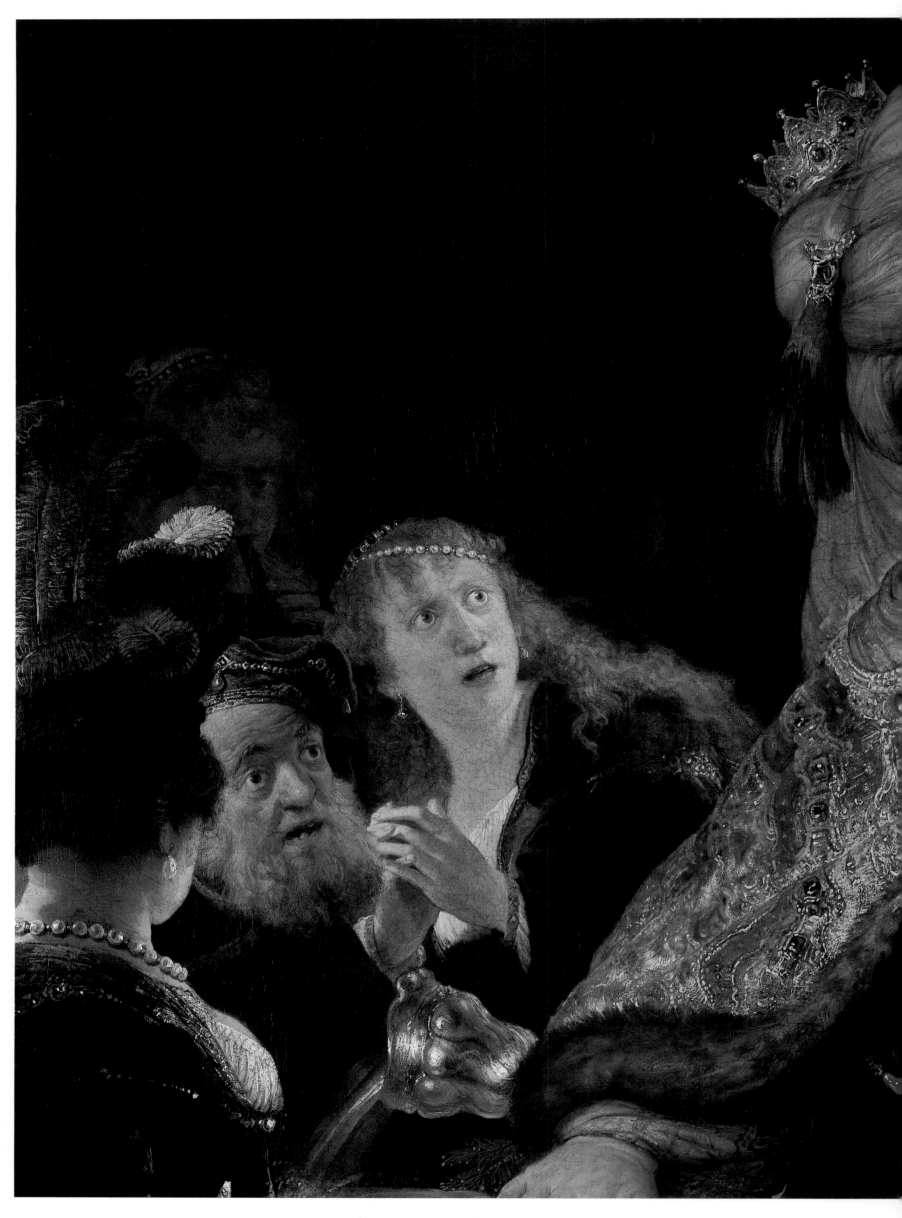

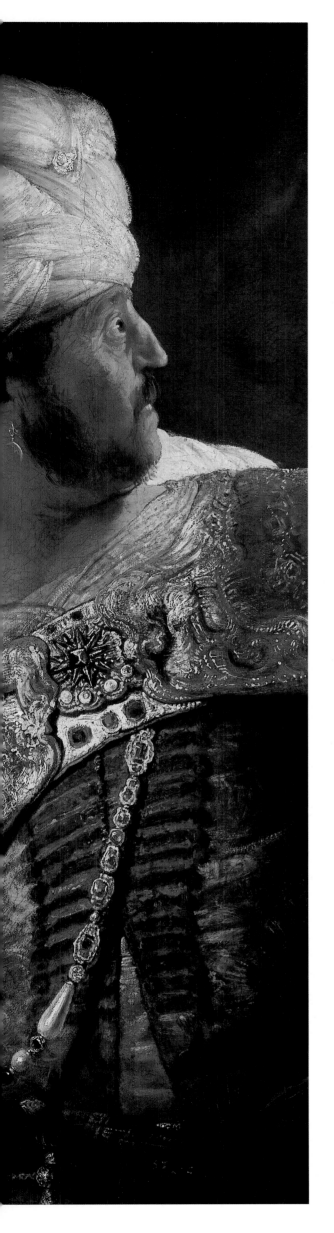

Detail of *Belshazzar's Feast*, *c*.1636-38, oil on canvas, 65½ × 81¾ inches (167.6 × 209.2 cm), The National Gallery, London.

fantastically rich robe, is horrified by the appearance of the words and knocks over goblets of wine to the left and right. His guests, with their startled expressions, and emphatic gestures, are likewise dismayed; they concentrate on his expression and so draw the viewer's attention to it. The figures on either side with their backs to the viewer seem almost to penetrate the picture plane and increase the immediacy of the onlooker's experience of the event. A careful study of the figures (and particularly their hands) shows that anatomical accuracy has been abandoned in favor of effective gesture.

Rembrandt's rendering of the subject closely follows the text:

Belshazzar, while he tasted the wine, commanded to bring the gold and silver which his father Nebuchadnezzar had taken out of the temple which was in Jerusalem; that the king, and his princes, his wives and his concubines, might drink therein.

In the same hour came forth fingers of a man's hand, and wrote over against the candlestick upon the plaster of the wall of the king's palace: and the king saw the part of the hand that wrote.

Then the king's countenance was changed, and his thoughts troubled him, so that the joints of his loins were loosed, and his knees smote one against another.

Then came in all the king's wise men: but they could not read the writing . . .

Then was Daniel brought in before the king . . .

And this is the writing that was written, MENE, MENE, TEKEL, UPHARSIN.

The moment depicted by Rembrandt would appear to be that at which 'The king's countenance was changed'. The emphasis placed upon drinking and the gold and silver was made much of by the artist; an impression of great opulence is given by the rich clothing, pearls and jewels, the plate from the temple, and fruits on the table. Some of the metalwork may have been inspired by contemporary Dutch craftsmanship.

At first it appears that Daniel, the interpreter of the momentous message, has not been depicted. But in the gloom of the left background there is a musician who is the only figure in the painting that stares out at the viewer – this may be intended as the prophet.

The prophecy, which appears in the upper right, is a transcription of a Hebraic formula of the warning, which Rembrandt apparently obtained from a book by a Jewish scholar who lived near to his house in Amsterdam. The words are derived from Samuel Menassah ben Israel's *De termino vitae*, which was published in the city in 1639. The artist appears to have known the writer for some little while during the 1630s; he portrayed him in an etching of 1636 (page 92).

The Hebrew should be read vertically, from right to left (so the hand is just inscribing the last character). The text translates as 'God hath numbered thy kingdom and finished it . . . Thou art weighed in the balances, and art found wanting . . . Thy kingdom is divided.'

The power of such a message conveys something of the way in which the painting's purpose was probably intended as a didactic one. It may have had greater impact as such, in view of the nature of the subject, if, as has been suggested, it originally hung in a dining room.

Not only is the work no longer seen in its intended context, but it is also now seen in a cut-down state. Thin strips have been removed from all four sides of the canvas. In its present form the composition appears to slope slightly down toward the left. This impression, which aggravates the shock of Belshazzar, would not have been given originally; the table top would have been horizontal.

RIGHT Rembrandt *Four Orientals seated under a Tree*, c.1656-61, pen and brown ink with brown and gray wash on oriental prepared paper, 7⅝ × 4⅞ inches (19.4 × 12.4 cm), British Museum, London.

BELOW Rembrandt *Samuel ben Israel*, 1636, etching (state 3), 5⅝ × 4 inches (14.9 × 10.3 cm), Museum het Rembrandthuis, Amsterdam. It was from a book by this Jewish scholar that Rembrandt derived the miraculous inscription he used in his depiction of *Belshazzar's Feast*.

Rembrandt's interest in painting exotic and theatrical costumes is clearly apparent in *Belshazzar's Feast*. He also followed this orientalist theme in single-figure studies which were both painted and drawn at the same period.

One of these, that seems to lie fairly close to the figure of Belshazzar, is the artist's *Head of an Oriental with a Bird of Paradise* (right) of about 1634-35. In this drawing, which is now in the Louvre, Rembrandt made effective use of the play of white heightening over brown washes and penwork to give an impression of the rich textures of the cloths that form the man's turban and gown.

A number of painted studies of 'Turks,' 'Persians,' and 'Orientals' by and associated with Rembrandt and Lievens date from the 1630s. There was clearly something of a vogue for these works, which appear in the main to be studies of character and stereotypical eastern dress, rather than depictions of nameable individuals. A famous example of this type of image is the so-called *Noble Slav*, or *Man in Oriental Cos-*

tume (far right) of 1632 which is in the Metropolitan Museum of Art, New York. In this work Rembrandt achieved a sense of monumentality and forceful presence similar to that found in his almost contemporary portrayal of Nicolaes Ruts (page 58).

It has been suggested that the enthusiasm for such images may have been stimulated by the arrival in The Hague in 1626 of a mission from Shah Abbas I of Persia.

Rembrandt's personal interest in exotica was fed by his formative artistic influences, in the form of the works of

Lastman and Elsheimer, the theatrical props he made use of in his studio, and items in his own collection (see the inventory of 1658, page 158). It was also inspired by works of art imported to Amsterdam from across the globe via the Dutch Republic's extensive trading routes. These imports included oriental porcelain and armor, carpets and

ABOVE Rembrandt *Man in Oriental Costume* *('The Noble Slav'),* 1632, oil on canvas, 59⅝ × 43⅜ inches (152.7 × 111.1 cm), Metropolitan Museum of Art, New York.

LEFT Rembrandt *Head of an Oriental with a Bird of Paradise, c.*1634-35, pen and brown ink heightened with white on paper, 7 × 6⅝ inches (17.8 × 16.9 cm), Cabinet des Dessins, Louvre, Paris.

metalwork and, significantly for the present discussion, Indian miniatures.

Rembrandt later in his career made some studies after such images. The example of this category of drawing illustrated here (top left), shows how the artist remained interested in the patterning and form of exotic cos-

tumes. This is a free adaptation of a Mogul painting which was executed during Rembrandt's lifetime. Its creation was far from being an isolated exercise; it is recorded that in 1747 an album of 25 such drawings by Rembrandt were sold from the collection of Jonathan Richardson Senior.

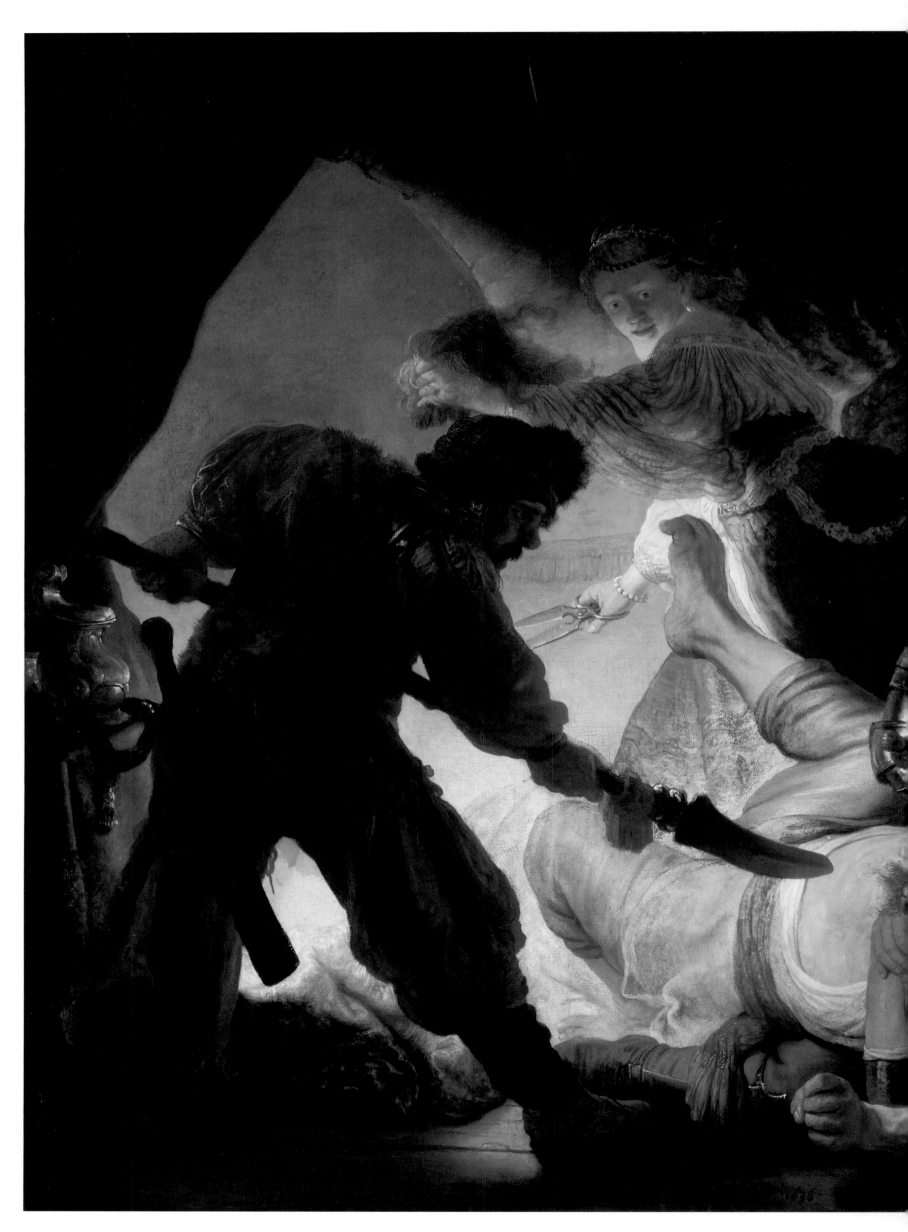

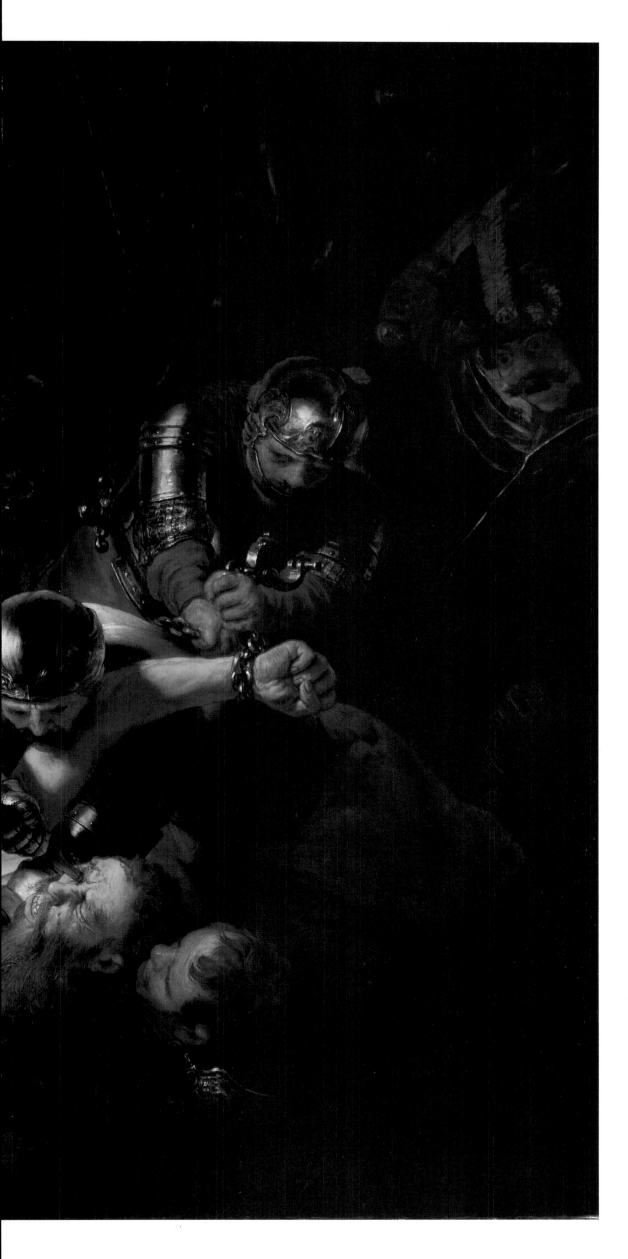

Rembrandt *The Capture and Blinding of Samson*, 1636, oil on canvas, 80 × 106¼ inches (205 × 272 cm), Städelsches Kunstinstitut, Frankfurt. It is possible that Rembrandt emphasized the brutality of subjects such as this in the 1630s, not simply because he was turning with new enthusiasm to the works of Caravaggio and Rubens for inspiration, but also because he wanted to implicitly convey something of the morality of the Old Testament (ie 'an eye for an eye'). Such an attitude can be contrasted with the artist's altogether more restrained and serene depictions of New Testament subjects.

Returning to Rembrandt's dramatic Old Testament history paintings of the 1630s, perhaps the most violent of this group of works is his *The Capture and Blinding of Samson* (left), of 1636.

As Delilah rushes out into the light clasping some of Samson's hair, which was the source of his strength, he is horribly mutilated in the foreground (Judges 16: 20-21). This attack is of such ferocity that it is almost unbearable to look at. Acts of this type had been painted previously, notably by Caravaggio and followers of his such as Artemisia Gentileschi, but no one earlier had depicted this part of the story of Samson in such a grotesque manner.

The pain of the blinding is conveyed by every part of Samson's body; he clenches his fist and his toes curl because of the agony. In many ways this is the conclusion of Rembrandt's earlier explorations of extremes of expression. Exactly why this memorable image was painted has not been established; no record of a commission survives. It is thought though that the work may have been given by the artist as a gift to Constantijn Huygens, as a way of thanking him for securing commissions for Rembrandt at the Court in The Hague.

The violent nature of the action had in part been rehearsed by Rembrandt in upright format, in his *Abraham's Sacrifice* (page 96), of 1635, which is known in two versions. The one more firmly attributed to the artist, in the Hermitage, St Petersburg, is illustrated here.

God tested the faith of Abraham by requesting that he should sacrifice his son Isaac. Just as he was about to carry out the sacrifice an angel intervened to stay his hand (Genesis 22: 1-13). Abraham's relationship with the angel is comparable to that between Belshazzar and the miraculous writing explored earlier in Rembrandt's work (page 89 *et seq*).

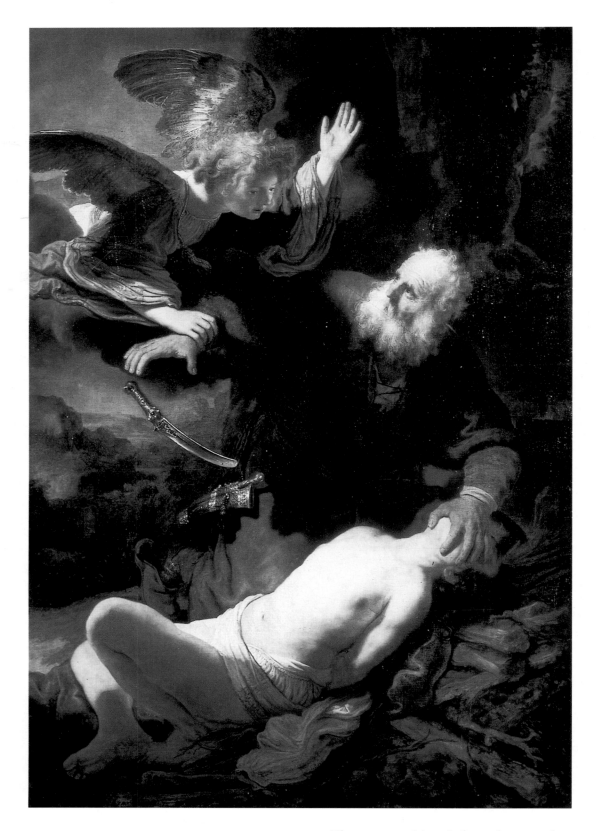

RIGHT Rembrandt *The Angel Leaving Tobias and His Family*, 1637, oil on panel, 26½ × 20¼ inches (68 × 52 cm), Louvre, Paris. Signed: *Rembrandt f. 1637*. The angel who had helped the family of Tobias ascends to heaven.

ABOVE Rembrandt *Abraham's Sacrifice*, 1635, oil on canvas, 75⅜ × 52 inches (193 × 133 cm), The Hermitage, St. Petersburg. Signed and dated: *Rembrandt f. 1635*. God tested Abraham by requesting that he sacrifice his son, Isaac, and once he had proven his faith, at the last moment an angel intervened.

The composition is based upon that of a painting of the same subject by Pieter Lastman (Rijksmuseum, Amsterdam), which was in turn inspired by a work of Caravaggio. Its series of intersecting diagonals creates an appropriate sense of collision for such an encounter. The device of covering the face of Isaac with a hand was, however, Rembrandt's rather than Lastman's invention. It has a peculiar and disturbing psychological effect, by removing the identity of the figure and making him appear more an object of sacrifice than a person.

The other version of this composition, which is intimately related to it, is in the Alte Pinakothek in Munich. It has been variously attributed, but is currently thought to be by an anonymous pupil of the artist. In it the figures of Abraham and Isaac appear to be almost identical in terms of pose to those in the St Petersburg painting, but the angel is treated quite differently. It may be that this alteration reflects a new solution by Rembrandt to the problem of effectively juxtaposing the figures, which was followed through by one of his assistants.

The appearance or departure of an angel is a theme which runs through a number of the other history paintings and etchings of these years, such as *The Angel Leaving Tobias and His Family* (right), of 1637. Subjects from the book of Tobit, as has already been noted, were returned to on numerous occasions by Rembrandt.

In this work the point at which the archangel Raphael left the family of Tobias is depicted (Tobit 12: 20-22). The angel had accompanied Tobias on a journey and told him to keep the heart, liver, and gall of a large fish which attacked him. These were later used to cure the blindness of his father, Tobit. In the painting the angel, having revealed its identity, ascends toward a golden light and the family are fearful and give praise. Tobit has fallen to his knees on the pavement, while Tobias is open-mouthed with shock and a dog cowers behind them.

Interactions between the earthly and the heavenly were also notably explored by Rembrandt during this decade in two multifigure etchings, *The Angel Appearing to the Shepherds* (page 99) of 1634, and *The Death of the Virgin* of 1639 (page 100).

The Angel Appearing to the Shepherds was Rembrandt's first etched nocturnal scene, but he by no means used the medium of etching in a tentative fashion to define the startling lighting effects required. He soon discovered how ideally suited such a linear graphic technique was for establishing both the subtleties and stark contrasts of illumi-

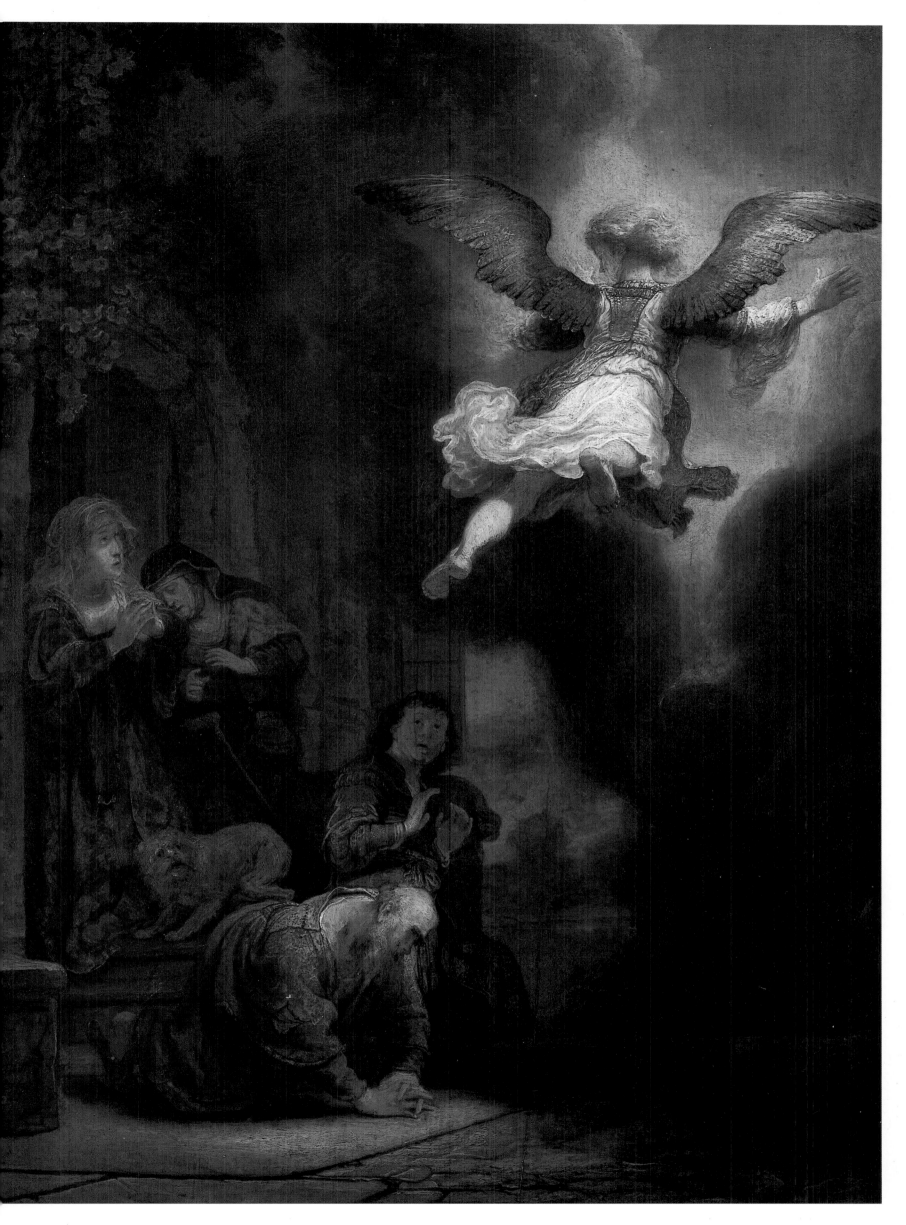

nation necessary for the depiction of such an event.

The angel of the Lord appeared to the shepherds who were watching over their flocks at night 'and they were sore afraid. And the angel said unto them, fear not . . . And suddenly there was with the angel a multitude of the heavenly host' (Luke 2: 8-10, 13).

At the center of the brilliance at the upper left is a dove which represents the Holy Ghost. It is surrounded by cherubs who constitute the 'heavenly host.' The angel below with a raised hand appears to be addressing the shepherds, who scatter as their cattle

and sheep stampede in different directions. They are shown as frightened and vulnerable and, in the case of the two central figures, awestruck. The animation of the men and animals in the lower reaches of the composition balances the concentration of illumination in the upper half. The radiance around the dove seems, in terms of its magnificence and explosive nature, similar to the type of decoration found on Italian baroque altarpieces.

All of this splendor and movement is contrasted with the still landscape at the left, which seems gradually to become legible. On the far side of the

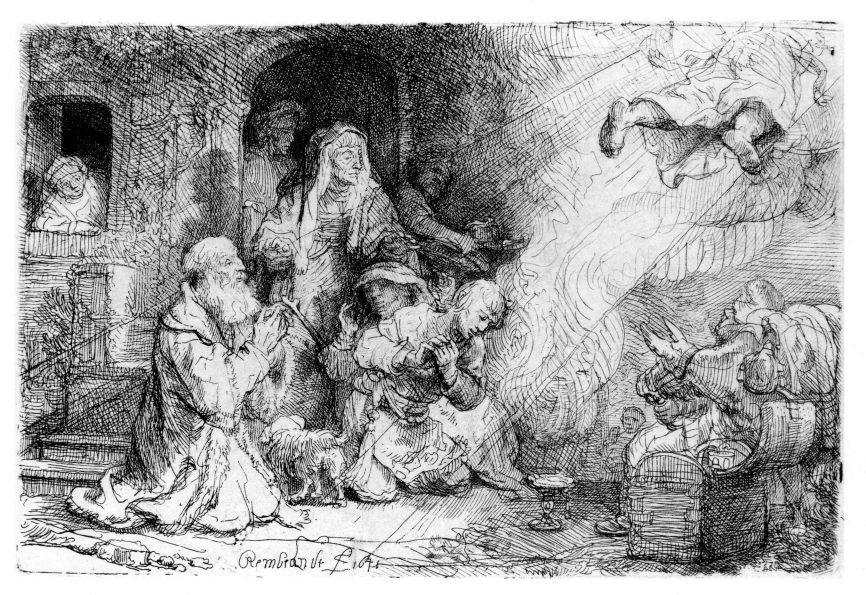

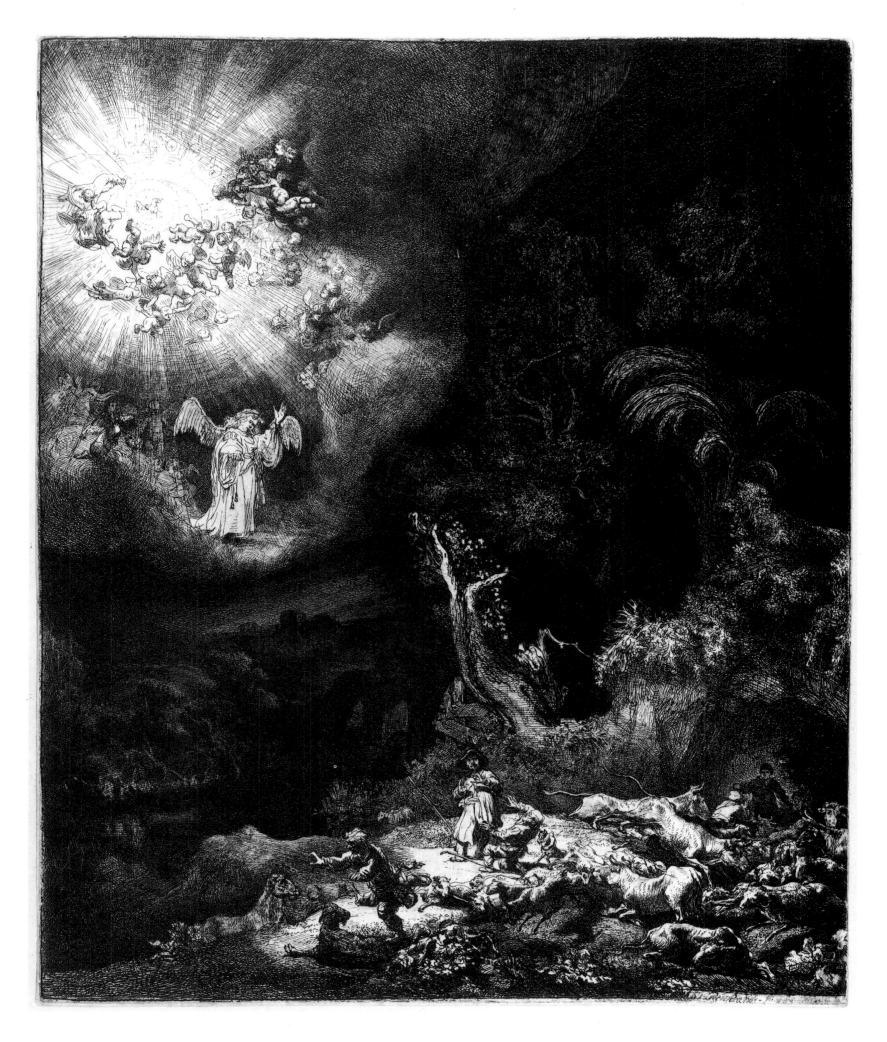

river another group of figures is sil-houetted before a camp fire.

Rembrandt transferred the theme of intercession between heaven and earth to an interior, with his later etching of *The Death of the Virgin* (page 100), which is no less grandiose in conception. The subject comes from the *Golden Legend*, a thirteenth-century compilation of the lives of saints and tales associated with

the Virgin, which was written by Jaco-bus de Voragine. It had been depicted by artists in the past on a number of occasions – notably Dürer, whose print in part inspired Rembrandt. Usually the Virgin was shown as being attended by the twelve apostles. But here Rembrandt includes a number of other exotically clad figures, including a doctor who takes her pulse.

As was the case with his grisaille paintings of the 1630s (page 73 *et seq*), the artist clearly thought it appropriate to include representatives of the mass of humanity in a sacred story such as this. He may also in this instance have drawn on harrowing experiences from his personal life, because it seems likely that the depiction of the Virgin in this context was influenced by a small

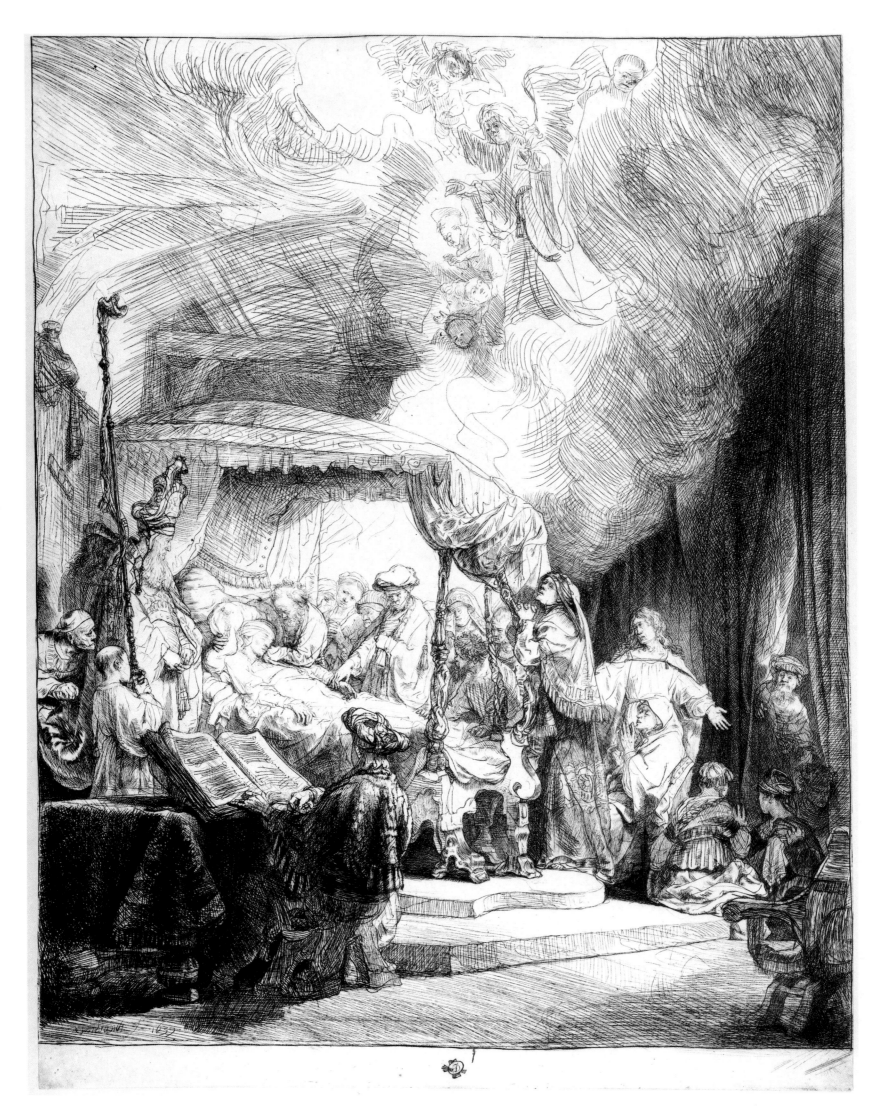

ABOVE Rembrandt *The Death of the Virgin*, 1639,
etching (drypoint) (state 1), 16 × 12¼ inches
(40.9 × 31.5 cm), British Museum, London.

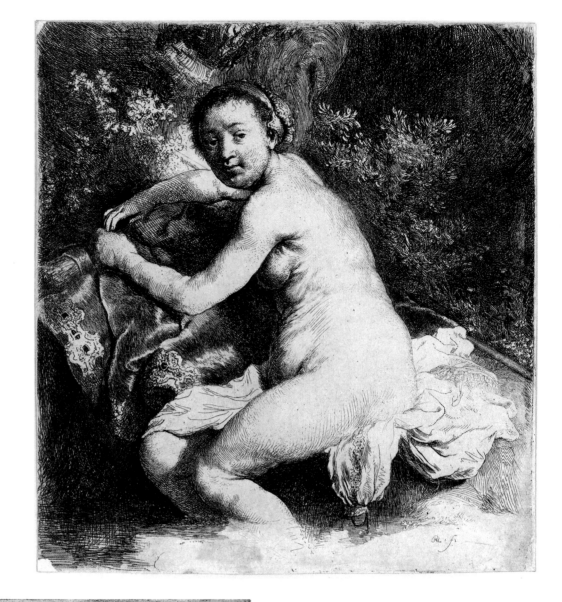

group of drawn and etched studies Rembrandt made, in the last years of the decade, of his wife Saskia, who was then frequently ill in bed.

The cult of the Virgin is a Catholic pre-occupation, and it has been suggested that Rembrandt may have made this print with such a market in mind. From above an angel surrounded by putti descends to receive her into heaven. This upper region is far more sketchily defined than the figure group, so making a clear distinction between the temporal and the celestial realms.

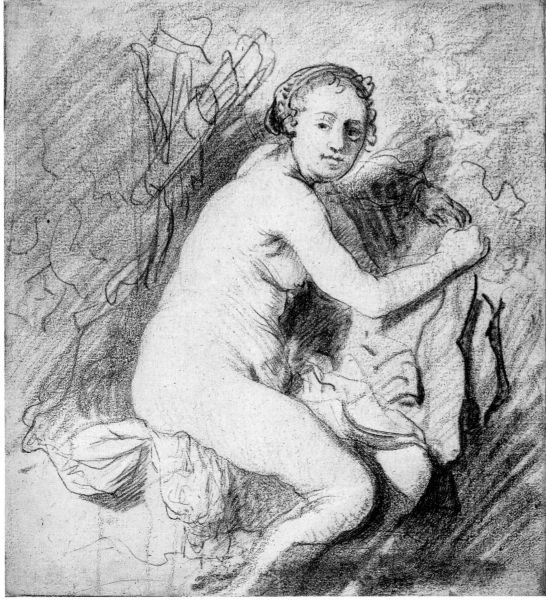

Mythology

The history paintings and etchings of the 1630s discussed so far have all been depictions of religious subjects. Rembrandt also painted, drew, and etched a number of mythological themes. These works do not constitute such a significant element, numerically speaking, in his output, but provided equally fruitful opportunities to develop his skills at establishing both intimate and dramatic naratives.

The artist seems to have taken a particular interest in the life of the hunter goddess Diana. He initially depicted her in an etching which is thought to date from about 1631 (left). The drawing which formed the preparation for this work survives in the British Museum (above).

One could easily be forgiven for not immediately recognizing these studies as depictions of a goddess. An unidealized nude woman is shown sitting on the wooded bank of a pool, with the lower half of her legs immersed in the water. She leans across to the drapery or cloak beside her and turns toward the viewer. Diana was often depicted bathing, and as a hunter goddess one of her attributes was a quiver of arrows – which appears in both of these works (hanging on the tree in the drawing, and in her hands in the etching).

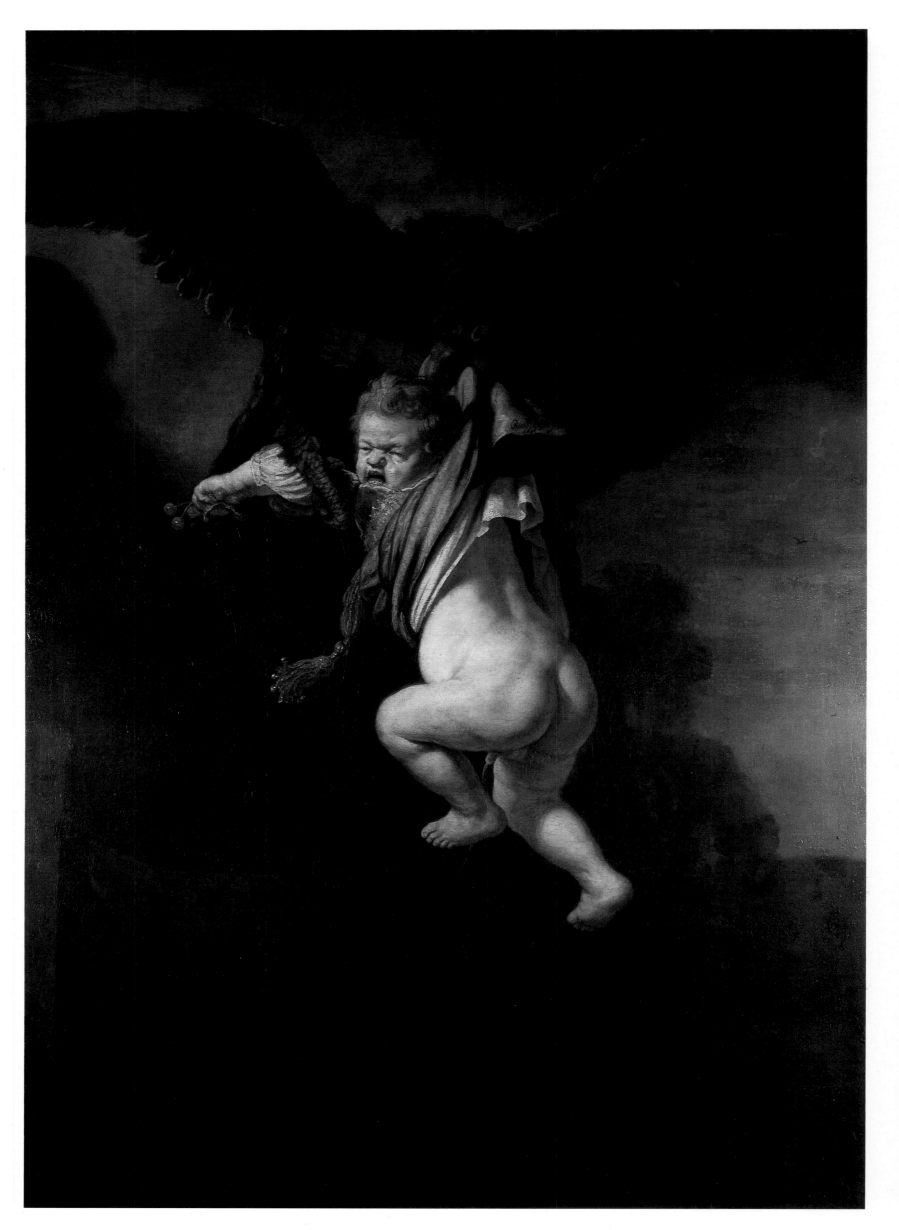

This is Rembrandt's earliest fully worked-up nude study. He was later to produce a number of notable images of this type – female nudes in the guise of mythological or Biblical women. As must have been the case here, they were all studied from models posed in the studio and, in spite of the ideal nature of their literary inspiration, were never transformed into depersonalized archetypes. This trend to a certain extent makes his work stand out from that of many of his contemporaries who repeatedly idealized the female form.

A number of the lines which define the woman in the drawing have been quite deeply indented, and it has been plausibly suggested that this could have been done in order to transfer the design to the copper plate from which the etching was printed. After the basic pose had been copied in this manner, the composition would then have been worked up in a more elaborate form on the copper sheet – this is notably the case in the foliage recorded on the etching.

More ambitious mythological works by Rembrandt date from the mid-1630s. In terms of approach and style these pictures are allied to the drama of religious history paintings such as *The Capture and Blinding of Samson* (page 94-95). *The Rape of Ganymede* of 1635 is a particularly memorable example of this type of image. Ganymede was, according to various ancient writers, the son of the king of Troy. He grew to be a beautiful youth, whom the god Jupiter coveted. The god transformed himself into an eagle and carried off Ganymede, whom he later made immortal by turning him into the constellation Aquarius.

Presumably an element of irony was here intended by Rembrandt, because the distressed but supposedly beautiful youth is depicted as a child who urinates as he is carried off. Various complex Neo-platonic and homoerotic interpretations have been associated with this odd creation, but they appear in the main to be projected onto, rather than legitimately extracted from, the image. The one suggestion which does seem reasonable is that the child, as the future Aquarius, the Waterbearer, is here unceremoniously, and again ironically, making reference to this role by urinating.

A drawn compositional study by Rembrandt (Staatliche Kunstsammlungen, Kupferstichkabinett, Dresden) shows the eagle and infant in approximately the same situation as they appear in the painting, but also includes two figures at the lower left. They were probably intended as Ganymede's parents, and their inclusion seems to have formed part of Rembrandt's initial conception of the subject. He may have decided that the isolation of the bird and youth made for a more startling image.

The motif of the crying child was reused by the artist in the following year, in what is both one of the most beautiful and most discussed of all of his mythological paintings, the so-called *Danaë* (page 104). The child appears here as the manacled and weeping golden cupid at the upper right.

This detail appears to provide the key to the nature of the overall subject. The painting has been given the title *Danaë* since the eighteenth century, and may well be a picture recorded in the inventory of Rembrandt's possessions of 1656 which was given the same name. But a debate about other possible subjects of the work has been running for many years, and at least twelve different Biblical and mythic titles have been suggested.

Danaë, according to a Greek myth, was locked up along with her nurse in a bronze chamber, by her father King Acrisius. It had been foretold that Acrisius would be killed by Danaë's son, so she was kept imprisoned to thwart suitors. But Jupiter, having transformed himself into a shower of gold, managed to visit her, and as a result of their union she had a son called Perseus.

The naked woman who lies in bed appears either to be beckoning, or looking out for an approaching and unseen lover. An elderly woman with a bunch of keys is depicted in the background, and gold showers down from above onto the reclining nude. All of these elements seem to suggest that it is the story of Danaë which is depicted. The cupid adds further weight to this interpretation because, as it is restrained against its will, it symbolically alludes to the enforced chastity of Danaë. This reading of the narrative is convincingly arrived at by the authors of the new Rembrandt *Corpus* (see Bibliography), and seems to confirm the authority of the traditional title.

When originally worked on in the 1630s, the painting would have looked quite different from its current appearance, in terms both of composition and size. Close analysis of the paint surface has shown that the artist reworked the canvas quite considerably in the early 1640s. The work was also later changed by being cut down at some time before the mid-eighteenth century. This has been established both because of the condition of the support, and because a pupil of Rembrandt called Ferdinand Bol painted a picture, the composition of which is dependent upon the original larger version of *Danaë*.

The original dimensions of the canvas were very similar to those of Rembrandt's – *Blinding of Samson* (page 94), which was painted around the same time as the first period of the artist's work on *Danaë*. Other links between the two paintings include the arrangement of their compositions, which both have a central brightly lit subject surrounded by shadowy draperies, and an emphasis on diagonals.

As has been shown Rembrandt had already begun to explore the subject of

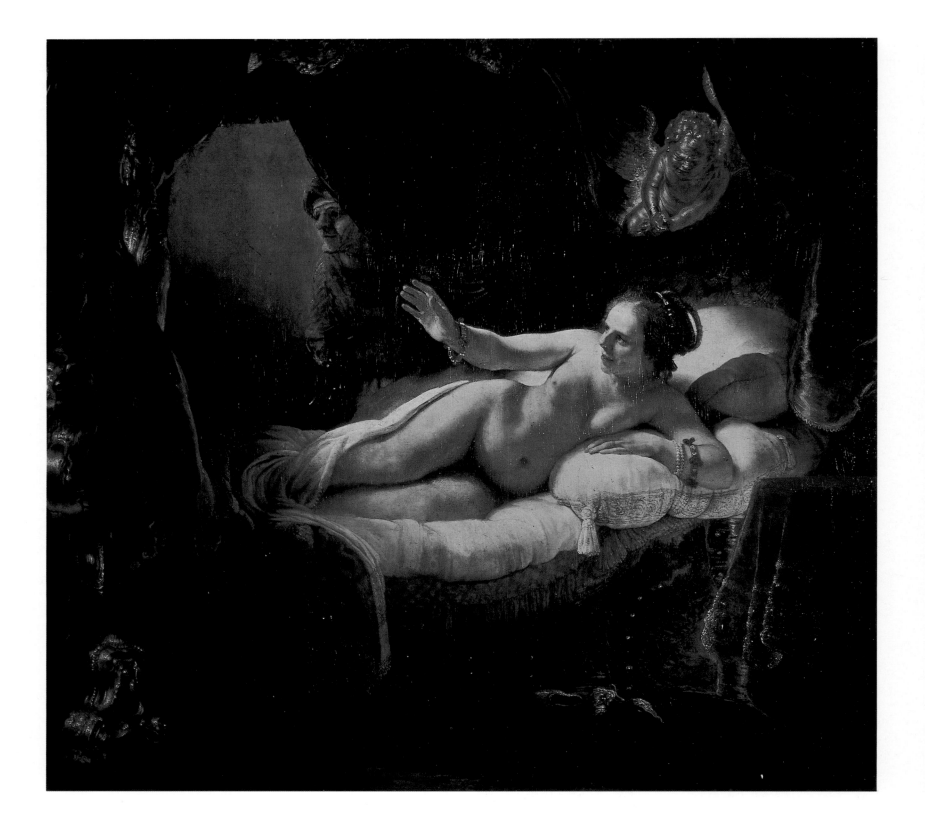

ABOVE Rembrandt *Danaë*, 1636, oil on canvas,
64½ × 79¼ inches (185 × 203 cm), The
Hermitage, St Petersburg.

BELOW Rembrandt *Jupiter and Antiope*, 1659, etching (burin and drypoint) (state 1), 5⅜ × 8 inches (13.8 × 20.5 cm), British Museum, London.

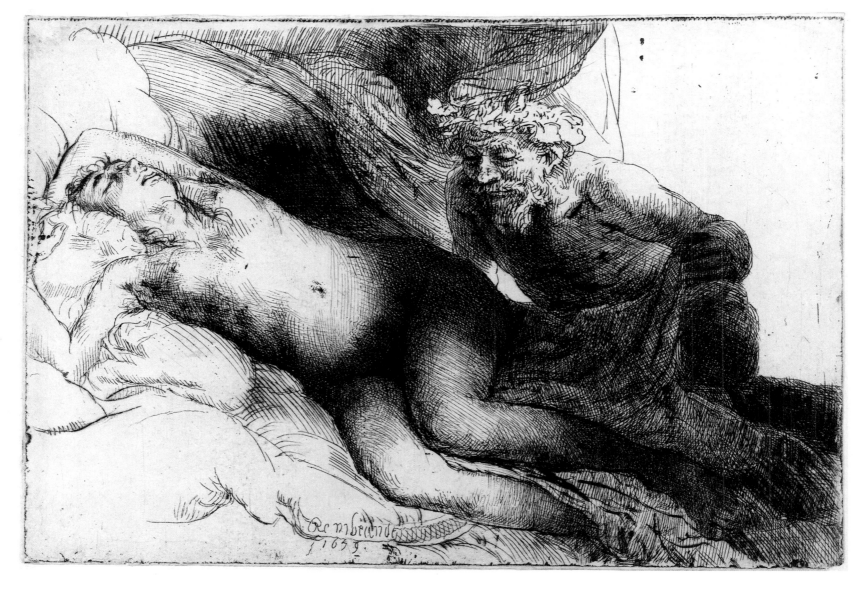

the female nude, but here he moves beyond earlier tentative studies and creates one of his most sensuous and skillful depictions of such subjects. The reclining nude in a mythological guise, as depicted in this case, forms part of a strong tradition, which was particularly eloquently explored in sixteenth-century Venice, and originated in antiquity. Rembrandt would have been aware of such a heritage but, as is so often the case, he was energized, rather than stifled by, tradition.

He explored the relationship between the god Jupiter and his naked lovers on other occasions, notably in a much later etching of *Jupiter and Antiope* (above). In this case the god transformed himself into a satyr when approaching the sleeping Antiope, who was the daughter of the king of Thebes. Rembrandt shows him tentatively removing the sheet covering the slumbering woman, who lies back in a luxuriant fashion. Her pose is ultimately based upon a Roman statue, the *Sleeping Ariadne* in the Vatican, Rome, which, through the medium of prints made after it, and numerous painted reinterpretations, inspired a large number of artists.

Court Commissions

Rembrandt executed seven paintings of scenes from the life and Passion of Christ for the Stadholder, Frederik Hendrik, between 1632 and 1646. The commissions for these works came as the result of the reputation he had acquired at the Court in The Hague. This had been chiefly developed because of the impact his work had made on Constantijn Huygens who, as has been discussed, recognized his talent early in Rembrandt's career. This appreciation clearly continued, because, according to an an inventory

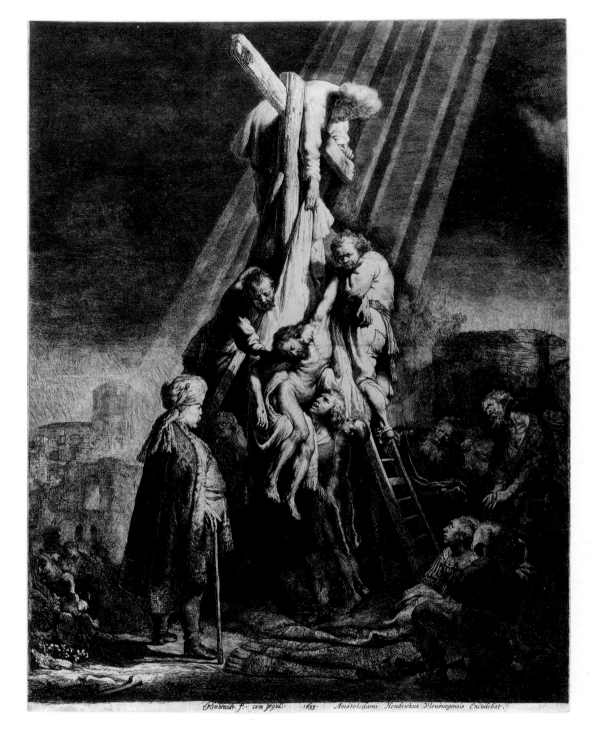

of 1632, Huygens had bought two paintings by the artist.

Huygens acted as artistic adviser to Frederik Hendrik, and so it comes as no great surprise to discover that he recommended Rembrandt as an painter who could carry out commissions for this patron.

The Passion paintings Rembrandt produced for the Stadholder ostensibly form a series, but because they were made over nearly two decades rather than in one session, they betray changing stylistic trends which parallel other shifts in his work, and so do not entirely comfortably relate to each other.

The idea of producing a series of images of this sort was not an innovation. Such cycles had for many hundreds of years been used to decorate the interiors of churches, in the form of frescos, sculptures, or oil paintings, but it was something of a novelty to have a series produced on the scale of cabinet pictures (small paintings for a domestic context).

The order in which they were painted, and in which they are discussed here, does not match the chronology of the narrative. This can be plotted as follows: *The Descent from the Cross*, c.1633, (page 107); *The Raising of the Cross*, c.1633, (page 109); *The Ascension of Christ*, 1635-39, (page 110); *The Entombment of Christ*, 1635-39, (page 111); *The Resurrection of Christ*, 1635-39, (page 112); *The Adoration of the Shepherds*, 1646, (here illustrated by another version of the same composition by Rembrandt, page 113); *Circumcision*, 1646, (lost).

It has been suggested that the first of the series to be painted, *The Descent*, may have been intended as an independent work, and that because it was so successful the rest of the commission was forthcoming. There are two significant reasons for supposing that it was conceived in isolation; firstly because it is the only one of all the paintings to be

executed on panel (the rest are on canvas), and secondly because its composition was used as the basis for an etching by Rembrandt which is dated to 1633 (above).

In both the painting and the print the slumped body of Christ appears swollen and completely unheroic. The features of the figure supporting his body from below appear to be those of Rembrandt; the inclusion of a self-portrait appears even more conspicuous in the next painting in the series to be executed.

The Virgin has swooned in the foreground at the lower left, and the very portly bearded figure who stands at the right contemplating the scene is probably Joseph of Arimathaea, who asked Pilate if he could receive the body of Christ, which he placed in a tomb he had made for himself.

The etching bears the name of Hendrick van Uylenburgh, the art dealer with whom Rembrandt lived when he first moved to Amsterdam. The production of such a work was clearly a

way of disseminating the artist's fame, and no doubt promoting the business interests of Uylenburgh, in a manner akin to the comparable enterprises of Rubens.

The composition of both the painting and the etching can also be related to Rubens in another sense; it is in part based on the composition of Rubens's painting of the same subject of 1612, which was made for Antwerp Cathedral. Rembrandt would not have seen this work, but probably knew it through an engraving. He did not slavishly copy it, but an element of homage remains.

In the print the supernatural source of light is made more blatant than in the painting; strong beams strike the central group from above. This diagonal emphasis brings the image even closer to the Rubens prototype, in spite of the enormous difference in terms of size between the works by the two men.

The second scene to be painted for the Stadholder, and the earliest in the

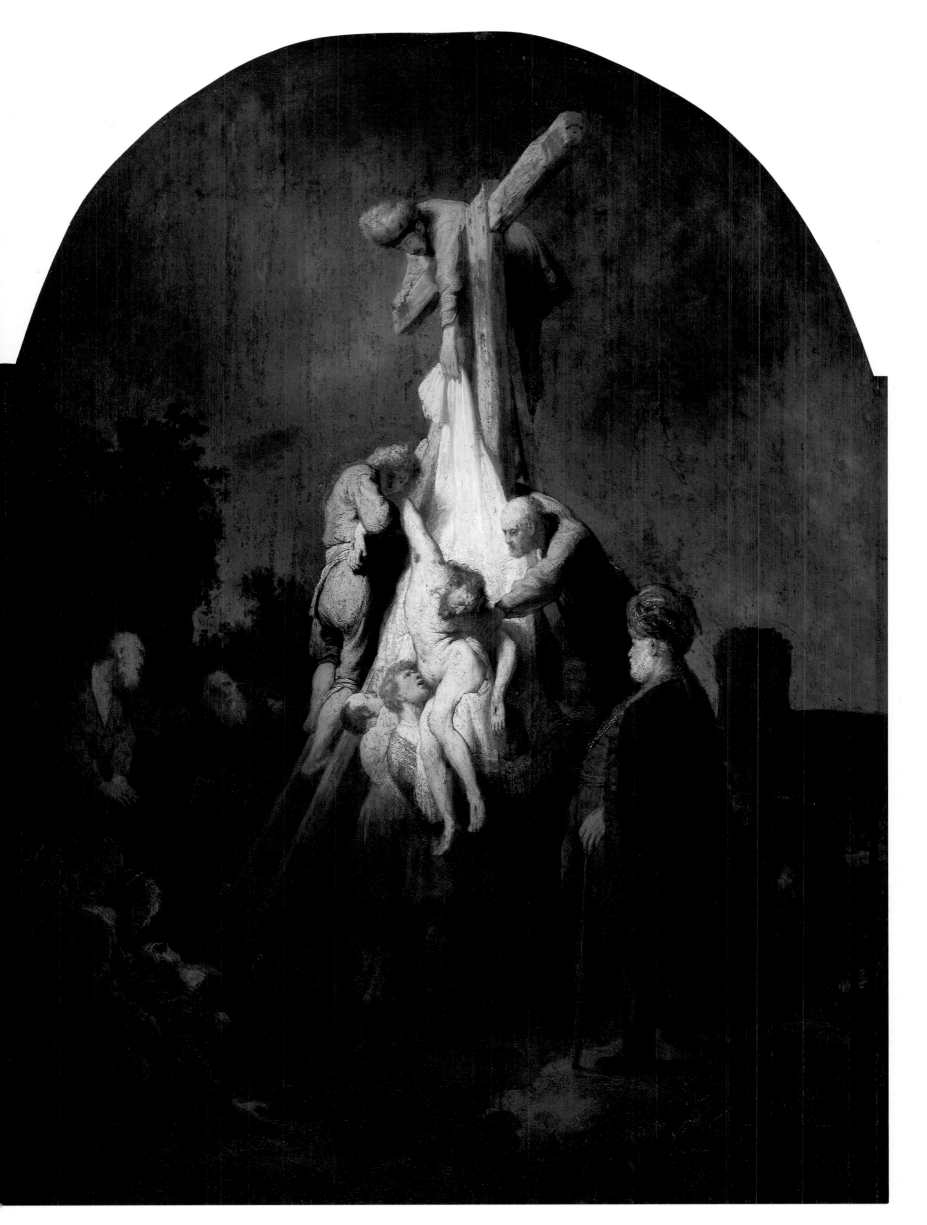

BELOW Rembrandt *The Raising of the Cross*, c.1628-29, black chalk heightened with white on paper, 7½ × 5¾ inches (19.3 × 14.8 cm), Museum Boymans-van Beuningen, Rotterdam.

chronology of the story, is the *The Raising of the Cross* (page 109). This subject had in part been rehearsed by Rembrandt in a drawing of about 1628-29, which is now in Rotterdam (page 108). In the drawing the cross is in a lower position, and is being raised in the opposite direction to the way it is depicted in the painting. There are, however, a number of links with the latter work, which include the poses of the men raising the cross, and the figure isolated at the back, above the rest, who wears a turban. He seems to be supervising the event, as does the figure on horseback in the painting, who may be the centurion.

In the painting many more details are included. The cross is slowly raised so that it can be placed in the hole which has been dug in the foreground. In the shadows at the right the two thieves are led forward to be crucified. At the left are the high priests and scribes, who according to the Gospel of Saint Matthew mocked Christ. One of them, with his palms turned out and arms spread, looks imploringly at the viewer, as does the centurion.

The most troubling attendant is the man wearing a hat who has his face by Christ's feet. He is thought to be a self-portrait of the artist. Exactly why Rembrandt should have portrayed himself in this role, both here and in the *Descent*, is not clear. Other artists had previously placed themselves in history paintings, but more often as extras, rather than stars. He seems here to be notably prominent, not just as a witness, but as an intimate participant. Different motives have been suggested as an explanation. It has been proposed that the intention may have been to depict himself as an 'Everyman' figure, of a type derived from medieval plays, who is representative of all sinful humanity; in this position he would represent our complicity in the ultimate crime. According to a second theory the placement of him in this position can be related to contemporary poetry, in which the individual is described as bearing responsibility for the horrors of the Passion. This idea can be related to wider Counter-Reformation literary teachings, in which close contemplation of elements of the Passion is promoted as forming a vital part of a religious education.

Alternatively, a more personal motive may be suggested; it could be that Rembrandt is here showing how he has to think about the minutiae and consequences of the subject in order to effectively depict it. In other words he

BELOW Rembrandt *The Raising of the Cross*, *c.*1633, oil on canvas, 37½ × 28¼ inches (96.2 × 72.2 cm), Alte Pinakothek, Munich. The figure wearing a blue beret at the foot of the cross is clearly a self-portrait of the artist.

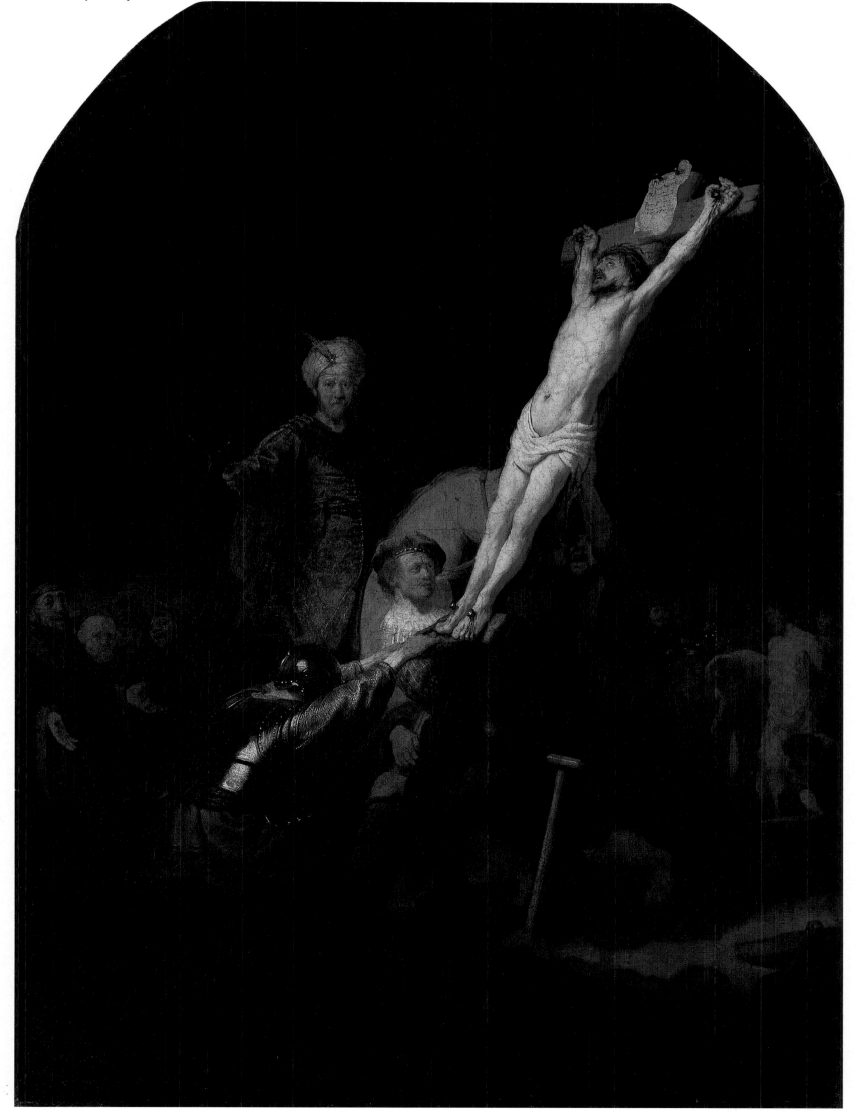

Rembrandt *The Ascension of Christ*, 1635-39, oil
on canvas, 36¼ × 26⅝ inches (92.7 × 68.3 cm),
Alte Pinakothek, Munich.

has to get inside it, as he did for example with the *Stoning of Saint Stephen* (page 23), so as to extract from it the essence of the narrative and convey a sense of personal relevance.

The first of the second batch of paintings from the Passion series to be delivered to the Stadholder was *The Ascension of Christ* (page 110) of 1635-9. This work, like a number of the others in the series, is unfortunately in a poor state of preservation. It is nevertheless still possible to get a fairly clear idea of Rembrandt's intentions. At the very top of the composition a dove representing the Holy Ghost hovers at the center of a burst of golden light. Below Christ, who is surrounded by putti, ascends to heaven, while the apostles look on in amazement from the ground. The composition, with the elements grouped in three distinct tiers, appears to be based on that of Titian's famous *Assunta* which is in the Church of S Maria dei Frari, Venice. Rembrandt would not have known this work in the original, but almost certainly was aware of it through engravings after it.

The subject certainly demanded a quite different treatment to the two works he had already produced for the Passion series, with its flood of light and supernatural elements, but there is some evidence to suggest that the artist attempted to make it conform with them in terms of style.

A series of seven letters written by Rembrandt to Huygens about the Passion paintings survive. These are the only autograph documents (apart from inscriptions on drawings etc) by the artist which are known. Unfortunately they do not, as might have been hoped, include profound revelations about the artist's thoughts. Their character is businesslike, deferential, and stilted. They do, however, include one or two phrases which illustrate how Rembrandt may have intended to relate the works to each other. The *Ascension* is re-

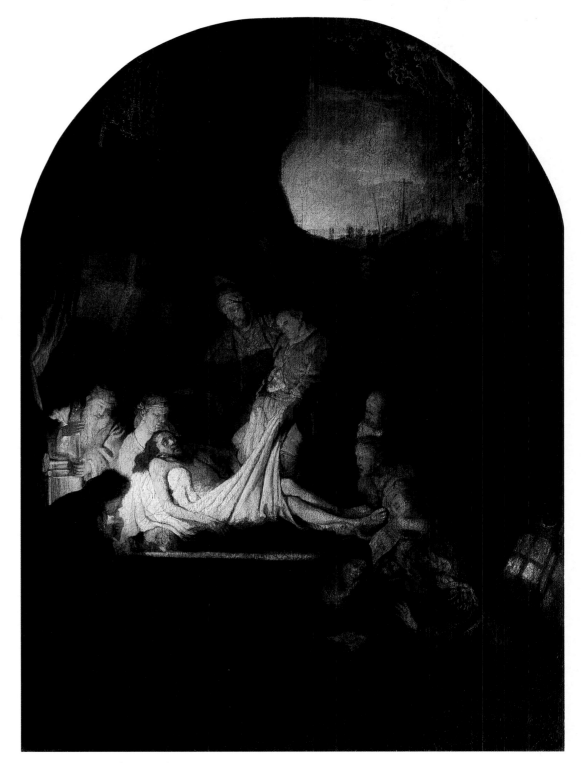

BELOW Rembrandt *The Entombment of Christ*, 1635-39, oil on canvas, 36⅛ × 26⅞ inches (92.5 × 68.9 cm), Alte Pinakothek, Munich.

ferred to in the second letter, in which Rembrandt expresses his desire to 'see how the picture accords with the rest.' Later in the same document he suggests that the work will be shown to the best advantage in the gallery of the

Stadholder, where there is a strong light. These two statements could be taken to suggest that the artist actually travelled to The Hague in order to see the works installed, but no records survive to corroborate this theory.

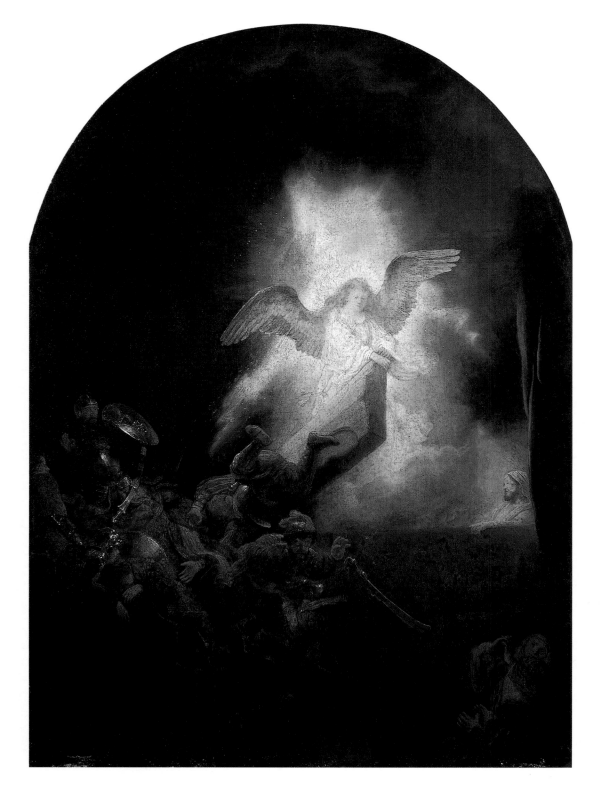

LEFT Rembrandt *The Resurrection of Christ*, 1635-39, oil on canvas transferred to panel, 37⅞ × 26⅛ inches (91.9 × 67 cm), Alte Pinakothek, Munich.

The next works Rembrandt painted for the series in the 1630s were *The Entombment of Christ* (page 111), and *The Resurrection of Christ* (above).

The *Entombment* appears to be related to some contemporary paintings by the artist which were discussed earlier, notably the Glasgow grisaille of the same subject (page 81), but it is by no means clear what the exact nature of the relationship between these two works is. The Glasgow painting can certainly in compositional terms be related to the figure of Christ and the group around him in the work from the Passion series, but the different format of the Munich painting, and the inclusion of Golgotha at the upper right, are sufficiently different to suggest that the grisaille was an independent rather than a preparatory study.

The *Resurrection of Christ* (above), in which an angel descends to open his tomb, can also be linked with other similarly dated works; for example the angel is comparable to those which appear in *The Risen Christ Appearing to Mary Magdalen* (page 85).

Rembrandt's interpretation of the Resurrection shows it as an almost chaotic incident, with the soldiers Pilate had sent to guard the tomb terrified by the appearance of the angel, cowering in fear and tumbling away. This provides a notable contrast with the way in which a number of earlier artists had treated the event; it had often been shown as a moment of great serenity with Christ rising triumphantly, holding a banner, and the guards quietly slumbering.

The final stage of this protracted commission dates from the mid-1640s, when Rembrandt completed it with two more paintings for the Stadholder, a depiction of the the Circumcision of Christ, which is lost, and an interpre-

tation of the the Adoration of the Shepherds, which like all of the other surviving works from the series is now in the Alte Pinakothek, Munich.

The Adoration of the Shepherds illustrated here (right) is not the Munich painting, but a very closely related interpretation of the same subject, which is similarly dated and now in the collection of the National Gallery, London. It is included, rather than the other work, to emphasize the way in which Rembrandt experimented with variations on a theme. There are a number of minor differences between the Munich and London canvases, but essentially in each of them the composition appears as a reversed version of the other. The painting of both pictures seems to suggest that Rembrandt was attempting to explore the different ways in which an image can be 'read'(ie from left to right and vice versa).

The London painting, when compared with the earlier works in the series, illustrates how the style of Rembrandt's pictures altered from the mid-1630s to the mid-1640s. It is worked up in an altogether broader manner in which the texture of the paint appears to take on a life of its own, which is in some areas almost independent of the forms it defines. This is quite far removed from the precision employed to define details in the earlier works.

A glow appears to emanate from the Christ Child; it illuminates the faces of those who crowd into the stable to adore him. Mary wearing red and blue stares down, whilst Joseph looks on from behind her; an ox eats quietly at the rear. Two shepherds kneel before the crib, one, silhouetted, clasps his hands in prayer, while the other with a staff is about to give praise. Behind him stand two women who hold up a small child so that it can peer at Jesus. In the shadows at the right stand a group of five other figures; three who are perhaps conversing, a man with a lantern

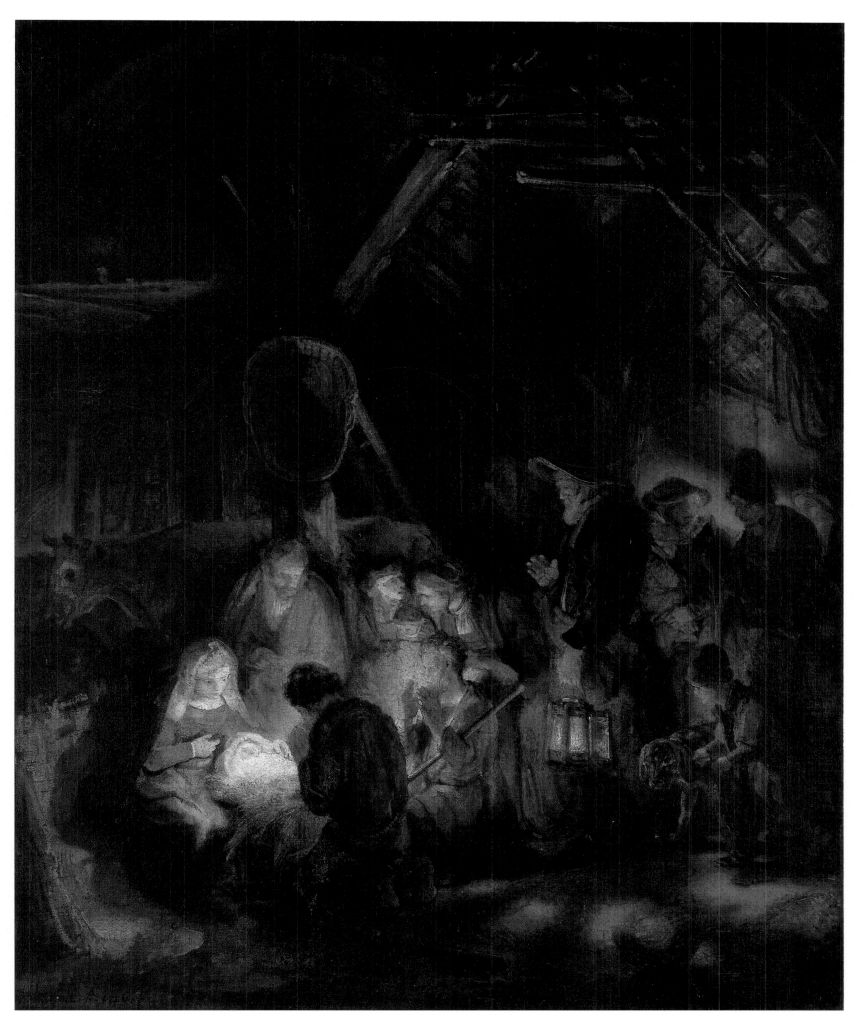

ABOVE Rembrandt *The Adoration of the Shepherds*, 1646, oil on canvas, 25½ × 21½ inches (65.5 × 55 cm), The National Gallery, London.

who eloquently gestures, and a boy with a dog. The carefully controled lighting creates an impression of intimacy, as well as emphasizing the mystery of the spectacle.

It has been suggested that one of the reasons why the commission for the Passion series took so long was because Rembrandt only took it up again when-

ever he was in need of more money. This seems a harsh appraisal, however, of what are undoubtedly some of the artist's most moving religious history paintings, and suggests that the artist rather than the patron took a leading role in their relationship. It appears from the letters related to the commission that the opposite was in fact true. This becomes particularly clear once it

RIGHT Rembrandt *Portrait of Saskia van Uylenburgh*, 1633, silverpoint on prepared parchment, 7¼ × 4⅛ inches (18.5 × 10.7 cm), Staatliche Museen Preussischer Kulturbesitz, Kupferstichkabinett, Berlin. The drawing is inscribed: *This is drawn after my wife when she was 21 years old, the third day of our betrothal, the 8th of June 1633.*

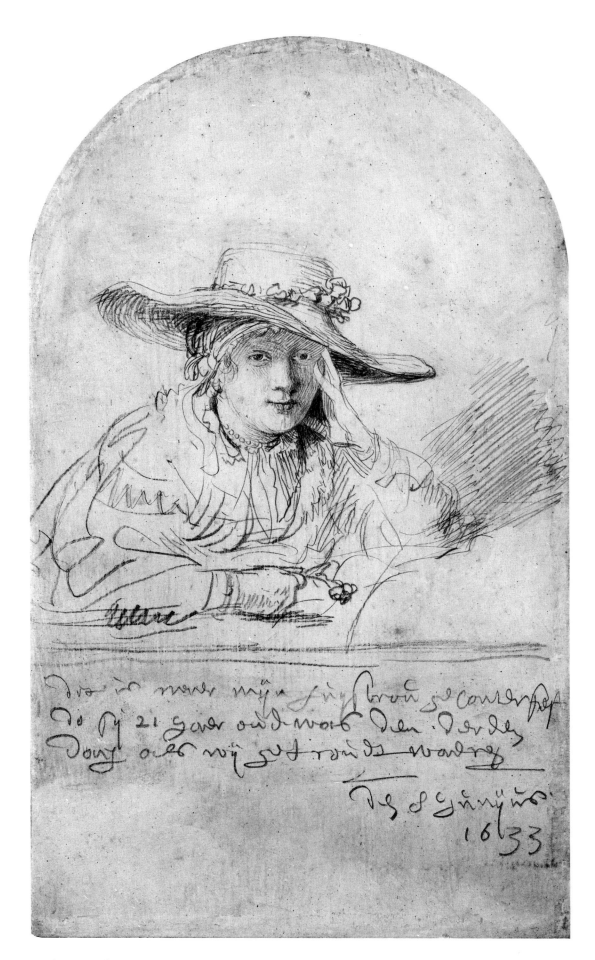

is established exactly how much Rembrandt was paid for the paintings, and how he had to court the Stadholder through the medium of Huygens.

Rembrandt requested 1200 guilders each for the pictures, but for the first five received only half of that price, and so in total was given 5400 guilders. There is no doubt that in contemporary terms this was a considerable sum, but it was an ambitious, time-consuming and prestigious project.

The little that the letters reveal about Rembrandt's intentions suggest that he felt the need to defend and promote his art. This is made clear by one particularly famous extract from them, where the artist describes the *Entombment* and *Resurrection* as works in which 'the greatest and most natural emotion has been expressed.'

Because this is the only comment of this type known by the artist it has received a lot of attention, but it seems to be unwise to build an entire aesthetic from a single piece of self-praise. The description needs instead to be viewed in the context of a series of letters which were chiefly intended to sell the works in question, and be seen as a part of a process of convincing the patron of the quality of the product he was receiving.

Saskia van Uylenburgh

This is drawn after my wife

Saskia van Uylenburgh (1612-42) was a cousin of the art dealer Hendrick van Uylenburgh with whom Rembrandt had lodged when he first settled permanently in Amsterdam. It is reasonable to assume that the artist met her via her uncle. She was the daughter of Rombartus van Uylenburgh who was the Mayor of Leewarden in Friesland. The artist was betrothed to Saskia on 8 June 1633, and they married in June of the following year at Sint-Annaparochie, near Leewarden.

The couple appear to have enjoyed a happy relationship and their union marked for Rembrandt a degree of social advancement. Saskia's family were members of the professions, rather than traders and manufacturers as Rembrandt's were. She had three brothers and three sisters. One of the brothers was an army officer, while the other two were lawyers, and the sisters were married to a commissioner, a professor of theology, and a town clerk. She was the artist's companion during his meteoric rise to fame during the 1630s, and shared the parallel improve-

ment in his material circumstances. As has already been mentioned, the couple moved in 1639 to a grand house on the Sintanthonisbreestraat.

They had four children (Rombartus, 1635; Cornelia I, 1638; Cornelia II, 1640; and Titus 1641). Only the last survived infancy, and Saskia, having been weakened by her pregnancies, was to die in the year after his birth, probably of tuberculosis. The joys and tragedies of the couple's life together can be traced through his portrayals of her as a young vivacious woman, and later as a saddened convalescent.

BELOW Rembrandt *Three Heads of Women, Probably all Saskia, c.*1637, etching (state 3), 5 × 4 inches (12.7 × 10.3 cm), Museum het Rembrandthuis, Amsterdam.

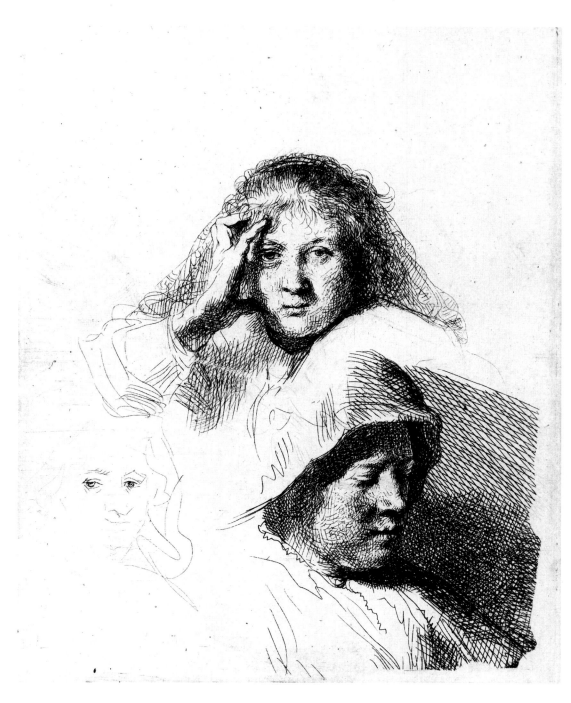

Rembrandt clearly expressed his love for and pride in his new bride in the depictions of her which date from the early part of their marriage. Of these one of the most tender, and important in terms of establishing Saskia's identity in other works, is a drawing of 1633 which is now in Berlin (left). It is executed in silverpoint on parchment, an unusual medium and support for this period, which may indicate the special nature of the sketch as far as the artist was concerned. Here Saskia stares directly at her artist husband with a half-smile forming on her face. He has inscribed beneath the portrayal 'This is drawn after my wife, when she was 21 years old, the third day of our betrothal, the 8th of June 1633.'

She wears a straw hat which is decorated with flowers and holds a single bloom in her right hand. These rural attributes were to re-emerge in a number of Rembrandt's depictions of his wife. In this instance they may be related to a traditional marriage costume (earlier Rubens had depicted his young wife in a similar guise). But when used later (as in page 117) they seem to be linked with a wider contemporary trend for arcadian escapism.

The pose she adopts in this drawing can be related to her appearance in a later etching (right), which includes three studies of her features. Works such as this provide useful information not only about the way in which Rembrandt etched, but also about how he scrutinized his models. Here he made records of different poses and lighting arrangements on an etching plate in a manner you might more readily expect to find in a sketchbook. The head at the lower left is only established in a very cursory fashion; the other studies would initially have passed through this stage before having been worked up with detailed hatching. In spite of the apparently casual nature of the work on the plate there is some evi-dence to suggest that exercises such as this were not simply carried out for the artist's benefit, but intended for sale in the same way that his more obviously 'finished' images were.

In a third depiction of Saskia from the mid-1630s (page 116) the artist again chose to depict her resting her head on her hand. In this drawing, which is now in Rotterdam, he placed his wife at a window and shows her looking directly at him out into the sunlight. Attention is focused by her eye contact with the viewer, the way in which she stands out before the darkness of the room behind, and the use of the window to 'frame' her. Later the artist was to return to the theme of frames within frames when working on his mature portraiture (see pages 142).

RIGHT Rembrandt *Saskia at a Window, c.*1633-6, pen and brown ink and wash on tinted paper, 9¼ × 7 inches (23.6 × 17.8 cm), Museum Boymans-van Beuningen, Rotterdam.

BELOW Rembrandt *Self-Portrait with Saskia,* 1634, etching (state 1), 4 × 3¾ inches (10.4 × 9.5 cm), British Museum, London.

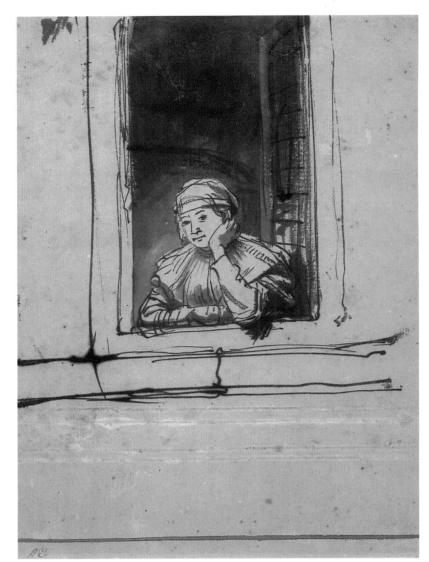

In the year after this beautiful study was probably executed Rembrandt depicted Saskia yet again, but this time with himself in an etching (below). This self-portrait and double portrait rolled into one shows the artist in a quite flamboyant feathered hat and fur-trimmed gown and his wife in altogether more ordinary, everyday clothes. By dressing in this way Rembrandt appears to be making a statement about his social standing, similar to that in the self-portraits discussed earlier (page 70-71). He

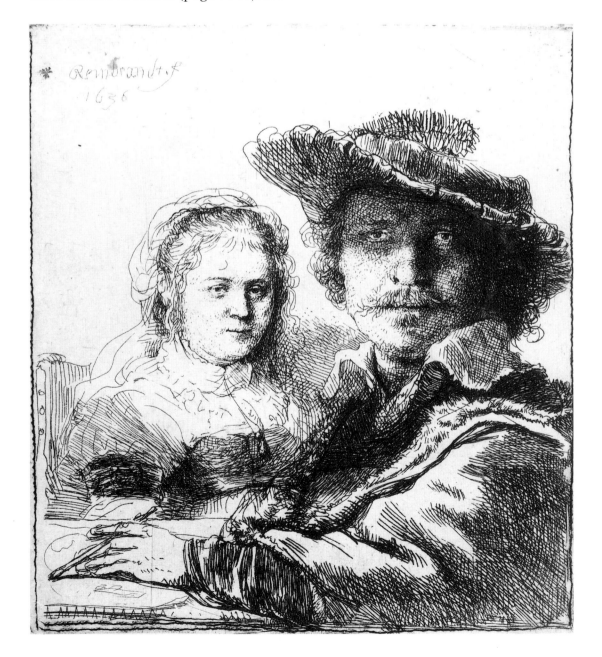

has also depicted himself with a stylus in his hand in the process of working on this study, so commenting on his status as an artist.

A comparison between Saskia's appearance in this work and her betrothal portrait of three years earlier (page 114) suggests that she seems to have aged quite unusually and rapidly. In the intervening period she had given birth to a child who had died in infancy.

The pastoral theme which first finds expression in the betrothal drawing of Saskia is more fully developed in three later paintings by Rembrandt (St Petersburg, Hermitage, 1634; London, National Gallery, 1635; Dresden, Gemäldegalerie, 1641). These appear to be either portraits of Saskia in the guise of a shepherdess, or the Roman goddess of Spring, Flora, or depictions of the goddess in which Saskia was used as a model.

The London painting (right) shows her in a rich voluminous gold and green dress, holding a bouquet and staff, with blossoms around her neck and head. If this is considered a portrait in the guise of the goddess, then it seems a particularly appropriate means of representation. To depict Saskia as an archetype of fertility was clearly fitting because of the stage of the couple's life together – the outset of marriage.

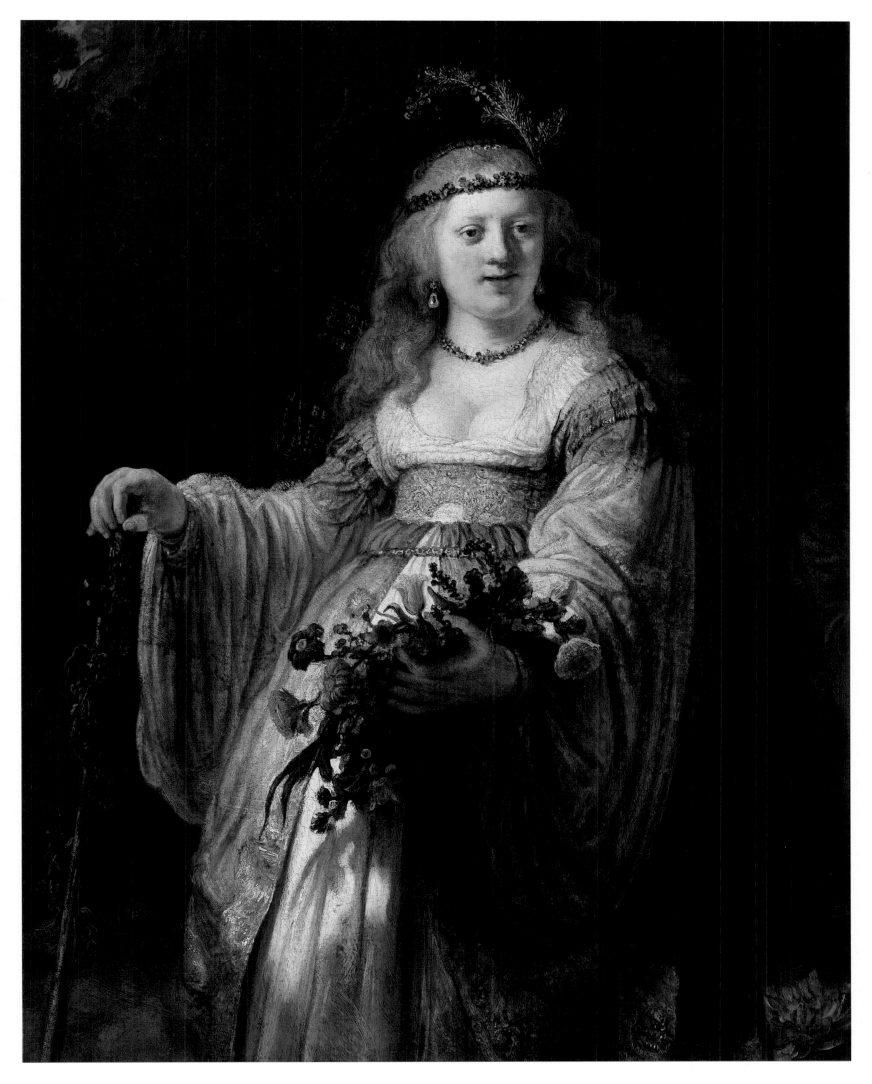

ABOVE Rembrandt *Flora*, 1635, oil on canvas, 48¼ × 38 inches (123.5 × 97.5 cm), The National Gallery, London. Saskia van Uylenburgh appears to be here presented in the guise of the Roman goddess of Spring, Flora.

Dressing a figure in such a consciously theatrical and archaic costume may seem bizarre from a twentieth-century viewpoint, but Rembrandt's decision to do this can in part be explained by relating it to a tradition of what have been called 'historiating portraits' or *portraits historiés*. These are portraits of individuals who are shown with the attributes of a historical, Biblical or mythological figure. Usually in such works some of the characteristics of the persona adopted are relevant to the actual subject, so that a soldier

117

might be portrayed with the trappings of a famous general from the past, or a young bride, as is the case here, with the clothes of a mythic figure who appropriately symbolizes new life.

That the artist appears to have decided to depict Saskia as Flora can also be associated with the contemporary trend for idealizing the pastoral life, a taste which was particularly indulged by town and city dwellers in an escapist sense, in poems, theatrical productions and paintings. The sources which were drawn upon when representing this 'ideal' were invariably the works of ancient writers who described Arcadia. Such ideas probably filtered toward the Netherlands from Italy, and pastoral portraiture first developed in the region in the work of Utrecht artists, before becoming fashionable in the 1630s in Amsterdam where Rembrandt worked. The artist was himself depicted by one of his pupils, Govert Flinck, in the guise of a shepherd.

As far as sources for Flora are concerned it has been suggested that a work by Titian may have provided some inspiration for Rembrandt. The Spanish collector Alfonso Lopez, who owned a work by Raphael which later inspired Rembrandt (see *Self Portrait at the Age of 34*, page 71), also had in his collection one of the most famous painted examples of pagan sensuality, Titian's *Flora*, which is now in the Uffizi in Florence. It is thought that Rembrandt knew of this work through the Lopez collection; his painting is not nearly as overtly erotic, but can perhaps be seen as being loosely related to such a Venetian precedent.

X-rays of the painting in the National Gallery reveal at the right the unclear image of a second figure, looking downward and wearing a flat hat. It has been suggested that the artist initially intended to paint a scene showing *Judith with the Head of Holofernes*, following the composition of a work by

Rubens which he could have seen in Leiden in the 1620s. If this is the case then the figure at the right would have been an attendant who holds the bag into which the head was dropped.

The texture of the picture Rembrandt chose to create instead has been worked by using different methods, suited to the different regions of the image. For example Saskia's waistband was built up in heavy impasto suggesting the quality of its decoration, whereas her hair was treated quite differently, being scored while the paint was wet to suggest flowing locks.

At the end of 1635, the year in which Rembrandt painted Saskia as Flora, Rombartus, the couple's first child was born. She was probably carrying him when she posed for this work. At this period though there was a very high infant mortality rate, and the boy died in

February of 1636.

A quite considerable group of drawings by Rembrandt from the 1630s and 1640s show infants and children being carried, taught to walk and sleeping. These works may reflect his preoccupation with children in view of the fact that only one of his own survived to adulthood. The models he used for these studies are likely to have been his nieces and nephews. Saskia's cousin, Hendrick van Uylenburgh, was the father of six children by 1634 and Rembrandt would have become acquainted with all of these new relatives.

A particularly attractive example of this type of work is the artist's *Woman with a Child Descending a Staircase* (above) of the mid-1630s. The downward movement is conveyed both by the way in which the woman's dress drags behind her and through the direction of the wash strokes used to

RIGHT Rembrandt *Two Women Teaching a Child to Walk*, c.1635-7, red chalk on gray paper, 4 × 5 inches (10.3 × 12.8 cm), British Museum, London.

BELOW Rembrandt *Saskia Sitting by a Window*, c.1638, pen and brown wash with white highlights on prepared paper 6⅞ × 5¼ inches (17.5 × 13.4 cm), Rijksmuseum, Amsterdam.

establish the wall at the right. The child appears very similar to the figure of Ganymede discussed earlier (page 102). This association suggests that the latter was worked up after studies from life.

In another sketch, this time executed in red chalk (above) which probably dates from the same period, the artist, with minimal description recorded what appear to be some of the first few tentative steps of a younger infant.

The decline of Saskia's health can be plotted in drawings which date from the late 1630s and early the next decade.

Rembrandt's *Saskia Sitting by a Window* (left) of about 1638 is an intimate depiction of a careworn woman who seems no longer the ebullient and trouble-free youth the artist married. She is seated in an interior wearing everyday clothes – an apron and a scarf wrapped around her head. Light enters from the window at the upper right and defines the shape of her billowing dress and her abstracted features with some precision.

A group of drawings which date from about the same time up to 1641 show Saskia in bed. These presumably are depictions of her during her confinement while pregnant, and perhaps during the subsequent illness leading up to her death.

Rembrandt was always keeping an eye on the potential pictorial uses to which his studies could be put, and it appears that even intimate sketches such as these were used as part of such a process. They seem to have influenced his contemporary etching of *The Death of the Virgin* (page 100).

Landscapes, Still Lifes and Genre

Landscapes

His landscapes we could look at forever, though there is nothing in them.

William Hazlitt, 1817

Landscape painting was a specialization pursued by many artists in the United Provinces: seascapes, dunescapes, riverscapes, panoramas, sunsets, night scenes, and storm scenes all had their practitioners. But for Rembrandt, who was essentially a history and portrait painter, the production of independent painted landscapes only constituted a very small element of his considerable output. However, his contribution to this type of work was immense.

He effectively used landscapes to create a context for a number of his history paintings (page 85), but they only start to appear as independent works from the late 1630s, for about a decade. Some scholars suggest that as many as eight such pictures by the artist survive, while others put the figure at half that number. Most agree that the works illustrated here are by him.

Landscapes are far more prominent in Rembrandt's graphic than painted work – they make up about 20% of his drawings and 10% of his etchings from the 1640s and 50s. Although there are some cross-references between these and the landscapes in oil, in the main there is a clear distinction between the two groups. The drawn and etched ones in many instances tend to be based upon his observation of the countryside and landmarks around Amsterdam, while the painted ones are imagined landscapes, which are at root based on observation, but provide

ABOVE Rembrandt *Winter Landscape*, 1646, oil on wood, 6⅝ × 9 inches (17 × 23 cm), Gemäldegalerie, Kassel.

LEFT Rembrandt *Landscape with a Stone Bridge*, c.1638, oil on wood, 11½ × 16⅝ inches (29.5 × 42.5 cm), Rijksmuseum, Amsterdam.

greater opportunities for invention. This distinction is in part explained by the fact that most of the drawings and many of the etchings must have been executed actually in the open air before the motif, unlike the paintings, which would mostly have been worked up in the studio.

The difference also appears to have developed because the painted landscapes are treated in a manner not unlike history paintings, in the sense that any opportunities for drama or mystery are taken full advantage of; the participants are simply natural phenomena rather than figurative subjects.

Rembrandt's *Landscape with a Stone Bridge* (left) of about 1638-40 is just such a work. It is modest in scale and, ostensibly, in subject, but on close inspection appears as profound and dramatic as any of the artist's apparently more lofty narratives.

The subject could not be simpler. A coach has stopped outside an inn at the left. Figures approach the stone bridge from either side, while others navigate the waterway and herd cattle at the right. Silhouetted on the horizon at the right is a church spire.

Such an innocuous scene is transformed into an extraordinary one by the light. Brilliant rays break through the clouds and illuminate the bridge and central trees, marking either the last moments before darkness falls, or the first warmth after a storm has passed.

The paint is built up in the brightest areas, but applied thinly elsewhere. This has a twofold effect – it means that the thicker saturated color draws attention at the center, while the ground is allowed to show through in other regions, such as at the upper right, so making it appear as though the sun is starting to penetrate the rain clouds. The way in which the light seeps across the composition towards the left is comparable to some of the effects achieved in *Christ Appearing to the Magdalene* (page 85), which may have been painted in the same year.

The drama here seems to reside in the atmospheric effects, but art historians have sought to extract other levels of meaning from the landscape. It has been suggested that the path which traverses the composition symbolizes the pilgrimage of life, and that while the inn represents sin, the church marks salvation. Because of the uncanny power of the painting it is possible to understand such an explanation, but not altogether easy to accept it.

121

BELOW Rembrandt *The Rest on the Flight into Egypt*, 1647, oil on wood, 13¼ × 18¾ inches (34 × 48 cm), The National Gallery of Ireland, Dublin. *'In the case of Rembrandt . . . the background and the figures are absolutely one. Interest is everywhere: you do not isolate any part, any more than when contemplating a beautiful scene in nature, where everything contributes to your delight . . .* Eugène Delacroix, *Journal 29 July 1854.*

Attempts have been made to identify the site of *Landscape with a Stone Bridge*, but with no reliable results. It would be equally futile to attempt to pin down the location of the artist's *Winter Landscape* (page 121) of 1646. Here again the phenomena are clearly based on observation, but the site is not specific. The high thin cloud and weak light effectively evoke a northern winter.

It has been suggested that the broad technique and aspects of the composition are intended as a reinterpretation of some of the paintings of the land-scapist, Esaias van den Velde (c. 1590-1630). There are some links with a winter landscape by this artist which is now in the Mauritshuis in The Hague, but the association is not very strong.

Rembrandt may not have con-sciously based his work on a specific precedent in this case, but in another notable instance did relate a painted landscape quite directly to a known prototype. His *Rest on the Flight into Egypt* (below) of 1647, can be associated with Elsheimer's depiction of the related subject, *The Flight into Egypt* (right).

Elsheimer, as has been previously noted, was an artist whom Rembrandt clearly admired (see page 23), and par-ticularly knew of through Lastman. One of the notable features of his work was his exploitation of multiple and varied light sources. Here he has three principal ones in the form of the camp fire, the torch held by Joseph, and the moon. Additionally there are the re-flections in the water, the stars which pepper the sky, and what is probably the first painted depiction of the Milky Way. Rembrandt may have known of

BELOW Adam Elsheimer (1578-1610), *The Flight into Egypt*, 1609, oil on copper, Alte Pinakothek, Munich.

the composition either through an etching after it, or a painted copy of it. It seems more likely that he referred to the latter because the design would have been reversed in an etching.

He shifts the focus to the left and has the campfire by the water as the center of attention. The Holy Family, rather than travelling, are now warming themselves by the fire, almost as figures who are entirely incidental to the true subject – the landscape. It was not until 1883 that their identity was established by the art historian Bode; previously they had understandably been simply regarded as insignificant.

There are still a number of light sources – the fire, reflections, the moon which has shifted to the upper left, the windows of a building on the hilltop, and a lamp held by a diminutive shepherd, left of center. The light and warmth of the fire provide a haven from what appears to be unfriendly terrain, on what was undoubtedly a journey fraught with danger.

The earliest of Rembrandt's etched landscapes date from the beginning of the 1640s. His *Windmill* (page 124) of 1641 is a detailed record of the type of landmark many most readily associate with the Dutch countryside.

The particular windmill depicted has been identified as one of those which existed on the fortifications that surrounded Amsterdam. The artist has effectively contrasted the bulk of the buildings with the empty horizon at the right, which gives an impression of the flatness of the countryside surrounding the city.

RIGHT ABOVE Rembrandt *The Three Trees*, 1643, etching (drypoint and burin) (only state), 8⅜ × 10⅞ inches (21.3 × 27.9 cm), British Museum, London. On the brow of the hill at the right an artist can be seen quietly sketching. He looks away from what is the most dramatic skyscape in all of Rembrandt's etchings.

RIGHT BELOW Rembrandt *The Omval*, 1645, etching (drypoint) (state 2), 4⅜ × 6 inches (11.2 × 15.3 cm), British Museum, London.

BELOW Rembrandt *The Windmill*, 1641, etching (only state), 5⅝ × 8⅛ inches (14.5 × 20.8 cm), Museum het Rembrandthuis, Amsterdam.

In the sky there appears to be a network of hairline cracks. These were probably created by the etching ground breaking up when the plate was immersed in the acid bath, (see Appendix 1).

The landscape around Amsterdam was never simply 'recorded' by Rembrandt; he often manipulated the topography and weather conditions in order to suit his pictorial and thematic aims. He perhaps most memorably succeeded in giving the scenery a mysterious significance and power of his own in his masterly etching of 1643 (right above), which is called *The Three Trees*.

The trees themselves are set on a piece of high ground by a river's bend. The flat landscape below recedes to the silhouette of a city on the horizon, which is probably intended for Amsterdam, as seen from the west. The sun casts shadows towards the left, and a storm with sheeting rain frames the sky. The grand sweep of these atmospheric effects is contrasted with the minutiae of life on the land; there are many details of people and animals working in the fields, a fisherman and companion are by the river, a loaded cart travels along the brow of the hill,

an artist sketches on its summit, and a pair of lovers are almost completely hidden in the undergrowth at the right.

It is almost as though the artist here took the advice given by Karel van Mander to landscapists in his *Het Schilder Boek* of 1604: 'you must not forget under any circumstances to place small figures next to huge trees. Show them either plowing or mowing, or loading up a cart further away. Elsewhere you may show them in the act of fishing.'

The possibility that the trees are intended to symbolize religious themes, such as the three crosses on Golgotha,

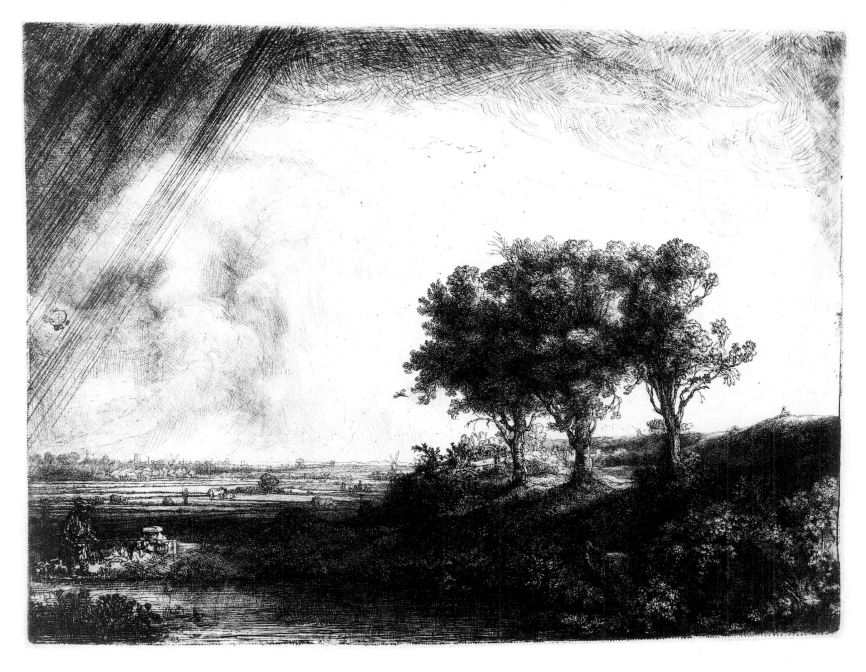

or the Holy Trinity, has been noted many times. The artist however does not force such analogies. It may be that he intended these associations to be made in the mind of the viewer, but the impression of the image which lingers is instead one of the power of nature, as represented by the skyscape, set against the insignificance of humanity.

The Three Trees is exceptional among Rembrandt's landscape etchings for a number of reasons, not least because it is the largest of his works of this type. It also stands out as being what can be described as among the most painterly – the swirling clouds and play on contrasts of light and dark are comparable with some of the effects achieved in his landscapes in oil. The landscape painter Philips Koninck (1619-88) is said to have worked in Rembrandt's studio at about the same time that this etching was executed, and his paintings, with their characteristic distant low horizons and turbulent skies, were clearly inspired by images of this sort.

Lovers also appear hidden in the undergrowth in another landscape etching which the artist executed two years later, called *The Omval* (right). The title of this work refers to a piece of land on a bend of the river Amstel. Rembrandt shows a view across the waterway towards a windmill, houses and moored boats. Closer to the foreground a man wearing a hat scans the river as passengers are rowed across it.

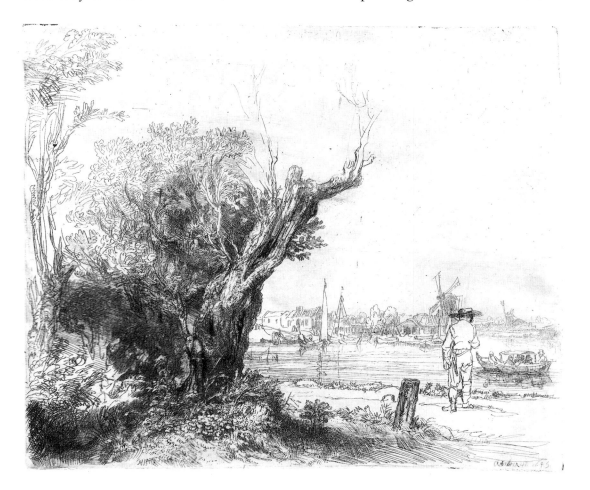

BELOW Rembrandt *The Flute-Player*, 1642,
etching (drypoint) (state 3), 4½ × 5⅝ inches
(11.6 × 14.3 cm), British Museum, London.

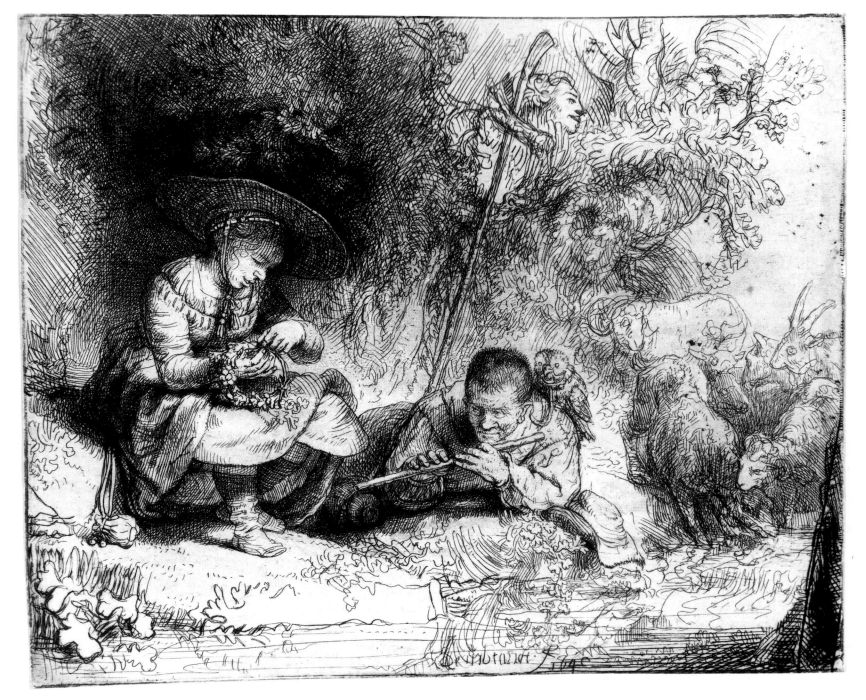

The lovers are hidden amid the foliage at the left; the young man crowns his companion with a wreath of flowers. This act may be intended as a sign of their betrothal (flowers featured prominently in Rembrandt's engagement portrait of Saskia of 1633, page 114).

By contrast the lovers in *The Three Trees* are depicted with a goat near to them. Such animals often symbolize unfettered sexuality, and the placement of one here may be intended to suggest the nature of the relationship between the couple.

Such a theme was explored more explicitly by the artist in another etching of figures in a landscape of this period, which is called *The Flute Player* (above).

In this work a shepherd lies by the water. He is about to take up his flute and appears to be trying to look under the skirts of his female companion. While an owl, a traditional symbol of sinfulness, perches on his shoulder, his sheep and goats frisk about at the right. The woman meanwhile concentrates on making herself a wreath of flowers.

BELOW Rembrandt *A Ditch with Overhanging Bushes*, 1645, black chalk on paper, 5⅝ × 4½ inches (14.5 × 11.5 cm), Library of the Ossolinski Institute of Polish Academy of Arts and Sciences, Wroclaw.

BOTTOM Rembrandt *Landscape with a Fisherman*, c.1652, etching (drypoint), 2½ × 6¾ (6.6 × 17.4 cm), Museum het Rembrandthuis, Amsterdam.

Because of the attitudes of the figures and the symbolism of their attributes this print can be seen as an anti-idyll. Rembrandt seems here to have inverted the tradition of pastoral escapism discussed earlier (see page 118), in order to explore the carnal side of sexuality.

In these works foliage close to water and reflexions in water are a recurrent themes. The artist made drawn studies of such motifs in the open air, which no doubt would have helped inform the establishment of detail in his larger etchings. One of the most attractive sketches of this type is a drawing in black chalk which is dated to 1645 and is now in Poland (right).

Rembrandt continued etching landscapes up until 1653. His *Landscape with a Fisherman* (below) of about 1652 provides a record of the type of buildings and views which peppered the land around Amsterdam, although it is embellished with imaginative touches. At the right large ships can be seen moored near to the shore. A dike along which a man and dog walk runs be-

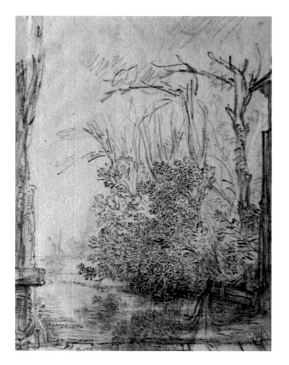

tween the open water and the farmstead at the left.

Again the subject of reflections of foliage in water appears as a preoccupation, and the sky is left blank, as is the case in most of Rembrandt's etchings (with the notable exception of *The Three Trees*). The hills at the far left are imaginary and are only included in the

second state of the etching. This particular picturesque farm is however not invented; it has been identified as one of those on the St Anthoniesdijk, which the artist and some of his pupils also depicted in other drawings and prints.

Some of Rembrandt's most beautiful and economic landscape studies of this period are drawn sketches of specific sites. One of these works, which is placed a little earlier in the chronology of his output, is a sketch that shows a bend in the river Amstel at Kostverloren, south of Amsterdam (page 128). This is one of six drawings by the artist of similar views. It was executed using a reed pen, in brown ink, on paper that had been prepared with a brown wash.

The artist's use of line is far bolder in the foreground and diminishes appropriately when defining forms in the distance. The washed sheet is left in order to denote the sky – in a manner similar to the way in which Rembrandt excluded clouds from most of his etched landscapes. Although the drawing was probably worked on before the motif, its composition appears entirely re-

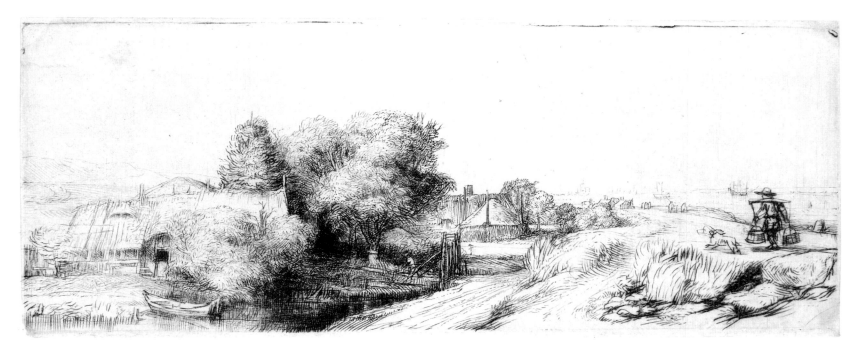

RIGHT Rembrandt *Vue du canal Singel à Amersfoort*, 1650-2, brown ink and wash on paper, 6 × 10⅝ inches (15.2 × 27.7 cm), Cabinet des Dessins, Louvre, Paris.

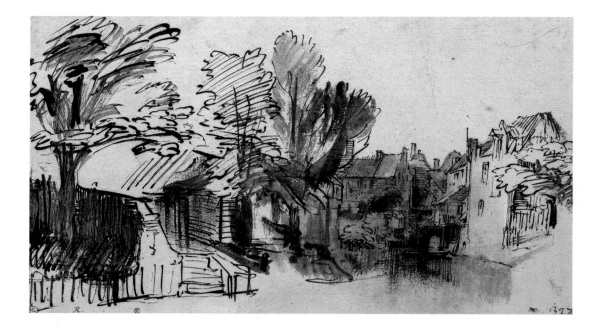

BELOW Rembrandt *A Farm seen through Trees on the Bank of a River*, c.1650-3, reed pen and black ink with gray wash on paper washed brown, 6⅜ × 9⅛ inches (16.2 × 23.4 cm), British Museum, London.

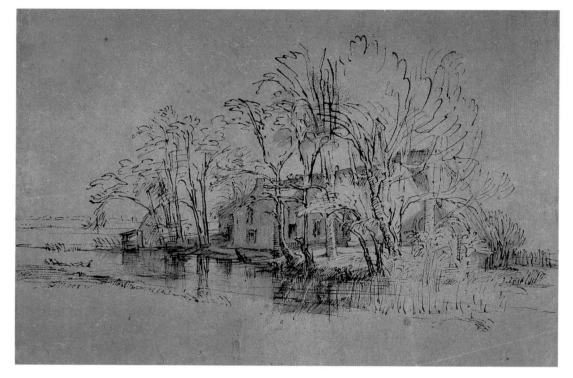

solved – its subject was clearly not simply noted down in passing, but carefully 'selected.'

In another drawing in the British Museum of similar date (above), which is a depiction of an as yet unidentified farm, quite different effects are explored. In this work, which is executed with a thinner and perhaps more rapidly placed line, Rembrandt captured the play of light on a screen of trees that are set before the side of a house in shadow. The wash used on the buildings is drawn down into the water in order to help place their reflections.

A similar approach was also used to depict a canal in a drawing which should really be classified as a town rather than landscape (top). This study of a waterway in Amersfoort, which is between Amsterdam and Utrecht, includes a curious combination of furiously and summarily defined forms in the foreground and more convincingly established buildings further back. The two techniques help establish the spatial relationship between

the foreground and background in a way which reverses the approach used in works such as the depiction of the Amstel at Kostverloren discussed above.

BELOW Rembrandt *Landscape: the Bend in the Amstel at the Kostverloren House, with a Dug-Out in the Foreground*, c.1650, reed pen with brown ink and wash touched with white on prepared paper, 5⅝ × 9½ inches (14.5 × 24.3 cm), British Museum, London.

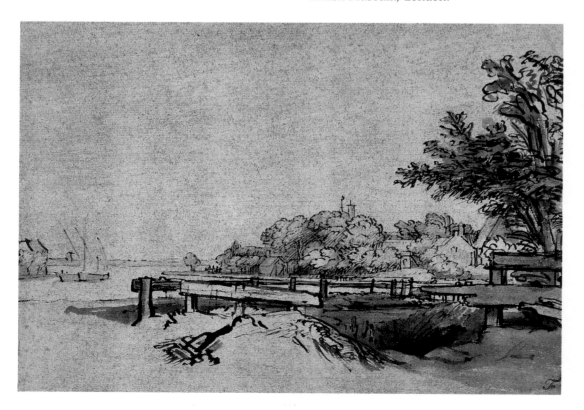

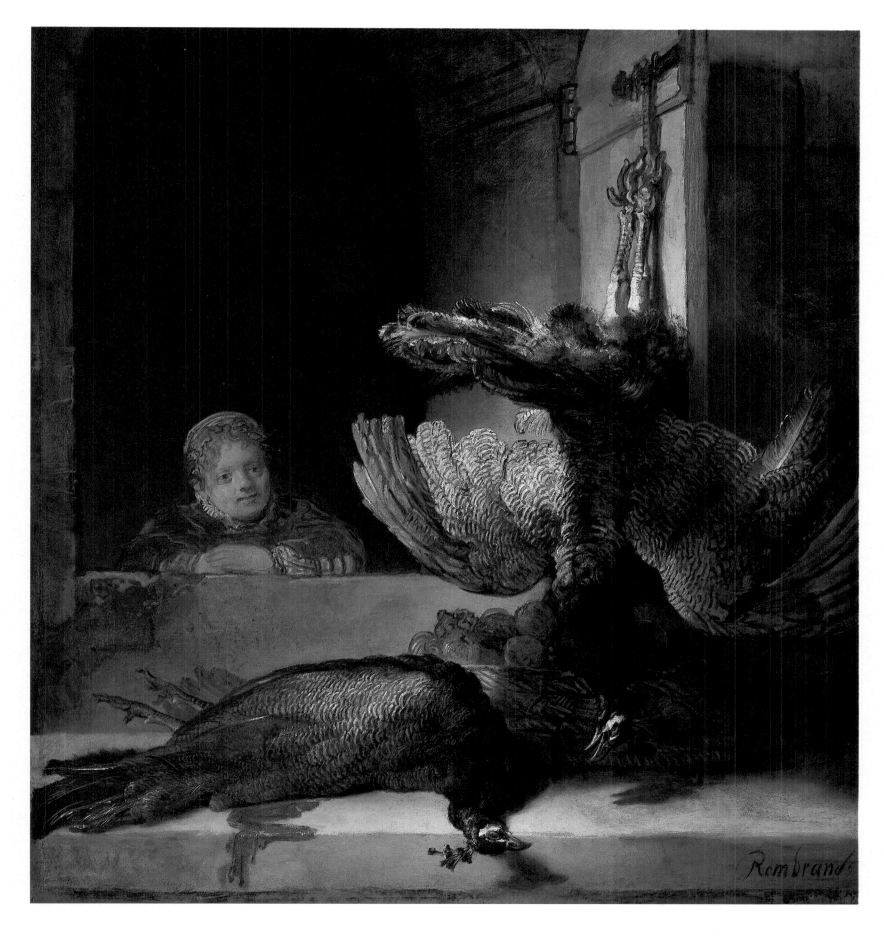

ABOVE Rembrandt *Still Life with Two Dead Peacocks and a Girl*, c.1639, oil on canvas, 56⅝ × 52⅞ inches (145 × 135.5 cm), Rijksmuseum, Amsterdam.

Still Lifes

[The] common footmen in the Army of Art
Samuel van Hoogstraten, 1678

The painting of still lifes (from the Dutch *stilleven*) – arrangements of inanimate objects – was, like landscape painting, another specialization pursued by a number of Rembrandt's contemporaries. As Hoogstraeten's comment suggests, however, such work was according to academic theories the most lowly form of art, coming in the hierarchy of subjects beneath histories, portraits and landscapes. But as was so

often the case in the Netherlands at this period, theory and practice stood some way apart. There was clearly a ready market for still lifes, which when created by painters of the caliber of Willem Kalf (1619-93), for example, can be seen as being among the most accomplished artistic products of the period.

Still life arrangements, like landscapes, had formed a significant part of Rembrandt's history paintings (e.g. on the table in *Belshazzar's Feast*, page 89). But there are very few works by him which can be considered independent pictures of this type. Those which do exist make references to the wider

129

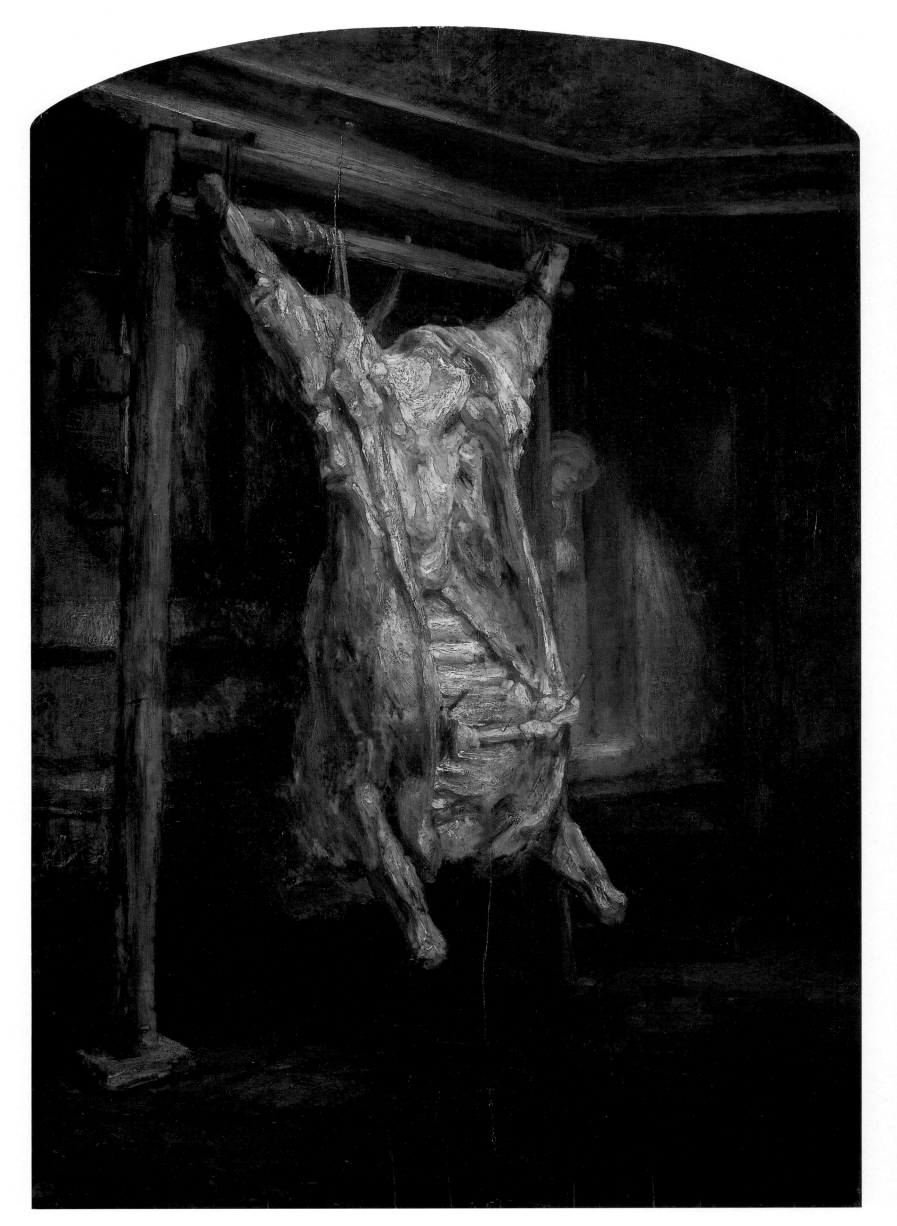

Rembrandt f. 1650.

ABOVE Rembrandt *The Shell (Conus Marmoreus)*, 1650, etching (drypoint and burin) (state 2), 3¾ × 5⅛ inches (9.7 × 13.2 cm), British Museum, London.

LEFT Rembrandt *The Slaughtered Ox*, 1655, oil on wood, 36¾ × 27 inches (94 × 69 cm), Louvre, Paris. '[Rembrandt] took any object, he cared not what, how mean soever in form, color and expression, and from the light and shade which he threw upon it, it came out gorgeous from his hands.' William Hazlitt, 1817.

trends in such imagery – an interest in recording domestic environments and a love of exotic objects.

In *Still Life with Peacocks* (page 129) of about 1639, Rembrandt does not simply make a study of the appearance of the subject, he also explores the way in which the viewer looks at its appearance. A child observes the spectacle, so matching the curiosity of the viewer. The birds are not cosmetically represented – that they are freshly killed is testified to by the pools of blood. These regions of the painting clearly offended nineteenth-century sensibilities, because they were painted over at that time, but recent cleaning has revealed the original look of the work.

Game pieces were a significant category of still-life painting which a number of artists concentrated on producing. Rembrandt here broke free from the hackneyed formulas they repeated, by arranging his subjects with the sort of care he would have employed for figures (x-rays reveal a number of changes were made to the composition), and by lighting the group so as to maximize the variation of textures, colors and tones.

Attempts have been made to extract an underlying theme from this paint-

ing. Some images of this type can be 'read' as reminders of the brevity and transience of mortality (*memento mori* – reminders of death). But the birds may simply be presented here as natural phenomena of considerable beauty, rather than objects which carry a symbolic message. The way in which the shelf in the foreground appears to slope slightly down towards the viewer may suggest that the picture was intended for a particular site, where it was hung at a height which would compensate for this impression.

The idea of mirroring the scrutiny of the viewer with a figure that stares at the object from within the work was one Rembrandt returned to in the mid-1650s when he painted *The Slaughtered Ox* (left). Here a woman peers from the entrance to the stairway at the right of the carcass. Her presence might mean that one could categorize the painting as a genre or everyday scene, rather than a still life, but it is clear that the ox is the focus of attention, and so to discuss it in the context of still-lifes seems most appropriate.

The vigor with which the texture of the flesh and bones has been depicted, the dramatic lighting and the isolation of the subject in this case does suggest

BELOW Rembrandt *The Star of the Kings*, *c*.1645-7, pen with brown ink and wash on paper, 8 × 12⅝ inches (20.4 × 32.3 cm), British Museum, London.

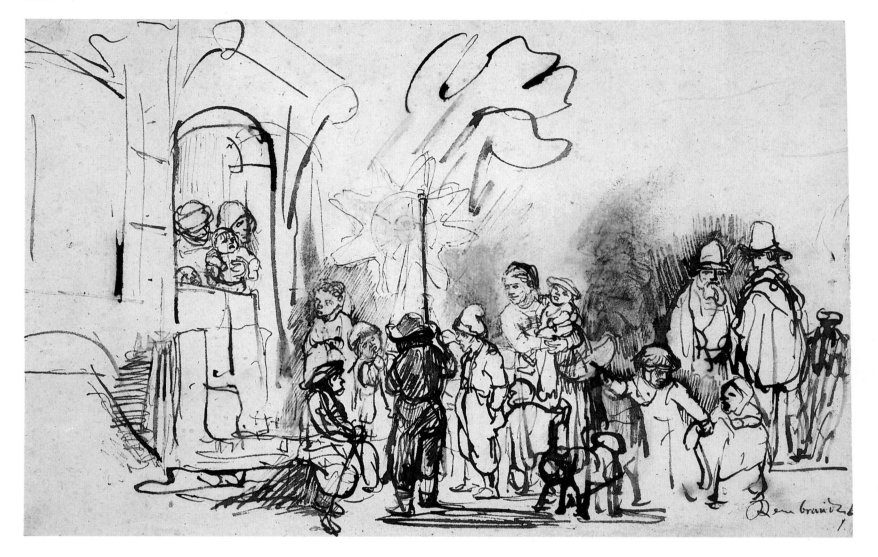

underlying themes. The artist has succeeded in giving an inanimate object emotive force particularly by appealing to our sense of the sacrificial nature of the subject. Much of the power of the image lies in the fact that it is at once repellent and fascinating. A number of contemporaries of Rembrandt painted similar subjects, but their works appear as cold technical exercises which convey nothing of the quiet horror found here. The manner in which this corner of an abattoir or store is considered appropriate for contemplation prefigures the unnerving work of some twentieth-century artists, such as Francis Bacon.

Not all of Rembrandt's still-lifes were

so forceful. His only etched still life is a depiction of a single shell which is as simple as it is beautiful (page 131). Exotic shells from across the globe were considered valuable rarities in the Netherlands in the seventeenth century and were avidly collected. This one, a *Conus marmoreus*, would have been shipped to Europe from the East Indies. The artist's own collection included objects which reflect the wider taste for such things; according to the inventory of it dated to 1656 he owned '23 items of marine and terrestrial fauna; A large quantity of horns, marine plants, casts from life . . . many other curiosities; [and] A large piece of white coral'.

Genre

When the subject of a painting, sketch or print is referred to as a 'genre scene', essentially this means it is drawn from everyday life rather than more lofty literary or historical sources. This umbrella term covers a huge diversity of material – it could describe, for example, a domestic interior, a street scene, or a depiction of an inn. Such images, like landscapes and still-lifes, tended not to form part of Rembrandt's painted output, but they do constitute a not insignificant element of his graphic work, from the early 1630s to the mid 1650s. The artist made a number of studies of beggars, food sellers, itin-

BELOW Rembrandt *The Star of the Kings: a Night Piece*, *c*.1651, etching (drypoint) (only state), 3⅝ × 5⅝ inches (9.4 × 14.3 cm), Museum het Rembrandthuis, Amsterdam.

erant musicians, craftsmen, and animals, which can all be included in this category of work.

Among the most appealing of his creations of this type are two records he made of a traditional children's celebration (left and above). In the Netherlands Epiphany (January 6) was, and is, celebrated by children carrying a star-shaped lantern from house to house at night. The lantern is intended as a reference to the star of the Three Kings, or Magi.

The artist initially made a drawing of this procession in the late 1640s which is now in the British Museum (left). This very attractive sheet shows a number of

children outside a house, beneath a large lantern. Although their expressions are placed with the most cursory of strokes it is still possible to tell that they are variously bored, fascinated and frightened by the spectacle. The adults either look on reassuringly or disapprovingly – as appears to be the case with the two men at the left. The lantern itself seems to have just been pulled down quite rapidly, and leaves an after-image and trail of light behind it against the night sky.

Three or four years later the artist returned to the same subject, but this time etched rather than drew it (above). In this case he was concerned with

lighting effects rather than varied expressions. Densely cross-hatched lines in varying degrees of intensity produce the rich darkness and weak light spreading from the lantern. Over at the left a second lantern can be seen in the distance, and lights from behind shutters on surrounding windows are also visible.

The Later Years, 1642-69

In spite of the unfamiliar spelling of Rembrandt's name it is possible to extract from this testimony by an English traveller a sense of the fame the artist enjoyed at the outset of the decade. Such status was marked by prestigious commissions, of which the so-called *Night Watch* (page 136-37) is the most well known.

The artist continued the financially advantageous practice of taking in pupils. Those painters who passed through his studio early in the 1640s include Abraham Furnerius (c.1628-54), Samuel van Hoogstraten (1627-78), and Carel Fabritius (1622-54).

Such professional success was not however matched by an untroubled private life. The 1640s were years of emotional turmoil and profound losses for Rembrandt. As has been noted, in July 1640 Saskia bore the couple's third child, who was called Cornelia. She did not survive infancy and was buried on August 12. Later in the same year Rembrandt's mother died at the age of 72. She was buried on September 14 in the *Pieterskerk* in Leiden, and her estate was divided between her four surviving children.

Rembrandt and Saskia's only child to reach adulthood, Titus, was born in 1641; he was baptised on 22 September. But Saskia herself died in the following year on 14 June.

Numerous problems are encountered if attempts are made to try and establish links between these personal tragedies and Rembrandt's work, because during this period no marked decline in the quality of his output can be perceived. Nor did he turn to morose subjects which might be seen to reflect a state of melancholy. In fact he was to ingeniously develop existing skills, and evolve new accomplishments. The artist continued to prove himself as a history painter and portraitist, and notably reached unprecedented heights with his landscape and religious etchings, which became ever more technically and aesthetically ambitious.

While busy with such projects Rembrandt needed someone to manage his household and look after his young son, who was only a year old when his mother died. During the second part of the decade he employed a nurse to fulfil the latter role. She was a woman called Geertje Dircx, who was the widow of a ship's trumpeter. Later the biographer Houbraken described her as a 'little farm woman . . . rather small but well made in appearance and plump of body.'

It appears that Geertje became the artist's lover, but their relationship was far from trouble-free; it ended in bitterness, court appearances and her detention in a 'house of correction.' When the couple were living happily together, however, as a token of his affection Rembrandt gave her some jewelry, including a valuable diamond ring that had belonged to Saskia.

In 1649 they split acrimoniously and Geertje was expelled from the house. She then took the artist to court, claiming that he had broken a promise to marry her, and that the ring he had given her was proof of his intent. She eventually secured a settlement because of this rejection, and was granted 160 guilders a year for life, which was considerably more than Rembrandt had offered.

He refused to appear in court and was represented there by a woman called Hendrickje Stoffels (c.1625-63) who was the daughter of a sergeant from Bredevoort. She appears to have joined the household a little earlier also in the role of housekeeper/nurse. Hendrickje, like Geertje, then became the artist's lover. It was probably because of the development of this new liaison that Geertje had to go.

Rembrandt's relationship with Hendrickje was to be more longlasting, sincere and mutually beneficial than that with Geertje. She lived in the house until her death, and although the couple never married, she took on the role of wife in all but name. It has been suggested that they were never wed because Rembrandt would have lost the income from the estate he had inherited from Saskia.

Meanwhile, Geertje continued to create problems for the artist. She pawned the jewelry, and it appears that partly as a result of this the artist managed to build a convincing case against her (probably with the approval of her family), which resulted in her being sentenced to detention for eleven years in a 'house of correction' in Gouda. She was however released, before having completed half of her sentence, and then returned to her home in Waterland.

Like Saskia, it seems that both Geertje and Hendrickje posed as models for Rembrandt. But because there are no documented portrayals of them, identifying likenesses of the two women in his work is extremely problematic.

The Night Watch, 1642

The titles of paintings can sometimes take on a life of their own, and through repeated use become accepted as a reliable description of their contents, however inappropriate they may be. Such is the case with Rembrandt's most famous work, a group portrait of 1642, commonly referred to as 'The Night Watch' (page 136-37). This huge canvas may be one of the artist's greatest

BELOW Rembrandt 'Ledikant', 1646, etching (fourth state), 4⅞ × 8¾ inches (12.5 × 22.4 cm), Bibliothèque Nationale, Paris. Erotic themes become gradually more prominent in Rembrandt's work of the 1640s, and culminate in this unabashed but tender lovemaking scene. Such subjects may tentatively be related to the artist's new relationships with Geertje Dircx and Hendrickje Stoffels which developed during this decade.

achievements, but is certainly not a depiction of a night watch.

It is a depiction of eighteen Amsterdammers who are shown as members of one of the city's militia companies, preparing to march, and walking out into shafts of brilliant sunlight. The nocturnal title appears to have been first used to describe the work in the late eighteenth century. There were probably two reasons for this; at that time patrolling at night was one of the few remaining duties of such companies, and although some areas of the composition are brightly illuminated, many of the shadows are very dark. Before the painting was cleaned recently its dulled appearance gave greater credence to the *Night Watch* label.

Journalists referred to it in its new grime-free state as the *Day Watch*, but this title was unlikely to be accepted because it conveyed nothing of the intimations of danger and perhaps romance, suggested by patroling at night. Other alternatives either appear very cumbersome, or equally inappropriate, and so with reservations Rembrandt scholars tend to retain the familiar misnomer (see Haverkamp-Begemann, 1982).

Having established what the picture is not, it isn't altogether easy to define what it is. It certainly marks the culmination of Rembrandt's experiments with group portraiture; the number of figures, complexity of their arrangement, and dimensions of the work are far more ambitious than anything he had previously tested, or was later to try. But to call it simply a group portrait is in many ways to belittle it. The pageantry, color, and endless interest provided for the viewer by the variety of relationships between the figures, make it appear as though Rembrandt has here created a new form – by rolling group portraiture and history painting into one. Essentially what he seems to have done is to create a group 'historiating portrait', so building on his earlier individual excursions into this field.

There is an appropriateness about such treatment in view of the role – both symbolic and actual – which the militia companies played in early seventeenth-century Dutch culture. Civic guardsmen, as they are also called, defended their towns and constituted the strong arm of the local political leaders within the town, although they increasingly fulfilled a ceremonial function.

Rembrandt *The Company of Frans Banning Cocq Preparing to March Out, known as 'The Night Watch'*, 1642, oil on canvas, 141¾ × 170¾ inches (363 × 437 cm), on loan from the City of Amsterdam to the Rijksmuseum, Amsterdam. This, perhaps Rembrandt's most famous creation, has recently been described by the authors of the Rembrandt *Corpus* (see Bibliography) as a picture which *'stands on a pinnacle of its own . . . [as] the Dutch national painting.'* The artist broke with the orthodox means of representing militia companies (see page 141), and created an animated, colorful and dramatically lit spectacle, that works both as a group portrait and a celebration of civic and militaristic values.

In Amsterdam at this period there were about twenty companies of cross-bowmen, archers and musketeers, each of which came from a different quarter of the city and was comprised of about 200 men. They were a source of pride, and as well as having contemporary significance could be seen in a historical perspective; it was after all through force of arms that the Spaniards had been repelled and independence established. This dual role is referred to in the painting by the way in which Rembrandt dresses and arms his subjects – some are shown with contemporary clothes and weapons, while others wear and carry those of the sixteenth century, which were by 1642 only used for ceremonial purposes.

The particular militia company Rembrandt depicted was one of the Kloveniers. 'Klover' is the name of the firearms they used in the sixteenth century, which were replaced with muskets in the seventeenth.

The arch behind them can be seen either as a reference to the gates of Amsterdam, which they defended, or temporary triumphal arches that were erected when prominent visitors came to to the city. *The Night Watch* has been associated with two such visits – that of Marie de Medici of France in 1638, and Queen Henrietta Maria of England in 1642, but no firm links with either has yet been convincingly found.

The names of the musketeers (or arquebusiers) were recorded, in order of seniority, not long after the work was completed, on the shield attached to the archway in the upper part of the painting. They can be read in translation as follows:

Frans Banning Cocq, Lord of the Manor of
 Purmerlant and Ilpendam, Captain
Willemvan Ruytenburch van Vlaerdingen,
 Lord of the Manor of Vlaerdingen,
 Lieutenant
Jan Visscher Cornelisen, Ensign

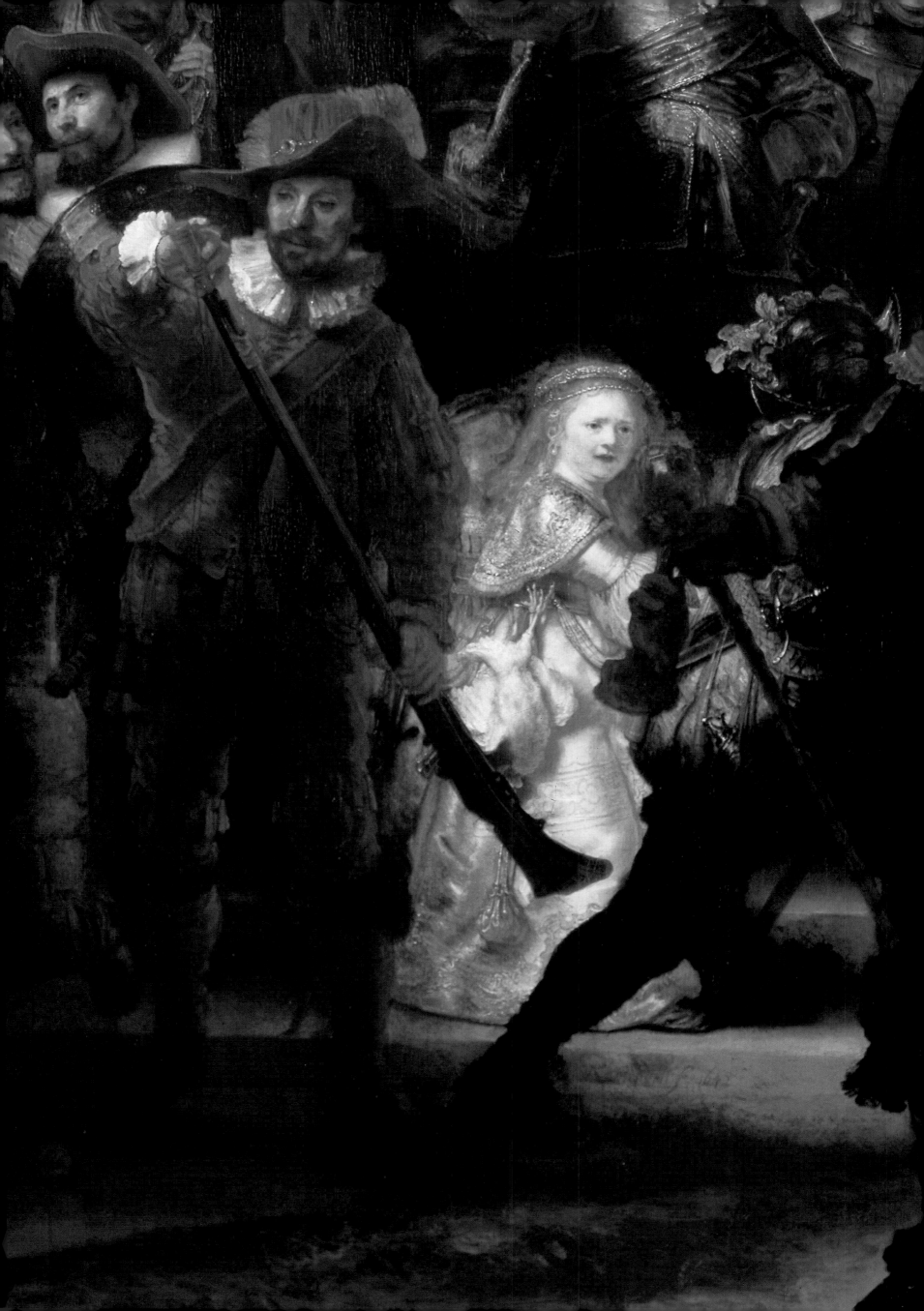

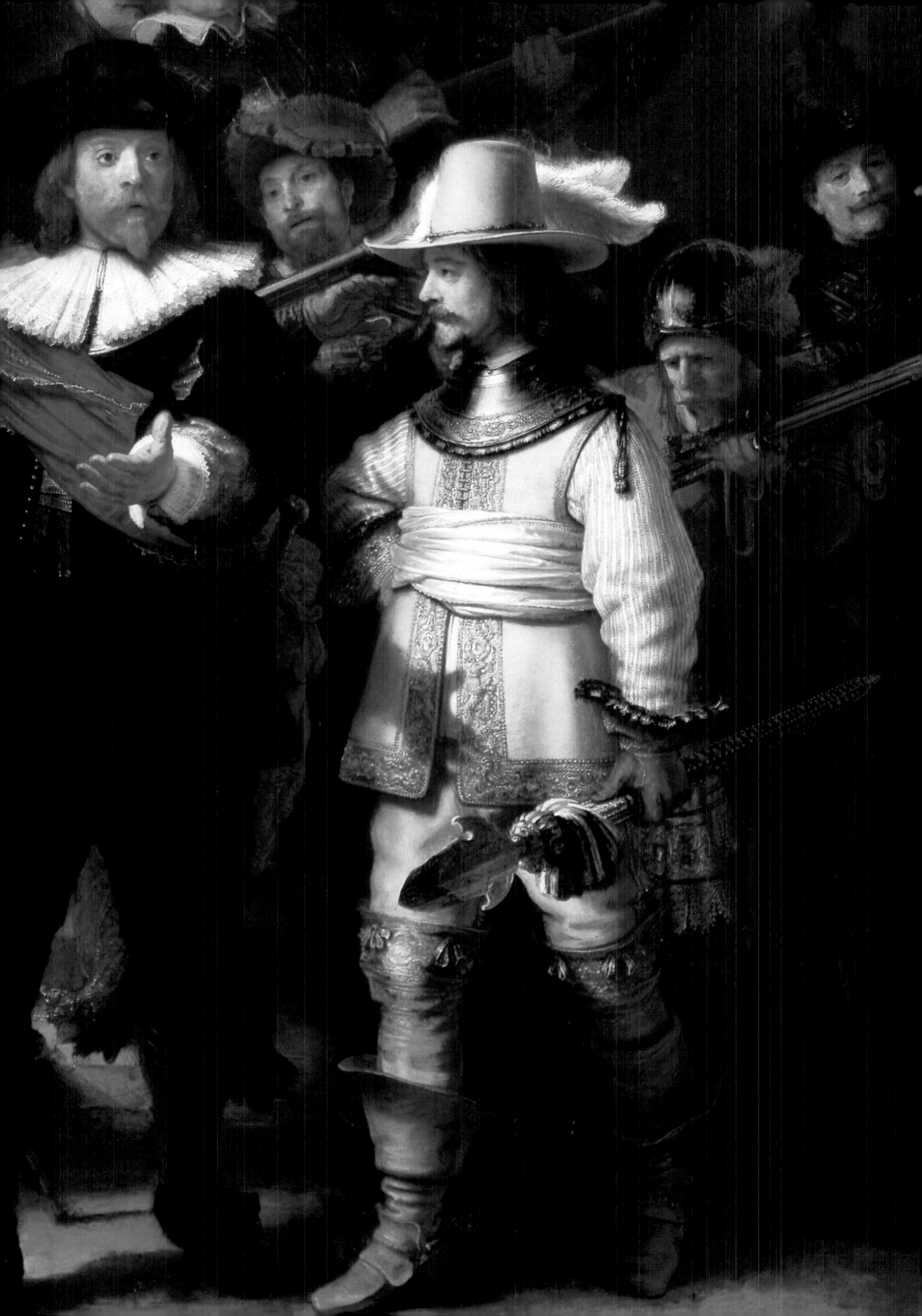

Rombout Kemp, Sergeant
Reinier Engelen, Sergeant
Barent Harmansen
Jrn Adriaensen Keijser
Elbert Willemsen
Jan Clasen Leijdeckers
Jan Ockersen
Jan Pietersen Bronchorst
Harman Iacobson Wormskerk
Jacob Dircksen de Roy
Jan van der Heede
Walich Schellingwou
Jan Brugman
Claes van Cruysbergen
Paulus Schoonhoven

The captain of the company, Frans Banning Cocq, who wears a red sash and black hat, is given prominence in the foreground as the focus of the composition. He was a wealthy citizen who lived in an impressive house built by Hendrick de Keyser, and was later to become a burgomaster. He had a watercolor copy of *The Night Watch* made in a family album, which is dated to about 1650 (on loan from the De Graeff family to the Rijksprentenkabinet, Amsterdam), and the inscription on it suggests that he is here depicted telling his lieutenant, Willem van Ruytenburch, who is magnificently dressed in yellow to the right, to prepare the men to march. Cocq's gesture also seems to invite the viewer to take in the spectacle.

Men prepare their muskets, a drum roll which has started at the right aggravates a dog, a standard is raised by a man on the steps at the rear, and a gun is fired behind the heads of the two principal figures. Almost every element in the painting seems to be moving, but the chaos is controled because the animation is contained within a balanced and unified composition.

As well as the members of the company depicted, a number of other figures also appear. They seem to play quite specific roles which expand the militaristic and flamboyant themes that run through the painting. The figure of this type who has received most attention is the young girl dressed in yellow and set back a little, to the left of the captain. She is brilliantly illuminated, has another child beside her, and counterbalances the splendor of the appearance of the lieutenant. Her face appears curiously knowing, and it has been suggested that she may a dwarf rather than a child. She has a chicken hanging from her waist which has been variously interpreted as either a punning reference to the surname of the captain, Cocq, or as an allusion to the coat-of-arms of the militia company, which included the talons of birds. A third theory posits that the girl may be the company's mascot, and that the bird is some sort of trophy related to a shooting match which is about to commence. None of these readings are explicitly implied, but the peculiarity of the figure does suggest that one, or a combination of them, is tenable.

It is known that children sometimes carried emblems at pageants, and another child, who is perhaps a boy, can be seen running away in the foreground at the left, holding a drinking horn, that might likewise be considered a form of trophy.

A third, apparently symbolic, element of this sort is also worth commenting on. The figure firing the musket behind the captain and lieutenant has oak leaves attached to his helmet. According the writer Van Mander (1616), these can symbolize protection for citizens. If this is what is intended here, then it would be an entirely appropriate ideal in view of the role of the musketeers.

The picture is signed, and dated by Rembrandt to 1642. A work on this scale would have taken some while both to prepare and execute, and it appears that he received the commission for it two years earlier; this has been established because one of the men portrayed, Jan Clasen Leijdeckers, died on 27 December, 1640.

The canvas includes almost the entire repertory of portrait types the artist had previously used: full, three-quarter and bust length, as well as frontal, three-quarter view and profiles. Each of the figures included had to pay individually, and to contribute different amounts, depending on whether they were depicted in full, or partially. Rembrandt's basic price was about 100 florins per individual, which is thought to have been less than they would have had to pay if commissioning a single portrait of themselves. It is likely that the captain and lieutenant contributed considerably more because of their prestigious positions. They may well have had a say in establishing the overall nature of the composition, but can hardly have expected the bravura performance Rembrandt carried off.

The quality of it was apparent to contemporaries, not only because of the merits of the painting itself, but also because of the comparison which could be made with the works it was intended to hang with. *The Night Watch* was painted for a room in the Kloveniersdolen, a building not far from Rembrandt's home at this time, which housed the practice range of the musketeers and served as a meeting place for them. It was to be one of six militia pieces that were executed to complete the decoration of the great hall on the upper floor of a new extension to the building. Other artists who worked on the series included Rembrandt's former pupil Govert Flinck, as well as Joachim von Sandrart (the biographer of Rembrandt), Nicolaes Eliasz., and Bartholomeus van der Helst. The merits of some of their works are considerable, but pale beside those of Rembrandt's contribution. In 1678 another of Rembrandt's pupils, Hoogstraten, wrote:

It is so picturesque in thought, so dashing

BELOW Cornelis Ketel (1548-1616), *The Militia Company of Captain Dirck Jacobsz. Roosecrans*, c.1588, oil on canvas, 81¼ × 160⅛ inches (208 × 410 cm), on loan from the city of Amsterdam to the Rijksmuseum, Amsterdam.

in movement, and so powerful that, according to some, all the other works there stand beside it like playing cards.

The analogy with playing cards effectively conveys something of the formal and regimented nature of many earlier militia pieces, such as Ketel's *The Militia Company of Captain Dirck Jacobsz. Roosecrans* (above), which is dated to about 1588.

It was such a tradition which the creator of *The Night Watch* clearly wanted to break free from. He achieved this in part because he redeployed the operatic effects created with lighting and spatial relationships, developed in his so-called 'baroque' history paintings of the 1630s; but also because to a certain extent he moved beyond them by energizing the composition with constant shifts of tone and color, which mean that the viewer tends to scan it in a restless fashion.

When *The Night Watch* hung in the hall with the other militia pieces it was slightly larger than it appears today. The canvas was cut down in order to fit a new location in 1715, but its dimensions before being reduced in size are recorded, because Gerrit Lundens (1622- c.1683) made an accurate copy of the painting. His work, which belongs to the National Gallery in London, is on long-term loan to the Rijksmuseum in Amsterdam, so it is possible to compare it with its prototype. It is important to remember that the painting as at present seen is dismembered, because in its original state the composition was clearly more successful; the arch appeared virtually in the center of the painting and the figures were not viewed in such a 'close-up' manner – a little more foreground space set them further back, and articulated the sense of forward movement far more effectively.

Just as the title and present dimensions of the painting are deceptive, so are a number of the myths which have grown up around it. One of the most enduring and inaccurate of these is the idea that it was not well received by contemporaries, and that its rejection helps to explain the financial and other problems Rembrandt was to encounter in the following decades. Such an estimation is very convenient, but not borne out by the facts. No negative comments by the sitters survive, and the critical history of the work appears essentially as a litany of praise. Certainly many writers have had problems in defining its merits, but most have considered its power undeniable. Filippo Baldinucci in 1686 described it as a work which 'won [Rembrandt] a great reputation, matched by hardly any painter.'

Many consider that one of the most stimulating and poetic commentaries

ABOVE Rembrandt *Portrait of Agatha Bas*, 1641,
oil on canvas, 41 × 32¾ (105.2 × 83.9 cm), Her
Majesty Queen Elizabeth II, Buckingham
Palace.

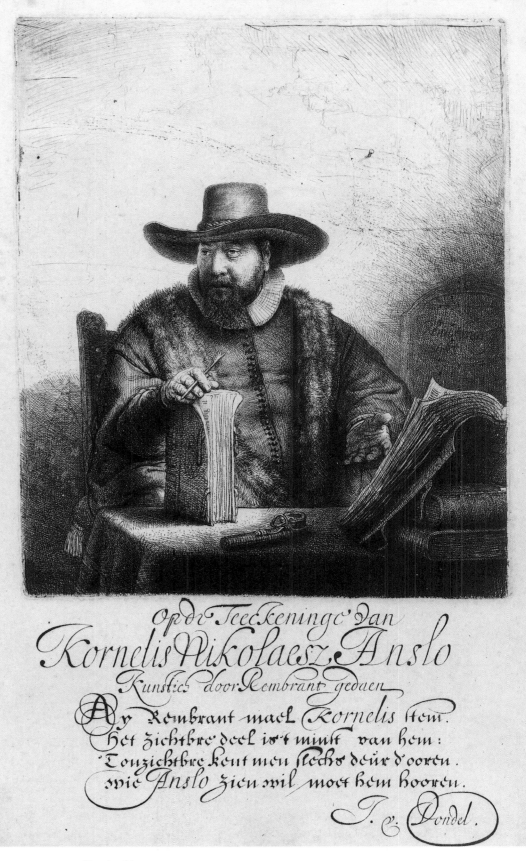

on the painting was written some 200 years after it was executed, by the French critic Eugène Fromentin. His insights provide such a healthy antidote to the desire to fully explain, and as a result over-interpret such a work, that it is worth quoting them extensively:

The Night Watch . . . perhaps . . . would have caused far less emotion if, for the last two centuries, people had not continued the habit of looking for its meaning instead of examining its merits and persisted in the folly of viewing it as a picture which was above all else enigmatic.

Considering the work in its literal sense, what we know of the subject seems to me sufficient. First, we know the names and occupations of the personages . . . and this shows that, while the painter's fantasy has transfigured many things, the basic elements were at any rate taken from real life. We do not know the purpose for which these people are coming out with their weapons . . . but as this is not a very profound mystery, I am sure that if Rembrandt failed to be more explicit, it was because he did not want or did not know how to be more explicit . . .

The only points on which opinion is unanimous, particularly nowadays, are the coloring of the picture, which is described as 'dazzling', 'blinding', 'unheard-of' (you will agree that words of this nature seem calculated to make one disregard them), and the execution, which is generally agreed to be masterly . . .

Chiaroscuro. I come at last to the undeniable interest of the picture . . . No one used it so continuously and ingeniously. It is the mysterious form par excellence, the most shrouded, the most elliptical, the most suggestive, the most capable of surprise to exist in the pictorial vocabulary of artists.

Rembrandt's . . . purpose was this: to illuminate a real scene by a light that was unreal; to endow a historical event with the ideal character of a vision.'

The Masters of Past Time, 1876

Portraiture

The superb quality of Rembrandt's individual portraits which date from the start of the 1640s is most effectively conveyed by his depiction of *Agatha Bas* (left), one of a pair of portraits of a husband and wife (its pendant is in the Koninklijk Museum van Schone, Brussels).

Agatha Bas (1611-58) was the wife of Nicolaes van Bambeeck (1596-1661). He came from Leiden and she was the daughter of an Amsterdam burgomaster. The couple lived on the Sintanthonisbreestraat in Amsterdam in the early 1630s, where Rembrandt had lodged with Hendrick van Uylenburgh, and lived with his wife.

Her depiction is one of Rembrandt's most convincing illusionistic experiments and tender characterizations. The subject is lit by a gentle, warm light which sculpts the planes of her clothes and gently defines the surface of her flesh. Rembrandt replicates the fall of light on skin by building up layers of glazes, through which light partially passes and is reflected back.

The subject is standing and stares directly at the viewer. She doesn't just look into the space of the onlooker, but appears also to be actually entering it. This forward movement is achieved because Rembrandt painted a frame which she rests against with her left hand and passes her fan over. By set-

BELOW Rembrandt *Portrait of the Preacher Cornelis Claesz. Anslo*, 1640, red chalk heightened with white color on colored paper, 6⅛ × 5⅞ inches (15.7 × 14.4 cm), British Museum, London.

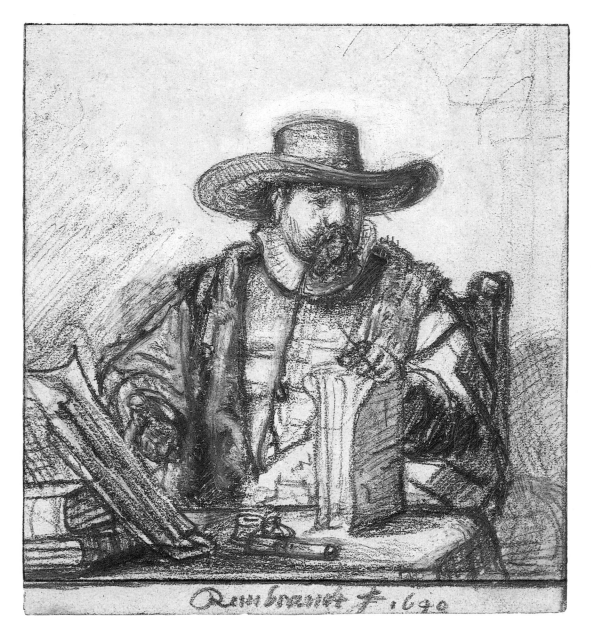

The artist continued to etch portraits during the early 1640s. One of the most interesting of his works of this type is a portrayal of the cloth-merchant and Mennonite minister Cornelis Claesz. Anslo (1592-1546) (page 143). We know something of the way he worked towards producing this image because a preparatory drawing for it survives in the British Museum (left).

The subject was a theologian and he is appropriately depicted as a man of learning in both the drawing and the print, seated at his desk with books and an inkwell and pencase before him. The principles of the composition were established in the drawing, which is executed in red chalk heightened with white, and the paper was indented so that the design could be transferred to the etching plate (as was the case with the *Diana* and *Ecce Homo* prints, pages 101 and 75). The details and textures of the features, clothes and objects were then worked up in a far more precise fashion on the copper plate.

The drawing, which is clearly signed and dated to 1640, may have been shown to the sitter in order to gain his approval before Rembrandt proceeded to work on the etching plate.

The artist also made another, more animated, drawn study of the subject in 1640, which was a preparation for a painted double portrait of Anslo and his wife of the following year (Gemäldegalerie, Berlin). It is surmised that the creation of these new works, in which his gestures are more forceful and eloquent, was prompted in part by a poem by Joost van den Vondel, that is inscribed on the mount of the British Museum drawing:

O Rembrandt, paint Cornelis' voice.
The visible part is the least of him; the invisible is
known only through the ears; he who would
see Anslo must hear him.

ting up a barrier between the fictive space within the work and the actual space before it, and then appearing to break through it, he gives the portrayal a palpable quality of unnerving directness. A similar, although slightly less successful effect, was worked out for the *Self-Portrait at the Age of Thirty-Four* (page 71) of 1640 in which the artist's arm extends beyond the ledge.

For the clothes and accoutrements of Agatha Bas, Rembrandt employed different techniques in order to give an impression of their respective textures and positions in space. Areas such as the fan and brooch at her breast are built up with paint in impasto. This is because they would protrude by comparison with the surrounding flatter areas, which are more smoothly defined, but also means that they reflect the light in more of an eye-catching fashion. Rembrandt is playing on the distinction between the illusion of space and the actual varied texture of the surface of the work; the relationship was to become a progressively important element in his later works.

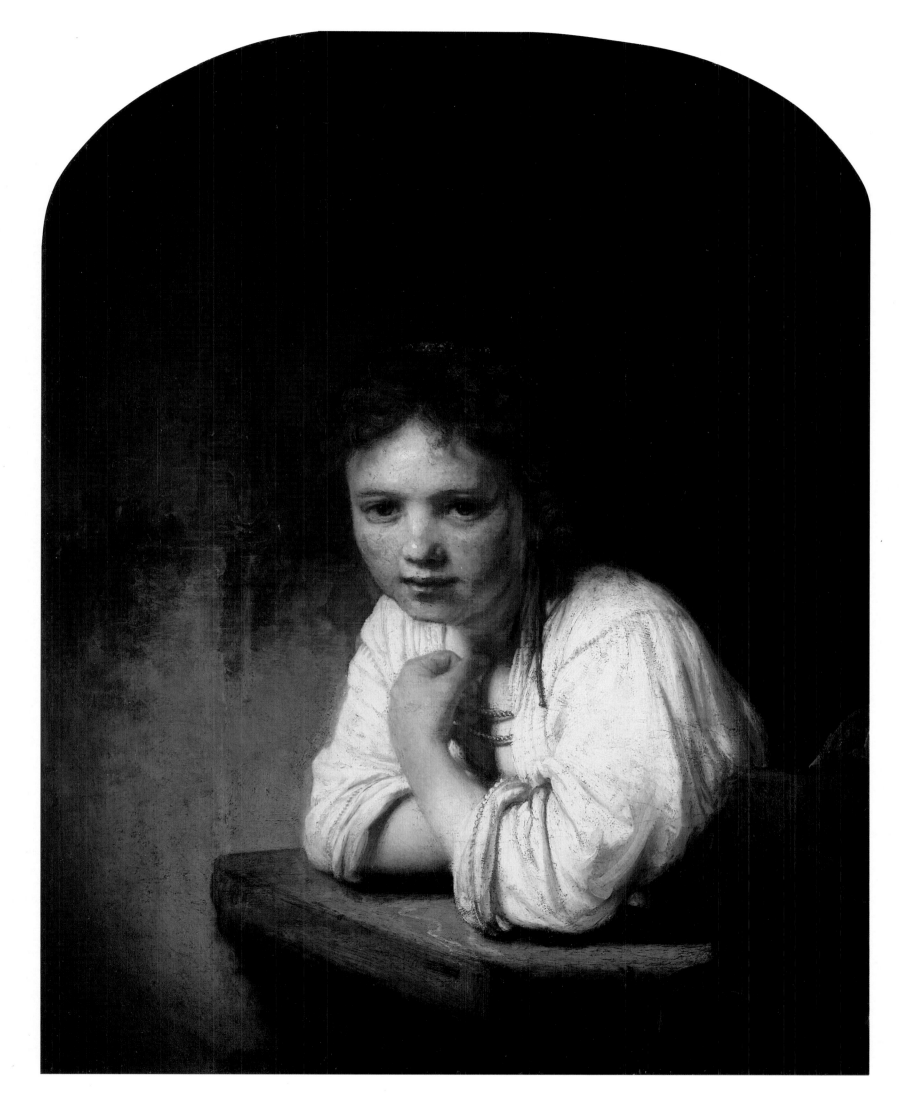

Rembrandt *Girl Leaning on a Windowsill*, 1645,
oil on canvas, 31⅞ × 25¾ inches (81.6 × 66
cm), Dulwich Picture Gallery, London.

This is another illustration of the continuing fascination which subjects from the Apocryphal book of Tobit held for Rembrandt. The composition, which was never converted into an etching or painting, shows the outcome of the help the angel Raphael had given to Tobias. He had enabled him find a means to cure the blindness of his father,

Tobit, and here Tobias is shown operating on him with a knife. Behind, the angel, whose wings are only summarily defined, looks on, and Anna, the wife of Tobit, stares over her son's shoulder. In the foreground at the right Sarah, Tobias's wife, like the viewer, plays the role of wincing spectator.

From the mid-1640s date two half-length studies of women by Rembrandt which cannot be considered as portraits of identified individuals in the sense that the portrayals of Anslo can, but may be depictions of members of the artist's household.

The earlier of these, his *Girl Leaning on a Windowsill* (page 145) of 1645 which is in the Dulwich Picture Gallery, London, is an affectionate depiction of an adolescent, who stares directly at the viewer and out into the light from a darkened interior. Her pose, the way in which she toys abstractedly with the chain around her neck, and the fixity of her gaze, tend to suggest that she is depicted as a daydreamer.

The idea of painting such a moment of reflection in a break from work was later used by the artist for a portrayal of his young son (page 177). Similarly, in other paintings by Rembrandt and his pupils of young women who are dressed as domestic servants (eg. *Girl at a Window*, 1651 by Rembrandt, National Museum, Stockholm, and *Girl at a Window: 'The Daydreamer'*, *c.*1655 by Nicolaes Maes, Rijksmuseum, Amsterdam) the theme of contemplation is explored.

The Dulwich girl appears to be based on a rapid chalk sketch which is now in the collection of the Courtauld Institute, London. The question of her identity has not been satisfactorily settled. The same model is depicted in the work by Rembrandt of 1651 mentioned above. She has been described as Hendrickje Stoffels, but Hendrickje was recorded as being 23 in 1649, and so would have been 19 in 1645 when this work was painted; in other words perhaps as much as five years older than the model appears.

She also cannot be identified as Geertje Dircx, because Geertje likewise would have been much older at this period. It may be instead that the model was simply a kitchenmaid, or young

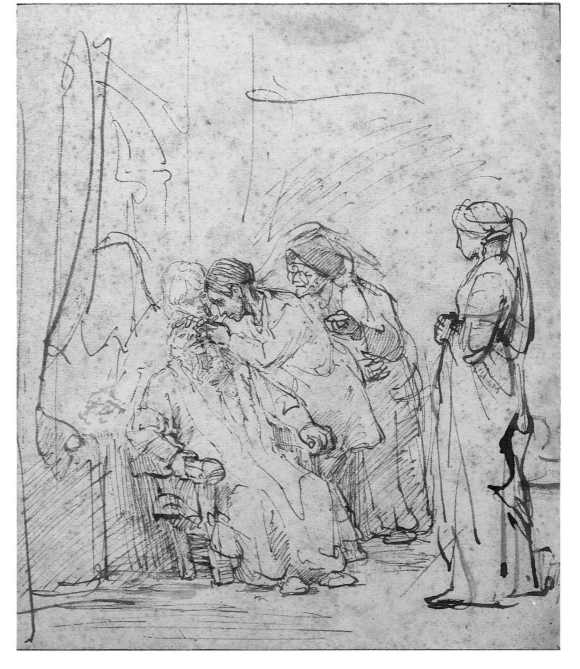

member of the Uylenburgh family that Rembrandt was still in touch with.

The second of these works, which may be dated to the same year, Rembrandt's *Young Woman in Bed* (right) is in the collection of the National Gallery of Scotland in Edinburgh. This different model is older, and may with some justification in this instance be identified as Geertje Dircx, who was a member of Rembrandt's household from about 1643 until 1649.

The unusual context and specific expression of the sitter suggest that it is not simply a portrait, however, but may also be intended as an illustration of a Biblical narrative. The story which has most convincingly been linked with it is that of

Sarah and Tobias from the Apocrypha. If this interpretation is correct, Sarah is here shown watching her bridegroom Tobias, who had vanquished the devil that had killed her seven previous husbands on their wedding nights (Tobit 8, 5: 1-4). Her position in bed, looking across with concern, would appear to support such an identification, but it has to be questioned whether such a subject was appropriate for a depiction of Geertje Dircx, who was a widow.

Her pose is similar to that used in Rembrandt's sensuous and skilful painting of *Danaë* (page 104), a picture which was originally executed in 1636, but reworked at about the same time that *Young Woman in Bed* was produced.

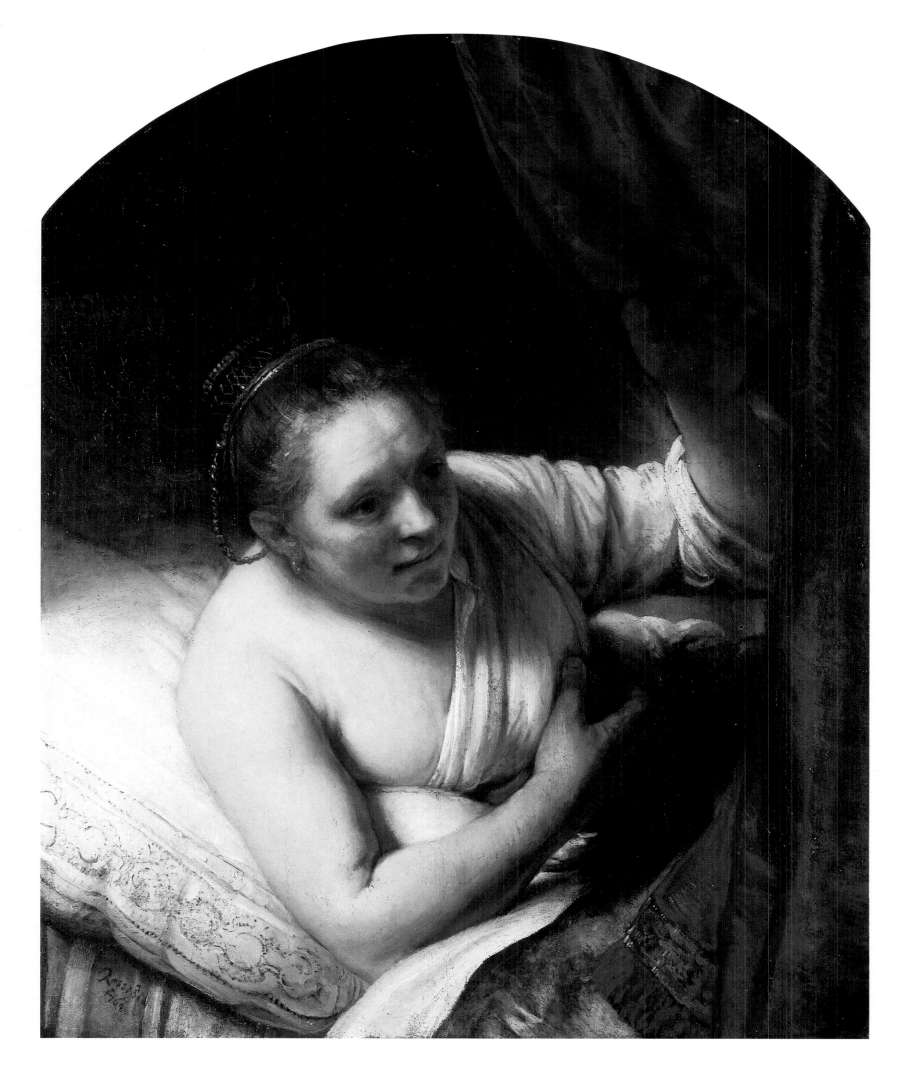

ABOVE Rembrandt *Young Woman in Bed*, c.1647, oil on canvas, 31¾ × 26½ inches (81.3 × 68 cm), The National Gallery of Scotland, Edinburgh.

Rembrandt *Susanna and the Elders*, 1647, oil on wood, 29⅝ × 35½ inches (76 × 91 cm), Staatliche Museen Preussischer Kulturbesitz, Gemäldegalerie, Berlin.

Religion: The Apocrypha

Male voyeurism was a subject Rembrandt explored in his history paintings on a number of occasions (e.g. *Bathsheba*, 1654, page 188). One of the artist's most accomplished explorations of this theme is his *Susanna and the Elders* (right) of 1647, which is now in the Gemäldegalerie, Berlin. This is another work in which Geertje Dircx may have been used as a model for the central figure.

Susanna, whose story is told in the Apocrypha, was the beautiful wife of Joachim. Two elders came upon her while she was bathing and *'their lust was inflamed.'* They told her that unless she slept with them they would say that they had seen her with a young man. The matter was brought to court and Susanna was condemned to death because of the lies of the elders. But Daniel, who was divinely inspired, recognized her innocence, and so the elders themselves were executed instead.

The combination of nudity, morality, and faith made this story a particularly attractive one for many seventeenth-century artists. In Rembrandt's interpretation the elders have emerged from the vegetation. One attempts to remove the towel Susanna draws around herself to hide her nudity, while the other steals up behind. She is vulnerable because her servants have left, and looks imploringly up at a point just above the head of the viewer. To the right are her slippers (beneath which the artist has signed his name) and a gorgeous red gown which is trimmed with gilt. Her pose ultimately derives from classical models, such as the *Venus pudica*, or chaste Venus, who attempts to conceal her sex.

At the left the water of the pool leads to the gardens before Joachim's palace. Susanna's step into the water sends a ripple in that direction which is illum-

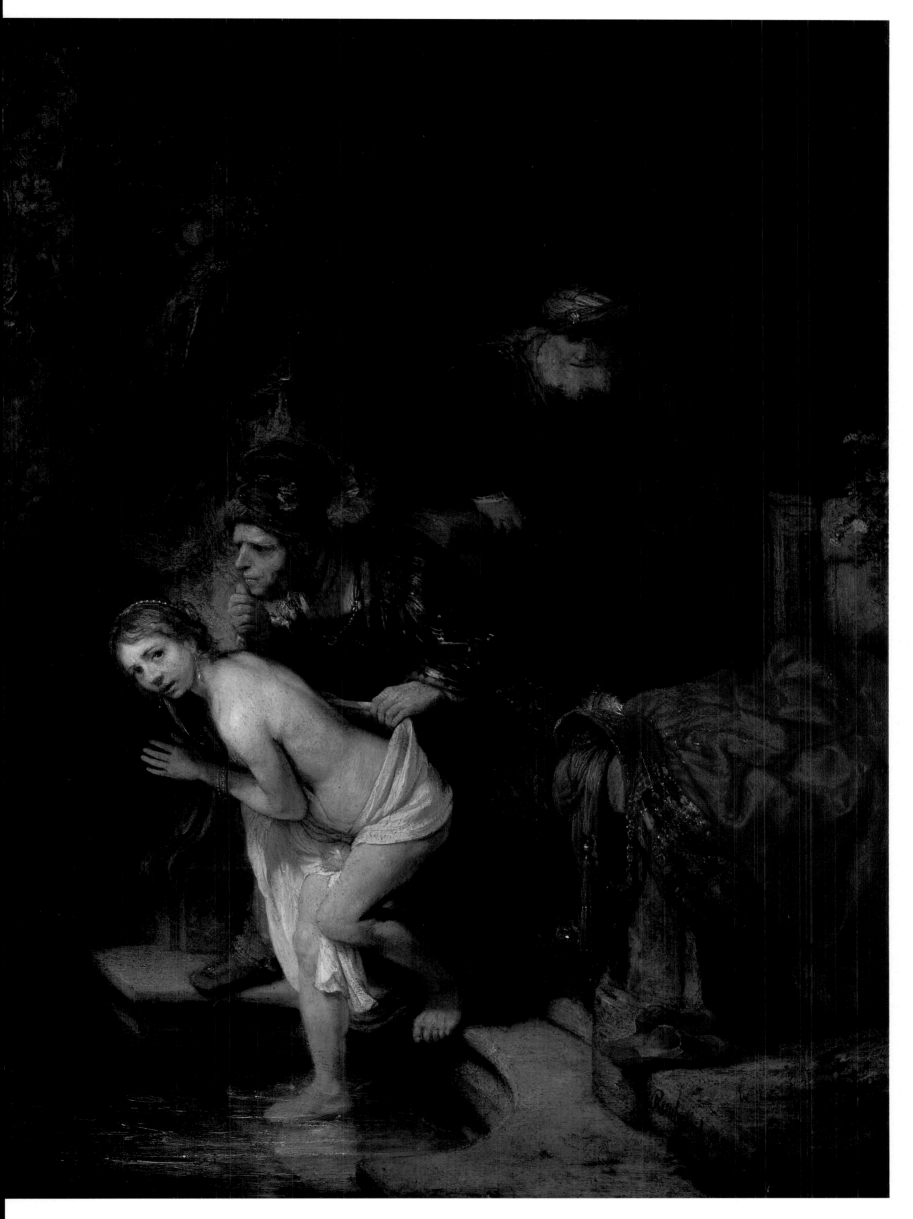

Rembrandt *The Holy Family with a Painted Frame and Curtain*, 1646, oil on wood, 18⅛ × 26⅞ inches (46,5 × 68.8 cm), Gemäldegalerie, Kassel.

nated with yellow light. It is not made clear how the main group are spot lit, but the contrast between them and the darkness at the left is used to effectively emphasize the way in which Susanna is alone with her enemies.

Rembrandt also painted Susanna on a panel dated to 1636 which is now in the Mauritshuis in The Hague. In this smaller work she is similarly posed, but an earlier moment in the story is depicted because the elders have not yet emerged from the bushes. Both The Hague and Berlin paintings are based upon works by Lastman – this homage illustrates the continuing respect Rembrandt maintained for his teacher.

The latter appears to have had a long evolution; x-rays reveal quite a large number of changes that were made to the composition, which are related both to the composition of the earlier painting, and preparatory drawings for the individual figures.

The Holy Family

The depictions of the Holy Family Rembrandt made during the 1640s continued to emphasize the theme of ideal domesticity, which was explored in earlier works of this type (see page 82). With his *The Holy Family with Painted Frame and Curtain* (right) of 1646, he additionally explored aspects of the fictive nature of painting, and the ways in which works of art were normally displayed at this time.

In this picture the seated Virgin holds the Christ Child before a bed, beside his crib. Her naked feet are warmed by a small fire which is also enjoyed by a cat. In the background at the right Saint Joseph can be seen cutting wood, either for fuel or his carpentry.

The painted frame and curtain serve a number of different functions. Essentially they are a witty piece of deception intended to fool the viewer. The highlights on the frame's lower edge, and

BELOW Rembrandt *The Holy Family in the Carpenter's Workshop*, c.1645, pen with brown ink and wash touched with white on paper, 7⅛ × 9⅝ inches (18.4 × 24.6 cm), British Museum, London.

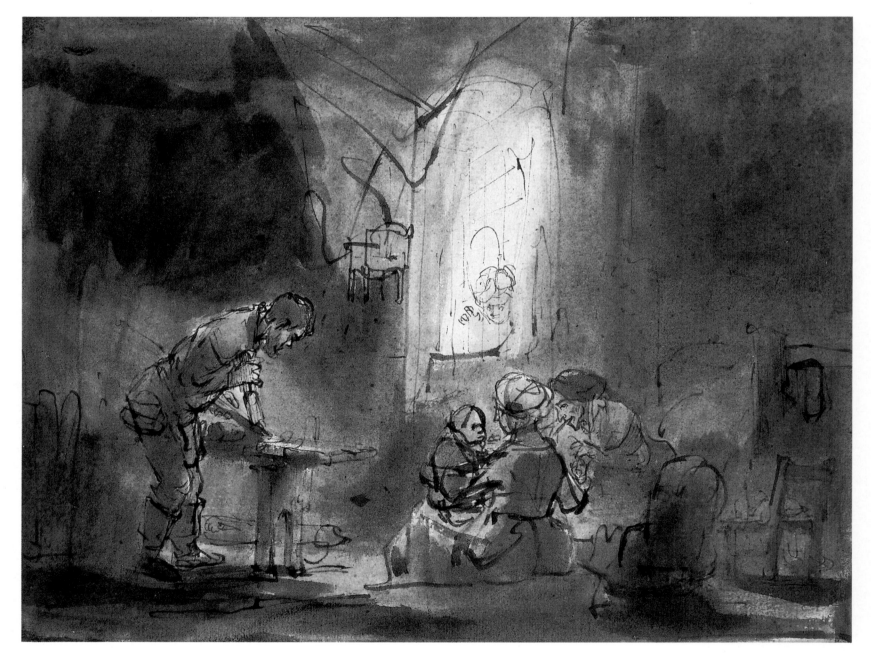

the way in which the curtain appears to have just been swung back, are convincingly defined.

The structure itself is of a type which Rembrandt clearly intended some of his works to be contained within (it can be compared, for example, with his drawing of a frame for *John the Baptist Preaching*, page 77).

The idea of protecting a valued work of art with a curtain appears to have been quite common in the seventeenth century (see the curtain before a painting in the background of the artist's etching of Jan Six, of 1647, page 166). Although the fictive arrangement depicted here is something of a novelty within Rembrandt's own work, it is by no means unique – other artists such as Vermeer and Maes painted such curtains, which have the peculiar effect of both drawing the viewer's attention to the image, and implying that a moment of great privacy has been revealed.

Such an impression is also given by a drawing of a related subject that was probably executed about a year earlier (above). It would be easy to mistake this depiction of the Holy Family for one of any other family, but the prominence of the carpenter (Saint Joseph) and links with other works by the artist suggest the identification of the subject. The Virgin is seated with the Christ Child on her lap and Anna beside her, while the woman tapping

BELOW Rembrandt *The Virgin and Child with the Snake*, 1654, etching (only state), 3¾ × 5⅝ inches (9.5 × 14.5 cm), British Museum, London.

on the window in the background may be Saint Elizabeth. The gloom of the interior, which is broken by the light from the window, is conveyed with an extensive use of wash. It gives a fairly 'finished' appearance to a figure group which appears to have been extremely sketchily defined.

The idea of showing a figure staring in through a window at the Holy Family was used again by Rembrandt in the following decade in his *The Virgin and Child with the Snake* (below) of 1654.

Here it is Saint Joseph who peers through the window into a room, which in terms of layout can be com-

pared with that in the artist's Kassel painting (page 150). The oval pane of glass in the window ingeniously doubles up as a halo for the Virgin. At her feet a snake can be seen emerging, and at the left a cat sits by the chair; these two details can both be read as symbols of sinfulness. The serpent is a reference to the Fall in the Garden of Eden, and in this context implies that the Virgin is the second Eve who will overcome Original Sin. Such a subject is notably found in Catholic works of art, and may imply that this print, like others by the artist (for example that on page 100), was intended for the catholic market.

The group of mother and son was inspired by a print of them made by the Italian artist Mantegna (*c.*1431-1506) (page 154). Works by him clearly formed a valued part of Rembrandt's own collection; according to an inventory of 1656 he owned 'The precious book of Andrea Mantegna,' which was presumably a bound volume of prints and drawings.

In the Mantegna, and Rembrandt's reinterpretation of it, the Virgin is seated on the floor. This type of representation is called a 'madonna of humility' because in such a position she illustrates her humanity, as opposed to her regality and divinity – aspects of her

LEFT Andrea Mantegna (c.1431-1506), *Virgin and Child*, engraving, 13½ × 10⅜ inches (34.5 × 26.6 cm), British Museum, London.

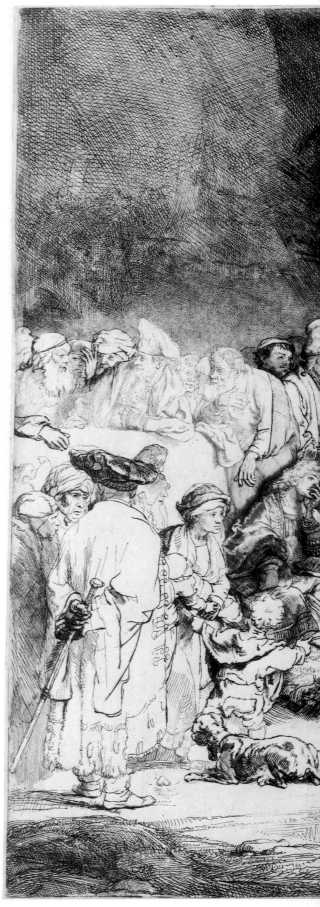

status that are emphasized in images which show her enthroned.

Humility in this sense seems to be a theme that runs through almost all Rembrandt's depictions of the Holy Family. In his work they are rarely thought of as distanced archetypes, but are instead far more often conceived as humble, hardworking, and easily identifiable with.

Christ's Ministry

That a work of art could be known by a title which is simply a description of its monetary value may seem odd, but such has been the case since the early eighteenth century for Rembrandt's so-called *'Hundred Guilder Print'* (right). Exactly how this masterly evocation of a number of episodes from Christ's ministry came to be named in this way is not entirely clear. According to one, probably entirely fanciful, story it acquired this peculiar label because Rembrandt himself had to pay one hundred guilders in order to buy back a copy of it.

What is clear is that the name conveys something of the nature of the esteem Rembrandt's graphic work enjoyed. The artist's etchings soon became valued collector's items, which were frequently copied.

Why this should have been the case becomes apparent once the technical mastery, emotional input and ingenious use of sources Rembrandt employed in *The Hundred Guilder Print* are outlined. It is not a depiction of a single event, but a drawing together of a number of incidents that are described in the Gospel of Saint Matthew. Christ is the focus of the composition and the link between the different episodes, the first of which is the arrival of the sick to be healed by him, which is enacted in the foreground at the right (Matthew 19: 1-2).

This incident is followed in the narrative by a description of the debate that Jesus had with the Pharisees about marriage (19: 3-12). Rembrandt has grouped the Pharisees at the left and placed before them mothers who bring their small children and babies to Christ (19: 13-14).

The rich youth who sought eternal life kneels before Jesus, right of center. He was told that he ought to give all his

BELOW Rembrandt, *Christ Preaching ('The Hundred Guilder Print')*, c.1643-9, etching (burin and drypoint) (state 1), 10⅞ × 15⅛ inches (27.8 × 38.8 cm), British Museum, London.

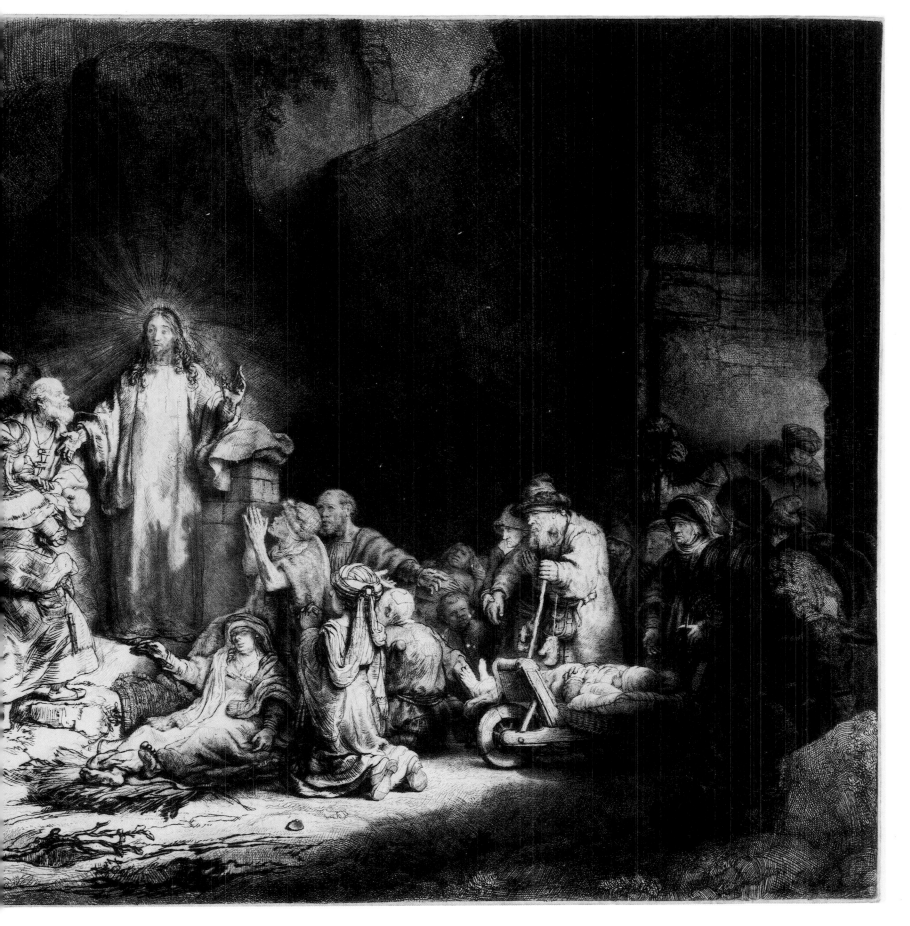

money to the poor and that it was easier for a camel to pass through the eye of a needle than for a rich man to enter the Kingdom of Heaven (19: 16-26). The camel under the archway at the left is presumably intended as an allusion to this statement.

The complex stage management required to integrate these different elements into a legible whole was a feat of considerable ingenuity. Within each group there are figures who illicit sympathy, empathy and curiosity from the viewer. Above them all rises the figure of Christ, who is isolated both by his exaggerated stature, and his brilliance before the dark backdrop.

The lighting effects across the work vary considerably, including as they do different degrees of natural and supernatural illumination. They tend to alter not only thematically, but also in accordance with the differing techniques the artist used – etching, drypoint and burin (see Appendix 1).

It is thought that the print was completed in about 1647-49 and may have been started some considerable time earlier. There are a number of thematic and compositional associations between it and some of the artist's paintings of the mid 1640s, such as his *Woman Taken in Adultery* (page 157), National Gallery, London.

The stature of Christ is also emphasized in this work, so that he has a commanding position above all the figures. At the right can be seen the altar with a high priest seated before it, and in the foreground are the Pharisees and Scribes who have brought the adulterous woman before Christ. She kneels tearful on the steps awaiting her fate, while Christ stares benevolently down at her.

They say unto him, Master, this woman was taken in adultery, the very act.

Now Moses in the law commanded us, that such should be stoned: but what sayest thou ?

. . . when they continued asking him, he lifted himself up, and said unto them, He that is without sin among you, let him first cast a stone at her . . .

Then spake Jesus again unto them, saying, I am the light of the world: he that followeth me shall not walk in darkness, but shall have the light of life.

(John 8: 3-7)

The precise moment depicted would appear to be that at which the woman is presented to Christ – 'Master, this woman was taken in adultery'. She is pointed out by the bearded man in black.

The nature of the lighting, which is brilliant, clearly directed and links the woman and Christ, can perhaps be seen as a reference to Jesus's role as *'the light of the world'*, and the salvation the woman is offered. This can be contrasted symbolically with the darkness which envelops most of the other figures.

The painting is signed in the bottom right: *Rembrandt.f.1644*. In spite of such a date the work displays a number of characteristics of the artist's paintings from the previous decade; the type of architecture, attention to detail and quality of *chiaroscuro* lie close to paintings such as *The Song of Simeon* (page 55), of 1631. This similarity is all the more extraordinary once it is considered how different other paintings by Rembrandt of the mid-1640s are. The disparity suggests that the artist's stylistic evolution did not take place in a wholly even and logical way, and that he was able to alter his approach to suit the demands of the subject in question. What distinguishes *The Woman Taken in Adultery* as a work of the 1640s, however, is the figure style and rich color scheme.

It has been suggested that the design on the ornate altar may have been inspired by contemporary Dutch silverware, such as that which was worked by Joannes Lutma (1584-1669), of whom Rembrandt etched a portrait in 1656.

The work is executed on a thick oak panel, which may originally have been rectangular. The main group of figures is defined in considerable detail with quite thickly applied paint. They can be contrasted with the figures set further back in space and the architecture – areas which are established in a thinner and more cursory manner, with the priming being allowed to show through.

1650s

While the 1640s were a period of private loss and turmoil for Rembrandt, the following decade was one of public humiliation brought on by financial difficulties and personal ties.

Signs of financial problems began to develop in 1650, and worsened over the next five years. Three factors seem to have contributed particularly to Rembrandt's misfortunes. The period was one of general economic depression brought on by the First Anglo-Dutch war, and this situation was aggravated personally for the artist by the way in which he had made unwise investments and had overstretched his resources.

There is some evidence to suggest that Rembrandt had lost money in a shipping enterprise he had hoped to profit from which failed. He was living in a large home that had not been fully paid for, and had amassed an impressive art collection, which included prints, drawings, paintings and exotic imported objects. Saskia's family had made it known that they felt Rembrandt was squandering the inheritance of Titus. But it appears that the artist continued collecting, and dealing on the side, being single-minded to the point of obstinacy in this as in so many of his other activities.

BELOW Rembrandt *The Woman Taken in Adultery*, oil on wood, 32½ × 25⅛ inches (83.3 × 64.4 cm), The National Gallery, London.

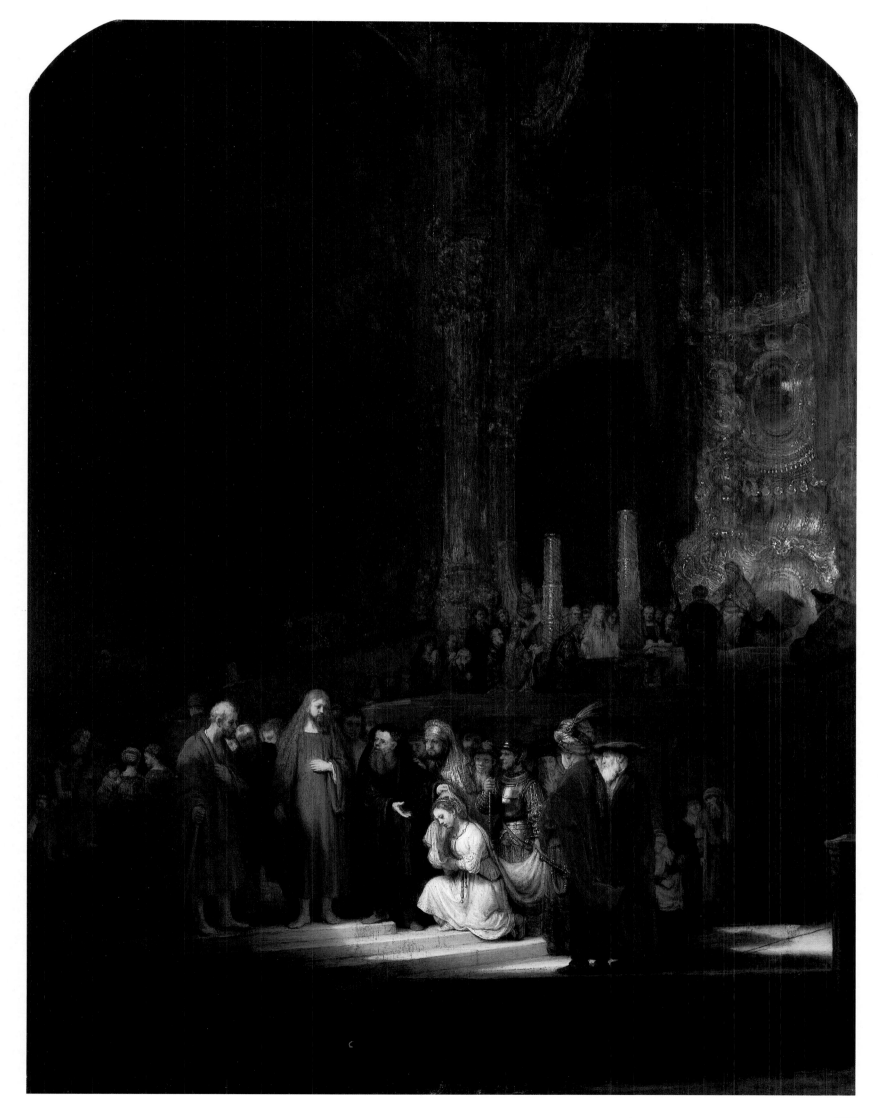

RIGHT *The Official Announcement of the Sale of Rembrandt's Goods*, 1658, poster, 76⅛ × 66½ inches (195 × 170 cm), British Museum, London.

DE Curateur over den Insol=
venten Boedel van Rembrant van Rijn / konstigh
Schilder / sal / als by de E. E Heeren Commissari=
sen der Desolate Boedelen hier ter Stede daer toe ge=
authoriseert / by Executie verkopen de vordere Papier
Kunst onder den selven Boedel als noch berustende /
bestaende inde Konst van verscheyden der voornaemste so Italiaensche /
Fransche / Duytsche ende Nederlandtsche Meesters / ende by den selven
Rembrant van Rijn met een groote curieusheyt te samen versamelt.

Gelijck dan mede een goede partye van
Teeckeningen ende Schetsen vanden selven Rembrant van Rijn selven

De verkopinge sal wesen ten daeghe /
ure ende Jaere als boven / ten huyse van
Barent Jansz Schuurman / Waert in
de Keysers Kroon / inde Kalver straet /
daer de verkopinge voor desen is geweest.

Segget voort.

In 1653 he organized to pay the 8470 guilders he still had to provide in order to buy his house, but raised this capital by borrowing money, and so shifted rather than removed the debt.

In the following year the nature of his unmarried relationship with Hendrickje Stoffels entered the public domain in a dramatic way. She was summoned before a council of the Reformed Church in Amsterdam, described by it as 'living like a whore', and banned from celebrating communion. Because there is no record of the Church castigating Rembrandt, it can be assumed that while Hendrickje regularly attended services, he was not considered a member of the Calvinist community.

The couple remained together in spite of this condemnation. Hendrickje stood by the artist and played a key role in helping him cope with his financial difficulties, which were becoming ever more acute. In October of 1654 she gave birth to their only child, a little girl called Cornelia.

In 1655 Rembrandt attempted to buy a cheaper house, and started to sell off some of his possessions to enable him to raise money for this acquisition and settle his debts at the same time. His goods were sold at seven sales which were mainly held at the end of the year in an inn called the Keizerskroon which was used as an auction house. Unfortunately no record of which objects or assets Rembrandt decided to part with has survived.

He did not succeed in buying the new house, or sorting out his debts, so tried to make one final bid to save the family home. In May of the following year he transferred the title for it to his young son, Titus.

This move however only delayed what was perhaps by now inevitable. In July of 1656 Rembrandt was compelled to apply for a voluntary form of bankruptcy, called a *cessio bonorum*.

This meant that he avoided the imprisonment that could face debtors, as long as he declared all of his debts and assets before a tribunal, and gave an explanation of how he had reached this position. The artist followed this procedure and was subsequently allowed freedom to work, but could only keep earnings which would enable him to look after his family.

After this climax to a spiral of problems, the winding up of Rembrandt's case was to slowly run on into the next decade. It was only in 1661 that he was finally recognized by the Court of Insolvency as having met all his obligations.

Earlier the Receiver had drawn up an inventory of the contents of the artist's house, with a view to disposing of it at auction. The first sale took place in December of 1657, and the rest of the property was auctioned in the following year. The inventory provides an invaluable record both of the artist's collection and the furnishings and utensils which made up the physical side of his domestic life. It gives a very evocative impression of the nature of his surroundings, even though it only records

part of his possessions, because he had already sold some of them in 1655-66.

Rembrandt's belongings are grouped in the inventory according to the rooms in which they were kept. By following the list it is possible to make an imaginary tour of the house, which involves walking through the entrance hall, anteroom, and room behind this, as well as the back parlour (or salon), the art gallery, its anteroom, the small studio which was divided into five compartments, the large studio, the storage room for the studios, the office, the small kitchen, and finally another corridor. The items in these rooms included a large number of paintings, 58 of which are described as being either by, or touched up by, Rembrandt. The list includes a further 55 pictures by other named artists, such as Brouwer, Lievens, Lastman, Raphael and Bassano, and numerous portfolios of drawings and prints, by men ranging from Dürer and Cranach, to Barocci and Mantegna. This extraordinary diversity reflects the breadth of Rembrandt's taste, and goes some way to explaining how he was able to draw on such a variety of sources.

BELOW Rembrandt *'Faust'*, *c.*1652, etching (drypoint and burin), 8¼ × 6¼ inches (21.0 × 16.0 cm), British Museum, London. Inscribed with an anagram which reads in concentric circles from the centre out: INRI + ADAM + TE + DAGERAM + AMRTET + ALGAR + ALGASTNA + +. The title given here has been used since the 1730s. It is however by no means clear that Rembrandt intended to depict Faust – the doctor who according to legend sold his soul to the devil in return for a life of magic. The associations with this subject have nevertheless continued because some have seen links between the print and Marlowe's play about Faustus, and Goethe had a copy of it engraved as the titlepage for his own *Faust*. The key to the subject would seem to lie in the miraculous anagram which is depicted beside a mirror-like object that a hand points to. The same inscription has been found on amulets, but a precise interpretation of it so far eludes scholars.

The inventory additionally includes a heady mixture of exotic and valuable imports, which decorated the house and could have been used in the studio. These range from Venetian glass and pieces of armor, to musical instruments, porcelain figures, items of clothing and examples of classical statuary.

For a man who was clearly something of a compulsive collector, to see all of these things sold must have been very painful. To add insult to injury the house in the Sintanthonisbreestraat was auctioned on the 1st of February 1658 for 11,218 guilders, which was nearly 2000 fewer than he had agreed to pay for it in 1639.

As was the case when the artist suffered personal losses in the 1640s, however, the troubles he endured in this decade do not appear to have had a disastrous effect either on his skills as an artist, or opportunities for work. If anything his reputation could be said to have been enhanced by the works he produced. These include a brilliant depiction of a philosopher which was painted for a Sicilian aristocrat (page 160), another group portrait of Amsterdam surgeons (page 178), some of his very finest single portraits and history paintings (page 169), and the crowning achievements in his career as a printmaker (pages 182 and 184).

Amid the adverse conditions of his external life, as marked by bankruptcy and the church's condemnation of Hendrickje, Rembrandt seems to have found what can only be described as a haven of serenity within his work. His compositions become increasingly simplified and take on a new-found grandeur. This shift in emphasis, which is particularly noticeable in a number of his later paintings, means that he had moved far beyond the physical drama of his juvenalia – to studies of greater psychological depth and profundity.

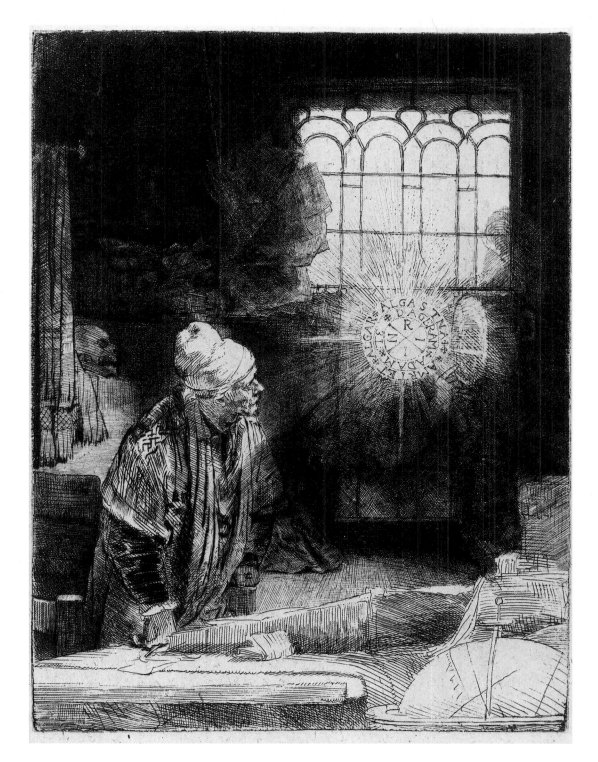

Rembrandt *Aristotle Contemplating the Bust of Homer*, 1653, oil on canvas, 55⅞ × 53¼ inches (143 × 136 cm), The Metropolitan Museum of Art, New York. This is the first painting Rembrandt executed for his Sicilian patron Don Antonio Ruffo. The philosopher Aristotle is depicted contemplating a bust of the poet Homer, whom he held in deep admiration. He wears around his neck a medallion on which is a portrait of his pupil, Alexander the Great.

A European Reputation

I sincerely esteem [Rembrandt] a great virtuoso.

Il Guercino, Bologna, 13 June 1660

No incidents perhaps convey more effectively how Rembrandt's reputation grew at this period, despite his financial problems, than the commissions he received from the aristocrat Don Antonio Ruffo (1610-78), who lived in Messina on Sicily. That such patronage should have been forthcoming illustrates the geographical extent of the artist's reputation, which had to a great extent been disseminated because of the distribution of his etchings.

Ruffo was a rich connoisseur, who by the mid-century had nearly 175 oil paintings in his collection. It mainly consisted of works by contemporary Italians, but also included paintings by Dürer, Lucas van Leyden, Jordaens and Van Dyck. He wanted to add a painting by Rembrandt, but appears not to have felt the need to precisely specify its subject, apart from stating that he wanted 'a philosopher'.

It may be that the type of image he had in mind was suggested by an etching Rembrandt had made in about 1652 of a figure in a study being confronted by an apparently miraculous vision (page 159). This work, which is now commonly known as 'Faust', could be a depiction of an alchemist, a cabalist, a scholar or a philosopher.

The painting the artist delivered to Ruffo in 1653, which is now called *Aristotle Contemplating the Bust of Homer* (right), can be broadly related to the *Faust* precedent in terms of the pose of the subject, but remains one of Rembrandt's most original creations.

The philosopher Aristotle (384-322 BC) is here shown as an ostentatiously dressed figure wearing a large gold chain and broad dark hat. He rests his hand upon a marble bust of the epic poet Homer. Attached to his chain is a medallion which has on it a depiction of his pupil Alexander the Great. In his *Poetics* Aristotle expressed his view that Homer was the most accomplished of all poets, a belief which here seems to be given material expression.

The specific relationship between the living philosopher and the poet as depicted also seems to be given additional significance if a text called the *Physiognomics,* associated with Aristotle, is taken into account. According to it there was a relationship between intelligence and character on the one side, and physical appearance on the other. This might in part explain the decision to depict the philosopher contemplating a likeness of the poet, rather than to show him poring over one of the latter's texts.

A more mundane consideration may also have had something to do with this choice, because according to the inventory of Rembrandt's belongings of 1656 the artist owned a bust of Homer, which he presumably used as the model for the sculpture in the painting. Exactly what prompted Rembrandt to produce such a work may never be known, but its power as a study of deep introspection and tender respect remains, and is indeed so compelling that an entire novel has recently been written around it, Joseph Heller's *Picture This* (1988).

Aristotle was crated up and put on a boat called the *Bartholomeus* which was bound for Naples. When it eventually arrived in Sicily it seems that Ruffo did not properly comprehend its subject. In an inventory of the contents of the Palazzo Ruffo of 1654 it is referred to as either an *Aristotle* or an *Albertus Magnus*. However, this confusion appears not to have affected his estimation of its worth because he later ordered another painting from Rembrandt.

At about the same time as this second commission, Ruffo also asked the

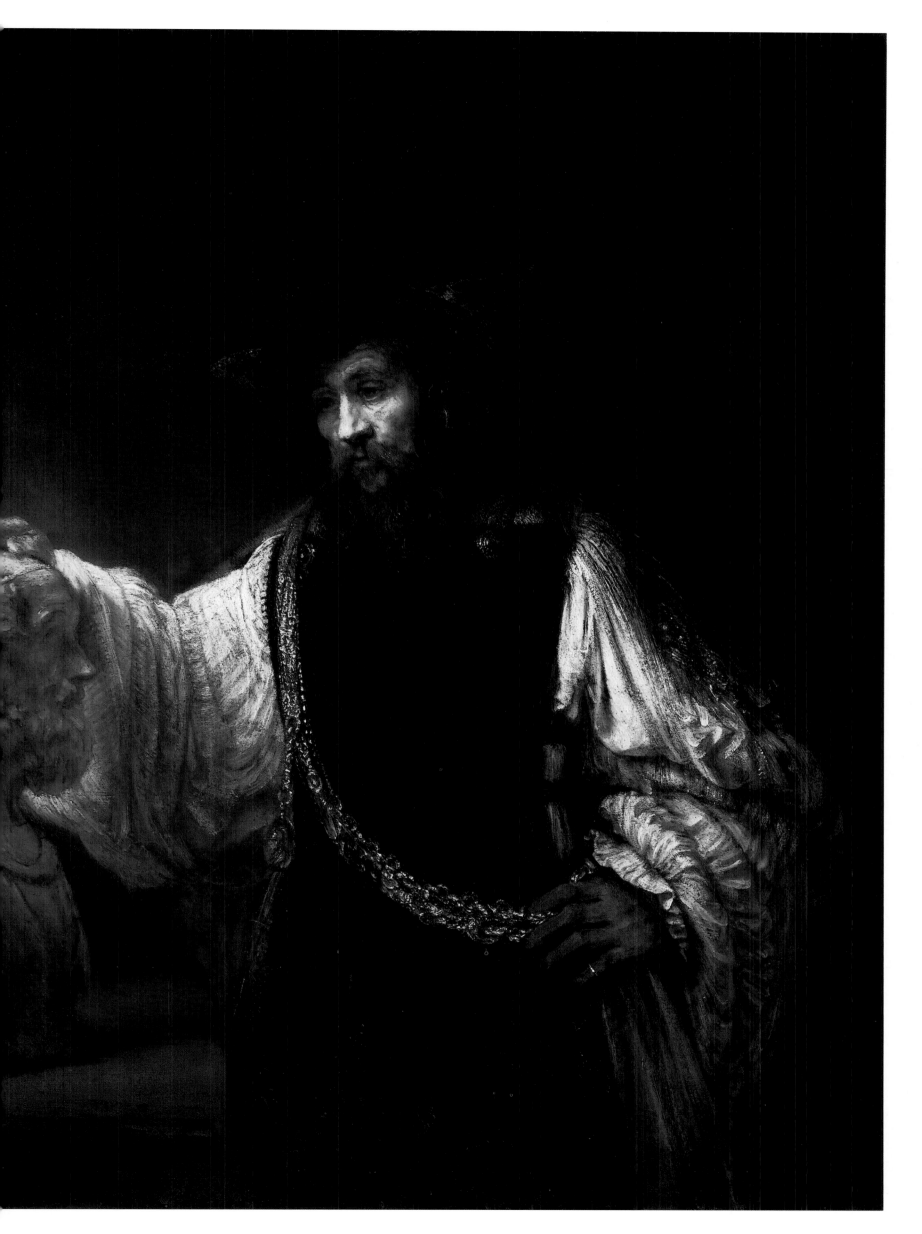

RIGHT Rembrandt *A Man in Armor*, 1655, oil on canvas, 53¾ × 40⅞ inches (137.5 × 104.5 cm), The City Art Gallery and Museum, Glasgow. Recent technical analysis of this work would seem to suggest that it is the second painting Rembrandt delivered to Don Antonio Ruffo; its support appears to have been expanded with pieces of canvas in a manner comparable to the description given by Ruffo in the correspondence related to the commission. If this identification is correct, then the true subject is Alexander the Great, the pupil of Aristotle.

Bolognese painter Guercino (1591-1666) to execute a pendant for Rembrandt's *Aristotle*. Guercino was sent a sketch of it and expressed the view that a depiction of a cosmographer might make an appropriate companion for what he saw as a depiction of a physiognomist. This exchange illustrates the continuing confusion over the subject of Rembrandt's *Aristotle*.

Guercino's painting, which no longer survives, did not meet with approval from Ruffo, and so the patron passed on the commission to his pupil, Mattia Preti (1613-99), who painted an *Alexander the Great*. That such a subject should have been chosen means that the *Aristotle* canvas was now finally understood. This can be inferred because Alexander was the ideal companion for Aristotle – he had been taught by him and was depicted on the latter's medallion in Rembrandt's painting.

The second commission given to Rembrandt was also for a depiction of Alexander. Ruffo was disappointed with the work he received from the artist because he recognized it as a study of a head which had been enlarged with other pieces of canvas, rather than a painting that had been conceived as a whole. Acrimonious letters were exchanged via intermediaries between Ruffo and Rembrandt, but the painting appears to have remained in Italy. It is thought that it is likely to be the work now in the Glasgow City Art Gallery (right), which was expanded in a manner similar to that which Ruffo describes in the related correspondence.

Rembrandt sent the *Alexander* off to Sicily with a third picture, a depiction of *Homer* (page 164), which Ruffo approved of. The trilogy of paintings – the *Homer*, the *Aristotle* and the *Alexander* – have a number of thematic links. Homer was an inspiration for Aristotle, and Aristotle was Alexander's mentor, who taught his pupil to admire Homer. So a chain of respect associates the subjects.

Some ten years separate the *Aristotle* and *Homer* canvases, and in that time Rembrandt's technique altered considerably. In the earlier picture the areas which command greatest attention, such as the face of the philosopher, are worked up in some detail, while in the latter work the whole is painted in a heavier, broader fashion with a densely loaded brush.

The *Homer* was sent to Messina with the *Alexander* in an unfinished state. It may seem quite extraordinary that Rembrandt should ship a painting across Europe on approval, but that appears to be what happened. Because Ruffo liked the work and wanted it completed, he returned it to the artist; it was then finished in Amsterdam and sent back from the Netherlands in 1664.

In spite of the stylistic differences, it must have made an ideal foil for the other canvases. Firstly, because life had here been breathed into the bust of Homer, and so fascinating comparisons could be made between the poet himself and his sculpted portrayal in the Aristotle canvas. The relationship between the works was also stimulating because, before the *Homer* painting was reduced in size in the eighteenth century, the poet was shown dictating to a scribe seated at the right, and so their master/pupil relationship could be associated with that between Aristotle and Alexander, referred to in the other pictures. (The complete composition of *Homer* is recorded in a drawing in the Nationalmuseum, Stockholm).

A third significant link between the three works has also been noted. It has been suggested that the figures in them are ideal personifications of the three types of human activity Aristotle described – the active, poetic and contemplative, ie. Alexander, Homer and Aristotle himself, respectively.

Two further aspects of these commissions particularly warrant discussion – their originality and cost. To include busts of revered ancients such as Aristotle and Homer in the portraits of contemporaries in seventeenth century was not unusual; they appeared on various occasions as references to the learning of the sitters. But to animate the lives of the ancients in the manner achieved in these three works was virtually without precedent.

Rembrandt clearly thought that he ought to be appropriately financially rewarded in view of the quality and originality of the paintings he was providing. He charged Ruffo, for example, 500 guilders for the *Homer*, which was much more than he could have expected for a comparable commission in Amsterdam.

It has been suggested that the subject of *Aristotle Contemplating the Bust of Homer* could only have been established by someone very well versed in the classics, such as another of Rembrandt's important patrons at this period, Jan Six (Schwartz 1985). There may be some truth in this theory, but it would be wrong to belittle Rembrandt's command of classical literature, as he had previously shown a mastery of a number of ancient sources.

The composition of the Aristotle canvas is one of simplicity and grandeur. These principles, as has been noted, can also be seen to have been applied by Rembrandt to a number of other works of the 1650s. This shift away from more busy and complex designs of the previous decades marks a new development in the artist's evolution, a move towards what has been described as a more reflective and 'classical' aesthetic.

Such an approach was also applied to a work of the following year (page 165), which is a depiction of the Roman goddess of Spring, Flora.

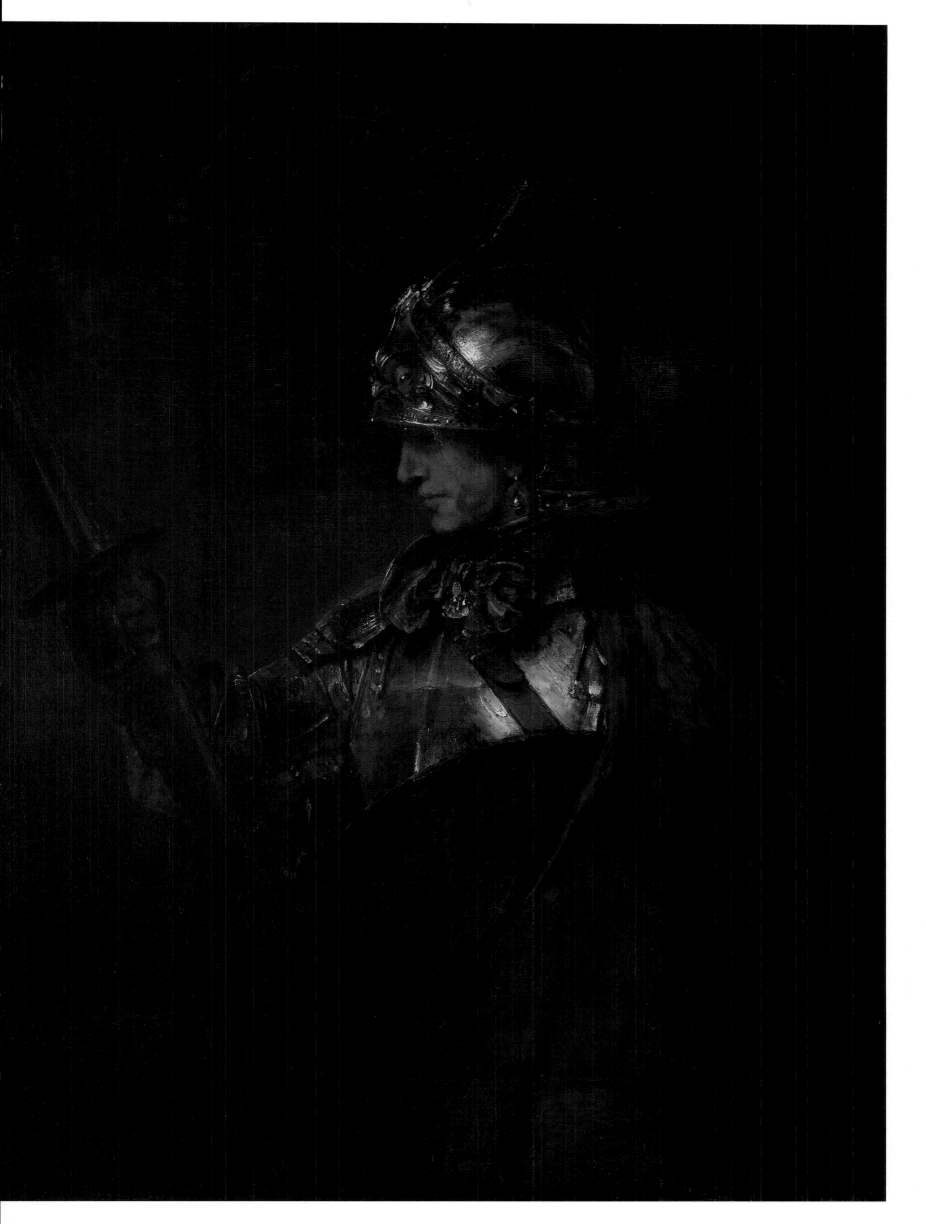

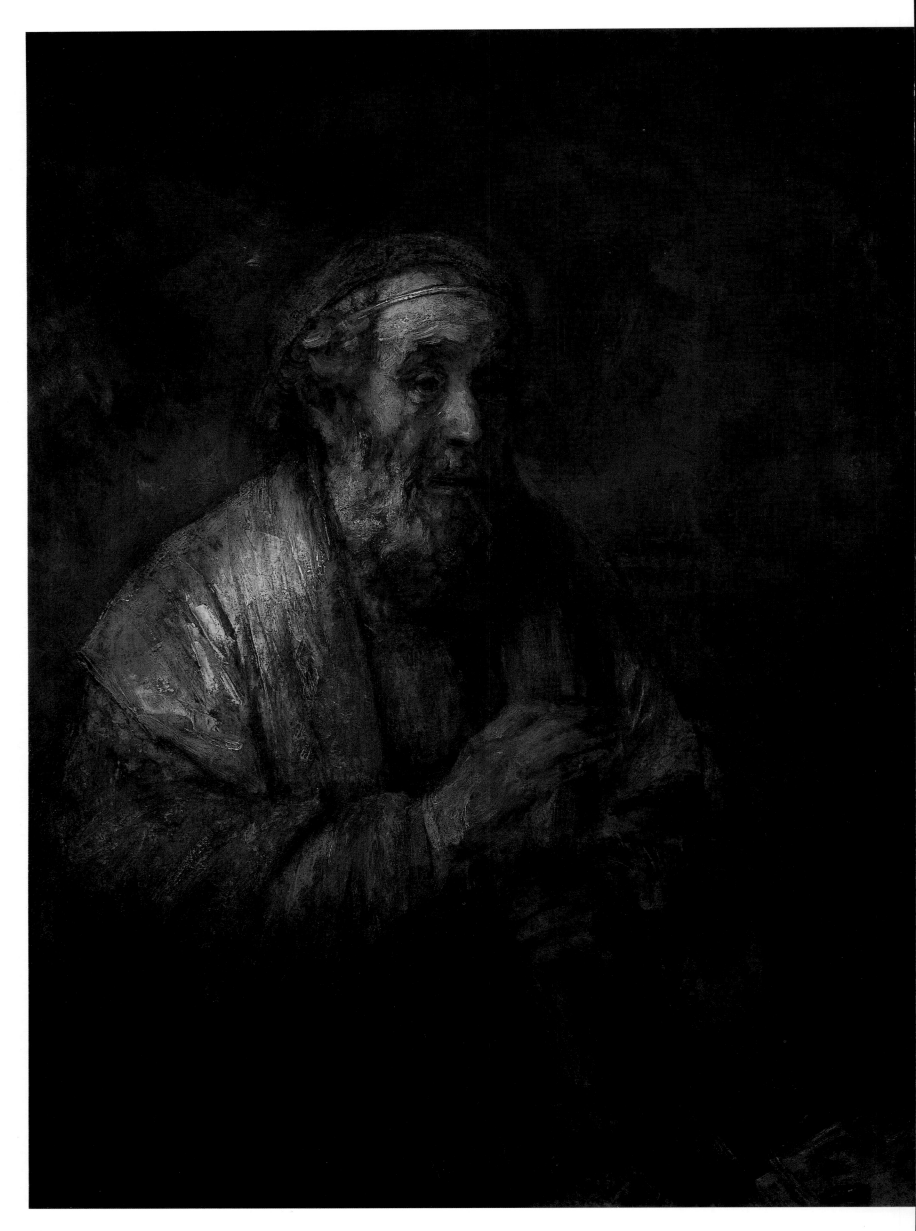

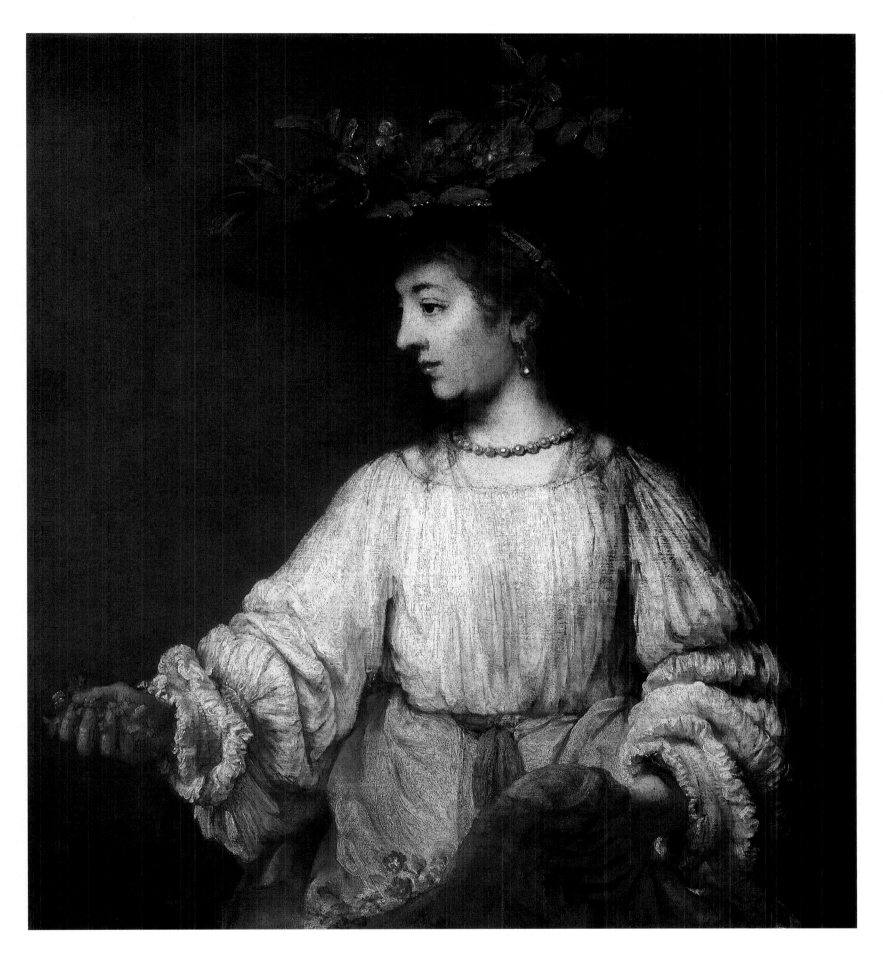

ABOVE Rembrandt *Flora*, c.1654, oil on canvas, 39 × 35⅞ inches (100 × 91.8 cm), The Metropolitan Museum of Art, New York. This depiction of the goddess of spring is more restrained and serene than the artist's earlier interpretations of the subject (page 117). Compositionally, and in terms of the costume, it can be compared with Rembrandt's *Aristotle* of the previous year (page 160).

LEFT Rembrandt *Homer Dictating to a Scribe*, 1663, oil on canvas, 77⅜ × 32⅛ inches (198 × 82.4 cm), The Mauritshuis, The Hague. This is the third painting Rembrandt painted for Don Antonio Ruffo. It is now in a fragmentary state, but in its original form included the scribe to whom the aged Homer dictated, at the left.

Rembrandt had previously painted Saskia in the guise of this goddess on no less than three occasions (see page 116-117). A comparison between those pictures and this later reworking of the same theme illustrates something of the new found grace and poise of the works of the 1650s.

The choice of a profile rather than a three-quarter or frontal view gives the image a static and calm quality not found in the earlier paintings. The design has also been pared down in other respects in comparison with earlier work; there are enough blooms here for

us to identify the figure, but far less than the cascades of flowers used previously. Robust sensuality (as represented particularly by the London *Flora* (page 117), is here replaced with greater reserve and dignity.

It had been thought until recently that the model Rembrandt used for the 1654 *Flora* was Hendrickje Stoffels, but this, like many other such identifications in Rembrandt's work, is now being questioned (for further discussion of similar issues, see Hendrickje Stoffels, pages 172-77, and *Bathsheba* page 188).

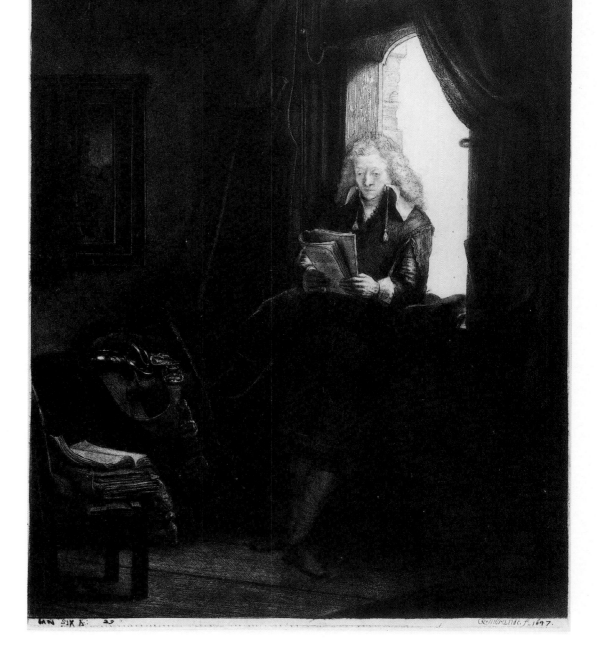

Jan Six

Jan Six (1618-1700) was a well-connected, learned, Amsterdam burgomaster who was a patron of, and good friend to, Rembrandt during his problems of the early 1650s. The two men shared an interest in collecting (they had both bought Dutch and Italian paintings and Antique sculpture), and Six appears to have been an admirer of Rembrandt's work – among other paintings by the artist he owned his *John the Baptist Preaching* (page 76).

Six came from a wealthy family of merchants and dyers. He was involved in the family silk business, but also pursued a number of other interests as a lawyer, connoisseur and accomplished poet. He embarked on a Grand Tour through Italy in 1640-41, and was the author of a number of plays and two albums of Latin poems.

The artist and the poet may initially have come into contact in the early 1640s. In the first year of this decade Rembrandt is recorded as having painted a portrait of Six's mother, Anna Wijner. The portrait has unfortunately not been identified, although it has been suggested that a depiction of an elderly woman that now belongs to the Duke of Buccleuch (page 167), may be a later depiction of Anna Wijner, by Rembrandt (Schwartz 1985).

The treatment of this subject recalls some of the affectionate and reverential studies the painter made in the late 1620s and early 1630s, of elderly figures who may have been his own parents (pages 51 and 52). The idea of reflecting light from a book up on to the features of a reader had also been used earlier by the painter (page 53), and was to employed in the first of Rembrandt's two depictions of Jan Six himself (above and page 169).

In this etching of 1647 Rembrandt fused informality and elegance to create a memorable portrait of his friend. Six is shown leaning nonchalantly back against the sill of a window. The light from outside illuminates the book he reads and reflects back to reveal his concentrating face. There is a bold contrast between the brilliance of the daylight and the gloom of the background interior, the darkness of which has been created with dense masses of thinly hatched lines on the etching plate.

The objects in the interior refer to the various literary and visual interests of the subject. Books and folios are placed on the chair, while a painting protected by a curtain hangs on the wall at the left. The overall impression is of a cultivated man at ease, an ideal gentleman. Such a formula was reworked by Rembrandt for another depiction of a friend of his who was a collector, Abraham Francen (page 168). Again in this work, the artist's only portrait etching in an oblong format, he utilizes the light from the window to illuminate the object under scrutiny.

ABOVE Rembrandt *Portrait of Jan Six*, 1647, etching (drypoint and burin) (state 3), 9½ × 7½ inches (24.5 × 19.1 cm), British Museum, London. Rembrandt's friend is here shown as a gentleman collector. The sunlight from outside reflects back from the papers the sitter holds to illuminate his face. The two preparatory drawings for this portrait, along with the original etching plate, remain in the Six collection.

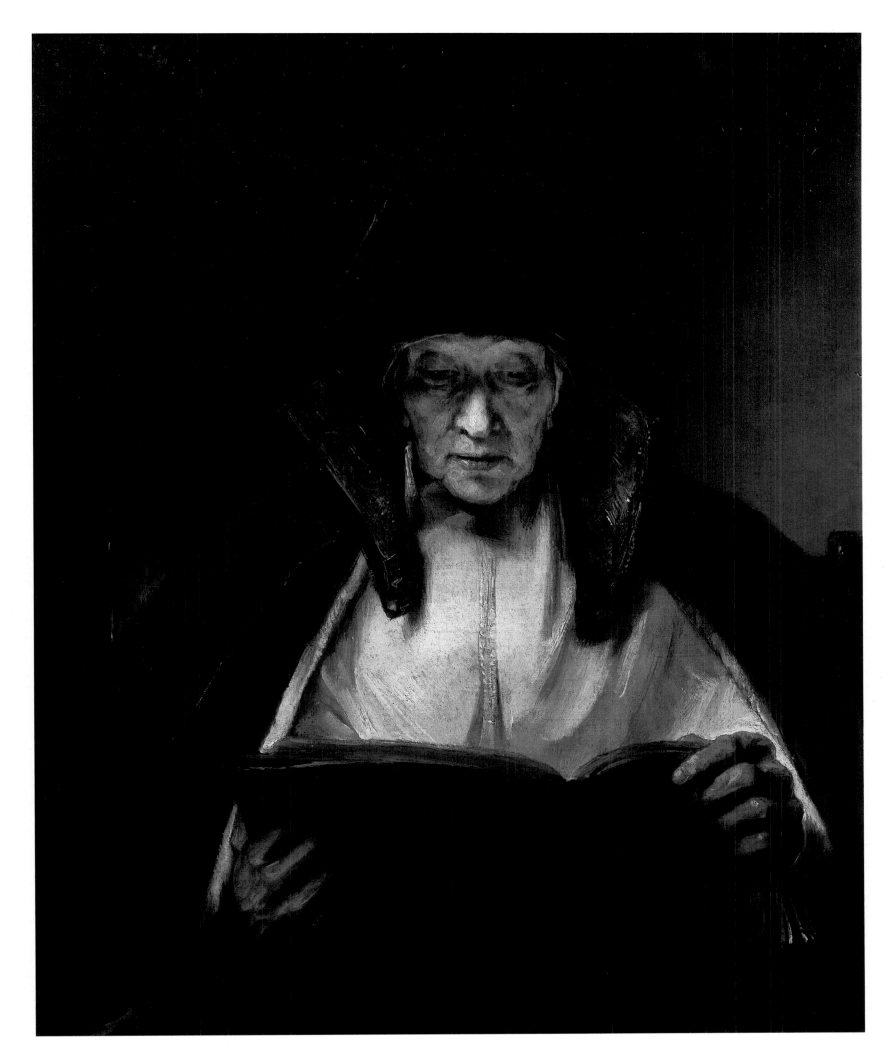

ABOVE Rembrandt *An Old Woman Reading*,
1655, oil on canvas, 31¼ × 25¾ inches (80 × 66
cm), Collection of the Duke of Buccleuch,
Drumlanrig Castle, Scotland.

BELOW Rembrandt *Abraham Francen, Apothecary*, *c*.1657, etching (drypoint and burin), 6⅛ × 4¼ inches (15.8 × 10.8 cm), British Museum, London. Francen was, like Six, a friend of Rembrandt; he became guardian of Cornelia, the daughter of Hendrickje Stoffels and the artist. Here he is depicted as a connoisseur. He studies what is perhaps a mounted print taken from the open folio before him, and is surrounded by artworks; an oriental figure and jar on the desk, and on the wall a triptych with a crucifixion as its centerpiece, flanked by two landscapes.

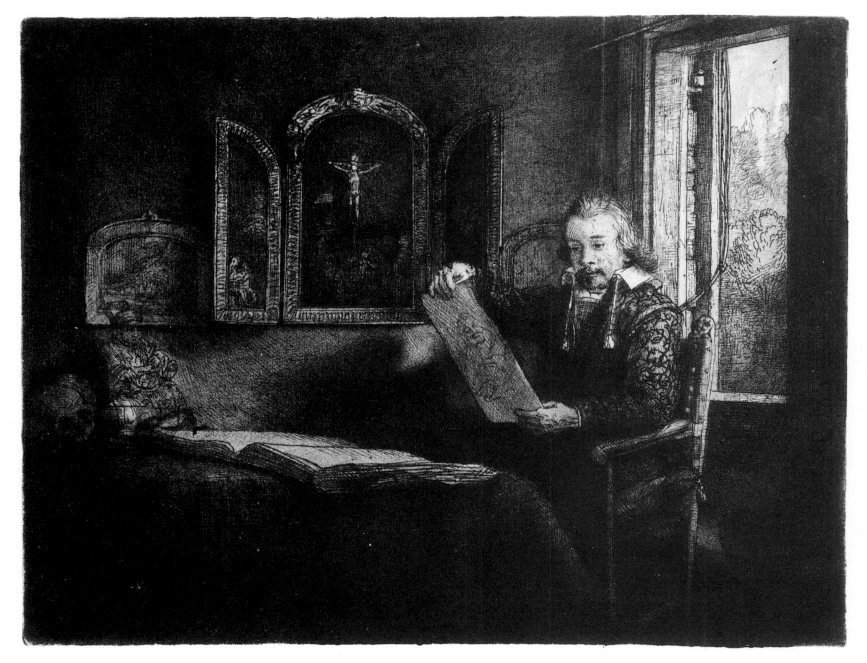

Returning to Six, Rembrandt's relationship with him continued in 1648 when the artist produced the etched title page for his tragedy *Medea*. It can be further plotted in 1652 when Rembrandt agreed to sell Six three of his paintings from the 1630s, and made some drawings for him. These include a sketch of Minerva in her study which remains in the Six family collection. Minerva, as the Roman goddess of Wisdom, Science and the Arts, was clearly and ideal exemplar for a polymath such as this patron.

The friendship between the two men was expressed in less lofty terms when in 1653 Six lent Rembrandt 1000 guilders without interest to help him stave off creditors.

In the following year, the poet married Margaretha Tulp, the daughter of the doctor Rembrandt had portrayed in 1632 (page 60), and the artist depicted Six in a second portrait (page 169), which many consider his greatest.

It is certainly true that to experience this work is to come closer than in almost any other instance to the manner in which Rembrandt enjoyed using paint. The rapidity and bravura of the brush strokes which effectively capture the fall of light, the textures of the clothes, and the movement of the hands of the subject, as he pulls on a glove, are virtually unparalleled in the artist's output.

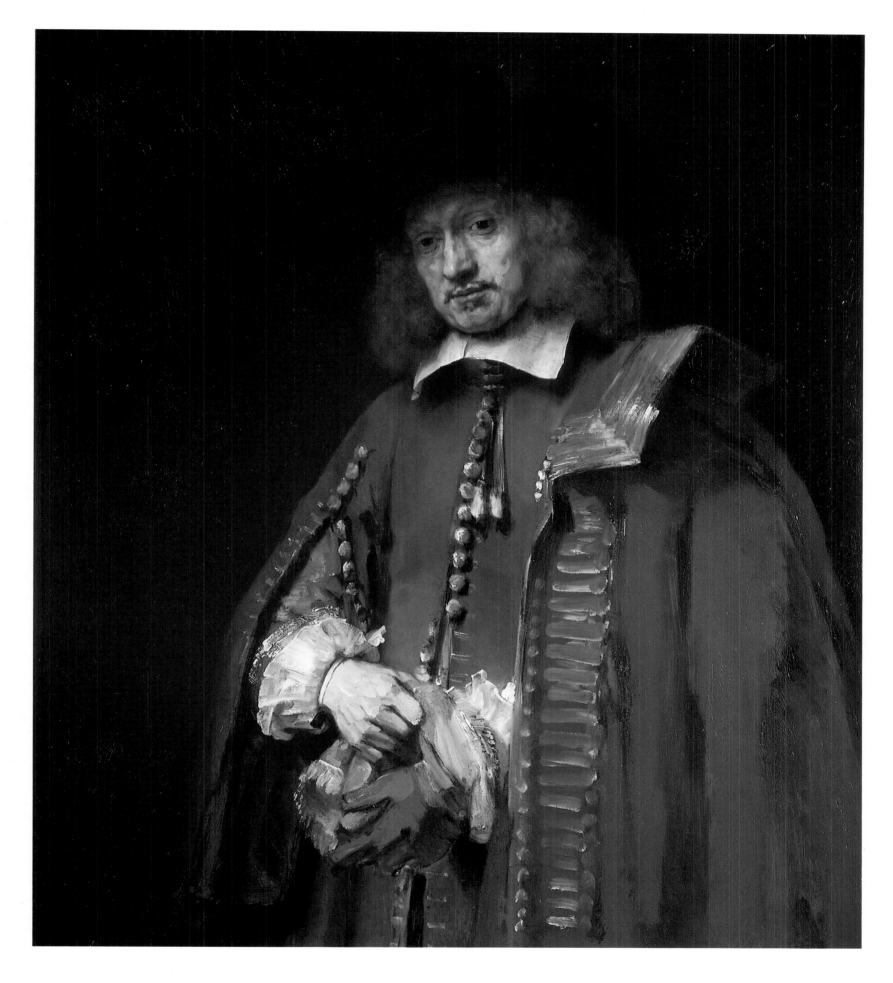

ABOVE Rembrandt *Jan Six*, 1654, oil on canvas, 43¾ × 39⅞ inches (112 × 102 cm), Six Collection, Amsterdam. The sitter wrote a Latin chronogram about this celebrated painting in one of his albums, which in its original form includes the numerals that reveals its date of execution. In translation it reads: *'Such a face had I, Jan Six, who since childhood had worshipped the Muses'*. The Muses were the goddesses who inspired creativity in the arts.

BELOW Rembrandt *Six's Bridge*, 1645, etching
(state 3), 5 × 8¾ inches (12.9 × 22.4 cm),
British Museum, London. The traditional title
of this work refers to the belief that it shows
part of the estate of Rembrandt's friend Jan
Six. Modern analysis suggests, however, that
the location is actually closer to Amsterdam
and shows land which belongs to another of
the city's burgomasters.

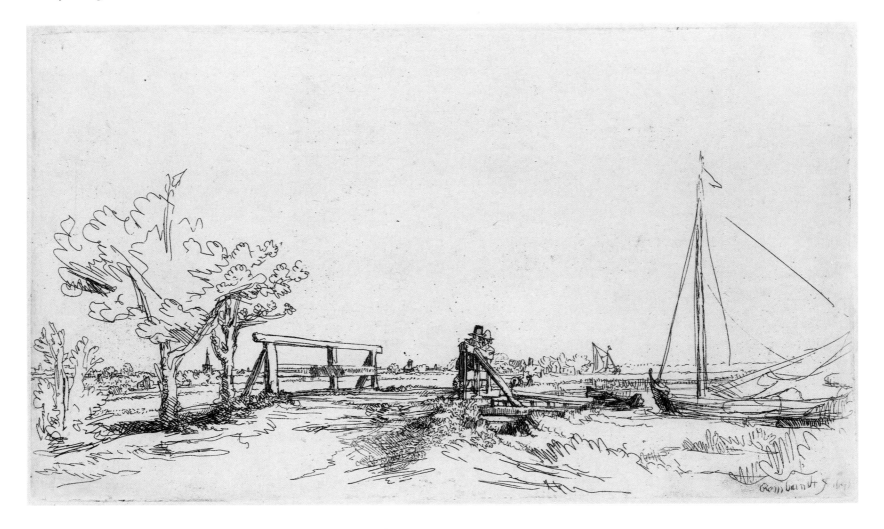

This ingenuity is matched by the daring nature of the design. The brilliant red and gold cloak and the figure are set to the right of the canvas, so creating an asymmetry which perhaps under other circumstances could not have been carried off. But the painter succeeds because of the potential for movement across to the left, and the balance created from top to bottom by the foci of the face and hands. Here he has unified a bold and simple composition, which is characteristic of the classicism of the 1650s, with a brilliant illusionistic exercise that, to a great extent, defies explanation.

This celebrated work, which gives an uncanny impression of the presence of an individual at a precise moment in time, is in superb condition. It is still in the possession of the Six family, thanks to their ingenuity during the Second World War, when it was hidden, along with other works of art, in a brewery in Amsterdam throughout the Nazi occupation of the Netherlands.

The painting seems to have marked both the high point and end of the relationship between the two men. Their friendship from here on appears to have dwindled, probably because the interests of a progressively successful patrician, Six, became increasingly at odds with those of a publicly humiliated painter.

RIGHT Rembrandt *A Woman Bathing*, 1654, oil on wood, 24⅛ × 18⅜ inches (61.8 × 47 cm), The National Gallery, London. Signed at the bottom left: *Rembrandt f 1654*. For the nineteenth-century writer on art, Mrs Jameson, '*Those who have been in Holland . . . must often have seen peasant-girls washing their linen and trampling on it, precisely in the manner here depicted. Rembrandt may have seen one of them from his window, and snatching up his pencil and palette . . . threw the figure on the canvas and fixed it there as by a spell!*' (quoted in *A Handbook to the National Gallery*, compiled by Cook, E. T., 1888, p. 250). Such a romantic view of this brilliant study has now been superceded; it is thought that the model may be Hendrickje Stoffels, and that she could be posed as either of the Biblical figures Susanna or Bathsheba.

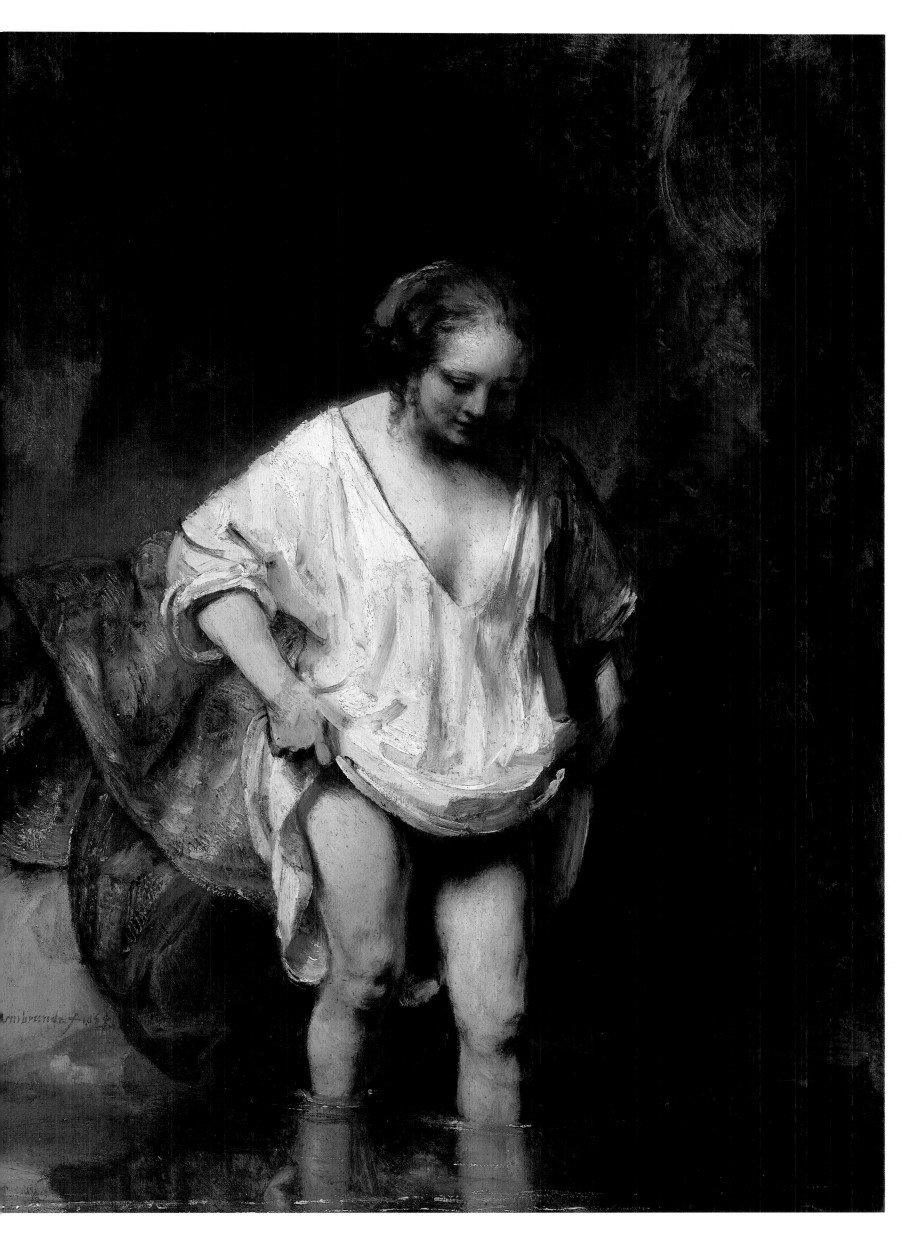

Hendrickje Stoffels and Titus van Rijn

Hendrickje Stoffels (*c*.1625-63) was first recorded as living in Rembrandt's household in October of 1649. It appears that she was employed as a housekeeper and nurse for Titus (1641-68), the artist's son, and then became, like Geertje Dircx before her, Rembrandt's lover. As was discussed earlier in the introduction to this decade, Hendrickje was condemned in 1654 by a church council in Amsterdam because of her unmarried relationship with Rembrandt.

In the same year she bore Rembrandt a child, who was called Cornelia. Such a choice of name had a considerable poignancy about it because Rembrandt's mother was called Cornelia, and he had had two daughters also called Cornelia by his wife Saskia, neither of whom survived infancy.

There is no documented portrait of Hendrickje, but an affectionately depicted model keeps on reappearing in Rembrandt's works of the 1650s, who can with some reservations be reasonably identified as her. One of the earliest pictures in this group is Rembrandt's *Woman Bathing* of 1654 (page 171), which is in the National Gallery, London.

This startlingly fresh and apparently rapidly executed work is among the most tender, and sensitive of all Rembrandt's paintings. A young woman, apparently unaware that she is being observed, wades tentatively into the water. She raises her shift so as not to wet it, and on the bank beside her are placed a pile of richly adorned clothes.

The spontaneous brushwork, particularly of her garment, gives the painting the look of a sketch, but the clear signature and date suggest that the artist considered it a finished work, and no pictures for which it might be considered a preparation are known.

It has been suggested that this is not a straightforward depiction of Hendrickje, but may be a depiction of a Biblical or classical character in which she was used as a model. This is particularly implied by the presence of the luxuriant robe she seems to have just removed. The 'true' subject could be either of the mythological goddesses Diana or Venus, but is perhaps more likely to be one of the Biblical beauties Susanna or Bathsheba. In both of the latter stories the women were spied upon by men; the Elders in the case of Susanna, and King David in the tale of Bathsheba. If the work does depict such a figure then the viewer takes on the role of voyeur. There is a very real sense in which we seem to break in on to a wholly private and unselfconscious moment, and so support such an identification.

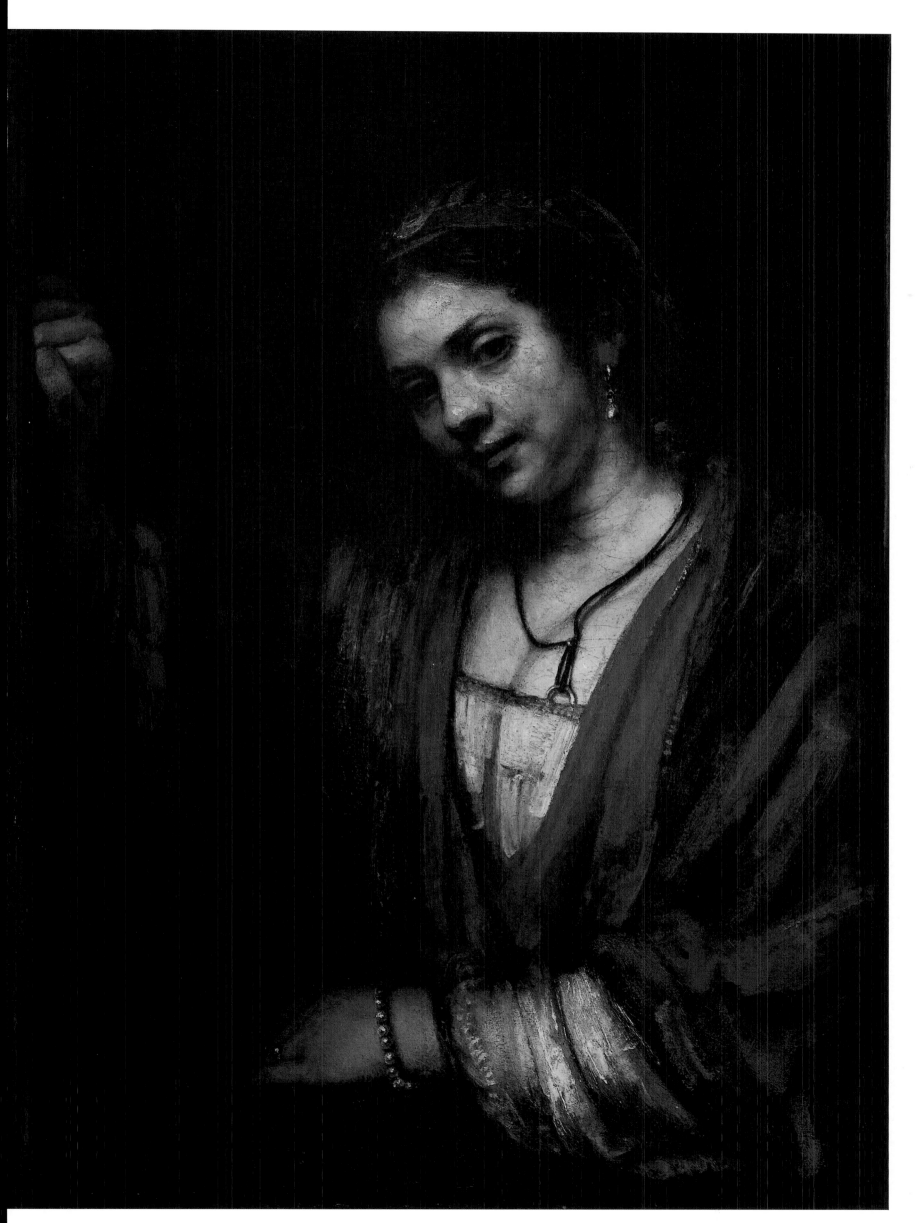

At other times Rembrandt painted the stories of Susanna and Bathsheba in a less oblique manner. In 1647 he executed *Susanna Surprised by the Elders* (page 148), and in 1654, the year the National Gallery picture was painted, produced a more ambitious work – *Bathsheba with King David's Letter* (page 188).

A Woman Bathing is painted on a single piece of oak, which was covered with a chalk ground and overlaid with a brown priming. This layer can be seen in a number of places, such as the curved strip at the lower edge of the woman's shift. Much of the painting was clearly worked up quickly, but it would appear that the whole picture was not executed in one session, with wet paint applied on to wet paint. This can be discerned because some of the major shadows, such as at the top of the woman's legs, seem to have been sketched in first and allowed to dry before further embellishments were made (Bomford 1989).

The depiction of the woman's shift is a brilliant example of the virtuosic handling of paint on Rembrandt's part. By contrast much of the woman's flesh is more smoothly defined, although her hands are ingeniously modeled, at great speed with cursory strokes.

Such rapidity also characterizes the execution of a sketch now in the British Museum (page 172), which is thought to be dated to the same year, and to similarly be a study of Hendrickje.

Here she is shown apparently seated on the floor, resting her head on her crossed arms, which are perhaps placed on the seat of a chair. This famous drawing is unusual among the artist's works on paper because it is executed entirely with a brush. Rembrandt may not often have employed such a tool, but here illustrates his complete mastery of it. The lines, which are quickly dabbed and drawn over the paper, place the pose and attitude of the model with the utmost brevity, but complete conviction.

While the *Woman Bathing* and British Museum drawing allow the viewer to look in on moments of privacy and enclosure, in other painted depictions of Hendrickje Rembrandt set up a far more direct dialogue between the subject and onlooker.

This is certainly the case with his *Woman at an Open Door* (page 173) in Berlin, of about 1656. The impression given in this work is that Hendrickje is looking in on the viewer, rather than the other way around. She wears an earring, a pearl bracelet, a ring on her hand, and a further ring hanging from a cord around her neck. The marital associations of such jewelry may be of particular significance because Hendrickje, was, as has been explained, the artist's unmarried partner.

Her pose and clothes appear to be inspired at root by sixteenth-century Venetian courtesan paintings, such as the works of Palma Vecchio (*c*.1480-1528). Rembrandt could have been aware of these through an intermediary print or drawing, and via the work of pupils such as Willem Drost who were similarly inspired.

Influences of this type may also have affected another, later three-quarter length portrayal of Hendrickje which is in the National Gallery in London (right). Here she is shown in what are perhaps luxurious night clothes, with pearl earrings, a chain around her neck and an adorned headpiece. The color scheme, dominated by creams, deep reds and accents of gold, enhances the impression of opulence. Her head emerges into the light, but almost half of her face remains in shadow. This use of *chiaroscuro* recalls some of the artist's earlier experiments with daring illumination (page 34).

It is hard to discern much of the exact nature of the setting, and indeed of the type of garment she wears, because of the free nature of the brushwork. This has led to the suggestion that the painting is unfinished. But in works of his maturity Rembrandt brings things to a resolution quite unlike the more prosaic and customary 'finish' in the work of other painters.

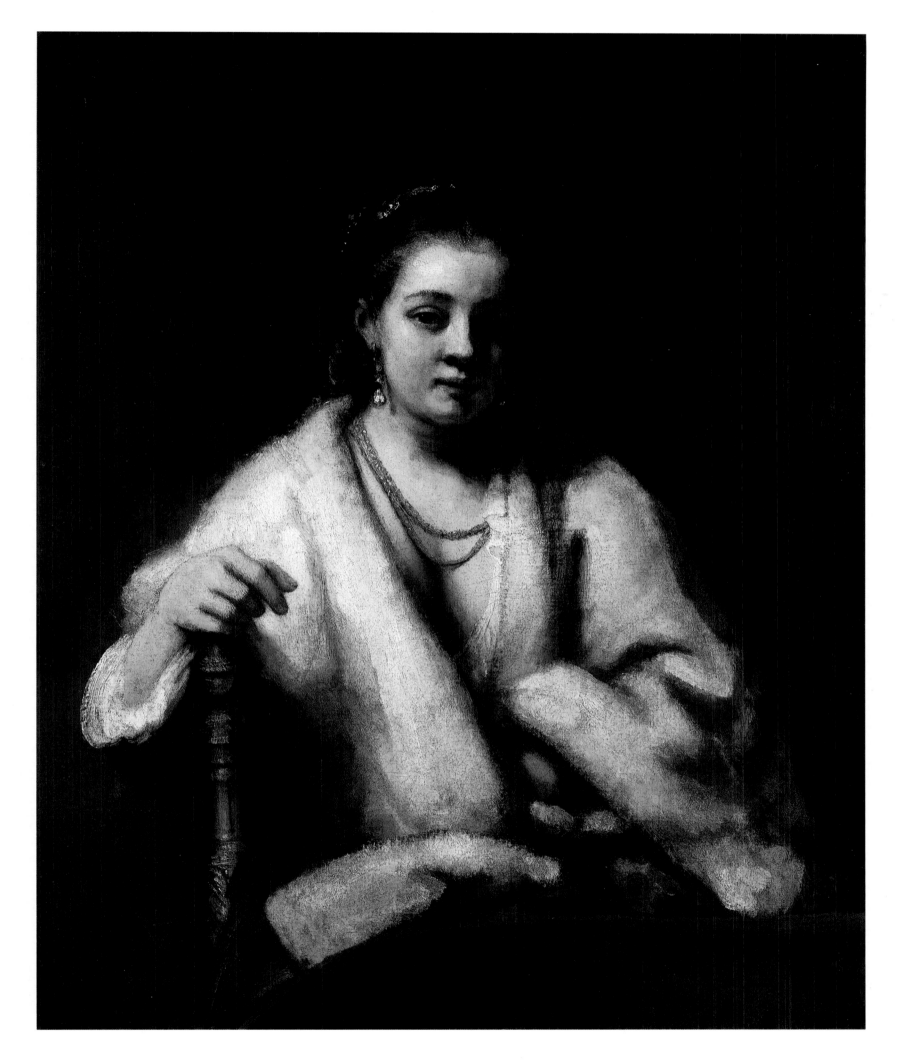

ABOVE Rembrandt *Portrait of Hendrickje Stoffels*,
1659, oil on canvas, 39¾ × 32⅝ inches (101.9 ×
83.7 cm), The National Gallery, London.

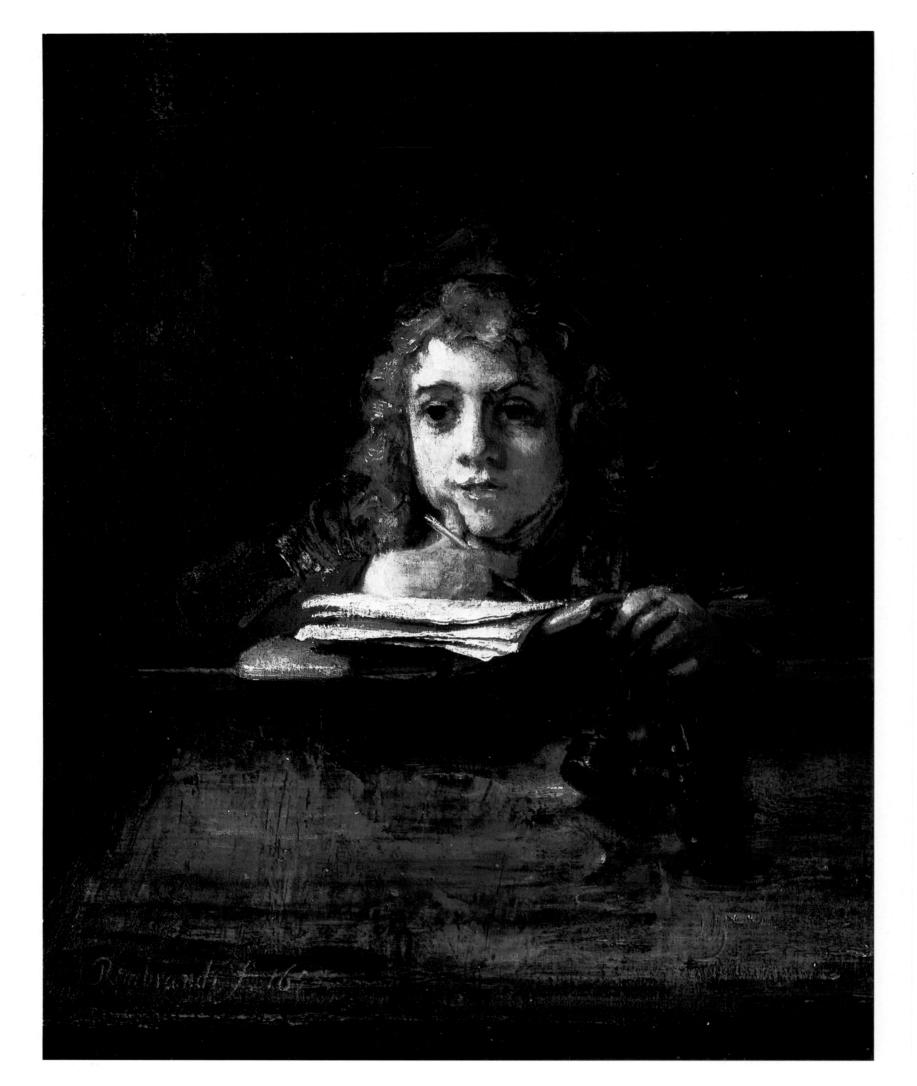

LEFT Rembrandt *Titus at his Desk*, 1655, oil on canvas, 30 × 24½ inches (77 × 63 cm), Museum Boymans-van Beuningen, Rotterdam. Titus, Rembrandt's son, would have been fourteen years old when this study was made. He wears a beret, similar to those seen in some of the artist's depictions of himself at work, and pauses, apparently searching for inspiration, before proceeding with his studies. (The inkwell and pencase can be compared with those in Rembrandt's earlier portrayal of Cornelis Claesz. Anslo, page 143).

BELOW Rembrandt *The Anatomy Lecture of Dr Joan Deyman*, 1655-60, pen and brown ink on paper, 4¼ × 5⅛ inches (10.9 × 13.1 cm), Rijksmuseum, Amsterdam. This sketch records the overall composition of Rembrandt's *The Anatomy Lecture of Dr Joan Deyman* (page 178), prior to its damage by fire.

Hendrickje's charge, Titus, was depicted by Rembrandt a number of times. Of these portraits, by far the most attractive is the artist's study of his son at his desk (left), which is as much a scrutiny of an individual as an exploration of a type – the contemplative, or melancholic.

Titus stares into space, resting his head on his hand. He seems to be searching for inspiration before writing again. In his left hand he holds an ink container and pen case which hang over the edge of the desk. The grain of its wood and the way it is knocked and stained provided Rembrandt with one of the many opportunities he took up to create an area which has independent abstract appeal. He achieved it here by thinly working paint in vertical strokes over horizontal marks.

The context is not specific enough for it to be established whether or not this is intended as a moment of quiet in a schoolroom, or during a lesson at home.

We know that Rembrandt trained his son both as a draftsman and painter, but no paintings which can be convincingly associated with him have been identified, although three are recorded in the inventory of Rembrandt's sale of 1658.

In 1655, the year this work was painted, the boy, who was only 14, had the ownership of Rembrandt's house transferred to him, and signed a will which meant that if he died before his father the property would return to the artist.

The Anatomy Lecture of Dr. Joan Deyman

Rembrandt had in 1632 painted a group portrait of members of the Amsterdam Guild of Surgeons (page 61). It was dominated by the *Praelator Anatomiae*, Dr Nicolaes Tulp. His successor, Dr Joan Deyman, was to be the center of attention in a second group portrait of guild members by the artist, which was painted 24 years later in 1656.

This work (pages 178-79) is now sadly only known in a fragmentary state. The original nature of its overall composition is recorded however in a sketch by Rembrandt (above), which was made to illustrate how he considered it ought to be framed and displayed.

At the center of the composition, and dominating the surviving fragment of canvas, lies a corpse which is dramatically foreshortened, to the extent that it appears as though its feet extend into the space of the viewer. It has been suggested on a number of occasions that this arrangement may have been inspired by Andrea Mantegna's famous painting of the *Dead Christ* (Brera, Milan) in which Christ's body is similarly placed. As has been mentioned (page 153), it appears that Rembrandt had a particular fascination for the works of Mantegna, and he could well have known of this precedent through the medium of an engraving made after it.

The corpse used for the lecture was, according to the records of the Anatomy Theatre in Amsterdam, that of Joris Fonteijn of Diest, who had been executed because he had pulled a knife during the course of a robbery.

The dissection being performed concentrates on the brain. The stomach

Rembrandt, *The Anatomy Lecture of Dr Joan Deyman*, 1656, oil on canvas, 39 × 52⅜ inches (100 × 134 cm), on loan from the City of Amsterdam to the Rijksmuseum, Amsterdam. Paintings of anatomical lectures were not uncommon, but those which concentrate on dissections of the brain are very rare. This work, which was damaged in a fire in 1723, is now known in a much reduced state; its original form is however recorded in a drawing (page 177) by the artist. In the early eighteenth century it is described as being hung in the Anatomy Theatre on the Nieuwe Waag in Amsterdam, along with Rembrandt's earlier depiction of Dr Tulp (page 61), who was Dr Deyman's predecessor as Professor of Anatomy.

and intestines have already been removed, and Dr Joan Deyman stands behind the propped-up head of the corpse, holding a scalpel. To the left, a master of the guild of surgeons, Gysbrecht Matthijsz. Calcoen, holds the cranium in his hand and watches the dissection. We know the names of the surrounding figures who are roughly indicated in the sketch, but they cannot be individually identified.

The sketch shows how the painting was to be set close to the ceiling of the room it was intended for (rafters are drawn in at the top), and by a window which is illustrated open at the left. It was to hang on one side of a fireplace in the Anatomy Theater in the Nieuwe Waag, with the *Anatomy Lesson of Dr Tulp* (page 61) on the other.

According to the drawing it appears that there may have been an open door behind Dr Deyman in the original painting, and that the figures on either side of him were shown standing within a round balustrade, of a type which existed at the center of many anatomy theaters.

There seems to be a greater formality about the organization of figures in this work than in the earlier of Rembrandt's two medical group portraits (page 61). Such a composition may reflect a specific request on the part of the patrons.

The fact that the surgeons should have given Rembrandt a second commission, in the year of his bankruptcy, apparently marks their continuing faith in his abilities.

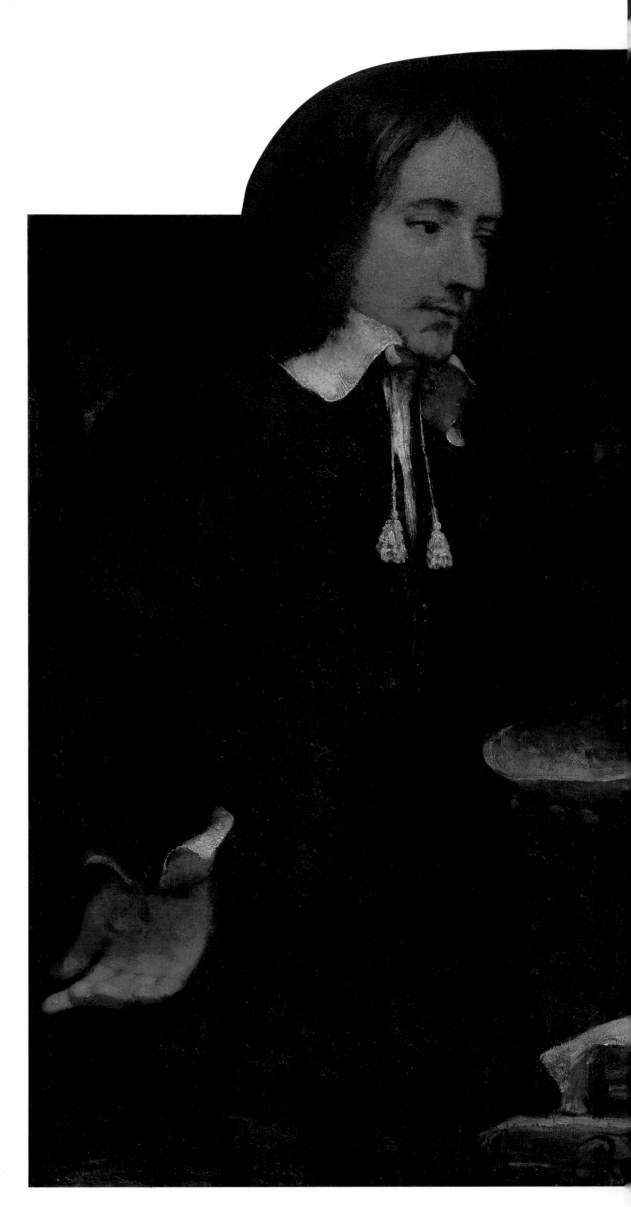

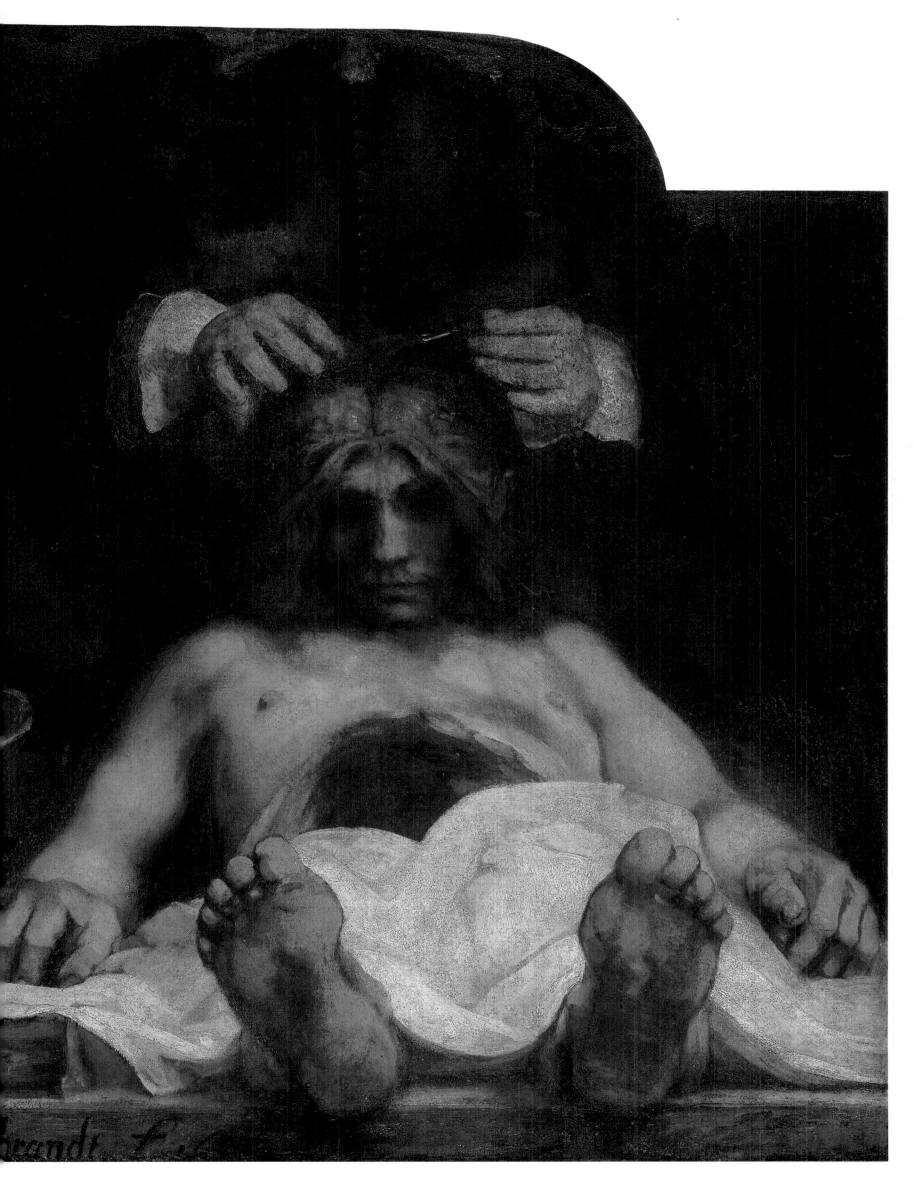

BELOW Rembrandt *Christ Preaching ('La Petite Tombe')*, *c*.1652, etching (drypoint and burin) (only state), 6 × 8 inches (15.5 × 20.7 cm), British Museum, London. In Rembrandt's interpretations of aspects of Christ's ministry, he repeatedly scrutinizes the variety of reactions of those who crowd around Jesus. Here they range from obstinate disbelief, to fumbling incomprehension and rapt attention.

Biblical Histories

During the first half of the 1650s Rembrandt executed what many consider his greatest etchings – depictions of New Testament subjects that are rethought in nothing less than a revolutionary fashion.

In a reworking of the themes explored in the *Hundred Guilder Print* (page 155), Rembrandt created a memorable and more intimate depiction of aspects of Jesus' ministry with his *Christ Preaching ('La Petite Tombe')* (below), which is dated to about 1652.

This is not an illustration of a particular verse from the Bible, but appears instead as a subject invented by the artist – an amalgam of Christ's disputes and teachings – which according to Rembrandt's imagination left some spellbound, others troubled and confused, and a few unconcerned and oblivious. This variety of individual reactions are seen in a number of his other crowd scenes.

Christ's presence is emphasized and divine authority confirmed by the halo and beam of light which descends vertically. He stares down at an inattentive child who draws lines in the dust with his finger and has a spinning top lying beside him. The youth who is seated to the right of Jesus, who may be intended as Saint John, also seems be preoccupied with the child.

In the following year Rembrandt created what is perhaps the most powerful print of his entire career, *The*

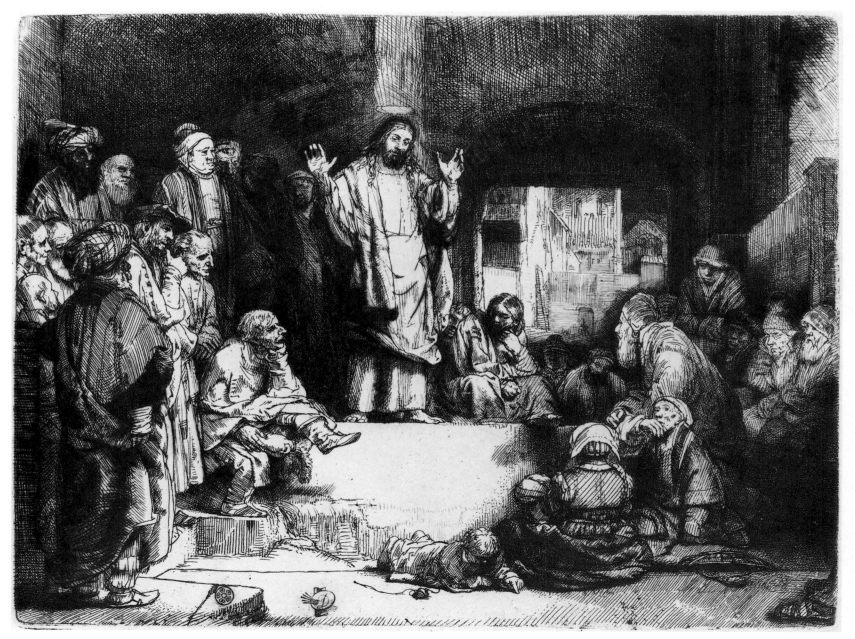

BELOW Rembrandt *The Three Crosses*, 1653, etching (drypoint and burin) (state 3), 15 × 17½ inches (38.5 × 45.0 cm). British Museum, London. The moment of Christ's death on Golgotha is the subject of this masterly etching. According to the gospel of Saint Luke '. . . *There was darkness over all the earth'*. Rembrandt swathed the sinful in darkness at the edges of the composition, but used light to bleach out and isolate the faithful in the immediate vicinity of the crosses.

Three Crosses, which was reworked by the artist in four different states, two of which are illustrated here (below and page 182). Elements of the events which took place on Calvary had been treated earlier by the artist (pages 106 and 107), but he had not previously conceived the climax to the Passion of Christ in such a monumental and terrifying fashion.

The arrangement of the main figures, with Jesus crucified centrally and the thieves to the left and right, follows traditional iconography (compare it, for example, with Lastman's interpretation of the subject, page 20). The attendant figures which one would also expect to find in such a scene also appear the print (below) – including the Romans and Jewish elders at the left, the centurion on his knees before the cross, the penitent Magdalen clasping at its base, the swooning Virgin to the right, and Saint John behind her looking up at Christ. But Rembrandt also

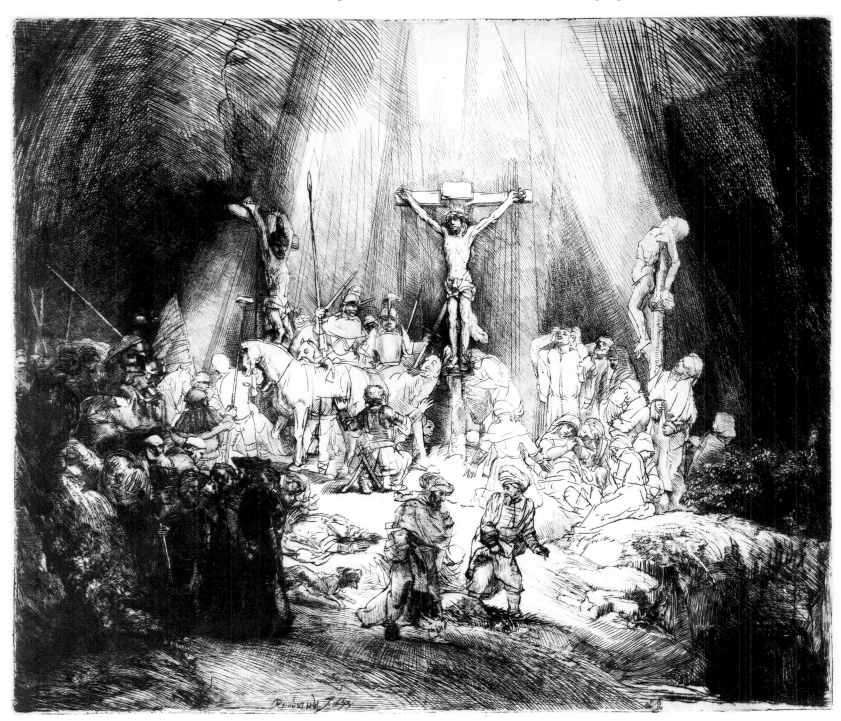

RIGHT Rembrandt *Ecce Homo*, 1655, etching (drypoint) (state 4), 15 × 17¾ inches (38.3 × 45.5 cm), British Museum, London. Pilate presents Christ to the people at the center of a composition rigidly based on horizontal and vertical emphases. It has been suggested that this etching may have been conceived as a pendant to Rembrandt's *Three Crosses*, of 1653 (page 181), and that the two works could have formed part of a planned, but unrealized, Passion series.

BELOW Rembrandt *The Three Crosses*, 1653-1661, etching (drypoint and burin) (state 4), 15 × 17½ inches (38.5 × 45 cm). British Museum, London. In this later reworking of his etching of 1653, the artist pared down the narrative further, to create an apocalyptic vision of the crucifixion. Light is still the key to the image; it now seems to isolate Christ's suffering, almost to the exclusion of all other concerns.

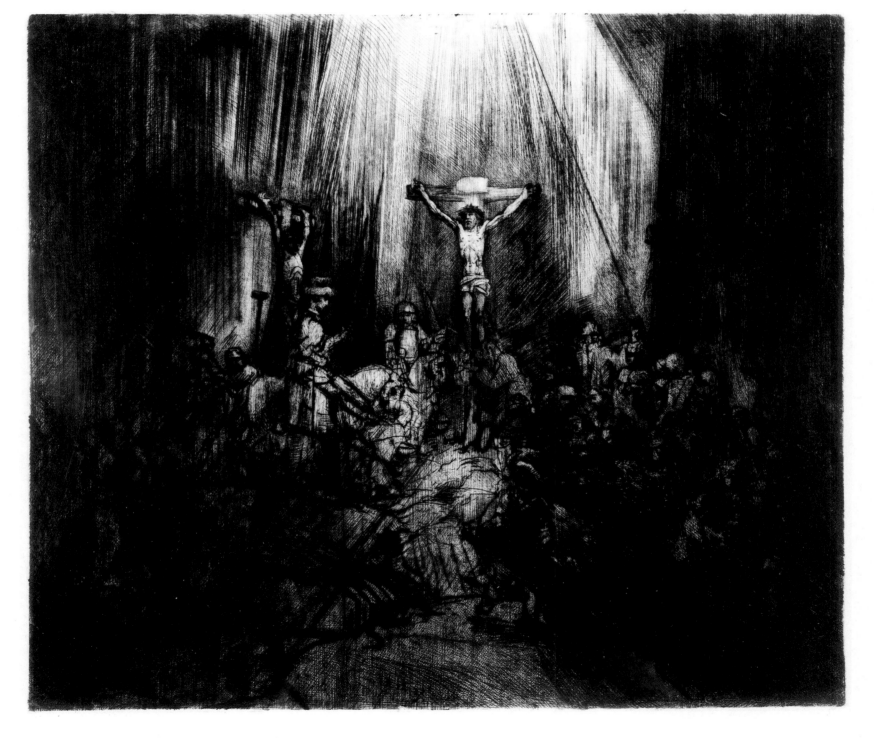

includes a number of other figures, whose individual identities cannot be determined but who collectively convey states of shock and fear. There is no potential here for the indifference found in works such as *La Petite Tombe* (page 180).

Most of the mourners and participants are contained within a cone of blinding light which pierces the surrounding darkness. The gloom is described in the Gospel of Saint Luke: 'and there was a darkness over all the earth until the ninth hour,' at which

point, while the centurion was looking on 'Jesus . . . cried with a loud voice, he said, Father, into thy hands I commend my spirit: and having said thus, he gave up the ghost' (23: 44-49).

So the light can be interpreted not simply as a dramatic form of illumina-

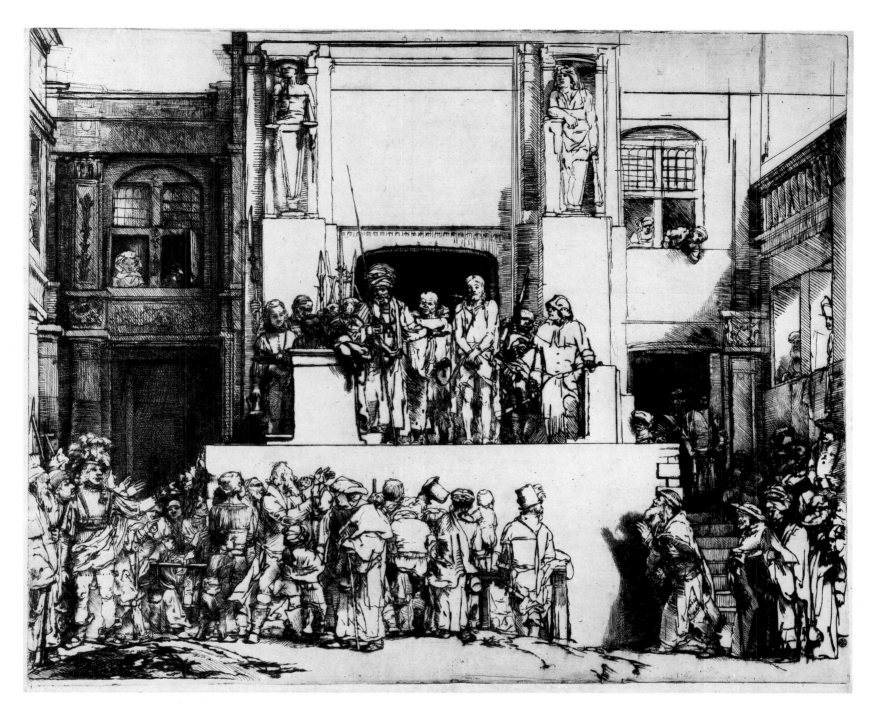

tion, but also as part of the narrative. In addition it helps create a sense of claustrophobia, and enables the viewer to discriminate between the good and bad thieves, because the sinful one, like many other unbelievers, is placed in the semi-darkness at the left.

The figures who are most brilliantly lit are appropriately those which are most sketchily defined – their forms and attitudes can be discerned, but the light has bleached out details of texture. They, like most of the rest of the image, were worked up directly on the plate in drypoint – a technique which allows for a freedom akin to that of sketching. Strokes worked in this manner on the copper throw up a residue on either side of the line made, which is called a burr. When this is left and inked it can create a very rich line. The potential for this type of mark appears to have been exploited particularly effectively here in areas of sketched outlines and shadow (see Appendix 1).

In Rembrandt's fourth state of the print (left), which may have been made some while later, he heavily reworked the composition to create an image that

seems even more apocalyptic. It has been suggested that these changes were made because the plate used for the previous states no longer produced a satisfactory impression.

The most significant difference is in the articulation of the light. Bold groups of dense parallel lines, which dissect each other, not only narrow the tonal range, but are also employed independently of the logical downward direction of the light, particularly in the foreground, to direct attention to the crux of the composition, and isolate Christ.

Some changes to the groups of attendants were also made, for example a figure on horseback with a lance, based on a medal by Pisanello (c.1395 – c.1455), has been introduced at the left. But it seems that the theme running through the work, rather than being a concentration on the complicity of the onlookers, is now the independent status of the suffering Christ, who is set above the mass of obliterated, sinful humanity.

Another print made by the artist in 1655 is thought, for a number of

reasons, to have been created as a possible pendant to, or companion for, *The Three Crosses*. The artist's *Ecce Homo*, which is known in eight different states, two of which are illustrated here (above and page 184-85), is very similar in size to the slightly earlier depictions of Calvary. It is also comparable in terms of technique, compositional principles, and the way in which the artist rethought the design.

In the 1630s Rembrandt had painted the same subject, *Ecce Homo,* in a grisaille which formed a direct preparation for an etching (pages 74 and 75). In both of these works, the confrontation between Pilate and Christ on the one hand, and the crowds on the other, was structured using strong diagonals.

In his new etched interpretation of the subject, however, which was made two decades later, the composition was established on an underlying structure of horizontals and verticals, with the main protagonists centrally placed. The confrontation therefore is as much with the viewer, as with the crowd in the work – an idea which was also applied to *The Three Crosses*.

Rembrandt *Ecce Homo*, 1655, etching (drypoint) (state 8), 15 × 17¾ inches (38.3 × 45.5 cm), British Museum, London. Here Rembrandt quite radically reorganized the composition of his earlier *Ecce Homo* (page 183), by having the plate polished in certain areas and working on it again. Many of the figures in the foreground were removed and replaced with two arches, which appear to have a sculpted figure of an old man in the shadows between them.

Inspiration for this arrangement appears to have been provided by an interpretation of *Ecce Homo* made by the great sixteenth-century printmaker Lucas van Leyden, which similarly had the main figures placed on a platform that lies parallel to the picture plane. Rembrandt is known to have collected the works of this artist, who came from the town of his birth.

In the fourth state of the print (page 183) Pilate, who wears a turban and carries a staff of justice, points to Christ and so is depicted at the precise point at which he declared 'behold the man' (Ecce Homo). Between them and slightly further back stands Barabas, the criminal who was given his freedom instead of Jesus, and to the left of Pilate is an intriguing anecdotal figure who appears to be either a scribe, or an artist who leans on the masonry and records the event.

Above this group are two statues, which ironically represent Justice and Fortitude, while below, and at the right and left, are the crowds who demanded Christ's death. The figures are all defined with an angular felty line which was made by using the drypoint technique that was heavily employed in the *Three Crosses*. One of them, a man standing in the foreground at the left, wearing a theatrical costume and feathered hat, seems to be introducing the trial to us rather than to any one within the work, and the bearded man standing next to him, at the very edge of the print, appears to be a rehearsal for Rembrandt's depiction of *Homer* (page 164).

The scheme of lighting here is far tamer than that used in the *Three Crosses*, but not entirely dissimilar. Essentially the illumination is very bright in the center of the composition – this is particularly emphasized by the shadow of the figure in the right foreground – and is framed by darker accents.

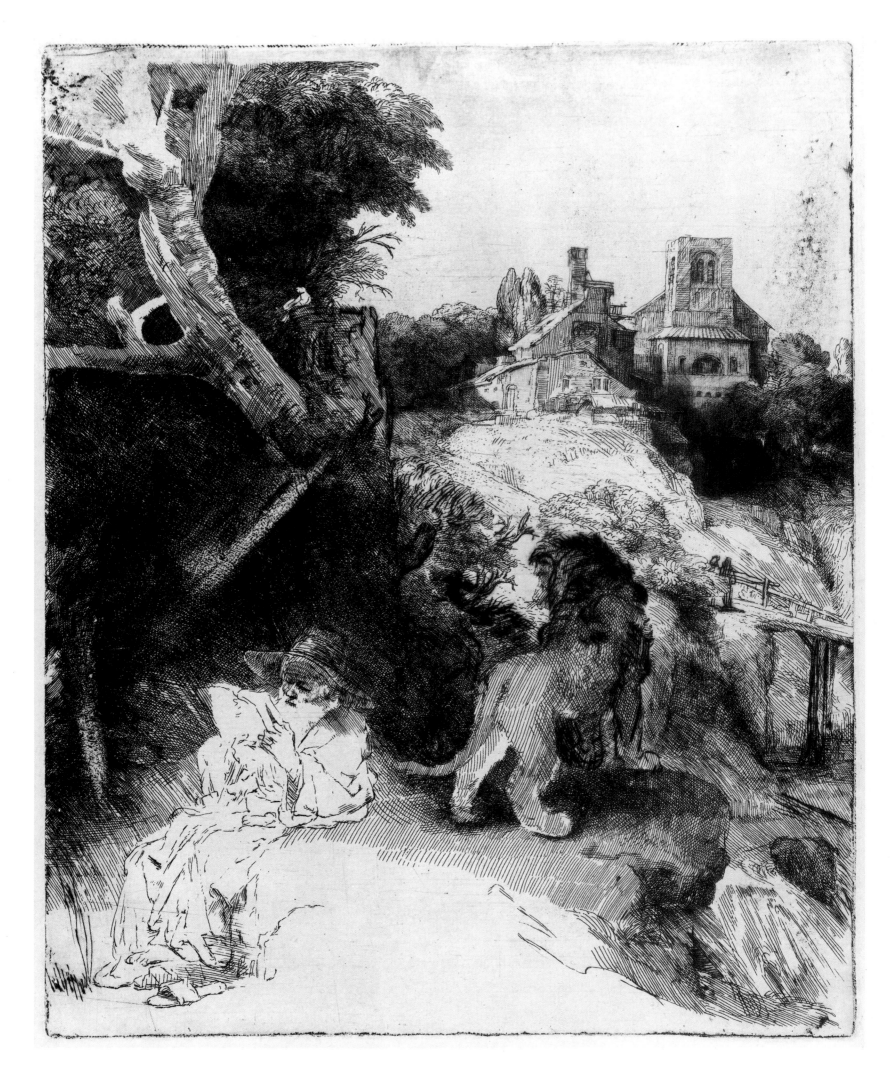

ABOVE Rembrandt *Saint Jerome in an Italian Landscape, c.*1654, etching (drypoint) (state 1), 10⅛ × 8¼ inches (25.9 × 21 cm), British Museum, London. Saint Jerome is depicted in the shade at the lower right. He is accompanied by the lion from whose paw, according to legend, he removed a thorn.

BELOW Rembrandt *Lion Lying Down,* late 1640s, pen and brown ink with brown wash on paper, 5⅜ × 8 inches (13.8 × 20.4 cm), Cabinet des Dessins, Louvre, Paris. Rembrandt and some of his pupils made a number of studies of lions which were imported to the United Provinces from North Africa by the East India Company.

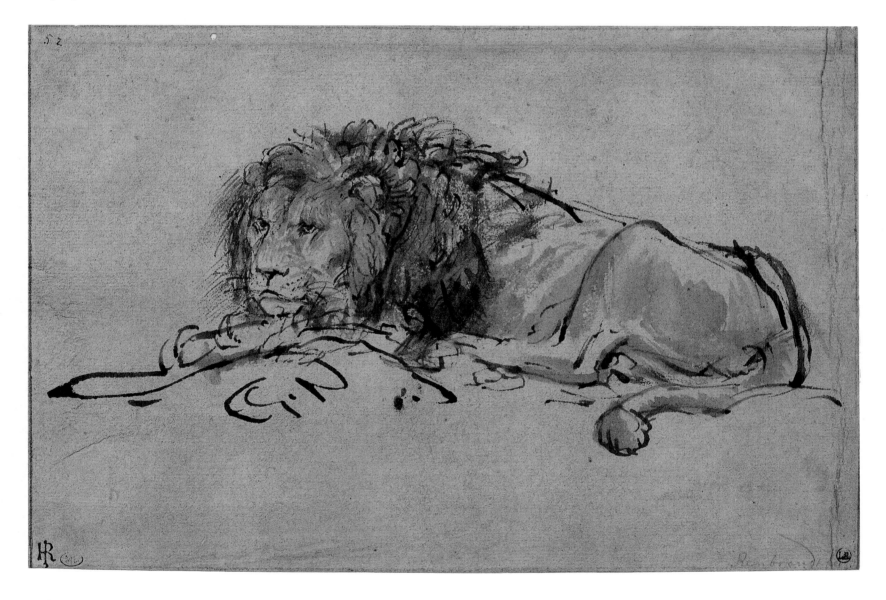

It is altered considerably in Rembrandt's reworking of the image which is recorded in the eighth state of the print (pages 184-85). The nature of this transformation is again comparable to the radical reworking which *The Three Crosses* had undergone.

Here Rembrandt smoothed down the copper plate and entirely re-organized the foreground, so removing the crowd and replacing it with two stone arches. He also darkened and added details to a number of other regions of the image, and in its new state signed it above the doorway at the right. He may have done all this because he considered the earlier composition unsatisfactory. It is certainly true that the mass of spectators in the foreground did not appear as an angered crowd, whereas the darkened arches provide an additional element of menace.

Not all of Rembrandt's religious prints of the 1650s dealt with such momentous events. Quite a different mood altogether is conveyed by his sun-filled depiction of *Saint Jerome in an Italian Landscape* (left), which is dated to about 1654. Saint Jerome, with his legs crossed and sandals off, is depicted in the shade at the lower right, studying a text. He had, according to a fable, removed a thorn from the paw of a lion which then became devoted to him, hence the appearance of such an animal here.

The artist drew lions from life (above) in the late 1640s, and such studies must have formed the groundwork for their inclusion in works such as this.

The landscape and buildings are reminiscent of similar details from sixteenth-century Venetian prints and paintings, which appear to have particularly pre-occupied Rembrandt during the 1650s.

Rembrandt's interest in earlier Venetian art was also expressed implicitly in the rich warm coloration of some of his paintings of this period, notable among which is the artist's *Bathsheba* (right), which was executed in the same year as the Saint Jerome etching.

Bathsheba, who was the wife of Uriah, was a woman renowned for her beauty. She was asked by King David to visit him and the couple slept together. When Bathsheba became pregnant, the king asked Uriah to visit her. But he refused, and so David ensured that he would be killed in battle. Bathsheba then mourned for her husband, before eventually becoming David's wife (II Samuel 1: 2-26).

Rembrandt's large painting is usually thought to illustrate the point in the narrative at which Bathsheba receives King David's message, which invites her to visit him. But there is an element of ambiguity here, because at least two other sections of the story could alternatively be depicted – her receipt of news of her husband's death, or her invitation to marry David.

There is no mention of a letter in the Bible, so whichever incident is thought to have been chosen is dependent mainly upon how you interpret the expression of Bathsheba. She has clearly read the letter, and now contemplates its contents, almost oblivious to the elderly attendant who carefully dries her feet. Her sadness might imply the loss of her husband, but the fact that she is at her toilet and has sumptuous clothes lying beside her, may suggest that she is preparing to go to marry David. Perhaps what Rembrandt has done here is to repeat a procedure he followed on a number of other occasions, and conflate incidents to create a new image, which is more an emotional statement, than a direct translation of a text.

X-rays of the face of Bathsheba reveal that Rembrandt quite radically altered her pose and expression while working on the composition. In the first instance he showed her looking up at the viewer in an imploring fashion, in a very similar manner to the way in which he depicted Susanna in his painting of 1647 (page 148). This would have had really quite different implications for the mood of the work.

Whatever the artist's intentions were about the moment chosen, it is clear that uppermost in his mind were the questions about how to paint a life-size nude. The concentration of tenderness in its depiction places it some way between the ideal and the actual. The artist's facility for layering glazes of paint enabled him to simulate in an almost palpable fashion the qualities of the body, in terms of weight, form, texture and color.

Bathsheba dominates the composition, which is essentially constructed from a relatively simple series of interlocking horizontals and verticals. Such simplification characterizes a number of Rembrandt's other works of these years, such as *Aristotle Contemplating the Bust of Homer* (page 160) and *Flora* (page 165), in which the same model appears to have been used.

Rembrandt *Bathsheba with King David's Letter*, 1654, oil on canvas, 55½ × 55½ inches (142 × 142 cm), Louvre, Paris. Painted with a warm, sympathetic palette, this is justifiably one of Rembrandt's most celebrated studies of the female nude.

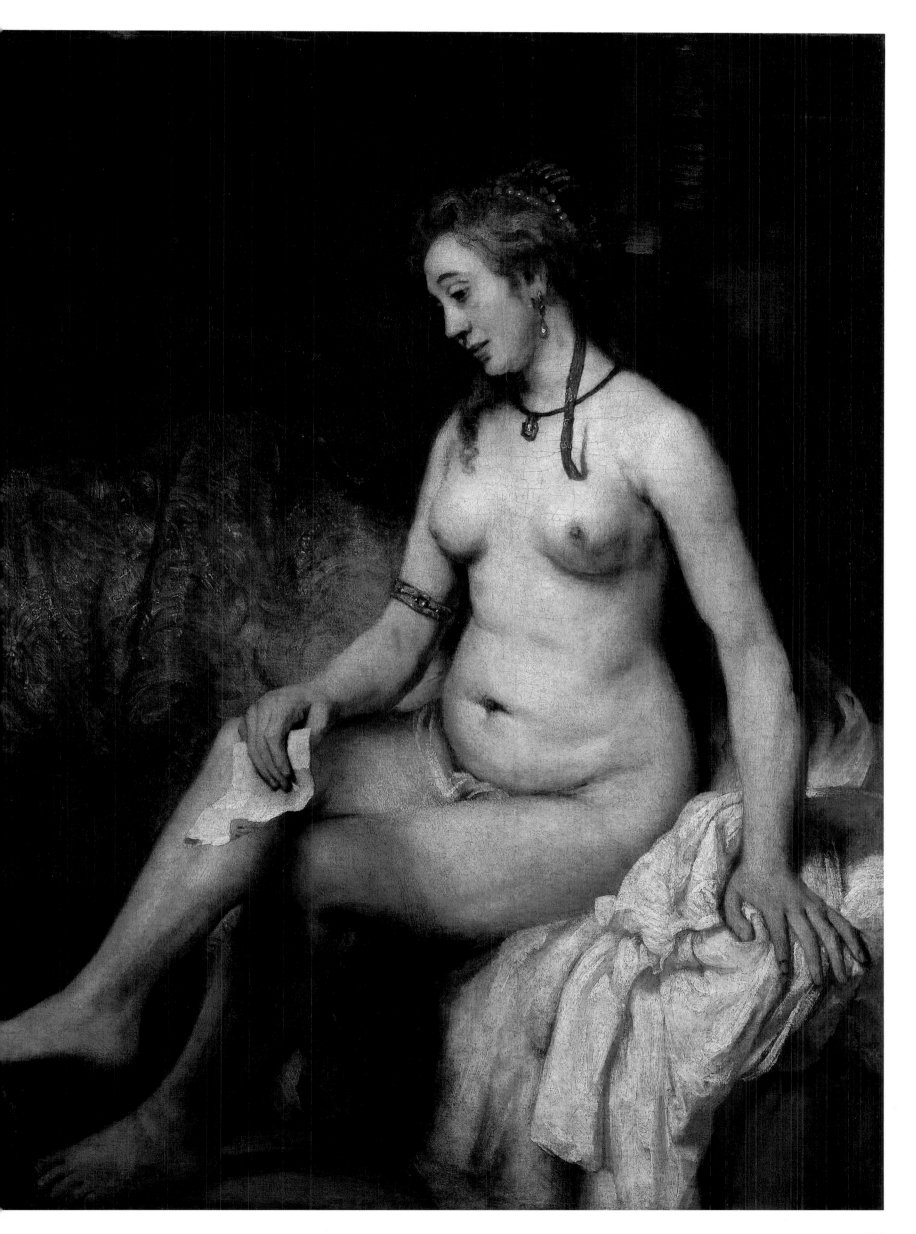

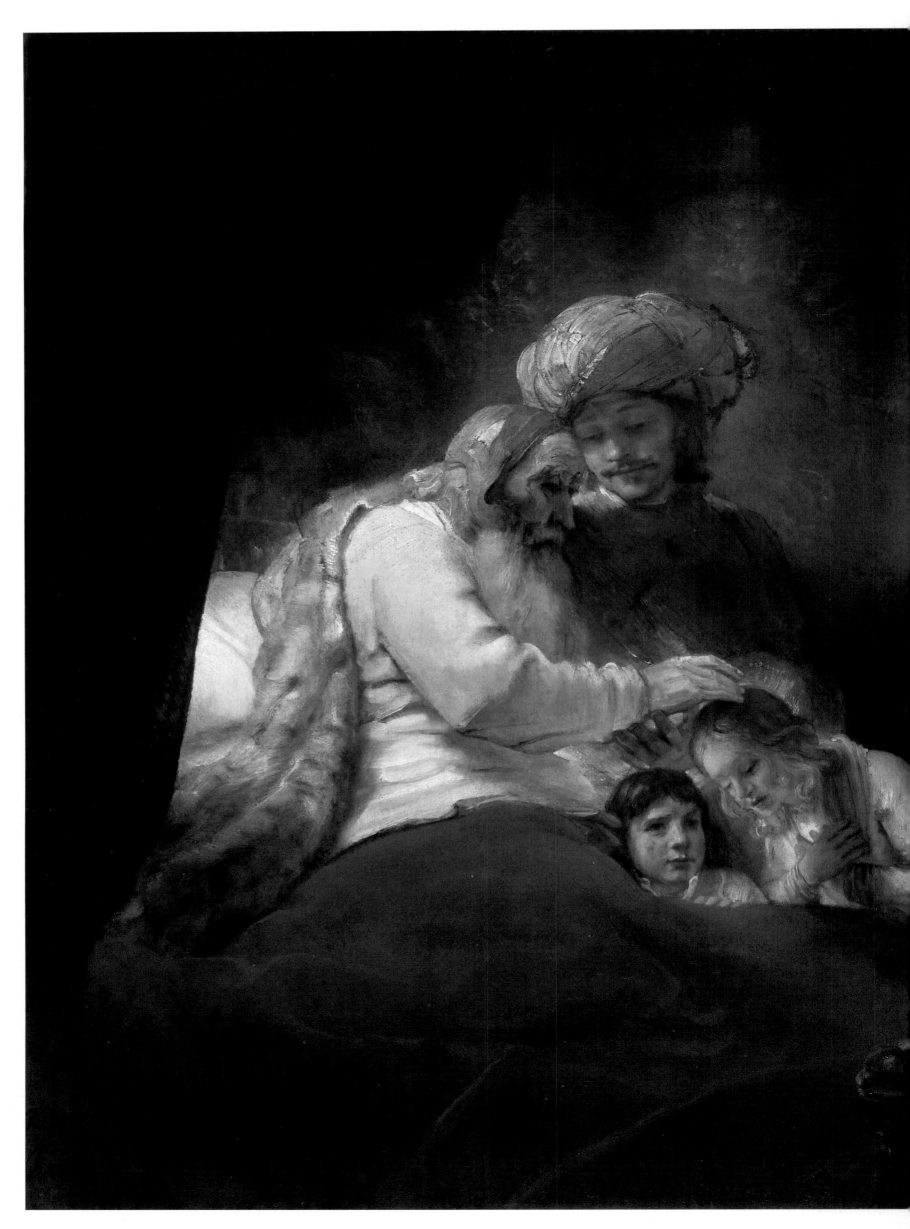

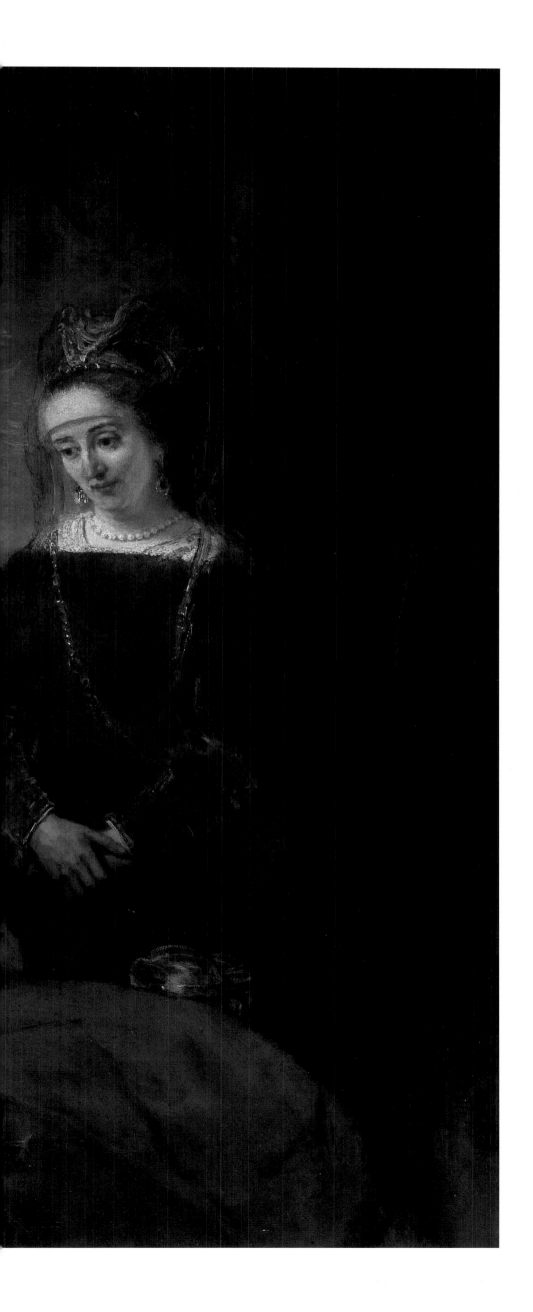

Rembrandt *Jacob Blessing the Sons of Joseph*, 1656, oil on canvas, 68½ × 82¼ inches (175.5 × 210.5 cm), Gemäldegalerie, Kassel. The patriarch Jacob is shown favoring the younger of his grandsons, Ephraim, by blessing him before his brother. He acted in such a way because he knew the boy was destined for a greater future.

Rembrandt returned to some of the compositional principles he had used much earlier in his career for other painted depictions of Biblical subjects from the 1650s. In *Jacob Blessing the Sons of Joseph* (left), of 1656, he employed a design and lighting scheme, with an interior framed by darkened drapes and lit internally from the upper left, which recalls works of the 1630s such as the *Danaë* (page 104) and *The Blinding of Samson* (page 94-95).

The mood, however, is utterly different. This is a solemn image, infused with a heartfelt spirituality, that illustrates a benediction given by the aging patriarch Jacob.

Joseph's father Jacob was blind, and gave greater honor to the youngest of his grandchildren by blessing him with his right hand, because he knew of the boy's destiny.

And Israel [Jacob] beheld Joseph's sons, and said, Who are these?
And Joseph said unto his father they are my sons . . . And he said, bring them, I pray thee, unto me, and I will bless them.
Now the eyes of Israel [Jacob] were dim with age, so that he could not see . . . and he kissed them and embraced them . . .
And Israel [Jacob] stretched out his right hand, and laid it upon Ephraim's head, who was the younger, and his left hand upon Manasseh's head, guiding his hands wittingly . . .
And when Joseph saw that his father laid his right hand upon the head of Ephraim, it displeased him . . .
. . . his father . . . said, I know it my son, I know it . . . [the] younger brother shall be greater.
And he blessed them that day . . .
Genesis 48: 8-20

The moment shown is that at which Ephraim, with his hands crossed before him, is blessed. There appears to be an aureole around his head. The elder brother and father look on, as does Asenath, Joseph's wife.

BELOW Rembrandt *Self-portrait Drawing at a Window*, 1648, etching (drypoint and burin) (state 2), 6¼ × 5 inches (16 × 13 cm), British Museum, London. The etching is signed at the upper left: *Rembrandt. f. 1648.*

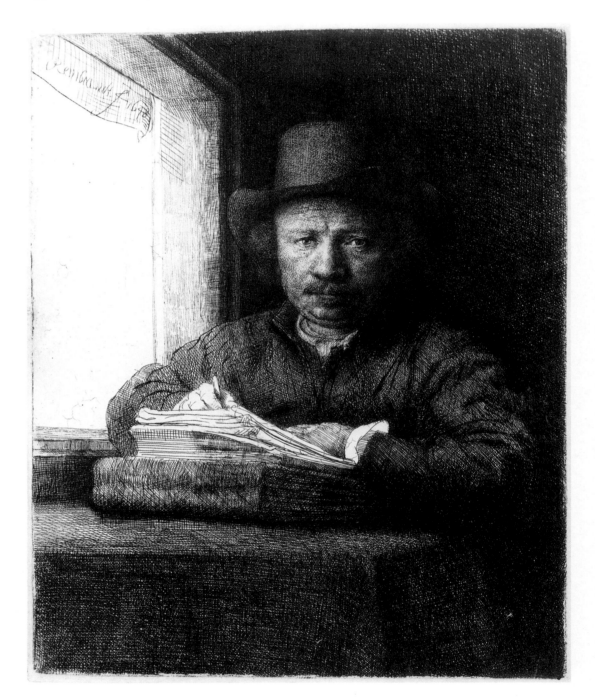

According to a theory proposed by Schwartz (1985), this work may have been painted for the councillor Willem Schijver, and could be a family portrait in the guise of a history painting, a *portrait historié*. That such a commission might have been made seems a reasonable assumption, but the idea that this is a group portrait is unlikely, chiefly because the figures appear insufficiently individualized, and the models seem to have been used elsewhere in the artist's work. The theme is essentially one of rightful inheritance, however, appropriate for a familial commission.

The handling of paint here is an exercise of great accomplishment – it varies appropriately, depending on the texture being represented. This differentiation becomes particularly clear if you isolate and look at a specific area, such as the head of Jacob, where the headdress is defined with broad rich strokes, while the features and beard are more sparingly worked up.

Self-Portraits

Rembrandt's self-portraits from the late 1640s and early 1650s expand on earlier themes he explored in works of this type – the subject as 'artist', 'thinker', and somewhat theatrical 'man of prestige', or 'courtier'. These works still appear as exercises in exploring infinitesimal variations in expression, posture, lighting and dress, but also increasingly become images projecting a particularly forceful impression of the individual. It is perhaps no accident that such paintings helped propagate the reputation of the artist and later led to much of the mythologizing about his work. They have an undeniable confrontational appeal.

The artist's *Self-Portrait Drawing at a Window* (right) of 1648 shows him at the age of 42, steadily working. It has in the past been suggested that he has here depicted himself etching, but there is no sign of a plate, and the pile of paper he works at would imply that he is sketching. His clothing is sober and workmanlike, and the impression conveyed by the print is very much one of a studious and purposeful attitude towards his profession.

Rembrandt also wears a hat, and what are probably clothes he wore in the studio, in a later self-portrait which is now in the Kunsthistorisches Museum, Vienna (right), that has been variously dated between 1655 and 1657. This is a 'close up' study of Rembrandt's features, in which a sense of considerable intimacy is achieved because of the way he fills the available space. The warm light which falls from the upper left defines his physiognomy in a sympathetic fashion.

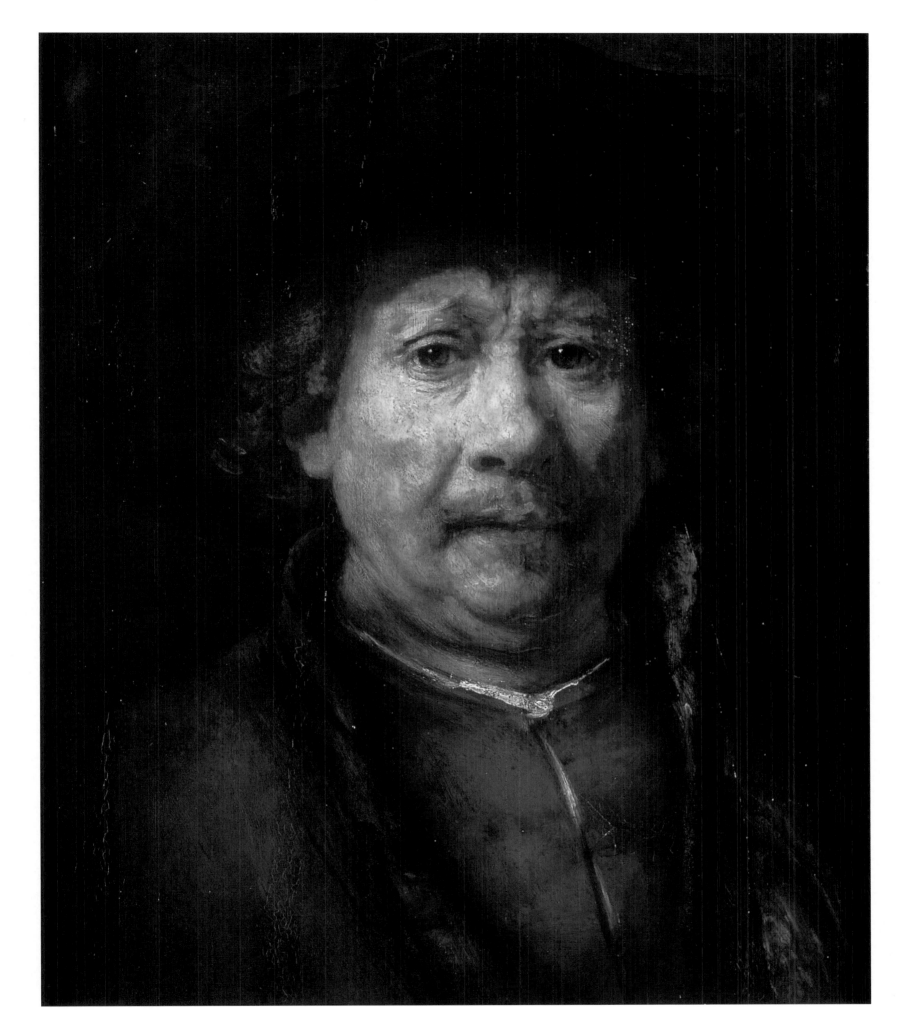

ABOVE Rembrandt *Self-Portrait*, c.1655, oil on
wood, 19¼ × 16 inches (49.2 × 41 cm),
Kunsthistorisches Museum, Vienna.

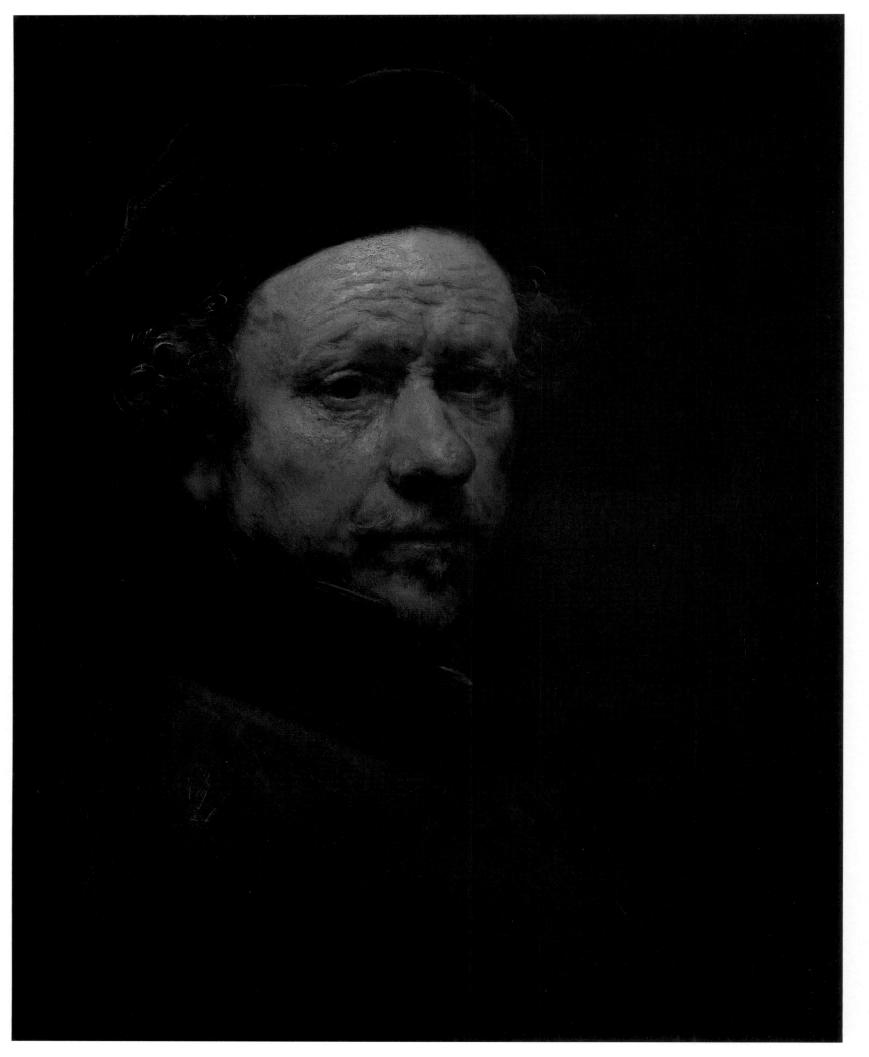

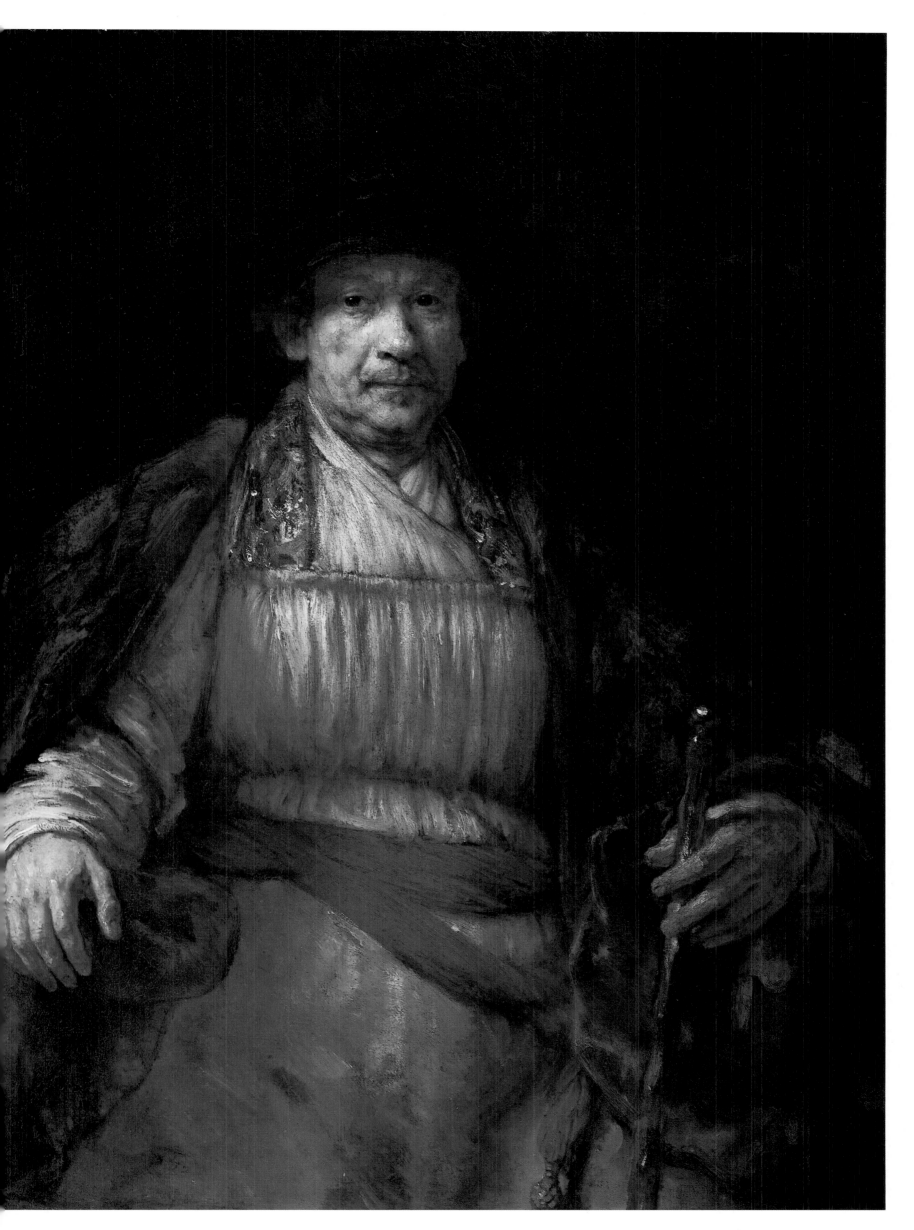

A harsher, whiter scheme of lighting results in a more crisply delineated portrayal which is now in the collection of the Duke of Sutherland (page 194). This work, which is dated at the lower right to 1657, returns to a pose Rembrandt employed much earlier in his career (page 34), which gives the impression that the artist has just turned to face the viewer.

It is thought that this self-portrait may originally have been larger. When it was restored in the 1930s pieces of canvas which were added on all four sides were removed. They may not have been original, but possibly reflected the nature of the format the artist intended.

In spite of their qualities, the etching and Vienna and Sutherland self-portraits appear tentative when compared with the ambition and power of the largest of this group of works – Rembrandt's slightly later *Self-Portrait* of 1658, which is in the Frick Collection in New York (page 195).

Here the fifty-two-year-old painter has depicted himself larger than life – both literally and in terms of the guise he has adopted. He seems to be not just seated, but rather enthroned, and wears clothes suitable for, and carries a staff worthy of, a monarch. No doubt these trappings were theatrical props from his studio, but the use to which he puts them and the frontal and hieratic pose give a compelling impression of regality.

But why make such an image? There seem to be no clear-cut answers to this question. It may be that the work is a statement of defiance, in view of Rembrandt's recent impoverishment and humiliation, or the creation of a form of escape. In an odd way though, the authority the artist here commands is most effectively conveyed not by the pose or costume, however self-aggrandizing these may seem, but by his mastery of the paint.

1660s

That noble brush need not ask for anyone's praise, It is famous by itself, and has carried its master's name Probably as far as Netherlanders sail.

From Jeremias de Deckers' poem in praise of Rembrandt, 1667

At the beginning of the decade Hendrickje and Titus established a company, with Rembrandt as an employee, so that they could still sell his paintings, along with prints, drawings, engravings and 'curiosities', in spite of continuing pressure from creditors. The reasons for this arrangement must have been apparent to many, but no objections appear to have been raised.

The family had moved house and established a new home on the Rozengracht, in an area that was occupied by small-time artisans, shopkeepers and a few artists. These relatively impoverished circumstances must have provided a pointed contrast with the opulent lifestyle Rembrandt had once known.

In 1661 Hendrickje made out her will, according to which her belongings were to be left to Rembrandt's children. This decision seems to indicate her full integration with the family, despite the fact that she was never legally married to the artist. She died in 1663, possibly of the plague which swept through the city in that year, and was buried in the Westerkerk, where Rembrandt was to be laid to rest six years later.

Titus took over control of the art dealership and continued to help his father who, although limping financially, was still making great aesthetic strides. During the 1660s Rembrandt's paintings are characterized by an extraordinary unfettered technique, with which he seems at one moment almost to sculpt the desired forms, by frequently building up paint with a palette knife, and at another to skim across the canvas with the lightest of touches. On close inspection of these works, which are executed in his so-called 'rough manner', expectations about what a hand, or eye, or sleeve ought to look like are defied, but overall pictorial logic is still retained. The intention remains to create the illusion of the appearance of an object or person, but the process – the selection and application of the paint – takes on an additional, more intrusive, and often highly expressive significance. This apparent freedom, which is actually carefully controled and based on a lifetime's experimentation, has been compared with the techniques used by the elderly Titian. Its application resulted in the creation of what are now considered not only some of Rembrandt's greatest works, but also some of the most haunting and powerful paintings ever created in oil.

Commissions came, but this highly individual approach appears increasingly to have been out of step with wider trends. This discrepancy is most poignantly illustrated by the apparent rejection by the burgomasters of Amsterdam of *The Conspiracy of Claudius Civilius* in 1662 (pages 198-99).

The broad style of Rembrandt's later years did not, however, die with him. In 1661 he took on another pupil, Aert de Gelder (1645-1727) who, when later painting as an independent artist, continued reinterpreting his master's mature work on into the eighteenth century.

Rembrandt's approach at this period may not have been deemed appropriate for large public commissions, such as the *Claudius Civilius*, but still seems to have been regarded as suitable for portraiture. He continued to develop his skills as a painter of pendant portraits (pages 206 and 207) and group portraits (page 208), and also extended his range in this field by executing an equestrian portrait (page 213).

BELOW Johannes Lengelbach, *The Dam at Amsterdam with the New Town Hall under Construction*, 1656, oil on canvas, 47¾ × 80½ inches (122.5 × 206 cm), Historiches Museum, Amsterdam. Amsterdam's new Town Hall, in which Rembrandt's painting of *The Conspiracy of Claudius Civiiius* (page 198) was briefly to hang, is here shown at the left, whilst still being built. Designed by Jacob van Campen in a classical style, it was constructed between 1648 and 1673. The other buildings which can be seen are, (left to right): the Nieuwe Kerk, the Weighhouse, and in the distance the tower of the Oude Kerk.

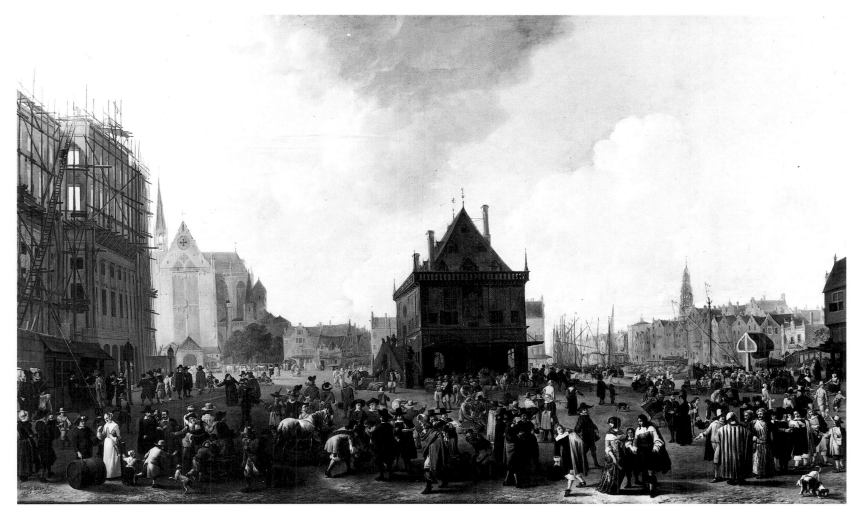

The artist in addition completed his third painting for the aristocrat Don Antonio Ruffo (page 164). The reputation that such projects brought with them was expressed later when in 1667 Prince Cosimo de Medici visited Amsterdam. He made a point of going to see 'Rembrandt the famous painter,' as well as a number of other artists, and may have returned to Florence with one of his self-portraits.

Rembrandt's late self-portraits become increasingly introspective, and as such follow a trend that can be plotted elsewhere in the artist's work during the last nine years of his life. He becomes less and less concerned with the externals of life, at a time when his own material circumstances were reduced, and instead turns his attention inward, to confront questions about the nature of identity and relationships at a fundamental level. It is perhaps not insignificant in view of this that few genre scenes and no landscapes – records of the world around – were produced during the 1660s.

The Conspiracy of Claudius Civilius

Rembrandt's most important public commission for a history painting came when he was asked to execute a work for the Town Hall in Amsterdam. It was to be the first in a series of large canvases, by different artists, that were set into lunettes around the top of a gallery in the new building.

The Town Hall (above), which was designed in a classical style by Jacob van Campen, was a focus of civic pride, and its decoration, both sculptural and painterly, included many of the most prestigious commissions of the period. Since the Napoleonic era the building has been used as a royal palace.

The painting Rembrandt delivered (pages 198-99), is now only known in a

Rembrandt *The Conspiracy of Claudius Civilius*, 1661-2, oil on canvas, 76½ × 120¾ inches (196 × 309 cm), Nationalmuseum, Stockholm. This is the remaining fragment of Rembrandt's largest painting, which was commissioned to decorate part of a gallery in the new Town Hall in Amsterdam. The scene shows the leader of the Batavians, who were early inhabitants of the Netherlands, making his followers swear an oath in defiance of the Romans who occupied the country. The picture was removed just after it was put in place, and never rehung in the new building. Its rejection may possibly be explained because the artist's mature approach seems to have been out of step with current fashion, but could also, as Schwartz (1985) has suggested, be explicable as part of a scheme of political manoeuvring by new burgomasters who controlled the commission.

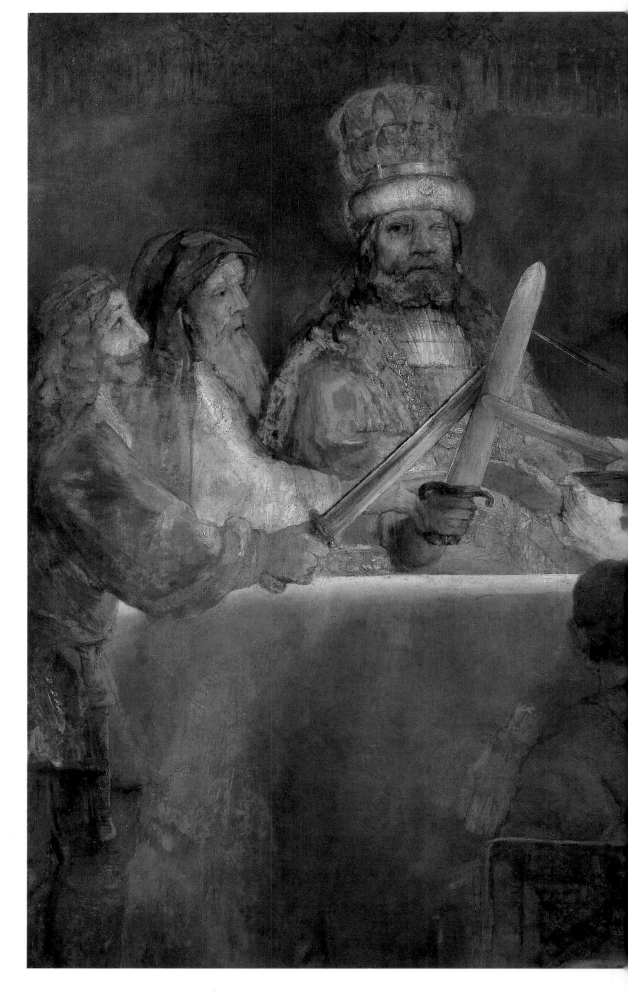

fragmentary state; in its original form it was larger than the *Night Watch*, and as such was the most monumental work of his entire career. Its subject, which was specified by the burgomasters – *The Conspiracy of Claudius Civilius*, may now seem obscure, but at the time was considered very pertinent to the young Republic.

It comes from the *Histories* of Tacitus (Book IV: 13-16). According to this text the Batavians, who were early inhabitants of the Netherlands, revolted against the occupation of Rome in the 1st century AD. This situation was seen as being analogous to the rebellion against the Spanish, which had started in the sixteenth century and led to independence. Such a historical precedent provided legitimacy for the recent struggle, and references to it formed part of a complex process of self-definition for the intelligentsia of the United Provinces. The same subject was used to mark the declaration of the Twelve Years Truce in 1609, when Otto van Veen was commissioned to paint works to decorate the assembly chamber in The Hague.

Rembrandt depicted the leader of the revolt of the Batavians, Claudius (or Julius) Civilius, swearing an oath of liberty with the chiefs he had assembled. He called them together at night in a sacred wood, ostensibly to have a banquet, but took advantage of the gathering to inspire the warriors to fight for freedom. According to Tacitus, Claudius Civilius had lost an eye, and Rembrandt shows him partially blinded.

The artist conceived the solemn occasion as a sort of secular Last Supper, with the participants grouped around a table. Their faces are illuminated by an unseen, flickering light source. It defines them against the murky backdrop, as a circle of initiates, and emphasizes the sanctity and secrecy of the occasion.

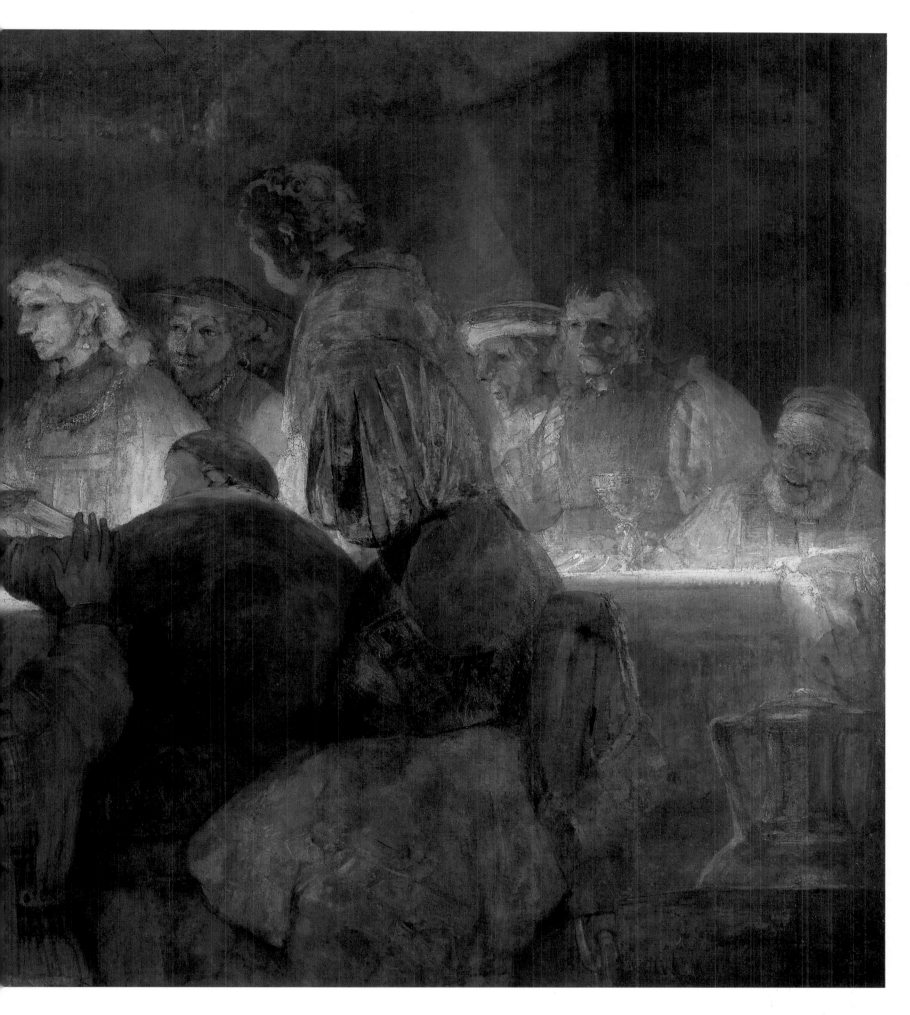

BELOW Rembrandt *The Conspiracy of Claudius Civilius*, 1661, pen and brown ink with brown and white wash on paper, 7½ × 7 inches (19.6 × 18 cm), Staatliche Graphische Sammlung, Munich. A compositional sketch, showing the complete design of the painting Rembrandt executed in 1661-2 for the New Town Hall in Amsterdam, of which only a fragment survives. It is drawn on the reverse of a funeral ticket.

BELOW Photograph of the interior of the south gallery of the former Town Hall, Amsterdam.

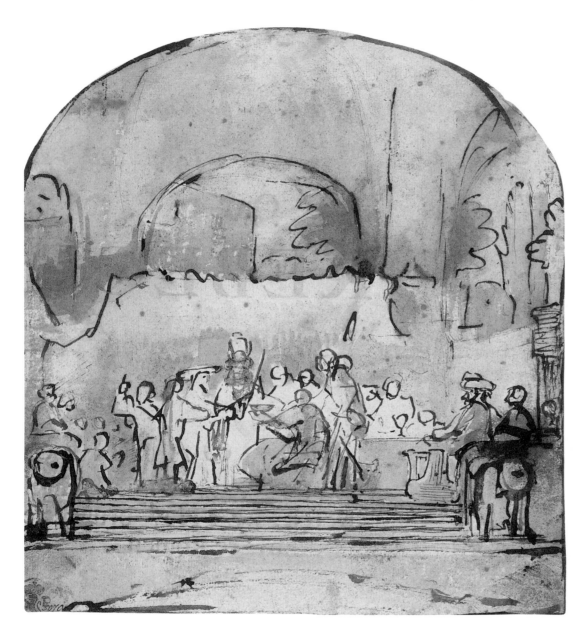

The vow is actually taken by touching swords. This motif appears to be quite an original one, for which Rembrandt was responsible. Such an action is not referred to in the text, and in earlier representations of the incident the figures are shown more prosaically shaking hands.

The application of paint is very broad and disarmingly free in places, but it is necessary to remember that the work was intended to be set high on a wall, and so the distance between the viewer and the painting might in part com-pensate for such an approach. It may well have been painted *in situ*.

When completed the painting, as has been noted, was much larger than it now appears. The nature of the original composition is recorded in a drawing in Munich (above). This reveals the scene as being set in a grand architectural space. The banquet was set at the top of a flight of steps, perhaps before a hanging, in a huge vaulted interior. Through the arches at the rear foliage can be seen – as close as Rembrandt got to depicting the 'sacred wood'.

BELOW Rembrandt's compositional study of his *Conspiracy of Claudius Civilis* with the surviving oil painting superimposed on it to give some idea of the original effect intended.

·When you look at a photograph of the interior of the Gallery as it appears today (above) it becomes clear why the artist chose to set the scene beneath a series of arches, because those within the painting would reflect the articulation of the architecture in the surrounding space.

The commission was not initially given to Rembrandt. In the first instance his pupil Govert Flinck was asked to paint in all 12 paintings for the Gallery, including the eight lunettes. Whether or not Rembrandt considered this a snub is not recorded, but because

of a twist of fate in his favor, the artist was eventually to work on the series.

Flinck made sketches for four of the compositions, and started painting *The Conspiracy of Claudius Civilius*, but died in February of 1660, about two months after he had embarked upon the project. The commission was then divided up and given to Jan Lievens, Jacob Jordaens and Rembrandt.

Rembrandt's contribution, which took the place of the canvas Flinck had started, is recorded in the Town Hall from 21 July 1662. It appears that it was

put in place, but then almost immediately removed and never returned to the site for which it was intended.

Exactly why the painting was rejected has not been established, although a number of theories appear to come close to an explanation. According to an idea proposed by Schwartz (1985) the taking down of the work may be explicable as part of a scheme of political manoeuvring by newly elected burgomasters who controlled the commission.

This is possible, but it may also be conjectured that the authorities wanted the artist to alter the work. Rembrandt may have removed it in order to change it, but then not satisfactorily met these new demands. It appears likely that the painting was then cut down in order to make it resaleable.

The alterations might have been desired because the painting did not fit comfortably with the 'classicist' aesthetic then prevalent, which found expression in the architecture of the Town Hall and the other contributions to the series of pictures. In Rembrandt's history painting the mystery of the event is emphasized, but the figures do not appear as elevated archetypes of military glory (as they might have if Jordaens or Lievens had treated the subject). Instead, they are shown as a mixed collection of aging, and perhaps all too human soldiers.

Other, less lofty factors, may also explain the rejection of Rembrandt's work. The scale of his figures, in relation to the surface of the canvas available, was quite small compared with that of the figures in the other surviving works from the scheme. It is also possible that the authorities tired of the artist because he worked slowly, and they were expecting important visitors.

The commission was passed on a second time to an artist called Jurriaen Ovens, who rapidly finished the work Flinck had started. His painting was

put in place, and momentum for the overall commission seems then to have dwindled because not all of the other spaces were ever filled.

Later, Rembrandt's canvas was sold at an auction in Amsterdam in 1734 to a Swedish merchant for a mere 60 guilders, and so reached Stockholm, where it now hangs in the Nationalmuseum.

Seen through modern eyes, which are accustomed to some of the harsher excesses of twentieth-century expressionist painting, its thick, almost sculptural brushwork appears admirable, rather than disturbing. But to contemporaries it must in many ways have seemed an anti-history painting. Given an opportunity to produce a large public pictorial statement in which idealized figures were supposed to play the role of exemplars, Rembrandt seems to have subverted tradition.

His heresy is now recognized as genius, but in 1661 it meant that a work by an unexceptional artist hung in the place of Rembrandt's own.

Juno and Lucretia

During the 1660s Rembrandt painted two memorable studies of powerful mythic and legendary women. The first, *Juno* (right), was executed in about 1662-5. The subject was the most important of goddesses in Greek and Roman mythology, who was both the sister and wife of Jupiter. She was associated with great wealth, and this quality might explain the commission for the work.

In 1665 a collector called Harmen Becker, who is known to have been in contact with the artist, complained that a depiction of the goddess which he had ordered was not as yet completed – it is not certain, but he may have been referring to the *Juno* illustrated here.

Jupiter frequently duped Juno, and by disguising himself enjoyed numerous love affairs, some of which

Rembrandt had earlier depicted. But here she is by no means treated unsympathetically as a weak figure. She appears as a serene and resolute woman, who is portrayed with regal trappings – a crown, ermine gown and staff. The artist possibly conceived her in this way because he may have been inspired by a print of the goddess designed by Elsheimer, in which she is similarly portrayed.

Her identity in the painting is established because she is accompanied by one of her attributes, a peacock, which can be discerned with some difficulty at the lower left. According to Ovid's *Metamorphoses*, Juno sent the hundred-eyed giant Argus to watch over Io. But Argus was killed by Mercury, and so in memory of him, Juno placed his eyes on the tail of her peacock.

Juno was a goddess who could be shown as steadfast in the face of male abuse, but the subject of the second of Rembrandt's studies of this type, *Lucretia* (page 204), was a mortal who took her life because of her perceived shame at the hands of a man. According to Book 1 of Livy's *History of Rome* she was raped by Sextus Tarquinius, the son of the ruler of the city, and after telling her husband, Colattinus, what had happened, could not live with the dishonor, so committed suicide. Later her death was avenged by Colattinus and Lucretia's brother Brutus, who together killed Tarquinius.

Rembrandt depicts the tragic climax of her story. The bloodstain shows that she has already made the fatal strike. Her expression appears not necessarily to register pain, but profound reflection on the wrong that has been done to her. The way in which she clasps the cord for support at the right seems to have little to do with the narrative, but to reflect a common studio practice of giving models a rope to cling on to when they are sustaining a single, perhaps awkward, pose for a long period.

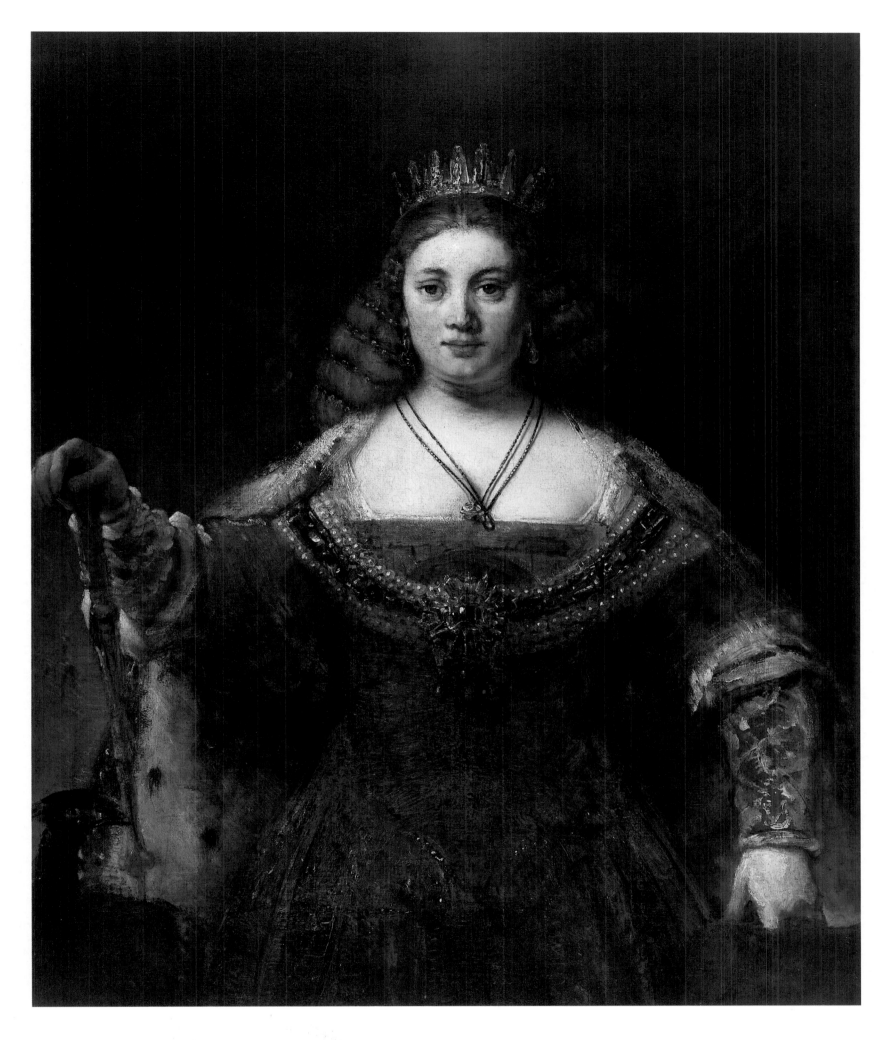

Rembrandt *Juno*, *c*.1661, oil on canvas, 49½ ×
42 inches (127 × 107.5 cm), Armand Hammer
Foundation, Los Angeles. The goddess Juno
was both the sister and wife of Jupiter. Her
portrayal in this manner may have been
inspired by a print by Adam Elsheimer.

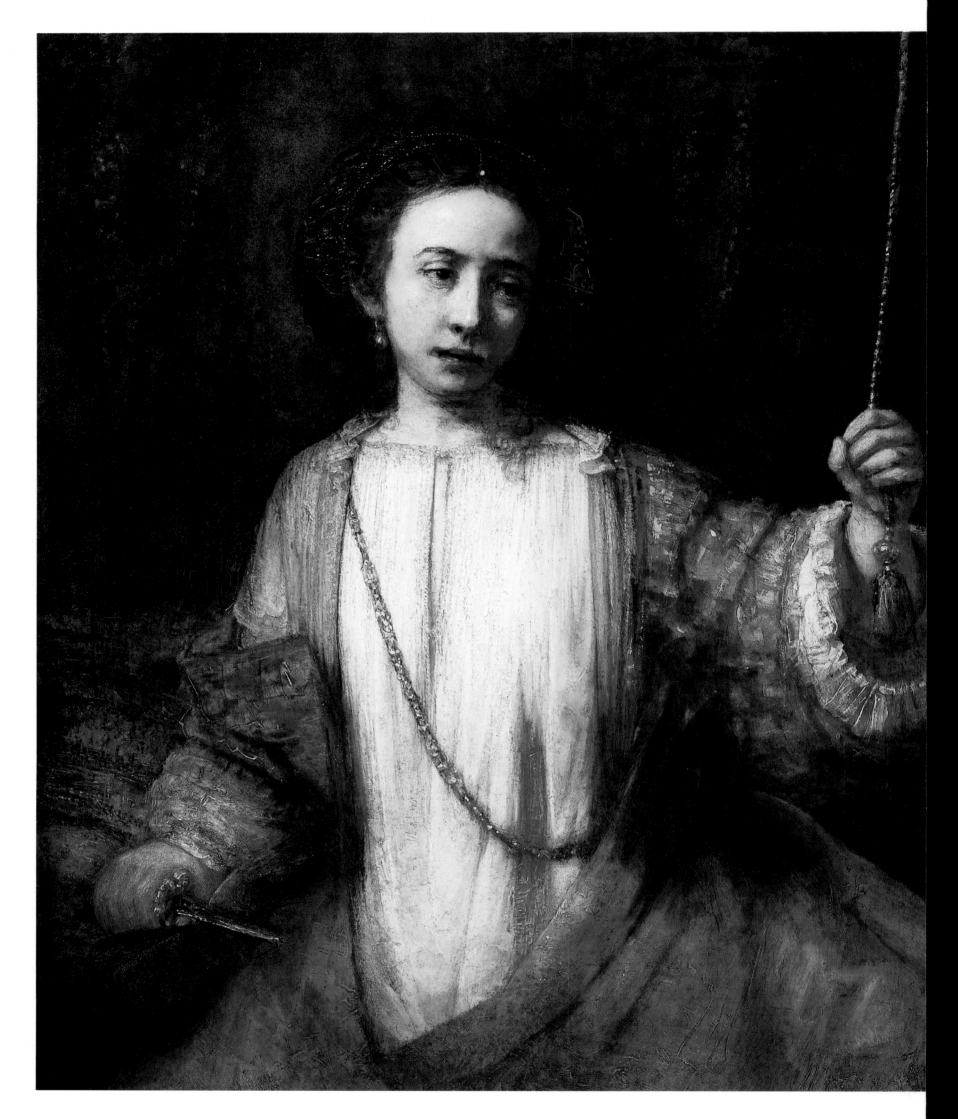

Rembrandt *The Suicide of Lucretia*, 1666, oil on
canvas, 41 × 37¼ inches (105.1 × 95.3 cm),
Institute of Art, Minneapolis. Lucretia was a
victim of rape who could not live with her
perceived shame, and so committed suicide.

Portraiture

There was no discernible decline in Rembrandt's abilities as a portraitist during the last decade of his life. Among the works of this type of the 1660s, his companion portraits of husband and wife, Jacob Trip and Margaretha de Geer (pages 206 and 207), stand out as being among the most arresting and authoritative.

Jacob Jacobsz. Trip (1575-1661) was a very wealthy Dordtrecht merchant who chiefly made his money from involvement in the family enterprise of manufacturing and dealing in armaments. Margaretha de Geer (1583-1672), who came from Liège, married him in 1603. Their portraits by Rembrandt, which were presumably executed during a visit the couple made to Amsterdam, are dated to about 1661 – the year of Jacob Trip's death when he was 86 years old, and when Margaretha de Geer was in her 78th year.

It has been suggested that the depiction of Trip may have been started after May of 1661, when he died, because although it is a penetrating study, it does not share the vitality displayed in the portrait of Margaretha.

With this in mind, a comparison of the techniques used for the two portraits is instructive. The male portrait shows a more economical and rapid style, whereas the female is more carefully worked over and labored. This distinction does not suggest that a different hand is responsible for one of the pictures, but is explicable if it is accepted that the *Jacob Trip* was painted posthumously from another portrait. The suggestion here is that the stimulus of a real face resulted in greater care (see Bomford 1989).

Both sitters are placed in an almost undefinable context. Jacob Trip, with his skeletal features the most precisely worked region of the canvas, stares to the left of the viewer. He is given by Rembrandt something of the abstracted authority found in portrayals of Venetian doges.

Margaretha de Geer, by contrast, confronts the onlooker directly, in a manner which recalls the artist's depiction of *Juno* (page 203). The effects of aging on her hands and face are depicted without compromise, and she wears clothes familiar to her; the large ruff and gown were fashionable about forty years before the work was painted.

Two of the sons of Jacob and Margaretha, Louis and Hendrick, followed in their father's footsteps and dealt successfully in armaments in Amsterdam. They had built for themselves between 1660 and 1662 a magnificent townhouse, the 'Trippenhuis', which was designed by Justus Vingboons. It is thought that the pendant portraits were probably commissioned by the two sons to hang in this building.

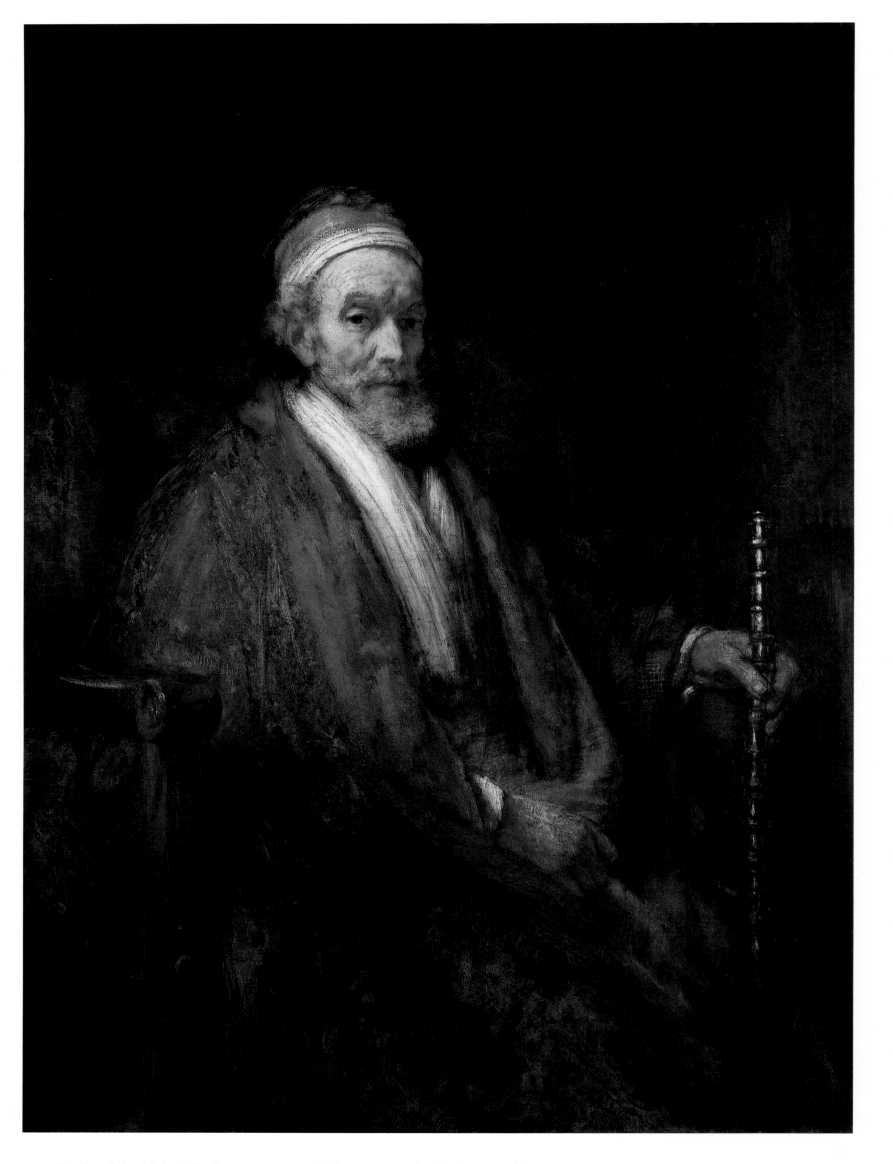

ABOVE Rembrandt *Jacob Trip*, 1661, oil on canvas, 51 × 37⅞ inches (130.5 × 97 cm), The National Gallery, London. This portrait, which was executed in the last year of the sitter's life, is a pendant to one of his wife (right), which is also in The National Gallery.

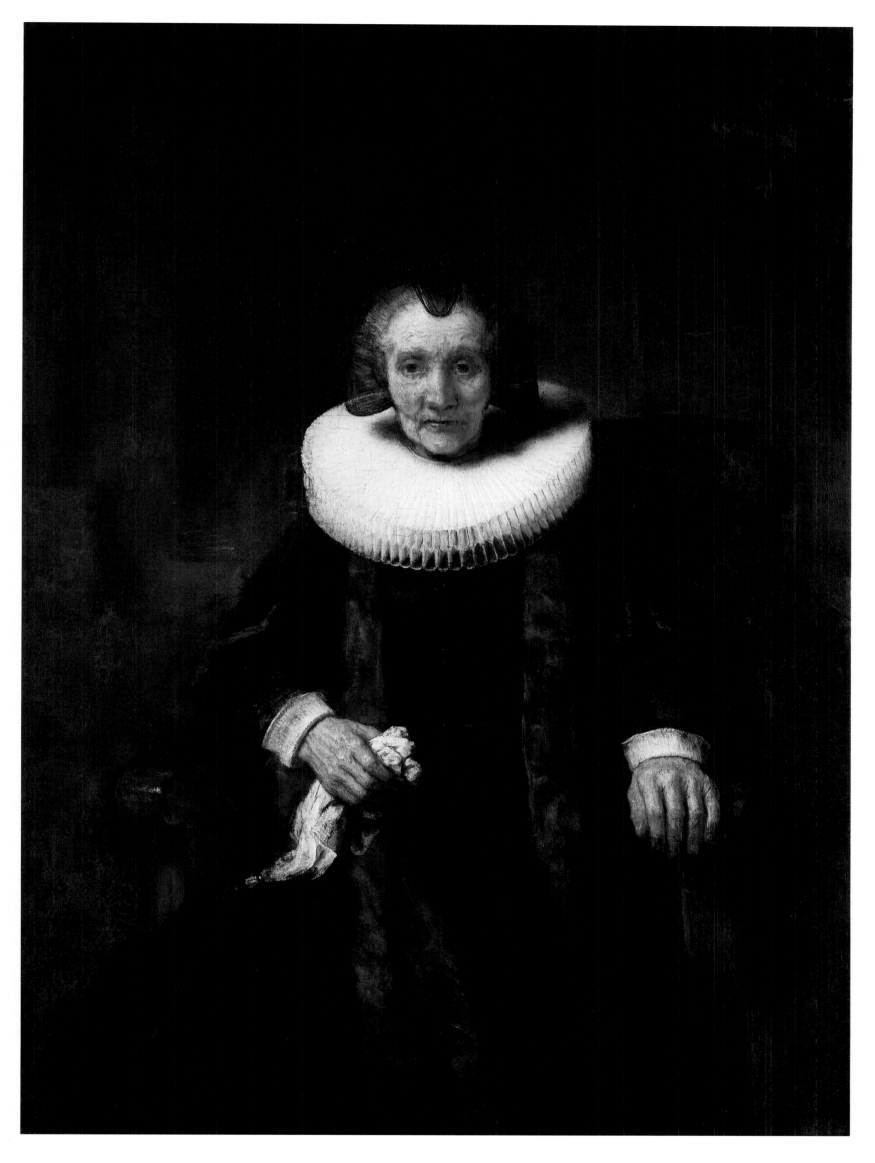

ABOVE Rembrandt *Margaretha de Geer*, 1661, oil on canvas, 51 × 38 inches (130.5 × 97.5 cm.), The National Gallery, London. The detail of the sitters hand clasping her kerchief adds a touch of urgency to the portrayal. Margaretha de Geer, who was 78 when this work was painted, was to live on however for another eleven years.

207

Rembrandt, *The Sampling Officials of the Drapers' Guild* (*The Syndics*), oil on canvas, 74¾ × 109 inches (191.5 × 279 cm), Rijksmuseum, Amsterdam. The picture was hung in the eighteenth century in the Staalhof, the meeting hall of the Drapers Guild.

Rembrandt's last group portrait, *The Sampling Officials of the Drapers' Guild* (*The 'Staalmeesters'*) (right), was painted in the following year, 1662. It has to be considered in the light of his earlier exercises in relating a number of figures in an interior in a complementary and visually stimulating arrangement. As with the *Anatomy Lesson of Dr Tulp* (page 61), the impression is given that the viewer has just entered the room inhabited by the sitters and interrupted their discussion.

The Sampling Officials were quality controllers for the dyed cloth produced by members of their guild. They were elected annually and such portraits as this were usually painted at the end of a period in office. Because the work is dated to 1662 it has been possible to establish who the sitters are by comparing the previous years guild records with the ages and status of the subjects. They are, from left to right: Jacob van Loon (born 1595); Volckert Jansz. (born *c*.1605-10); Willem van Doeyenburg (born 1615); Frans Hendricz. Bel (born probably 1629); probably Jochem de Neve (born 1629); and probably Aernout van der Mye (born *c*.1625).

Willem van Doeyenburg, who has before him the book which is likely to be filled with accounts, was the chairman of the samplers. The figure standing by the wall to the right of him, Frans Hendricz. Bel, was a servant; he wears a skull cap, rather than a hat of the type worn by the other men.

Three preparatory drawings related to the portrait are known. The one illustrated here (page 211), is a study for Jan van Looten, who is seated at the extreme left. It seems to be more a rehearsal for his pose, rather than his features, which it can be assumed were studied subsequently with the sitter before the canvas.

Numerous alterations, which are revealed by x-rays, were made to the composition on the canvas before

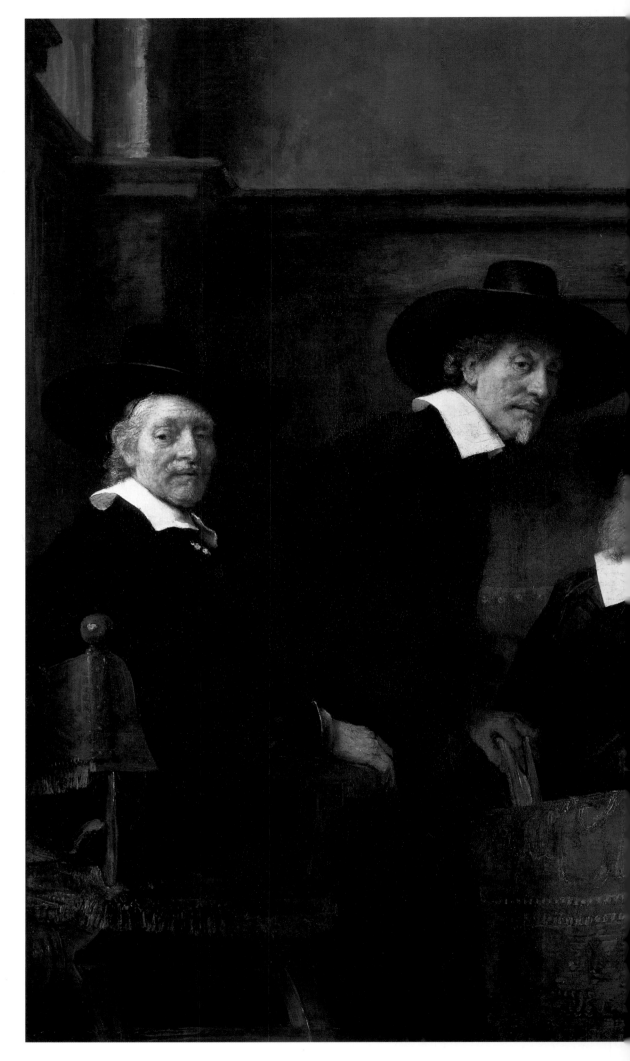

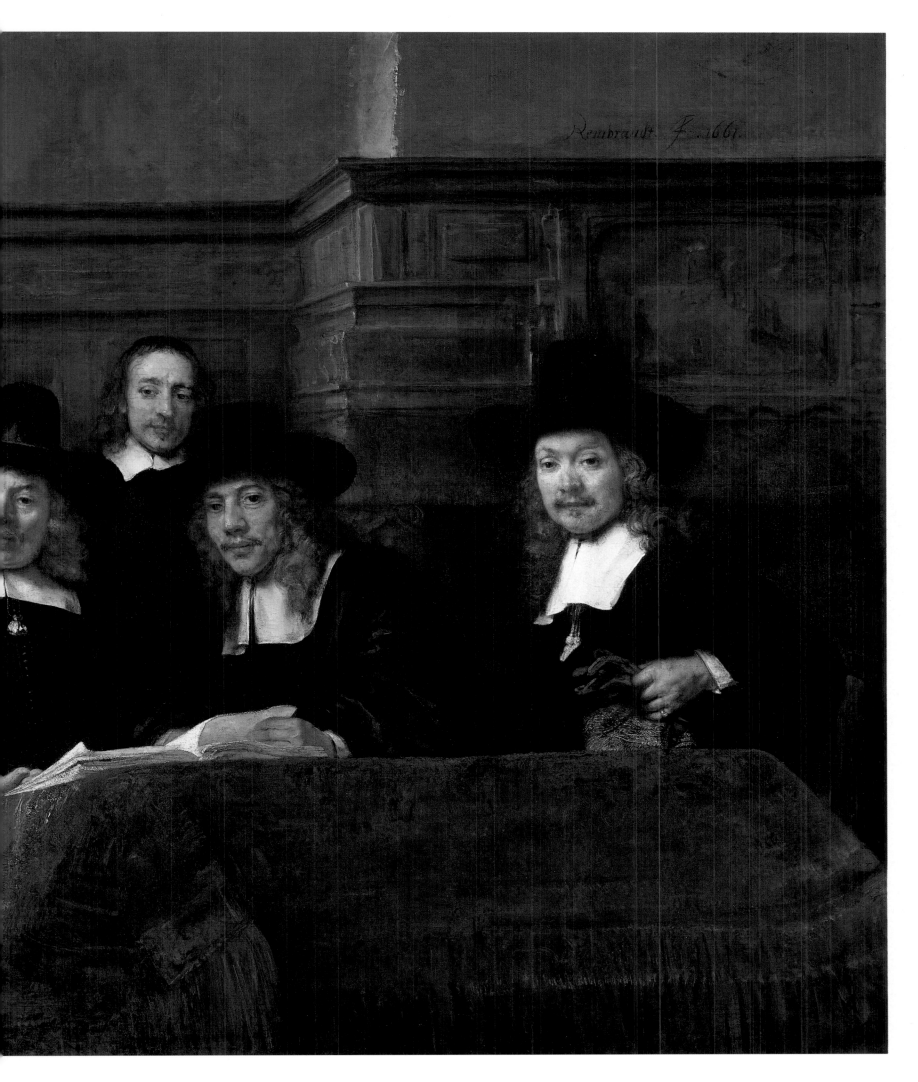

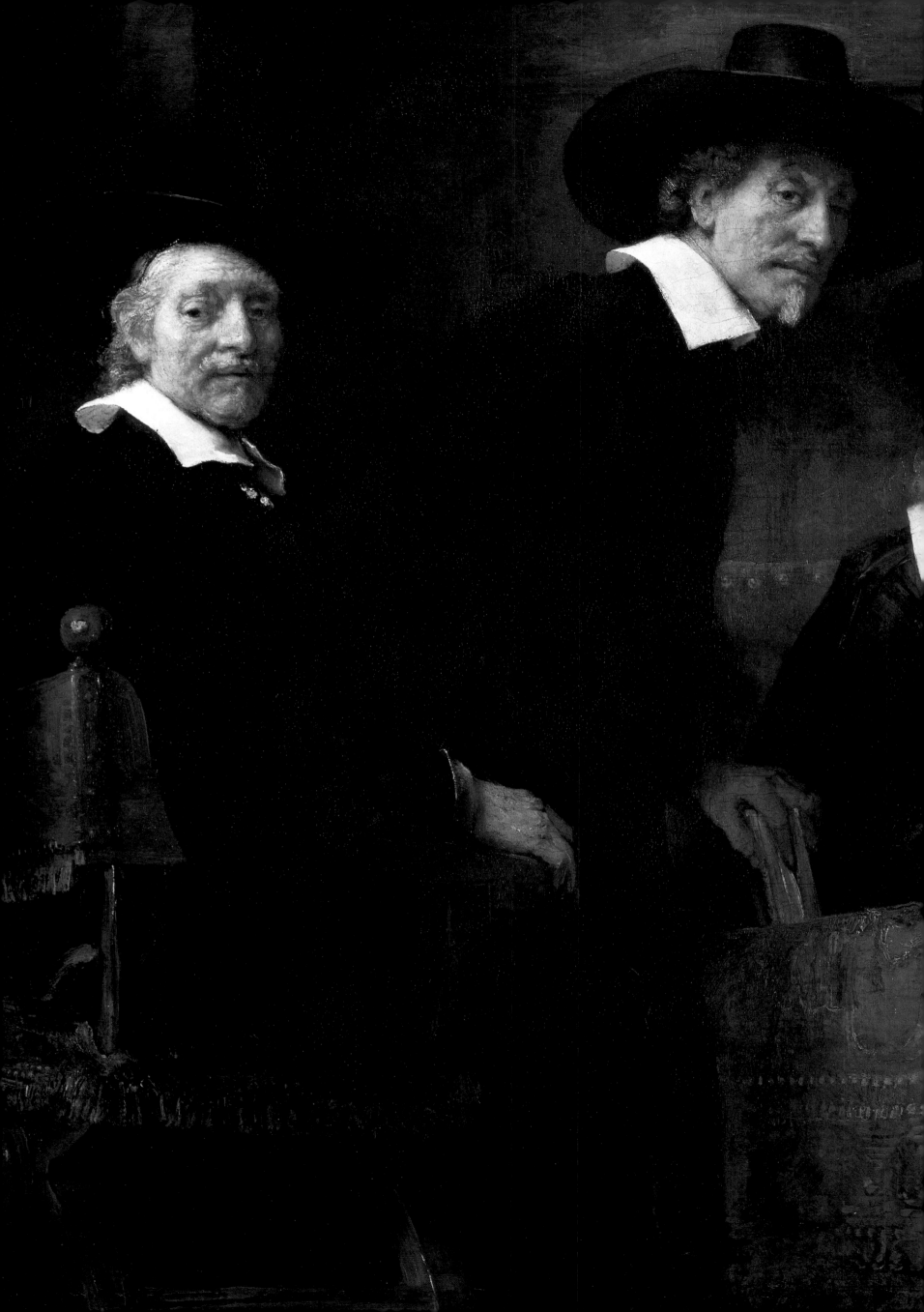

LEFT Details of *The Sampling Officials of the Drapers' Guild*, oil on canvas, 74¾ × 109 inches (191.5 × 279 cm), Rijksmuseum, Amsterdam.

BELOW Rembrandt *The Syndic of the Cloth Guild, Jacob van Loon, seated*, 1661-2, pen and brown ink heightened with white on paper, 76⅛ × 62½ inches (195 × 160 cm), Rijksmuseum, Amsterdam. A study, essentially for the pose, rather than the features, of the Syndic seated at the far left of the group portrait of the *Sampling Officials of the Drapers' Guild*.

Rembrandt was satisfied with it. Only at the fifth attempt at placing the servant was he willing to leave him.

It is not just the varied poses of the sitters which prevent the work from appearing too regimented. The accent of deep red on the carpet draped over the table effectively breaks up any monotony of color which might otherwise have been created by the preponderance of black and white.

According to an eighteenth-century description, the painting hung in the Staalhof (the hall of the Drapers Guild), in the Staalstraat, along with five other paintings of syndics, some of which dated back to the sixteenth century. It has been suggested that Rembrandt may have been aware of the site his work was intended to occupy, and that he took this into account when composing it. It may be that the panelling behind the figures in some way reflected the interior of the Staalhof, and it certainly appears that the perspective (particularly of the table) is arranged so as to be seen to the best advantage when the work is looked up at from below.

A painting, or bas-relief, is set into the panelling at the upper right. It is thought to have as its subject a beacon which guides ships to safety. This could be of relevance to the Samplers if vigilance and prudence are seen as virtues they would want to have associated with them. Previously Rembrandt had used a painting within a painting in a similar fashion, to expand on the general themes in a work (see *The Music Lesson*, page 25).

In about 1663 Rembrandt painted what is thought to be his only equestrian portrait (page 213).

The subject, Frederik Rihel, was depicted by the artist on a rearing grey horse, in a magnificent yellow and gilded outfit with a large white sash,

BELOW Rembrandt *A Coach*, c.1660-3, pen and brown ink with grayish brown wash on paper, 7½ × 9⅞ inches (19.3 × 25.4 cm), British Museum, London. This study can be tentatively associated with the coach that appears in the background at the lower left of the portrait of *Frederick Rihel on Horseback*.

which in part recalls that of the lieutenant in *The Night Watch* (page 136). He has a sword and pistol to hand and stares straight at the viewer; his pose is somewhat stilted and the depiction of the horse not nearly as successful as the accomplished portrayal of the man. This distinction has led to the suggestion that Rembrandt may have collaborated with an assistant on this work.

Rihel is taking part in a procession which winds back in an 'S' shape towards the left of the canvas. Behind him, at the right, is another horseman;

and at the left (from the bottom upwards), a stretch of water with the prow of a boat, a coach, illuminated from inside with three occupants, and behind the trees the façade of a building.

The depiction of the coach could be related to a drawing by Rembrandt now in the British Musuem (above), which shows a similar vehicle.

The rider, who was born in Strasbourg in 1621 and died in 1681, was a successful Amsterdam merchant. He appears to have had this work painted

to commemorate the part he played in the procession of the Prince of Orange into Amsterdam in 1660.

Rihel, who later became an official in the Civic Guard, was a keen horseman, who by having himself depicted in this manner was following a strong tradition of equestrian portraiture. Such imagery, particularly in terms of statuary, had originated in southern Europe in ancient times and spread across the continent. It remained however a rare form of portrayal in the United Provinces.

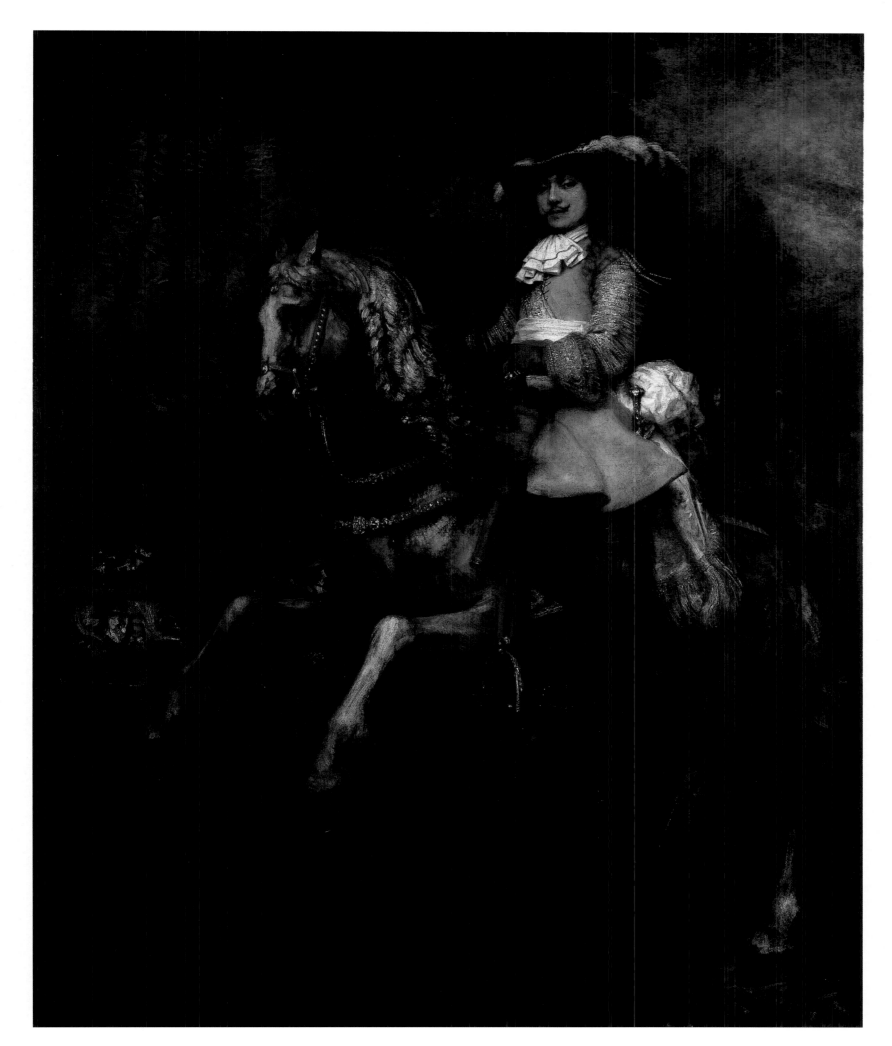

ABOVE Rembrandt *Frederick Rihel on Horseback*,
c.1633, oil on canvas, 115 × 94⅛ inches (294.5
× 241 cm), The National Gallery, London.
Equestrian portraiture was rare in the United
Provinces, and this is Rembrandt's only work
of this type.

213

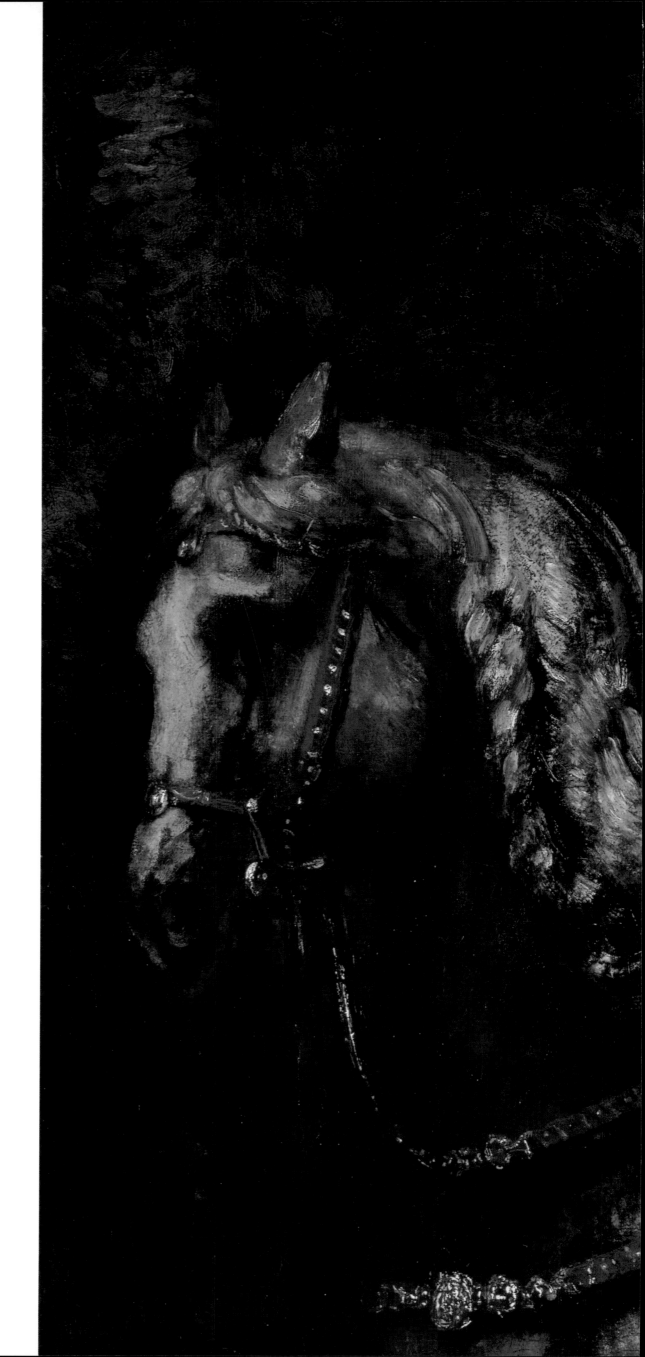

ABOVE Detail of *Frederick Rihel on Horseback*, *c.* 1633, oil on canvas, 115 × 94⅛ inches (294.5 × 241 cm), The National Gallery, London.

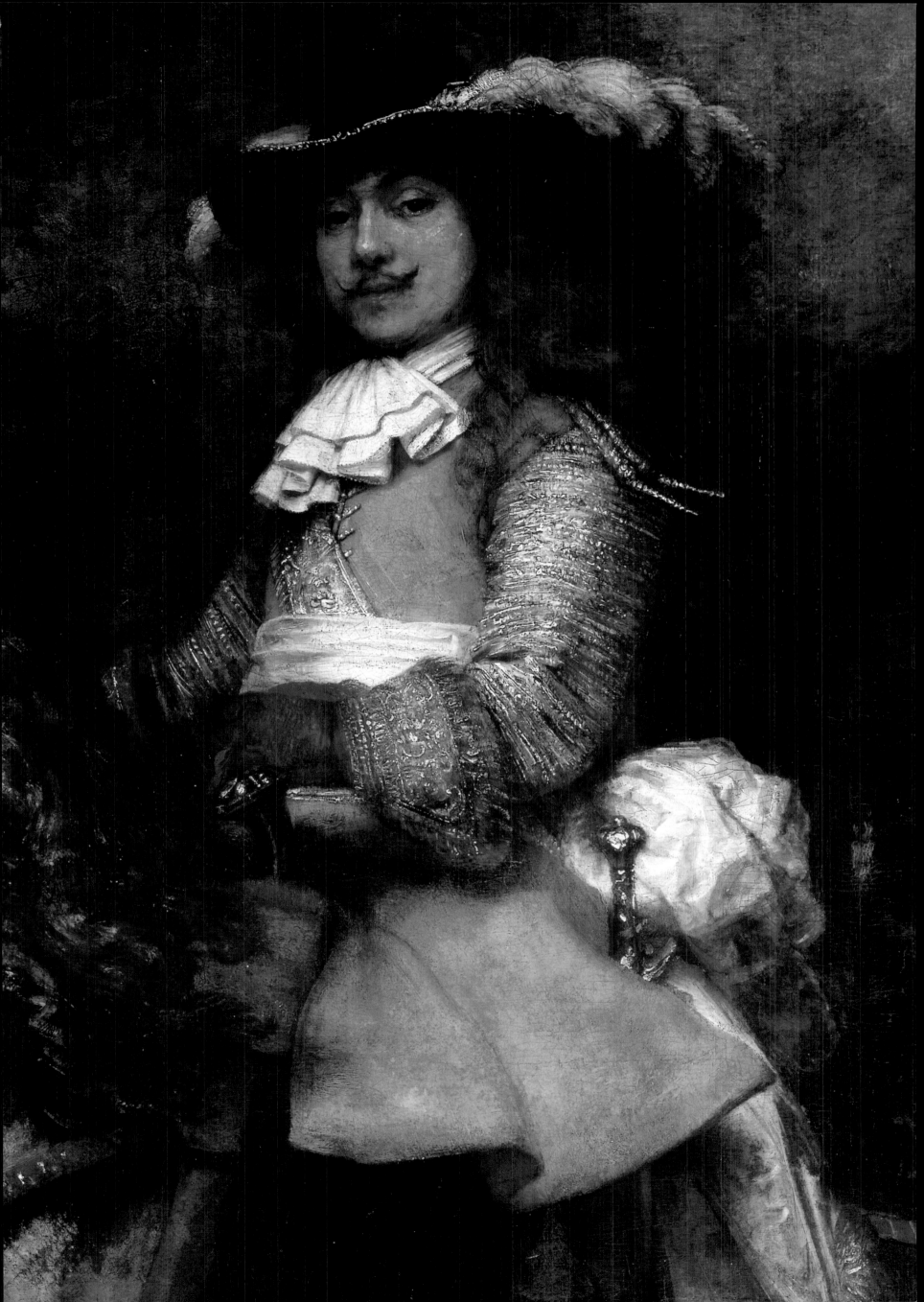

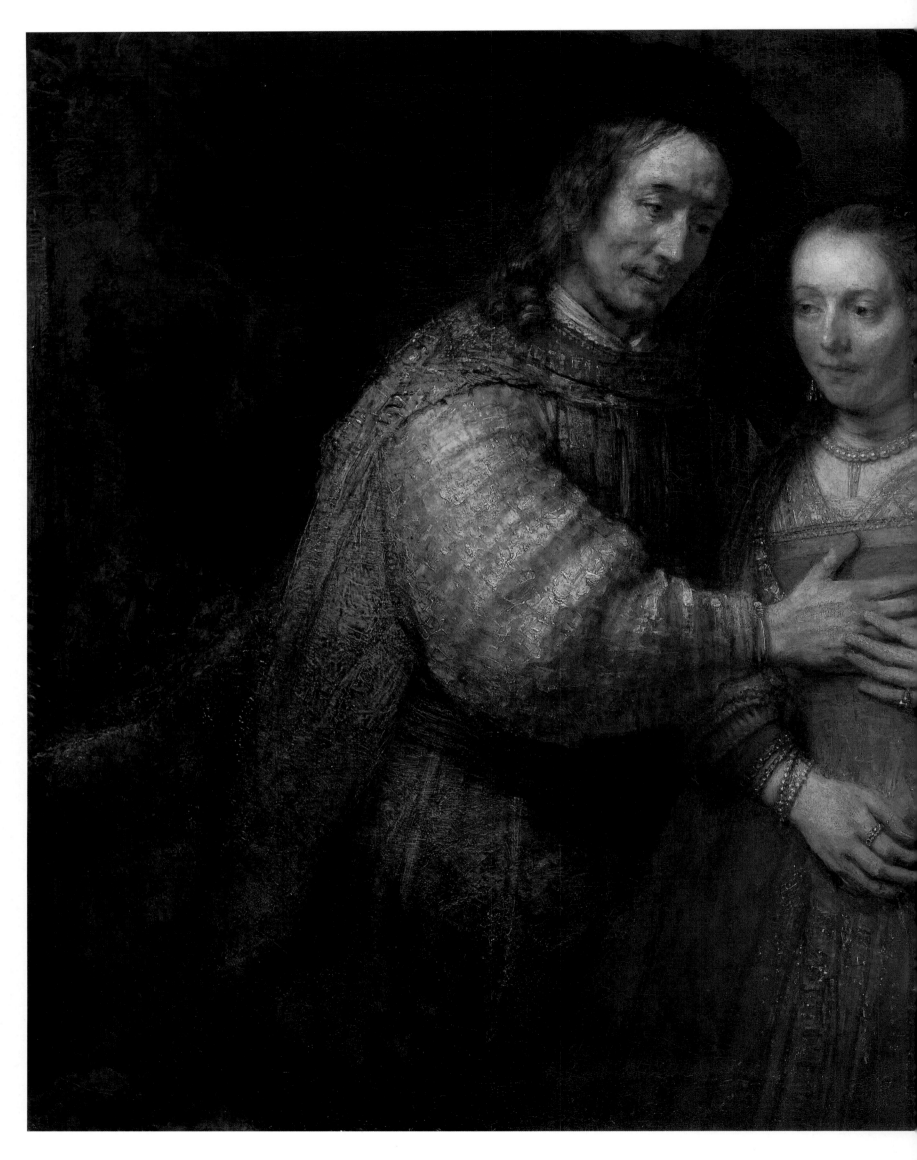

Rembrandt 'The Jewish Bride', c.1662, oil on canvas, 47½ × 65 inches (121.5 × 166.5 cm), Rijksmuseum, Amsterdam. Vincent van Gogh is reported to have said of this painting, that he would have given up ten years of his life in exchange for being allowed to sit before it for a fortnight.

The Jewish Bride

The Jewish Bride, of about 1665, like the *Night Watch*, bears a popular but apparently inappropriate title. The name appears to have been given to it in the nineteenth century when a number of paintings either by or associated with Rembrandt were described as depictions of Judaic subjects, in part perhaps because it had been established that the artist had links with the Jewish community in Amsterdam.

When given the title, the work was thought to be a depiction of a Jewish father placing a chain around the neck of his daughter on her wedding day. But there seems to be no justification for such a reading. What appears more likely is that the couple are either a husband and wife, or lovers.

Having established this, it is necessary to decide if they are in a double portrait in the conventional sense, a 'historiating' portrait, or a history painting. Claims have been made for all three possibilities. But all that can be said for certain is that while Rembrandt gives the characters of the figures a sense of individuality, the richness of their almost theatrical clothing suggests they represent characters from the Bible or another literary source, rather than being nameable individuals.

Identifications such as Isaac and Rebecca, and Cyrus and Aspasia have been proposed, but because they have not been greeted with widespread acceptance, the *Jewish Bride* label is usually retained for convenience.

It has been noted on a number of occasions how the artist made ingenious use in an eloquent fashion of the hands as well as the expressions of subjects in his works. Here they are used to convey tenderness, reassurance, and perhaps comfort at a time of loss.

The textures and colors of the clothes are defined so as to give them an almost

tangible richness. The succulent red of the dress of the woman and the glisten of the man's outfit are built up, often with a palette knife, in a constantly shifting series of rich tones and hues. The fluctuation creates a vibrancy which is ill-served by photographic reproduction, and has to be counted as one of Rembrandt's greatest exercises as a sensual colorist.

The same model used for the woman also appears in a depiction of a family group (pages 220-21) which is usually placed slightly later in the chronology of the artist's works. The forms here are even more freely defined.

It has been suggested that the family depicted may be of some of the artists's relatives, but there seems to be no particular justification for such an identification. Rembrandt so readily crossed the barriers between genre, portrait and history painting that it seems quite likely that, although the immediacy and intimacy expressed here is what you might expect from a portrait, this is actually a genre scene – an illustration of family life, rather than a depiction of a particular family.

LEFT Detail of *The Jewish Bride, c.* 1662, oil on canvas, 47½ × 65 inches (121.5 × 166.5 cm), Rijksmuseum, Amsterdam.

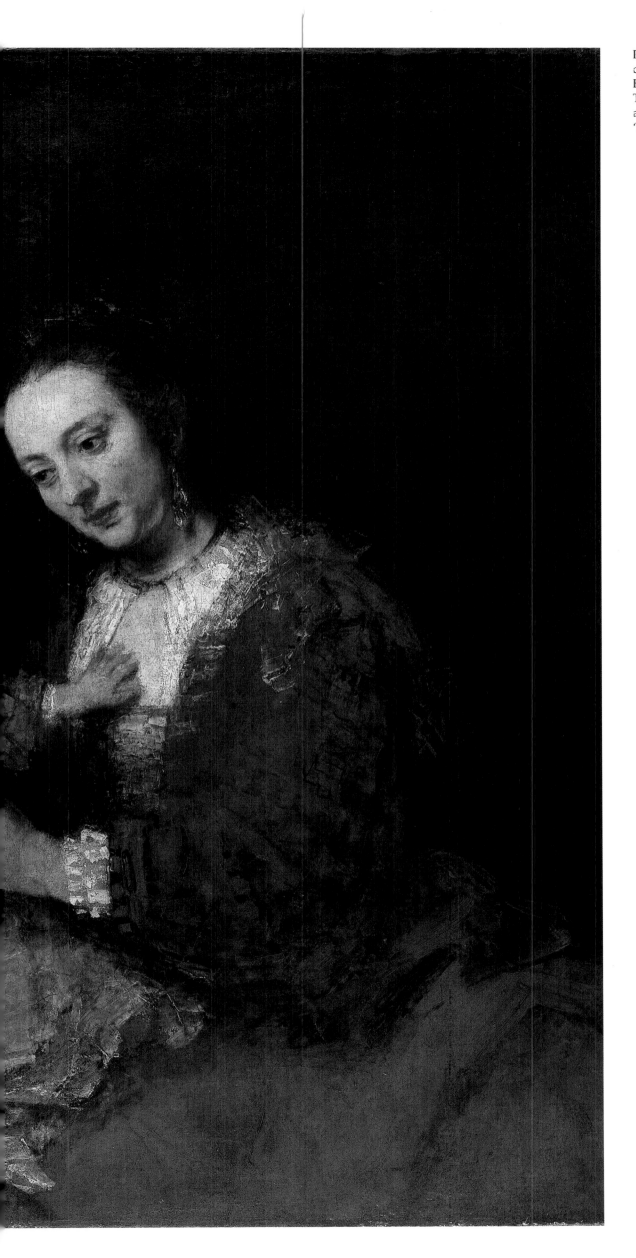

Rembrandt *A Family Group*, *c.*1663-8, oil on canvas, 49¼ × 65¼ inches (126-167 cm), Herzog Anton Ulrich-Museum, Braunschweig. The model for the woman in this painting appears to be the same that the artist used for '*The Jewish Bride*'.

RIGHT Rembrandt *Self-Portrait*, 1660, oil on canvas,Louvre, Paris. Not long after it was painted, this work entered the collection of King Louis XIV of France.

Last Self-Portraits

Rembrandt continued to depict himself right up until the end of his life. This process of self-scrutiny and commemoration appears to have been followed in an almost obsessive fashion.

During the 1660s he made two notable depictions of himself as an artist. The first, and more conventional of these, is a self-portrait of 1660 (right) which is in the Louvre, Paris. Rembrandt here shows himself, presumably in the process of painting this work, with a palette, brushes and maulstick in his hand. He is placed quite close to the support he works on at the right, and looks across at the mirror he must have used to create such an image. A composition of this type was employed by numerous artists of the period in their self-portraits.

No such conformity is displayed though in the second of these 'artist at work' portrayals. The slightly larger Kenwood *Self-Portrait* (page 225) of *c*.1661-2 is a bolder image which follows the grand manner of the Frick portrait discussed earlier (page 195). Rembrandt here appears more assertive – he is a painter and master of all he surveys, rather than just an artist at work.

This may have been the end result, but it appears that originally he intended to depict himself working, in a composition not too dissimilar to that of the Louvre picture. An x-ray of the painting reveals this scheme, which Rembrandt apparently felt the need to rethink.

The freedom and rapidity of the brushwork in its altered state brings animation to the portrayal. The way in which the handful of brushes, maulstick and palette are summarily defined provides a convincing sense of movement. It has been suggested that this area and other regions of the canvas are unfinished, but this seems an inadequate explanation for what are pic-torially successful effects, which in part recall the bravura of earlier portraits, such as that of *Jan Six* (page 169).

Admittedly the work is unsigned, and this might suggest that it is incomplete, but clear definitions of what is finished, as other artists might have intended, and what is resolved for Rembrandt are not easy to establish.

One passage of the work particularly effectively illustrates this problem. The right section of the turban has not been filled with white paint – the tan color beneath was left uncovered. This could be seen as being 'unfinished', but equally cannot be regarded as an oversight because it means that the shadow which runs up that side of the face is followed, so the darker tone beneath is consistent with the nature of the fall of the light, and helps establish the curved form of the headdress.

Whether or not finished, the work poses a more obvious conundrum in the function of the two half circles which are drawn on the canvas that is propped up behind the artist. Are they cabalistic signs, references to the classical artist Apelles, symbols which refer to perfection and therefore God, or the outline of a map of the globe? These possibilities, along with a number of others, have been woven around the portrait by art historians in a complex network of theories and counter theories, none of which have been universally accepted. The more esoteric they are, the more removed they seem to be from Rembrandt's pragmatism. It may be that he simply intended that the semicircles provide formal interest (which they certainly do), and that they were the first elements of the structure of the composition, its 'architecture', which he was currently working on. The mystery will no doubt remain and the painting retain some of its appeal because of it.

Such riddles over interpretation are not encountered in Rembrandt's *Self-*

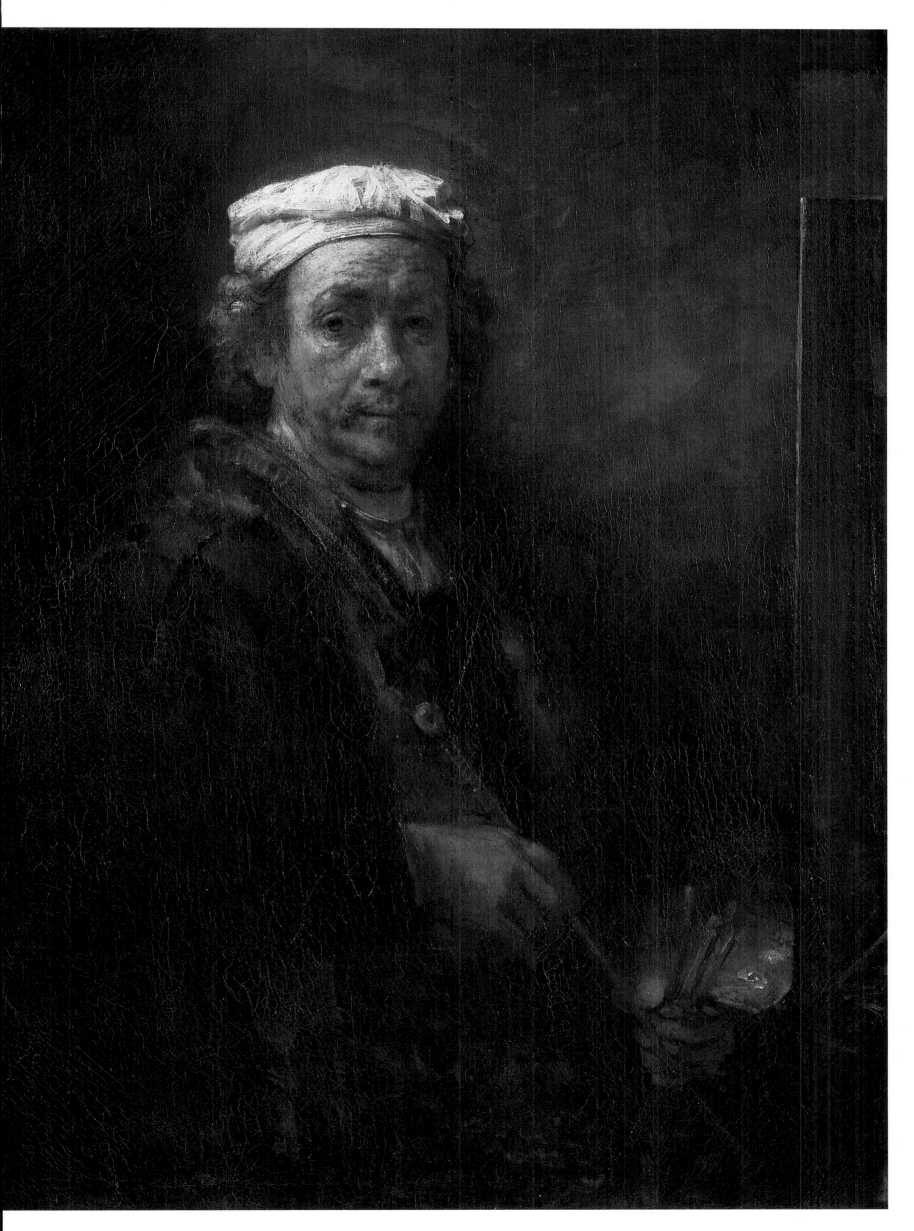

Portrait as the Apostle Paul (page 226) of 1661. The artist here has depicted himself in a *portrait historié*. Paul was not one of the original twelve Apostles but was regarded as a key founder, along with Peter, of the Christian Church. His teachings were particularly favoured by the Lutherans, and the attributes he was most commonly depicted with were a sword and book or scroll. Rembrandt has the handle of a sword emerging from his brown coat and holds a manuscript which appears to have Hebrew script written on it. His expression, which suggests both a state of questioning and innocence, appears to be part of the characterization of the saint, rather than the artist.

The last of Rembrandt's painted self-portraits, which date from the year of his death, 1669, are more straightforward, but no less poignant and humane. He remained unrelenting in his pursuit of studying the self, but in the final analysis removed the different persona of 'clown', 'artist', 'philosopher' and 'saint' he had previously adopted, and scrutinized in the mirror a vulnerable old man.

Two such works survive – one in the National Gallery in London, (page 227) which is probably the slightly earlier, and another in the Mauritshuis in The Hague (page 228), which can be claimed as his last painting of this type.

In the London picture the viewer continues to be confronted with a steady piercing gaze. The artist wears a deep red coat with fur trimmings and a beret upon his head. He is lit from above and clasps his hands at the right.

When the painting was cleaned in 1967 the broken signature and the date were revealed. X-rays show how the paint was built up in a manner characteristic of his late works, with a heavy use of lead white pigment below the top layers of paint used for the face and beret. They also reveal how in this, as in

so many of his other pictures, the painter changed his mind half way through its development. Initially he planned to have a much larger beret, similar to that in the Kenwood painting (right), and depict his hands open rather than clasped.

The Mauritshuis self-portrait shows a man in his sixty-third year who seems to have aged rapidly if a comparison is made with his appearance in the London picture, which at the very most can only have been painted ten months earlier. The brushwork and control of tone and hue are not, however, those of a man who was infirm. The ruddy face, straggling white hair and beret with its gash of orange are established with consummate assurance.

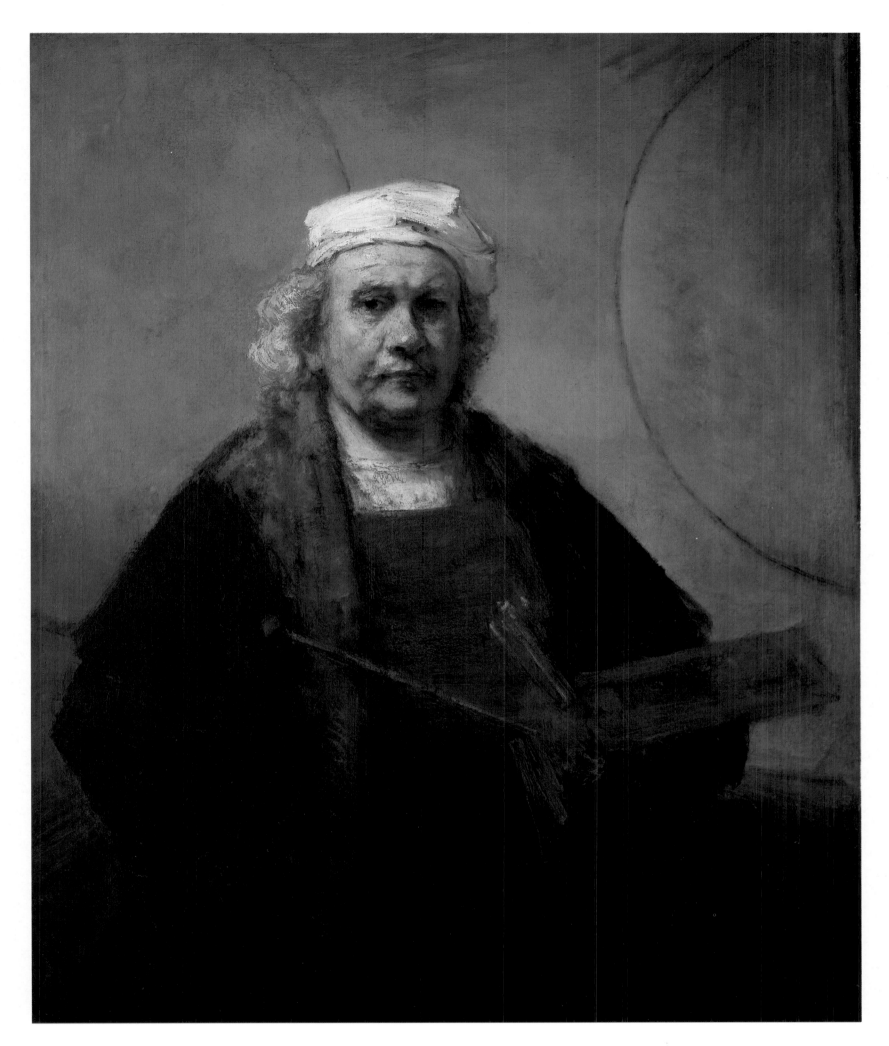

ABOVE Rembrandt, *Self-Portrait*, *c*.1661-2, oil on
canvas, 44⅝ × 37⅛ inches (114.3 × 95.2 cm),
The Iveagh Bequest, Kenwood House,
London. This, one of the greatest of all
Rembrandt's self-portraits, continues to retain
secrets. No one has yet found a convincing
explanation for the two curved lines marked
on the canvas which is propped up behind the
artist.

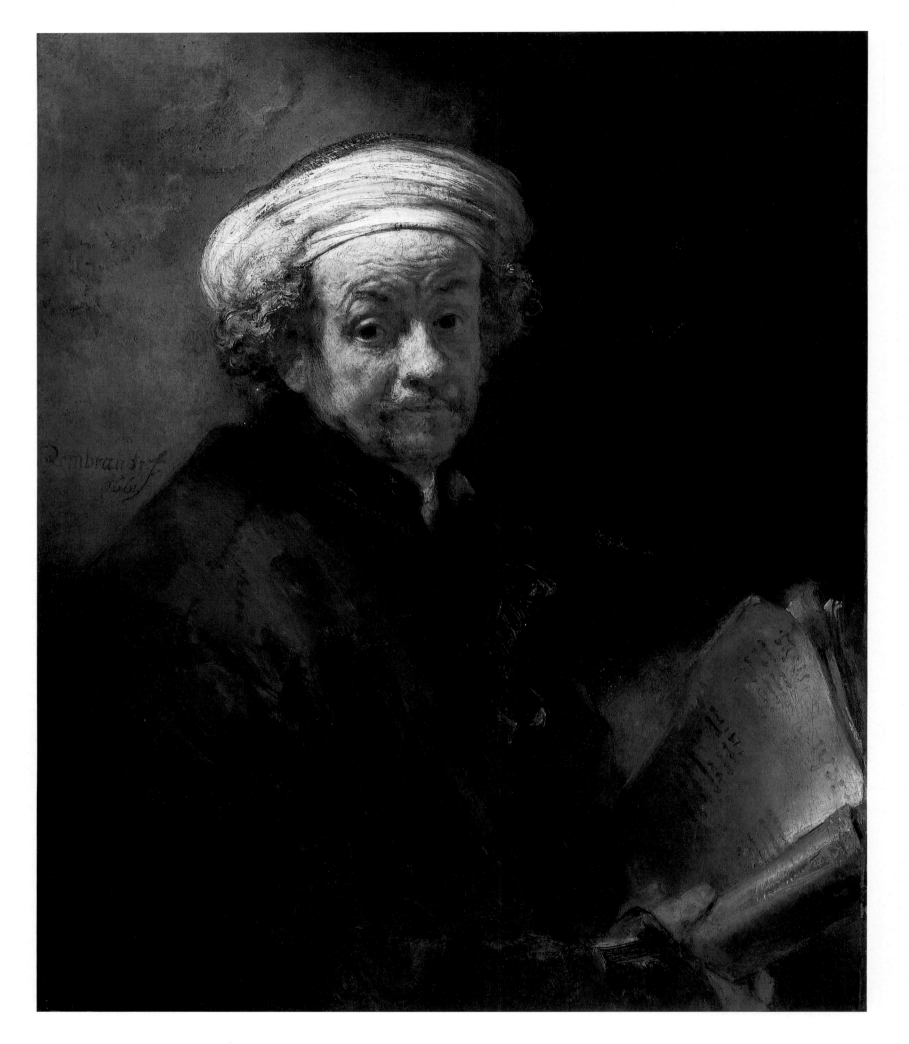

ABOVE Rembrandt *Self-Portrait as the Apostle
Paul*, 1661, oil on canvas, 35½ × 30 inches (91 ×
77 cm), Rijksmuseum, Amsterdam. It was
somewhat unusual for an artist to depict
himself in the guise of a saint. The painter
provides clues to his adopted identity by
having the hilt of a sword emerging from his
coat, and clasping a scroll – both attributes of
the Apostle Paul.

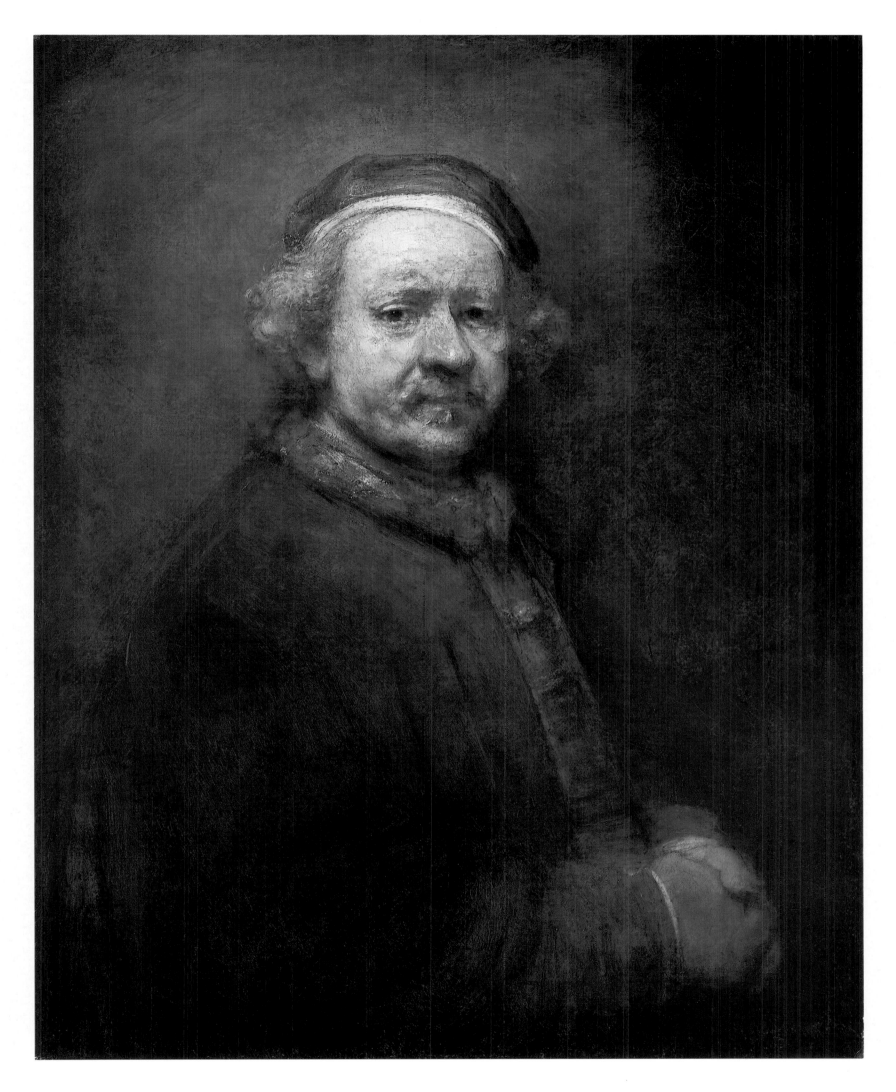

ABOVE Rembrandt *Self-Portrait*, 1669, oil on
canvas, 33½ × 27½ inches (86 × 70.5 cm), The
National Gallery, London. The antiquarian
George Vertue described this work in 1722 as *'a
fine head of Rhinbrants'*. It was bought by the
National Gallery at an auction in London in
1851 for 10 guineas.

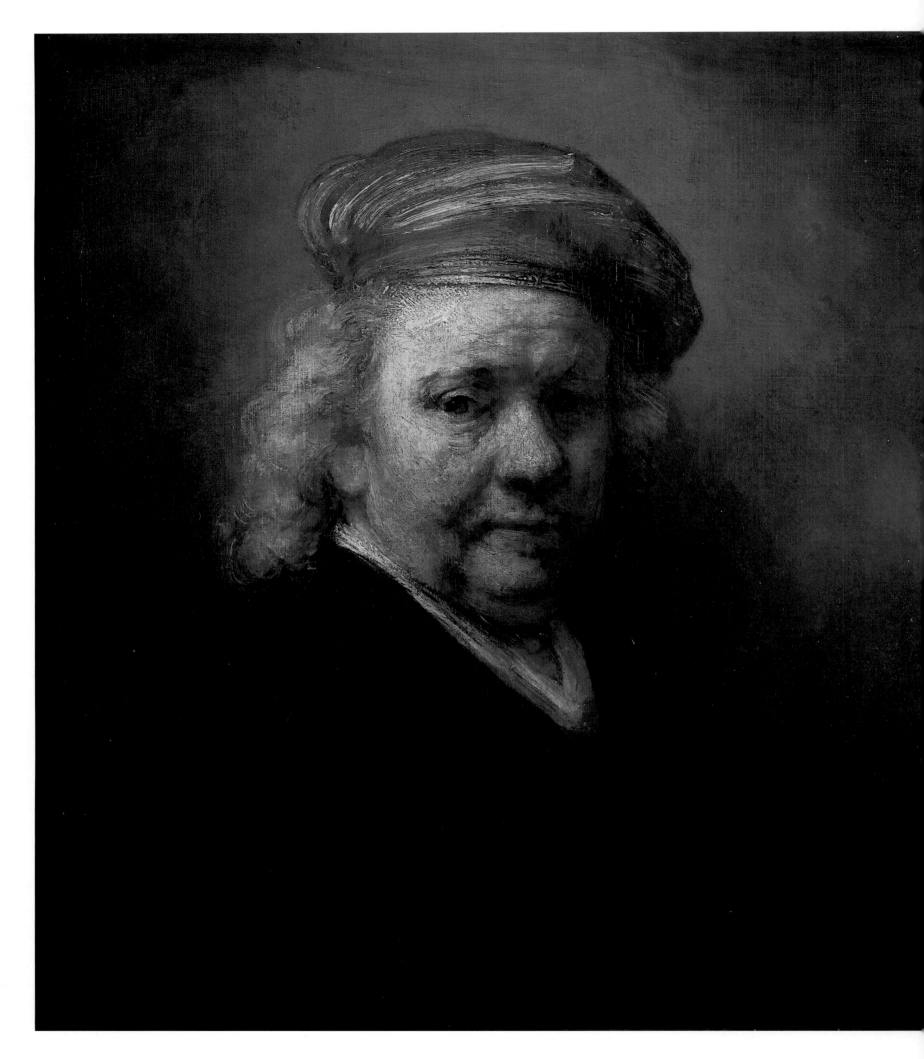

Rembrandt's Death

In 1668 Rembrandt's son Titus married a woman called Magdalena van Loo, who came from a family the artist had been friendly with for some years. Six months later Titus died, possibly of the plague, and was buried in the West-erkerk. So Rembrandt survived his companion Hendrickje and his son. He did live to see the birth of his only legiti-mate grandchild, however, because Magdalena had a daughter who was named after her father, Titus, and bap-tised as Titia on the 22nd of March 1669.

Rembrandt himself died on 4 October of the same year, at the age of 63. No record of the cause of death has been found. Four days later he was buried in the Westerkerk (page 13). The Register of Burials for the church records that there were 16 pall bearers at the funeral, but includes no descrip-tion of the precise site of the grave, which has not been located.

The number of bearers suggests that this was no paupers' burial, but it

BELOW Rembrandt *Death Appearing to a Wedded Couple*, 1639, etching (only state), 4¼ × 3 inches (10.9 × 7.9 cm), Museum het Rembrandthuis, Amsterdam. Images such as this reflect a common preoccupation in Netherlandish art of the sixteenth and seventeenth centuries – to remind the viewer of the brevity and transience of human life.

appears that the artist was not mourned by the populace of Amsterdam. There was no public expression of loss for the man who was to become the city's most celebrated inhabitant.

An inventory of his belongings was made on the day after his death. Rembrandt's possessions seem to have consisted predominantly of household goods – a meager record of material circumstances by comparison with the luxuries listed in the inventory of 1656. There were also, tantalisingly, some unfinished paintings among the furnishings, and a few other artworks, which show the artist could not resist to continue collecting. Magdalena had the more valuable items sealed in three rooms in the house.

She died in October of 1670, having ensured that the contents of the building were taken away in the name of her daughter, Titia, who lived on until 1715, as the last surviving member of the family.

One final question about Rembrandt's relations remains – what happened to Cornelia, his illegitimate daughter by Hendrickje Stoffels? The little that is known of her life seems to provide a fitting conclusion to an account of her father's. She married a painter, and had two children whom she named after her parents, Hendric and Rembrandt.

Rembrandt only depicted Death once, thirty years earlier in an etching dated to 1639 (right). In this work he showed a young optimistic couple, elegantly dressed in sixteenth-century clothes, greeting the grim reaper. He is conventionally represented as a skeleton who holds a scythe and an hourglass, and rises from beneath the earth to beckon them.

Afterword

Rembrandt is so deeply mysterious that he says that for which there are no words in any language.

Vincent Van Gogh, October 1885

There is a considerable degree of truth in Van Gogh's observation. To try and fully explain Rembrandt's achievement is in the first instance an uphill, and ultimately an impossible, task. But while it is clear that the elusive, or 'mysterious' quality of his work is central to its appeal, it is also true that this can be effectively complemented by studies of his preoccupations, methods and context.

Such research has, in recent years, sharpened a dulled image of the artist which had been cultivated because of the familiarity in reproductions of his paintings, and an often unquestioning view of his genius.

A Rembrandt who can be understood within a specific social and political environment has emerged thanks to careful reading of documentary material and a close analysis of his subjects. Such an artist is offset against what might be called a technological Rembrandt – a figure whose working methods have been elucidated as a result of the scrutiny of the physical nature of his pictures.

This more sustainable perception, which is still evolving, is the latest episode in the story of how the artist has been critically received – a rolling narrative that has been shaped by swings in taste and the development of new forms of art history.

Although he died unfêted and relatively poor, during much of his life Rembrandt was admired and could claim a European reputation. Subsequently praise for him grew and reached new heights in the eighteenth century when the dissemination of his work led to frequent imitation. The literature of the time tended to cultivate an ethereal, unfocused view of his greatness, which is perhaps only now being abandoned.

The first moves away from this were made with the more systematic approach of professional art historians of the nineteenth century, which resulted in methodical cataloguing of Rembrandt's work. (The painter also took on a new persona at the time as a hero of Dutch rationalism).

With the increasing specialization of art history in the twentieth century, progressively detailed studies of style, iconography and technique, as well as archival discoveries, have been published. These have formed the background to a more rigorous approach to cataloguing which has radically reduced the number of works attributed to the artist, as opposed to his numerous pupils and followers.

This process has, since the 1960s, culminated in the findings of the *Rembrandt Research Project*, the work of a group of eminent Dutch academics, who more rigorously than anyone else hitherto have set themselves the task of establishing which paintings are by Rembrandt. Their combination of connoisseurship and technical analysis, set out in a published *Corpus* (see Bibliography), is coming to form the basis of all future appraisals of him.

It has not, however, nor was it intended to, provide that elusive thing, a 'definitive' view of the artist. Establishing facts such as what sort of fibers make up one of the his canvases, or the date of the baptism of his maternal grandmother, creates a web of certainty around Rembrandt's work, but in no way diminishes the enduring and 'deeply mysterious' force which many continue to perceive at its center.

LEFT: Rembrandt *Flora*, 1635, oil on canvas, 48¼ × 38 inches (123.5 × 97.5 cm), The National Gallery, London.

Appendices

1. Printmaking

The incomparable Reinbrand, whose Etchings and gravings are of a particular spirit
John Evelyn, 1662

In order to appreciate Rembrandt's achievement in this field it is necessary to know something of the processes he employed. Although the artist is often described as an etcher, he actually made prints using three techniques, by etching, and by engraving either with a burin, or in drypoint. Rembrandt sometimes used these techniques in isolation, and on other occasions combined them.

Etching and engraving are categorised as intaglio forms of printmaking. 'Intaglio' is the Italian word for carving. Such techniques involve either cutting, scratching or biting with acid into the surface of a smooth metal plate, which is then inked and printed from.

Etching

An etcher uses chemicals to erode marks into metal. This procedure appears to have been initially developed not for printmaking, but for the decoration of armor in the Middle Ages. Etched plates were probably first used to print from in the late fifteenth century.

To make an etching the artist would have to take a thin copper sheet (the 'plate'), which had been prepared by being smoothed and cut to the desirable size. The plate would then be covered with an acid-resistant layer of resin and wax (the 'ground'). Various tools, such as needles, could then be used to make incisions in the ground, so exposing parts of the copper beneath, although leaving them untouched by the needle.

The plate is then immersed in a mild solution of acid. The acid bites into the exposed areas of metal, but leaves unscathed those covered by the ground.

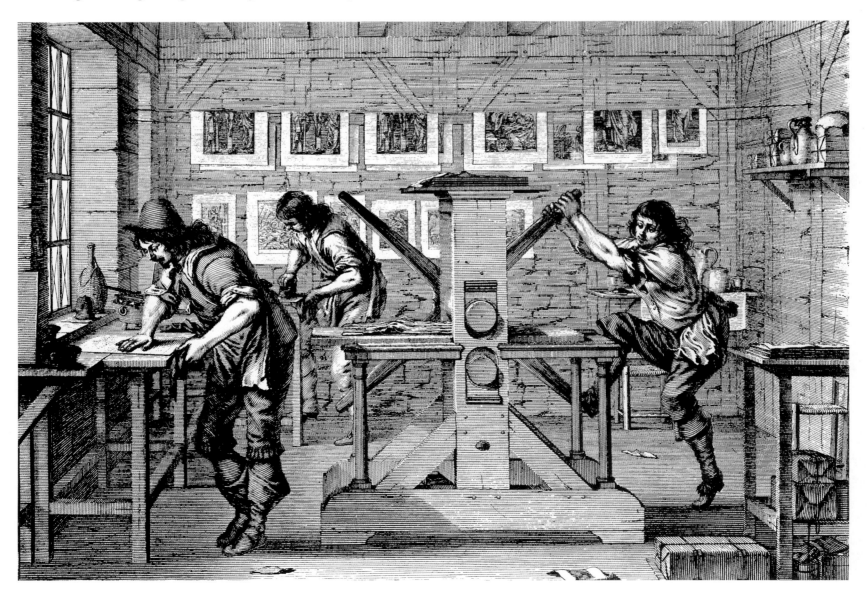

ABOVE Rembrandt *An Elephant*, c.1637, black chalk and charcoal on paper, 7 × 10 inches (17.9 × 25.6 cm), British Museum, London. In this study of a female elephant the artist brilliantly recorded the craggy texture of the skin, and bulk of the animal. An elephant called *Hansken* had been imported to Holland by 1641, and this may be the creature Rembrandt depicted.

LEFT Abraham Bosse, *A Printer's Workshop*, 1642, etching, Museum het Rembrandthuis, Amsterdam.

The extent to which the plate is bitten can be controled by the strength of the acid, and the length of time the plate is left immersed.

Once the plate is removed from the bath, the remaining ground is taken away, and it is wiped clean. It can now be inked with a roller. The ink rests in the channels which have been bitten into the copper.

Excess ink is then removed, and a dampened piece of paper is finally placed upon the plate. The two are pressed together under great pressure, and by this means the design initially marked by the artist into the ground is transferred to the paper. An impression is said to have been 'pulled' from the plate.

Because creating the print reverses the design, the artist has sometimes to conceive compositions in reverse in the first instance, as they are 'corrected' in the printing.

It is important to emphasize that because of the malleability of the ground, considerable freedom, akin to drawing, which allows for both fluid and subtle linear design, can be exploited when making an etching.

If particularly fine lines are required, then the plate can be removed from the acid bath after a short period, and the areas in question 'stopped out' with ground before re-immersion. This means that they will later take up less ink.

The composition can be quite extensively reworked, on a number of ocassions if the artist chooses. Each different development of the print is called a 'state'.

Drypoint and Burin

The drypoint and burin are tools which can be used to carve, or engrave lines directly on to the plate.

The drypoint is a sharp needle which, as it passes through the metal, throws up the copper it has gouged out on either side of the line made; this residue is called a 'burr'. As well as the incised line, the burr retains ink during printing, and creates a rich, velvety mark on the paper. This type of mark, which is quite unlike thinner etched lines, can be used to create pictorial effects that are not otherwise achievable. After a few impressions are made, however, the burr wears away.

The burin is a lozenge-shaped chisel that can be pushed across a copper plate in order to incise or engrave a design. The lines it creates are cleaner and crisper than those made with drypoint, and do not leave a burr. Plates that have been worked with a burin therefore produce a larger number of similar impressions than are obtainable from drypoint.

2. Chronology

Political Events	Rembrandt's Life
1606	15th July (according to Orlers, 1641), Rembrandt was born in Leiden, the son of Harmen Gerritsz van Rijn, and Cornelia Willemsdochter van Zuytbroek.
1609 Outset of the Twelve Years Truce with Spain.	Rembrandt is educated at the Latin school in Leiden.
1618-20	
1620 Pilgrim Fathers depart for the New World.	May, Rembrandt enrols as a student at Leiden University, at the age of 14.
*c.*1620-3	According to Orlers, Rembrandt became a pupil of Jacob Isaacsz van Swanenburg of Leiden.
1621 Dutch West India Company established. End of Twelve Years Truce.	
1624	Rembrandt studies under Pieter Lastman in Amsterdam for about 6 months.
1625 Frederik Hendrik becomes Stadholder.	Rembrandt establishes his own studio back in Leiden. *The Stoning of Saint Stephen* (Musée des Beaux-Arts, Lyons).
*c.*1626	Rembrandt comes into close contact with Jan Lievens (1607-74) who was also a former pupil of Lastman; they probably share a studio.
1629	Constantijn Huygens, secretary to the Stadholder visits Rembrandt and Jan Lievens. In a written account (his autobiography) of the meeting Huygens praises the artists and says that he suspects they will have successful careers. *Judas and the Thirty Pieces of Silver* (Private Collection, Great Britain).
1630	April, Rembrandt's father, Harmen Gerritsz van Rijn, dies.
1631-2	Winter, Rembrandt moves to Amsterdam. He is last recorded in Leiden in June 1631, and first documented in Amsterdam in July of 1632. The artist enters the art dealership of Hendrick van Uylenburgh, with whom he lodges in the city. He invests 1000 guilders in the business and moves to Uylenburgh's house in Sintanthonisbreestraat. *Portrait of Nicolaes Ruts* (Frick Collection, New York).
1632	*The Anatomy Lesson of Dr. Nicolaes Tulp* (The Mauritshuis, The Hague).
1633	Rembrandt starts painting scenes from the life and Passion of Christ for the Stadholder, Frederik Hendrik. The commissions for these pictures runs on until 1646.
1633	June 8th, Rembrandt is betrothed to Saskia von Uylenburgh (1612-42), the daughter of a former burgomaster of Leewarden, and cousin of the art dealer Uylenburgh.
1634	June 22nd Rembrandt marries Saskia van Uylenburgh at Sint-Annaparochie, near Leewarden. The artist becomes a citizen of Amsterdam and a member of the local Guild of Saint Luke. *Ecce Homo* and *Portrait of an 83 Year Old Woman* (both, The National Gallery, London).
1635	Rembrandt's first son Rombartus is born; he is baptised on 15th December, but dies in infancy, and is buried on February 15th.
1636	*Portrait of Philip Lucasz, Saskia van Uylenburgh in Arcadian Costume, Belshazzar's Feast* (all The National Gallery, London) *The Blinding of Sampson* (Stadelsches Kunstinstitut, Frankfurt) *Danaë* (The Hermitage, St Petersburg).
1638 Marie de Medici, is given a state reception in Amsterdam.	22nd July, baptism of a second child, Cornelia. She dies and is buried on August 13th.
1639	12 January, Rembrandt and Saskia move to a large house in the Sintanthonisbreestraat. *The Death of the Virgin* (print).
1640	Rembrandt's mother dies, she is buried on the 14th of September in Leiden. 29th July, baptism of a third child, called Cornelia II (buried 12th August, 1640). *Self-Portrait aged Thirty-Four* (The National Gallery, London).
1641	Titus, Saskia and Rembrandt's only child to survive from infancy is born. He was baptised on 22nd Sept. *The Windmill* (print).

Political Events		Rembrandt's Life
1642		14th June, Saskia dies. She is buried in the Oude Kerk.
		'The Night Watch' (Rijksmuseum, Amsterdam).
1643		*The Three Trees* (print).
1644		*The Woman Taken in Adultery* (The National Gallery, London).
1646		*The Adoration of the Shepherds* (The National Gallery, London).
		Winter Landscape (Gemäldegalerie, Kassel).
1648	Treaty of Münster, the Eighty Years War is concluded, and Spain recognizes the complete independence of the United Provinces. Work starts on Amsterdam's new Town Hall.	
1649		Geertje Dircx, who earlier joined Rembrandt's household as a nurse, and then became the artist's lover, is expelled and given a financial settlement. Hendrickje Stoffels (*c.*1625-63) is first recorded as living in his house on the 1st October at the age of 23.
		Financial problems develop. Geertje Dircx is detained.
1650		
1650-72	First period without a Stadholder.	
1652-4	First Anglo-Dutch War.	
1653		Rembrandt is forced to borrow from friends in order to meet obligations.
		Aristotle Contemplating the Bust of Homer (The Metropolitan Museum of Art, New York)
		The Three Crosses (print)
1654		Hendrickje Stoffels is summoned before the church council in Amsterdam. She bears Rembrandt their only child, a daughter called Cornelia, who is baptised on the 30th of October.
		Portrait of Jan Six (Six Foundation, Amsterdam)
		A Woman Bathing (The National Gallery, London)
1655		*Titus at His Desk* (Museum Boymans-van Beuningen, Rotterdam).
		The Anatomy Lesson of Dr Joan Deyman (Rijksmuseum, Amsterdam).
1656		Rembrandt was granted a *Cessio bonorum*, a form of voluntary bankruptcy. An inventory of the contents of his house were drawn up by the Court of Insolvency.
1658		1st February, the house in the Sintanthonisbreestraat is auctioned for 11,218 guilders. Rembrandt moves to house on the Rozengracht in the Jordaan district of Amsterdam.
1660		Rembrandt receives praise from the artist Guercino.
		Hendrickje and Titus form a company, employing Rembrandt and selling his pictures.
1661		*Portrait of Jacob Trip, Portrait of Margaretha de Geer* (both, The National Gallery, London).
1662		*The Sampling Officials of the Drapers Guild* (Rijksmuseum Amsterdam). *The Conspiracy of Julius Civilius* (Nationalmuseum, Stockholm).
1663		21st July, Hendrickje Stoffels dies, on the 24th she is buried in the Westerkerk.
		Homer Dictating to a Scribe (The Mauritshuis, The Hague).
1665-7	Second Anglo-Dutch War.	
1667		29th December, Prince Cosimo de Medici visits Rembrandt.
1668		10th February, Titus marries Magdalena van Loo, but six months later dies, and is buried on 7th of September. Magdalena bears a daughter, Titia, who is baptised on the 22nd March 1669.
1669		*Self Portrait at 63* (The National Gallery, London)
		Self Portrait with a Turban (The Mauritshuis, The Hague)
		4th October, Rembrandt dies, on the 8th he is buried in the Westerkerk, Amsterdam.
1672	France invades Holland. The Stadholder William III comes to power (in 1688 he becomes William III of England).	
1672-74	Third Anglo-Dutch War.	
1713	Treaty of Utrecht; end of the War of the Spanish Succession. The southern Netherlands pass to Austria.	
1795	French Revolutionary troops help establish the Batavian Republic.	
1806	Establishment of the Kingdom of the Netherlands, with Louis Napoleon head of state.	
1813	Netherlands liberated; the north and south are united to form a Kingdom.	
1839	Final division between independent Belgium in the south, and the northern Kingdom of the Netherlands.	

BELOW Rembrandt *A Bearded Man in a High Cap*,
c.1633-5, pen with brown ink and brown wash
heightened with white on paper, 6⅝ × 4⅞
inches (17 × 12.5 cm), British Museum,
London.

Select Bibliography

The Rembrandt literature is enormous and rapidly growing. This bibliography is intended as an introduction to some of the more useful and accessible aspects of it. For more detailed bibliographies, see particularly the *Corpus*, Brown 1991, and Royalton-Kish 1992.

Alpers, S., *The Art of Describing – Dutch Art in the Seventeeth Century*, London, 1983, (republished 1989).

Alpers, S., *Rembrandt's Enterprise – The Studio and the Market*, London, 1988.

Bazelair, M. and Starcky, E., *Rembrandt et son école, dessins du Musée du Louvre*, Paris, 1988 (exhibition catalogue).

Bevers, H., Schatborn, P., and Welzel, B., *Rembrandt: the Master and his Workshop – Drawings and Etchings*, London, 1991, (exhibition catalogue).

Blyth, D., *Amsterdam, Rotterdam and The Hague*, London, 1992, (travel guide).

Bomford, D., Brown, C., and Roy A., *Art in the Making – Rembrandt*, London, 1989, (National Gallery exhibition catalogue).

Brown, C., et al., *Art in Seventeenmth Century Holland*, London, 1976, (National Gallery exhibition catalogue).

Brown, C., *Dutch Paintings*, London, 1983 (National Gallery).

Brown, C., *Dutch Landscape, The Early Years, Haarlem and Amsterdam 1590-1650*, 1986, (National Gallery exhibition catalogue).

Brown, C., Kelch, J. and van Thiel, P., *Rembrandt: the Master and his Workshop – Paintings*, London, 1991, (exhibition catalogue).

Bruyn, J., Haak, B., Levie, S. H., van Thiel, P. J. J., and van der Wetering, E., *A Corpus of Rembrandt Paintings*, 1982-, The Hague, Boston and London, (to date 3 volumes have been published: I, 1625-31 (1982), II, 1631-34 (1986), III, 1635-42 (1989).

Cabanne, P., *Rembrandt*, Paris, 1991.

Chapman, H. P., *Rembrandt's Self-Portraits, A Study in Seventeenth-Century Identity*, Princeton, 1990.

Clark, K., *Rembrandt and the Italian Renaissance*, London, 1966.

Clark, K., *An Introduction to Rembrandt*, (reprinted 1978).

Corpus, see Bruyn et al., 1982-.

Foucart, J., *Les peintures de Rembrandt au Louvre*, Paris, 1982.

Freedberg, D., *Dutch Landscape Prints of the Seventeeth Century*, London, 1980, (British Museum).

Fuchs, R. H., *Dutch Painting*, London, 1978 (reprinted 1989).

Giltaij, J., *The Drawings by Rembrandt and his School in the Museum Boymans-van Beuningen*, Rotterdam, 1988.

Gregory, J., and Zdanowicz, I., *Rembrandt in the Collections of the National Gallery of Victoria*, Melbourne, 1988.

Haak, B., *The Golden Age – Dutch Painters of the Seventeenth Century*, New York, 1984.

Haverkamp-Begeman, *Rembrandt: The Nightwatch*, Princeton, 1982.

Hind, A. M., *Rembrandt's Etchings*, London, 1912, (two volumes).

Holtrop, M., Schatborn, P. and Ornstein-Van Slooten, E., *The Rembrandt House - the prints, drawings and paintings*, Amsterdam, 1991.

Kitson, M., *Rembrandt*, Oxford, 1969, (revised 1982).

MacLaren, N., (revised and expanded by Brown, C.), *The Dutch School 1600-1900 (National Gallery Catalogue)*, London, 1991, (2 volumes).

McNeil Kettering, A., *The Dutch Arcadia, Pastoral Art and Its Audience in the Golden Age*, New Jersey, 1983.

Rosenberg, J., Slive, S. and ter Kuile, E. H., *Dutch Art and Architecture 1600-1800*, London, 1966 (latest revised reprint 1991).

Royalton-Kisch, M., *Drawings by Rembrandt and his Circle in the British Museum*, London, 1992, (exhibition catalogue).

Schatborn, P., *Drawings by Rembrandt and his anonymous pupils and followers in the Rijksmuseum*, Amsterdam, 1985.

Schneider, C. P., *Rembrandt's Landscapes*, Yale University, 1989.

Schuma, S., *The Embarrassment of Riches – An Interpretation of Dutch Culture in the Golden Age*, London, 1987, (reprinted 1991).

Schwartz, G., *Rembrandt, His Life, His Paintings*, 1985, Netherlands (reprinted 1991).

Schwartz, G., *The Dutch world of painting*, 1986, Amsterdam, (Vancouver Art Gallery exhibition catalogue).

Starcky, E., and Bazelaire, M., *Rembrandt et son école, dessins du Musée du Louvre*, Paris, 1988, (exhibition catalogue).

Slive, S., *Rembrandt and his Critics*, The Hague, 1953.

Strauss, W. L. and Van der Meulen, M. et al., *The Rembrandt Documents*, New York, 1979.

Tomes, J., *Blue Guide – Holland*, 1987, London, (reprinted 1989).

Tümpel, C., *Rembrandt*, Amsterdam, 1986.

Vels Heijn, A., *Rembrandt*, London, 1989.

Vogelaar, C. et al, *Rembrandt and Lievens in Leiden*, Leiden, 1991, (exhibition catalogue).

Wheelock, A. K., *Vermeer*, London, 1988.

White, C., *Rembrandt as an Etcher – A study of the artist at work*, London, 1969, (2 volumes – text and plates).

White, C., *The Dutch Pictures in the Collection of Her Majesty the Queen*, Cambridge, 1982.

White, C., *Rembrandt*, London, 1984, (reprinted 1989).

Williams, J. L., *Dutch Art and Scotland – A Reflection of Taste*, 1992, (National Gallery of Scotland exhibition catalogue).

Index

Acknowledgements

The author would like to thank Alison Brooks for her patience and numerous improvements to the text; Lynda Stephens for suggestions about the introduction; Aileen Reid for her editorial work; Suzanne O'Farrell for picture research; Susan Lovelock for hospitality in Amsterdam; and Dr Christopher Brown, Nicola Kalinsky and Elspeth Hector for help in a number of other ways. The publisher would like to thank Martin Bristow, who designed this book, and the following agencies, individuals and institutions for supplying the illustrations:

Alte Pinakothek, Munich/Artothek: pages 83, 107, 109, 110, 111, 112, 123

Armand Hammer Collection, Armand Hammer Museum of Art and Cultural Center, Los Angeles: page 203

Ashmolean Museum, Oxford: page 37

Bibliothèque Nationale, Paris: page 135

Cleveland Museum of Art, Cleveland: page 146 (purchase from the J H Wade Fund)

Collection of the Duke of Buccleuch and Queensberry KT, Drumlanrig Castle, Dumfries and Galloway: page 167

Courtesy of the Trustees of the British Museum: 1, 35 (both), 52 (left), 70 (above), 72, 73, 75, 79, 82, 87 (above). 92 (above right), 99, 100, 101 (both), 105, 106, 116 (below), 119 (above), 125 (both), 126, 128 (left and below), 131, 132, 143, 144, 152, 153, 154, 155, 158, 159, 163, 168, 172, 180, 181, 182, 183, 184-185, 186, 192, 212, 233, 236, 240

Courtesy of the Trustees of the National Gallery, London: pages 7, 12, 13, 18-19, 23, 41, 58 (above), 64, 65, 70 (below), 71, 74, 78, 88-89, 90-91, 113, 117, 157, 171, 175, 206, 207, 213, 214-15, 227, 230

Dulwich Picture Gallery, London: page 145

Fitzwilliam Museum, Cambridge: page 9

The Frick Collection, New York: pages 58 (above), 195

Gemäldegalerie, Museen Preussischen Kulturbesitz, Berlin: pages 28-29, 76, 148-89, 173

Gemäldegalerie, Dresden: page 102

Gemäldegalerie, Kassel: pages 66, 121, 150-51, 190-91

Gemeentelijke Archiefdienst, Amsterdam: page 56

Gemeentelijke Archiefdienst, Leiden: page 14

J Paul Getty Museum, Malibu: page 47

Glasgow Museums; Art Gallery and Museum, Kelvingrove: pages 96, 104

Hermitage Museum, St Petersburg/Bridgeman Art Library: page 81

Herzog Anton Ulrich-Museum, Brunswick: pages 220-221

Historisches Museum, Amsterdam: page 197

Huntarian Museum and Art Gallery, University of Glasgow: page 81

Isabella Stewart Gardner Museum, Boston: page 86

The Iveagh Bequest, Kenwood House, London: page 225

Koninklijk Paleis te Amsterdam: pages 200-201

Kunsthistorisches Museum, Vienna: pages 40, 193

Kupferstichkabinett, Staatliche Museen Preussischer Kulturbesitz, Berlin: pages 69 (below), 114, 193

Los Angeles County Museum of Art: page 42 (Gift of H R Ahmanson and Co in memory of Howerd F Ahmanson)

Maurithuis, The Hague: pages 2, 36, 54, 60-61, 164, 228

The Metropolitan Museum of Art, New York: page 93 (Bequest of William Kijk Vanderbilt, 1920), 160-61 (Purchased with Special Funds and Gifts of Friends of the Museum, 1961), 165 (Gift of Archer M Huntington in memory of his father Collis Potter Huntington)

Minneapolis Institute of Arts: page 204 (The William Hood Dunwoody Fund)

Musée des Beaux-Arts, Lyon: page 22

Musée Jacquemart André, Paris: page 30-31

Musée du Louvre/Réunion des Musées Nationaux: pages 6, 32-33, 51 (below), 52 (right), 77 (above), 92 (below right), 97, 128 (top), 130, 187, 188-89, 222-23

Museum Boymans-van Beuningen, Rotterdam: pages 69 (above), 108, 116 (right), 176

Museum of Fine Arts, Boston: page 38-39 (Zoe Oliver Sherman Collection. Given in memory of Lillie Oliver Poor)

Museum het Pinsenhof, Delft: page 59

Museum het Rembrandthuis, Amsterdam: pages 8 (both), 20, 24, 51 (above), 57, 80, 87 (below), 92 (left), 98, 115, 124, 127 (below), 133, 170, 229, 232

Museum and Art Gallery, Brighton: page 43

National Gallery of Dublin, Ireland: page 122

National Gallery of Scotland, Edinburgh: pages 23, 147, 194

National Gallery of Victoria, Melbourne: page 27

Nationalmuseum, Stockholm: pages 68, 198-99

Library of the Ossolinski Institute, Polish Academy of Arts and Sciences: page 127 (above)

© **The Pierpoint Morgan Library, New York, 1993:** page 118

Private Collection: pages 44-45

Rijksmuseum, Amsterdam: pages 10-11, 15, 25, 26, 34, 48, 49, 53, 84, 119 (below), 120, 129, 136-137, 138-139, 141, 177, 178-179, 208-209, 210, 211, 213, 214-215, 216-217, 218-219, 226

Royal Collection, Buckingham Palace. © 1993 Her Majesty The Queen: pages 62-63, 85, 142

Royal Collection, Windsor Castle. © 1993 Her Majesty The Queen: page 50

Six Collection, Amsterdam: page 169

Staatliche Gräphische Sammlung, Munich: page 200

Städelsches Kunstinstitut, Frankfurt: pages 94-95

Stedelijk Museum 'de Lakenhal', Leiden: page 17

Teylers Museum, Haarlem: page 77 (below)

Tiroler Landesmuseum Ferdinandeum, Innsbruck: page 46